VERITAS

The Ewers-Tyne Collection of Worcester Porcelain at Cheekwood

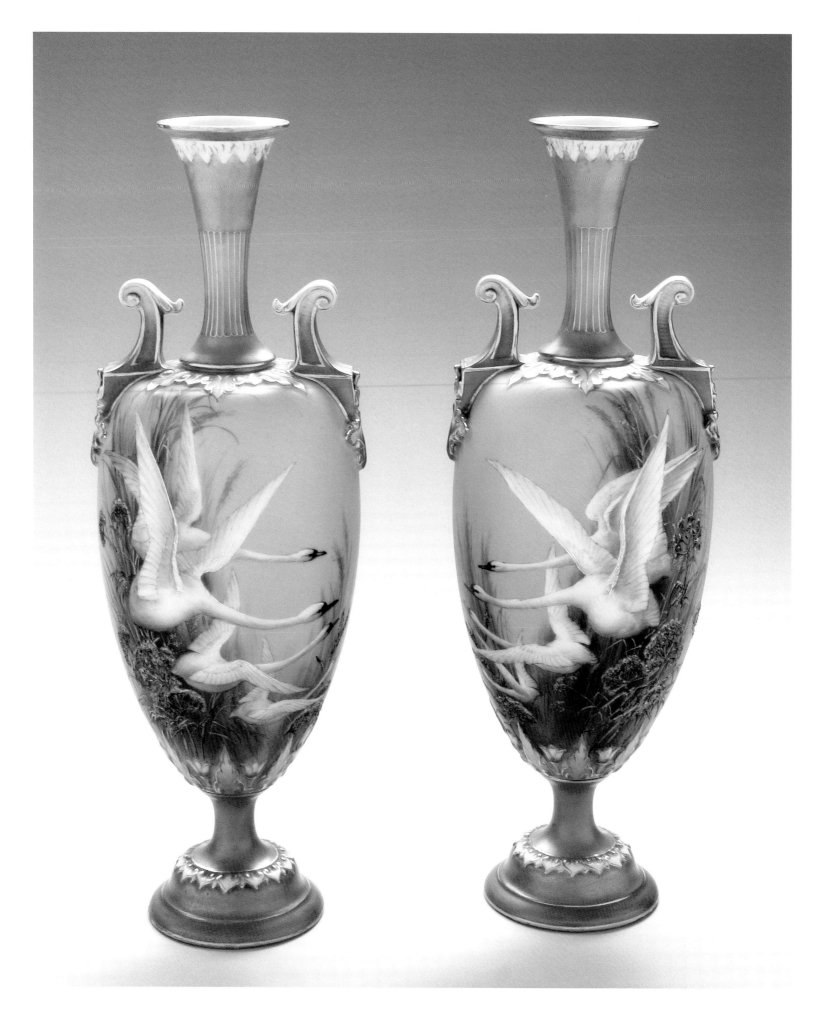

THE EWERS-TYNE COLLECTION OF WORCESTER PORCELAIN AT CHEEKWOOD

John Sandon

Antique Collectors' Club

Hardback

ISBN: 978-1-85149-558-0

Paperback

ISBN: 978-1-85149-559-7

British Library Cataloguing-in-Publication Data

A catalogue record for this book is available from the British Library

Printed in China

for the Antique Collectors' Club Ltd., Woodbridge, Suffolk

Frontispiece: Pair of vases by Charley Baldwyn. See catalogue no. 138.

CONTENTS

ABOUT CHEEKWOOD

Within its fifty-five acres, Cheekwood is an institution rich with history, beautiful gardens and fine art collections. The history of Cheekwood is intimately interwoven with the growth of Nashville, the Maxwell House coffee brand and the Cheeks, one of the city's early entrepreneurial families. During the first decades of the twentieth century, Leslie Cheek invested in the Cheek-Neal Coffee business, later known as Maxwell House coffee. When the business sold in 1928 to Postum (now General Foods), Leslie and his wife Mabel took their proceeds and purchased one hundred acres in West Nashville and built their dream house which became known as Cheekwood. The couple hired New York residential and landscape architect, Bryant Fleming, to create the 30,000 square-foot Georgian-style mansion complemented by formal gardens. The house was deeded to the Cheeks' daughter, Hulda, and her husband Walter Sharp who later donated Cheekwood to become a botanical garden and art museum that opened to the public in 1960. Over the years Cheekwood has become of one of Tennessee's greatest cultural treasures. In the renovated Cheek Mansion, visitors today discover an art museum holding important collections of fine and decorative arts, and outdoors they encounter a diverse array of gardens and botanical collections. Accredited by the American Association of Museums and listed on the National Register of Historic Places, Cheekwood offers visitors a unique indoor and outdoor experience of art and gardens.

ACKNOWLEDGEMENTS

This book is a testimony to nearly thirty years of collecting Worcester porcelain at Cheekwood and there are a number of people who have helped to make this book a reality. First and foremost, a very special thanks to Dr. E. William and Marge Ewers. The Ewers started the collection in the 1970s and since then have nurtured this collection to the point that warrants this fine book. The Ewers were also the major underwriters of this publication and without their leadership neither the collection nor the book would be here today. Another individual instrumental in the building of this collection was Harriet Tyne, who was a long time supporter of Cheekwood and the porcelain collection. Her bequest to Cheekwood helped provide funding for this important book.

A book project needs many champions and Cheekwood was fortunate that Lillias and William Johnston were early supporters. A porcelain lover, Lillias has been one of its most devoted advocates. Significant support provided by William J. Tyne Jr., the son of Harriet Tyne, made possible the photography of the collection. The Henry Laird Smith Foundation made a generous contribution and Mrs. Laird Smith had been a long time supporter of the porcelain collection at Cheekwood. Additional support was provided by Patricia Hart and Nancy Keene Palmer. Cheekwood wishes to acknowledge all that Michael Ryan King has done in support of this project and the development of this collection. The Cheekwood Board of Trust also deserves recognition for their stewardship of Cheekwood and this collection over the years.

The initial proposal for this book came from Lisa Porter, then Associate Curator of Decorative Arts at Cheekwood. She undertook significant study of the collection and helped to define the direction of the book and Cheekwood gratefully acknowledges her efforts. Building upon this initial research, noted porcelain scholar, John Sandon, brought his years of expertise to writing this book. His scholarship elucidates the beauty, design, and importance of these objects within the context of porcelain production and European decorative arts. Cheekwood was also fortunate to enlist the noted Worcester scholar, Henry Sandon, to write a history of the factory. Henry Sandon played a crucial role in the forming of the Cheekwood collection acting as a curatorial consultant giving his advice to Cheekwood over the course of many years.

The production of this book would not have been possible without the efforts of several Cheekwood staff members. In particular, Kaye Crouch deserves special thanks for orchestrating the photography of the collection, working closely with the author, and handling a multitude of details associated with this book. Additional staff support was provided by Todd McDaniel, Patrick DeGuira, and Taylor Linnehan. Special thanks to the Nashville photographer Bill Lafevor, and to Peter Greenhalf and Janet Pollard of Greenhalf Photography. Cheekwood thanks Diana Steel, Prim Elliott and Craig Holden at the Antique Collectors' Club for their collegial partnership on this book.

Over the years many individuals have supported the porcelain collection at Cheekwood. We acknowledge all of the donors to the Worcester collection below.

Anonymous donors
Mr. and Mrs. Charles Atwood
Mr. and Mrs. David Paul Banks, Jr.
Mrs. Martin S. Brown
Dr. and Mrs. Benjamin H. Caldwell, Jr.
Mr. and Mrs. Paul V. Callis
Mr. and Mrs. Monroe Carell, Jr.
The estate of Jeffrey S. Childs
Mr. and Mrs. Thomas K. Connor
Mr. Michael Corzine
Mrs. Wayne T. Delay and William DeLay
Mr. and Mrs. P.M. Estes, Jr.
Dr. and Mrs. E. William Ewers
The Ewers Acquisition Fund
Mr. and Mrs. Rufus E. Fort, Jr.

Mr. and Mrs. James Fowler
Mrs. Robert Goodin
Mr. and Mrs. Horace Haworth
Mr. and Mrs. Horace G. Hill
Mr. and Mrs. John A. Hill
Horticulture Society of Middle
　Tennessee
Mr. and Mrs. Clay T. Jackson
Mr. Michael Ryan King
Dr. and Mrs. Roland Lamb
Mr. and Mrs. Jack C. Massey
Mr. Ralph Owen, Jr.
Dr. and Mrs. Robert W. Quinn
Mr. and Mrs. Vernon H. Sharp
Mrs. Laird Smith

Mrs. Reese L. Smith
Mrs. Hugh Stallworth
The bequest of Anita Bevill Michael
　Stallworth
Ms. Estelle Shook Tyne
Mrs. William J. Tyne
Mr. and Mrs. William J. Tyne, Jr.
Tyne Acquisitions Fund
The children of Myron Wander
Mr. and Mrs. Albert Werthan
Linda and Raymond White
Mr. Robert Woolley
Mr. and Mrs. Robert K. Zelle

Jack Becker
President/CEO Cheekwood

THE EWERS-TYNE COLLECTION OF
WORCESTER PORCELAIN AT CHEEKWOOD
A HISTORY

Dr. and Mrs. Ewers

Harriet Tyne

One of the many treasures at Cheekwood Botanical Garden & Museum of Art is the Ewers-Tyne collection of Worcester porcelain. Spanning nearly three centuries, this remarkable collection reveals the history of one of the world's premier makers of porcelain wares. Such a remarkable body of work could not have developed without the inspiration and generosity of a special group of individuals and that is the case with the Ewers-Tyne Worcester collection. The Worcester collection reflects the friendship, camaraderie and keen aesthetic of three close friends: Dr. E. William Ewers, a noted physician; his wife Marge Ewers, an accomplished Nashville designer; and Harriet Tyne, a community leader and decorative arts enthusiast. Over the years, these three individuals developed a strong friendship revolving around their shared passion for the decorative arts, Cheekwood, and Nashville.

Cheekwood opened to the public in 1960, and the decision to establish a porcelain collection happened early within its history. The Ewers remarked that the early years for institution were a struggle to raise funds, professionalise the staff, and grow awareness of the unique combination of art and gardens that is Cheekwood. Dr. and Mrs. Ewers made a generous donation to support Cheekwood in the 1970s. Although the funds were not earmarked for a particular project, Harriet Tyne approached them with an idea. What if the funds the Ewers had provided Cheekwood could be used to start a porcelain collection. The Museum's collections were modest at the time, with works transferred from the Nashville Museum of Art and gifts from local collectors. The Ewers responded positively to Harriet's idea. Harriet Tyne and the Ewers believed that building a decorative arts collection made perfect sense for the elegant Cheek home now converted to an art museum. William Tyne Jr. recalls that his mother thought that 'the Museum could make an impact in the world of decorative arts. She naturally picked up on porcelain since she had a substantial knowledge base'.

Working together, Harriet and Marge gave direction and focus to the project through the decision to collect solely Worcester. Always interested in design and the decorative arts since her childhood, Marge believed that Worcester provided the perfect opportunity to create a comprehensive collection while focusing on one important aspect of porcelain. The factory presented a consistent history of good design, decoration, and a breadth of styles and wares that would offer the public a rich resource for discovery. With foresight Marge and Harriet realised that selecting Worcester would provide something lasting and outstanding for the young museum and for Nashville.

Over the years, Harriet Tyne helped to guide the development of the collection at Cheekwood. The porcelain scholar Henry Sandon also played an instrumental role in developing this collection and offered his advice freely to Harriet, Marge and Bill. Acting as a curatorial consultant, Henry Sandon visited Nashville often and helped guide the collection from his office in London, always on the lookout for something remarkable for Cheekwood. Henry Sandon's essay in this catalogue provides a history of Worcester and his involvement with this collection. His son, John, continues the family tradition and wrote the majority of the catalogue.

The collection grew quickly during the late 1970s and 1980s and a number of important works were purchased. Early on, Clara Hieronymus wrote articles about Worcester for the local newspaper, *The Tennessean,* keeping the public aware of Cheekwood and the growth of the porcelain collection. Initially, monies came from the fund provided by the Ewers. As the collection grew, the Ewers solicited support from other Nashvillians. Several individuals, many of whom were good friends of the Ewers or Harriet Tyne, gave funds to help purchase works. In recent years several key objects have been donated to Cheekwood, adding depth and importance to the collection.

Through the efforts of so many people over the years, the Worcester collection at Cheekwood has grown in stature and significance to warrant this comprehensive catalogue. What began as a labour of love has become a true community endeavour. A cornerstone of Cheekwood, the Ewers-Tyne collection continues to delight visitors from Nashville and afar. This catalogue shares with scholars and porcelain aficionados world wide many of the masterpieces that can be found in the Ewers-Tyne Collection of Worcester Porcelain at Cheekwood.

Jack Becker
President/CEO Cheekwood

Foreword and the Story of Worcester Porcelain
By
Henry Sandon

When I first visited Cheekwood in 1979 to give a talk about their collection of the Royal Worcester Doughty birds, I was struck by two things. First was the fantastic beauty of the house and gardens and second the many lovely pieces of early Worcester porcelain that had been donated by Nashvillians inspired by the artistic personalities of Harriet Tyne and Dr. E. William and Marge Ewers.

My lecture tours in previous years had taken me to many great American museums and collections which generally specialised in just the gorgeous wares of the eighteenth century or the equally gorgeous Doughty birds of the twentieth century. Nowhere was there a place exhibiting the whole two hundred plus years of Worcester's porcelain production and, being Curator of the magnificent Dyson Perrins Museum at the Royal Worcester Porcelain factory, I felt something lacking like someone who had had soup and pudding but no main course. I discussed this with Harriet Tyne and the Ewers and we felt that, with a big effort, the gap could be plugged and a complete range of porcelain covering the whole history of Worcester's production could be formed. While I was there someone donated a nice piece from the 1880s, so I returned to Worcester a happier and hopeful man.

Since then, of course, the collection has grown to be something unique in America, a magnificent and complete collection of Worcester's porcelain. It is a happy task to give some background to the history of this great factory but, first, Worcester itself.

The city of Worcester lies 110 miles north-west of London and twenty-five miles west of Stratford-upon-Avon. The River Severn runs through the heart of the city, rising in Wales and emptying into the Bristol Channel. A crossing point at Worcester led to the establishment of a settlement in the Bronze Age and I found evidence of continuous occupation of 4,000 or more years when I conducted archaeological excavations in the central area. In Roman days it was called Vertis, so named because of an un-Roman like bend in the great Roman road from the north-east to the river then heading south to Gloucester and Exeter (the cester ending to English towns denoting a Roman fortified town). The Saxons founded the first cathedral in 680, rebuilt by Oswald, the Worcester bishop and saint, and this was rebuilt by the Normans in 1084 by Wulston, also bishop and saint. The cathedral was extended over the next centuries and became a place of great pilgrimage to the tombs of the two revered saints.

It was between these two tombs that the 'wicked' King John

(he of Magna Carta) elected to be buried in 1216 as he hoped that with their aid he would get to Heaven. In his will he directed that his body was to be dressed in monk's clothing with his cowl pulled down over his head and sandals on his feet so that he could shuffle past St. Peter unawares. When the tomb was opened in 1846 he was found to have been buried as he had requested and Chamberlain's porcelain factory in Worcester made a copy of the tomb as an inkstand.

By the seventeenth century Worcester was a prosperous city with a population of a few thousand, many of whom were employed in the gloving trade. In 1642 the outbreak of the Civil War saw Worcester host the first skirmish between King Charles I's Cavaliers and Oliver Cromwell's Republican Army. The city remained loyal to the King until he was beheaded, and later to Charles II, and the final battle of the Civil War in 1651 saw Worcester besieged and devastated with the King escaping and setting off on his perilous journey to safety in France, on one occasion hiding hiding in an oak tree. To this day on Oak Apple Day the front of Worcester's Guildhall is garlanded with oak leaves and its proud motto is 'City Faithful in War and Peace'.

The eighteenth century began a period of prosperity which saw the city expand beyond its medieval walls and its population increase. It had two Members of Parliament and new trades such as carpets and, in 1751, porcelain which owed everything to the River Severn, one of the major waterways in Europe, with Worcester as an inland port. A fine new hospital was built in 1771 by Dr. John Wall and others and it was there in the nineteenth century that the prestigious British Medical Association was founded. Expansion continued with three sizeable porcelain manufactories, which eventually merged, a move into heavy engineering utilising the new railway and a fortuitous invention by chemists Lea and Perrins of Worcestershire Sauce.

The twentieth century saw Worcester settle into a stately old age as a tourist town, visitors coming to see its major attractions: the cathedral, porcelain factory, Guildhall and river, having lost its gloving and heavy industry but gaining a large mail order firm, the town's biggest employer. It also lost a large number of old buildings in the 1950s to be replaced by concrete monstrosities which the national press called the 'rape of Worcester'. The worst loss was the removal of the original 1751 porcelain factory on the banks of the river. In its place was built a technical college of great ugliness but this gave me the opportunity of carrying out a thirteen year series of excavations on the car park that now covers part of the original factory buildings and grounds, which have been of great importance in our knowledge of the history of this great factory.

WORCESTER PORCELAIN

So, why Worcester porcelain, when there are no suitable raw materials in the area? There were plenty of red clay marls, used by the Roman and medieval potters to make opaque pottery, but nothing suitable for white translucent porcelain to rival the Chinese.

I think there are two reasons: the River Severn to bring in the raw material and transport the finished porcelain and the urge to produce this wondrous material. You could liken it to the current need to have an international airport in your city in order to keep up with the Joneses. The Chinese kept secret from the West the materials and process of making their true porcelain and it was not until about 1710 that Meissen in Germany succeeded in producing Europe's first hard paste porcelain from kaolin (China clay) fired very high at temperatures exceeding 1400 degrees centigrade.

All Europe was aflame to make true porcelain but most had to content themselves with making an artificial body from all sorts of different ingredients, the result being softer and often unsuitable for hot liquids, generally now known as soft paste porcelain. In England Chelsea is usually credited as being the first successful factory in about 1743, followed by other London factories in St. James's, Bow, Limehouse and Vauxhall. Various secret formulae were used with materials like white clay, glass, calcined animal bones and a stone known as soapyrock from Cornwall. Limehouse lasted only a couple of years from 1746-48, its failure seemingly caused by problems of firing the ware, although one partner moved to Staffordshire and another to Bristol, as noted by Dr. Richard Pocock. Writing of a visit to the factory of Miller and Lund in Bristol he said that it was established by 'one of the principal manufacturers at Limehouse, which failed'.

One aim of these early London factories and Derby, which started in about 1748, was to make teaware to satisfy the growing craze for tea drinking. Most of the wares were not ideal for this purpose, however, as the soft paste porcelain often cracked with hot liquids. This led to the curious English habit of warming the teapot before pouring in the boiling water and putting cold milk first into the teacup to avoid cracking. The only early English porcelain not to crack with hot liquids was that made at Limehouse and Bristol, the other factories tending to move into the manufacture of ornamental vases and figures.

On 4 June 1751 the 'Articles for carrying on the Worcester Tonquin Manufacture' were drawn up as a partnership agreement. There were fifteen original partners investing amounts up to £675. Most of them were local but there was one Londoner, Edward Cave, publisher of the *Gentleman's Magazine*. Two of the partners, 'Doctor John Wall of Worcester, Doctor of Physic' and 'William Davis of Worcester, Apothecary', were described as inventors of the 'new manufacture of Earthenware' and they were to receive £500 in shares as a reward. A twenty-one year lease had already been taken out by Richard Holdship, a maltster, on behalf of his fellow subscribers, on Warmstry House, a fine house with gardens sweeping down to the River Severn, almost in the shadow of Worcester Cathedral.

The articles, which are still held by the Worcester Porcelain Company, contain clear evidence that some kind of manufacture had been carried out by Dr. Wall and William Davis for some time. In recent years it has been assumed that their claims to have invented a new porcelain were merely a cover to make use of the successful body of Miller and Lund at Bristol, involving sand from the Isle of Wight, ball clay from Barnstaple and the magic ingredient of soapyrock from the Lizard in Cornwall. On 21 February 1752 Richard Holdship bought the process of manufacture, entire stock, utensils and effects of the Bristol porcelain factory and the lease of soapyrock mines from Benjamin Lund. The *Gentleman's Magazine* for August 1752 announced that 'the sale of this manufacture will begin at the Worcester Music Meeting on 20th September 1752' and illustrated this with a print of the manufactory. An earlier notice in the *Bristol Intelligencer* noted on 24 July 1752 that the china manufactory in Bristol was 'now united with the Worcester Porcelain Company where, for the future, the whole business will be carried out'.

There has long been a query over whether Worcester made porcelain before using the Bristol knowhow. Mr. R.W. Binns, the great Worcester historian of the second half of the nineteenth century, believed they made a frit porcelain and there were local rumours that Wall and Davis had carried out experiments over a hot stove in the latter's apothecary shop in Broad Street. On our archaeological digs some strange shards were found in the very lowest levels that are unlike any other English porcelain and may have been these experimental productions. Some people now believe a few poorly fired teapots and pickle dishes are surviving relics of this earliest Worcester porcelain. Also found were fragments very like Bristol, which could have been part of the stock shipped up the River Severn, one part of a sauceboat having the moulded letters OL of the Bristol mark. The first Worcester production is certainly very similar to Bristol, which itself has great similarities to Limehouse, so the two defunct factories played a major part in Worcester's success.

The production of Bristol was mainly devoted to useful wares, especially sauceboats and pickle dishes with a certain amount of teaware, decorated in underglaze cobalt oxide in the Chinese style. The sauceboats were often marked with the moulded word BRISTOL or BRISTOLL under the base.

One ornamental piece was made, a white glazed figure of Lu Tung-Pin (now more usually Lu Dongbin) copying Chinese *blanc de chine*, and this has BRISTOL and the year 1750 embossed on his back. One of these rare figures is in Cheekwood (see catalogue no.1).

Worcester's earliest production concentrated on tewares and other useful wares decorated with mock Chinese scenes, nowadays referred to as Chinoiserie. Cobalt oxide was painted on the once fired 'biscuit' body, refired to burn away the oils, then glazed and refired again, trapping the blue under the glaze so that it would never wear off. The sequence in soft paste porcelain is the highest firing first, a little over 1200 degrees centigrade, producing the biscuit body, then glazing and firing at a lower temperature in the glaze or glost firing. Coloured wares had metallic oxides painted on the glazed body, then fired into the glaze in a further firing. Worcester's soft paste body has a granular or chalky like core covered with a layer of melted glaze. Hard paste has a more glass-like appearance all the way through.

The earliest productions of Worcester have a wonderful, naïve charm and are nowadays highly collectable. With the ability of the ware to resist hot liquids a huge amount of teware was made and I am sure that more Worcester blue and white survives than that of all the other English factories put together. It became very popular in Holland and was also exported to America. Benjamin Franklin sent specimens of different English porcelains to his wife in Philadelphia, including what he termed a 'Worcester bowl, ordinary' and gave a wonderful description of what was probably a Worcester blue painted mask jug that he said reminded him of a fat happy old dame wearing a blue printed calico gown.

No factory marks were used by Worcester until the late 1750s when the crescent began to be used. Earlier, on blue and white, symbols appear which may be the mark of the painter, but may be something else. The unique mark, the moulded word WIGORNIA under an early saucecoat, seems to have been a one-off effort to continue the tradition of Bristol using their name under saucecoats, Wigornia being the anglicised version of the Latin Wygorncastre. The Bishop of Worcester uses the term Wygorn and the Old Boys of Worcester's King's School, of which Dr. Wall was one, are still called Old Wigornians.

The use of transfer printing from copper plates helped to increase production by an enormous amount from its first use in about 1754. At first printing was onglaze in black or brown, then by about 1758 in underglaze blue. The usual mark for underglaze painting was an open crescent and for underglaze printing a hatched crescent.

Fine coloured painting was done, although the names of the painters are not known as very few pieces were signed. The only artists whose work can be recognised are I. Rogers, who painted birds and landscapes in the 1750s, and two Chelsea artists who came to Worcester in about 1769 – Jefferyes Hamett O'Neale, who painted magnificent wild beasts, and John Donaldson, known for scenes after Boucher and Watteau.

The most famous coloured ware of Worcester was underglaze scale blue, reserving panels into which coloured paintings would be put. Scale blue had a usual mark of a fretted square in blue. A lot of Worcester was sold at a special shop in London and also at auction and a quantity was sent just white glazed or with underglaze scale blue to be painted at the London studio of James Giles. Some of these wares are gaudy with exotic groundlay colours copying Sèvres and collectors must beware because a lot of fakes were produced in Victorian days, sometimes by taking a simple decorated piece and overloading it with colours. The usual way to spot this redecoration is that when refired later an old piece of soft paste porcelain will usually exhibit signs of blackening 'spit out' under the footrim. Some of the ware intended for decorating in London seems to have had a mark of the pseudo crossed swords mark of Meissen plus a 9 and a dot in the hilts of the swords.

The years from 1751 to 1776 are known as the Dr. Wall period. When the good doctor died the factory was run by William Davis until 1783 when the London agent Thomas Flight bought it for his sons for £3,000. There had been a decline in quality and profits, competition had been growing with the Shropshire firm of Caughley producing equal wares to Worcester and the production of a fine but inexpensive earthenware body in Staffordshire and elsewhere. I have termed the years 1776 to 1788 the Davis Flight period, a time of mass-produced bright blue printed ware with a new factory mark of a disguised numeral.

When John Flight came to take over the factory in July 1788 he found it in a very bad state. The Chamberlain family, who had been doing the best painting, had set up on their own and were shortly to start up a factory the size of Flight's. He found that the foreman, Shaw, had been defrauding the firm and whole kiln loads of ware were being spoiled. Without much knowledge of porcelain making he used his business brain to get the firm right again. When King George III visited Worcester in August 1788, to attend the Music Meeting, his Majesty toured the Flight factory and praised everything, ordering a service of a Chinese style blue and gold pattern called 'Royal Lily' and suggested that they opened a new retail shop in London. This they did, at 1 Coventry Street. The next year the King granted Flight his Royal Warrant and each succeeding monarch has regranted the warrant. This gave Flight a great pat on the back but was not in any sense like the royal ownership and support of many of the factories in Europe.

The factory decided to go up-market and aim at the nobility and gentry. Joined by a local businessman, Martin Barr, in 1792, the firm was known as Flight and Barr until 1804 when it was called Barr, Flight and Barr. Then in 1813 the title was changed to Flight, Barr and Barr, these name changes being noted in the factory printed, painted or impressed marks. During these periods some of the finest porcelain ever made was produced. Great services were made, examples in the Cheekwood collection from the Duke of Clarence 'Hope' service and the Stowe service for the Marquess of Buckingham being memorable. The finest ceramic

artist of the nineteenth century, Thomas Baxter, painted and taught the other artists from 1814-16 and his painting of shells, figures and landscapes have never been surpassed.

A superb coronation service for William IV was a final culmination of Flight, Barr and Barr's skills in 1831 and the factory seems to have suffered from the exhaustion of the soapyrock mines, having to move into a bone china body. Their style had become old-fashioned and in 1840 they sold out to their big rival Chamberlain and Company. The Warmstry House factory produced tiles until eventually being converted into a gloving factory.

Robert Chamberlain built his factory in the Diglis area of the city, on the far side of the Cathedral from Warmstry House. He had been a painter at Dr. Wall's factory and was a good businessman, seemingly able to arrange for the Birmingham/Worcester canal to be constructed alongside his factory. His great success was getting Admiral Nelson to visit his factory while the great hero was in Worcester in 1802 being given the freedom of the city. Nelson, who was accompanied by Sir William and Emma Hamilton, ordered a great service of an Imari design and this brought Chamberlain great kudos. At their best, the factory's production was as good as Flight's, especially the painting by Humphrey Chamberlain Jnr. and Thomas Baxter, who joined the factory after he returned from South Wales in 1819 and was there until his death in 1821.

With trade becoming difficult in 1840, following the takeover of Flight, Barr and Barr, a joint stock company was formed under the title of Chamberlain and Company. They tried to move into the taste of the Victorian period but lamentably failed, producing things like buttons, tiles and King John's tomb. The firm had a poor reception at the Great Exhibition of 1851, the critics damning them with faint praise. This led to the Chamberlain family leaving and the last remaining partner, W.H. Kerr, a Dubliner, forming a new joint partnership with Richard William Binns, under the title of Kerr and Binns, in 1852.

In 1853 Kerr and Binns had a considerable success at the Dublin Exhibition with an amazing dessert service based on Shakespeare's *A Midsummer Night's Dream*, using a daring mixture of bone china and parian bodies. This delighted Queen Victoria who ordered porcelain from the company. Among the innovations that Mr. Binns introduced was a range of small hollow based figures to be used as candle extinguishers. Large numbers of monks and nuns were sold by Mr. Kerr's shop in Dublin but in 1862 he retired and Mr. Binns formed a new company, the Worcester Royal Porcelain Company Limited, the title that it has held ever since.

R.W. Binns guided the company until the end of the century, introducing artists and modellers such as James Hadley, now regarded as the finest ceramic modellers of the late nineteenth century. A great range of new styles based on ancient ceramics from Persia, India, Italy and especially Japan were shown at the world's great exhibitions such as Paris, Philadelphia and Chicago, to great enthusiasm. Worcester's glazed parian body was especially popular when looking like old ivory or with a blushing tone. In 1889 the Grainger Company, founded by Thomas Grainger in 1806, added many fine shapes and painters, including the Stinton family.

The business of china making cannot be regarded as a licence to print money and by 1900, when Mr. Binns, died problems were to be seen. James Hadley set up his own factory in 1896, though his death led his sons to sell the business back to Royal Worcester in 1905. A small factory founded by Edward Locke, who had worked for Graingers, produced wares from 1895 to a little after 1905, though the firm was never bought by Royal Worcester.

From 1900 the main financial strength behind the company was Mr. Dyson Perrins, son of the Perrins who, with Lea, was the producer of the world famous Worcestershire Sauce. Some of the world's greatest artists and craftsmen worked for the company. Space allows only a few to be mentioned. My favourites include: George Owen, who did the most miraculous piercing of holes in the delicate parian body up to his death in 1917; the foreman painter William Hawkins; the Stintons – John and his son Harry (Highland cattle subjects) and John's brother James (game birds); Richard Sebright (the greatest of the fruit painters); and my great idol Harry Davis (Highland sheep and landscapes). Money was tight and the factory teetered on the edge of bankruptcy with Dyson Perrins paying the wages of the workers out of his own pocket when work was scarce in the 1920s. Joseph Gimson, works manager and later managing director, told me that in the 1930s he was making more money from the visitors' restaurant than from china.

Joe Gimson introduced oven-to-table ware in hard porcelain and one pattern of litho (decal) printed fruit called 'Evesham' became a huge seller world wide. Also popular was the introduction of small figures by two fine freelance modellers – Doris Lindner (dogs and horses) and Freda Doughty (children). An American dealer, Alex Dickens, asked Joe Gimson if he would make some American birds for the American market in limited editions. Joe asked Freda Doughty if she would do this but she suggested her sister, Dorothy, who was a keen ornithologist. So, almost by chance, the Doughty birds were born, the great climax of the Worcester porcelain collection in Cheekwood.

Dorothy Doughty's birds are incredible creations. Modelled from life, at first from tame or caged birds in England, then from two trips to America, they have a wonderful feeling of life and love. One lady visitor to my museum in Worcester was convinced that the factory had used live birds, dipped them in clay and baked them in the kilns. She threatened me with the R.S.P.B (the Royal Society for the Protection of Birds) and it wasn't until I took her around the factory that she realised she was mistaken. Do spend as long as you can in admiration of the beautiful birds in this great collection of Worcester porcelain.

Henry Sandon

LUND'S BRISTOL AND EARLY WORCESTER BLUE AND WHITE

In 1752 the newly-established Worcester Porcelain Manufactory joined forces with an ailing porcelain factory in Bristol that was managed by Benjamin Lund. Lund's Bristol is therefore seen as the direct precursor of Worcester porcelain and so it is appropriate that this catalogue of the Cheekwood collection commences with two important Bristol pieces. The statue of Lu Dongbin copies a Chinese white porcelain figurine that would have been very collectable at the time. The splendid Bristol mug also copies Chinese, but there is a significant difference. The painting in underglaze blue exactly reproduces Chinese porcelain, but the shape derives from an English beer mug in silver or stoneware.

Blue and white porcelain was China's great invention and during the eighteenth century a vast quantity was imported into England. Dr Wall persuaded other business partners to invest in the new Worcester manufactory on the promise of making copies of this valuable Chinese porcelain, but they encountered many problems. Worcester gradually overcame technical difficulties, but had a big problem with the price. Their copies of Chinese blue and white cost more to make than real Chinese plates and cups and saucers sold for in England. The Worcester factory had to make something different or they would never have survived.

The blue and white collection at Cheekwood illustrates very clearly the solution that Worcester came up with. The blue painted designs look for all the world like Chinese porcelain and this is what the fashionable public wanted to buy. The shapes, though, are far removed from the plain vessels that came from China. Instead these forms are English through and through, and up-market ones at that. Worcester took its inspiration directly from costly English silver. Sauceboats, jugs for milk or cream and dishes for sweetmeats and pickles, these are shapes associated with luxury and wealthy homes bought them from silversmiths. The craftsmen at Lund's Bristol and early Worcester transformed these silver shapes into porcelain. Then they painted them to look like the most fashionable porcelain of the time – which meant blue and white. The result was a hugely successful formula. The nobility of Britain left their silver sauceboats in the cupboard and served their guests from Worcester blue and white instead.

Success allowed the Worcester factory to grow and develop its potting skills and porcelain recipe. Within a few years they could manufacture teasets to rival the Chinese and customers wanted these decorated with Chinese patterns in blue and white. Worcester teapots were much better than Chinese ones, however. The uncomfortable straight spouts favoured by the Chinese were replaced at Worcester by curved moulded spouts that poured beautifully. Worcester also had another great advantage over its competitors. Their porcelain body contained soapyrock and this meant that Worcester teapots didn't crack when filled with boiling water. The fame of Worcester's unbreakable teapots soon spread and led to a huge demand for Worcester blue and white.

From small spoons to massive jugs, fancy baskets and table centrepieces, blue and white Worcester porcelain supplied every marketplace. Sets of china matching items in the Cheekwood collection were exported to the rest of Europe and to North America. Blue and white Worcester was even sent to China where direct copies were made by the Chinese themselves. To boost production to meet the demand, Worcester hit upon an invention that would eventually revolutionise the ceramics industry. Around 1756 they used printing techniques to decorate their blue and white tewares for the first time, transferring designs from engraved copper plates. During the 1770s production of blue and white printed porcelain at Worcester was substantial. Their technology was never patented, however, and in due course the pottery industry in Staffordshire used printing to mass produce blue and white earthenware with designs like the Willow pattern. Worcester was unable to compete and during the Flight period around 1790 they chose to abandon blue and white altogether.

Opposite: Water bottle or 'guglet'. See catalogue no. 9.

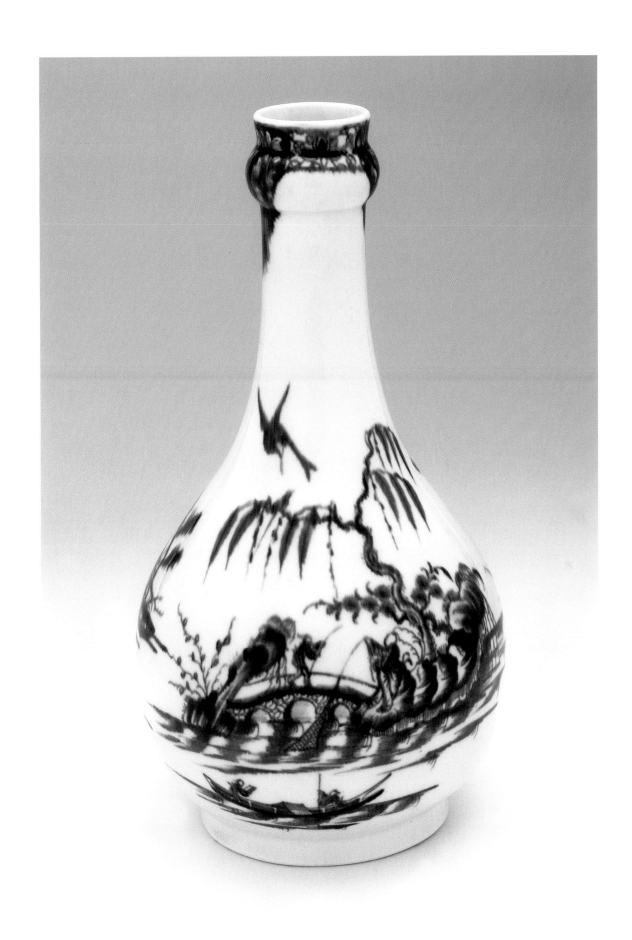

1. Figure of a Chinese Immortal, Lu Dongbin

Size: 17cm (6¹¹⁄₁₆in.) high
Date: c.1750
Mark: embossed *Bristoll 1750* and a Chinese emblem at the back of the model
Gift of Mr. Ralph Owen, Jr., 1988.9

We know this figure of Lu Dongbin was created at Bristol in 1750, for the factory's place name and the date was carved in the mould on the back of the model. Most Bristol soft paste porcelain followed English silver shapes, and this direct copy of Chinese porcelain is the firm's only known venture into figure making. The plain white glaze resembles the so-called *blanc de chine* porcelain made at Dehua in South-eastern China and exported to Europe around 1690-1700. By 1750 white porcelain figures were no longer imported from China in any quantity, but older examples had become popular with collectors.[1] Copies of Chinese white figures made at Derby, Bow, Chelsea and Longton Hall appealed to English connoisseurs. Bristol's forerunners at Limehouse made a seated Chinese figure, possibly cast from a Staffordshire saltglaze mould, and it is tempting to think this Bristol figure was also copied from saltglaze. It is far more likely, however, that the Bristol factory copied a contemporary coloured Chinese figure. Sets of standing figures of the eight Immortals, dating from the mid-18th century, occur in *famille rose* enamels. These *famille rose* Immortals lack the sharp detail of Dehua white figures and the Bristol version similarly lacks detail. The significance of the Chinese-like character embossed on the back of the figure is not known.

English porcelain collectors know this figure as Lu Tung-Pin, although in the new spelling used for Chinese names today it is more correct to name him as Lu Dongbin. One of the Eight Daoist Immortals of China, this deity's name first appears in a written record in the 10th century.[2] Lu Dongbin apparently lived from c.755 AD to 805 and was variously described as a hermit, a poet and a swordsman. A 12th century document, written as an autobiography, offered a physical description. 'I often wear a white scholar's gown with a horn girdle. Under my left eye is a mole as big as the thick end of a chopstick,' he said.[3] Known for his knowledge of healing the sick and his ability to tell the future, by the early 13th century Lu Dongbin had become a Chinese deity and the patron saint of barbers. He is usually pictured wearing a scholar's robes with a sword and a fly-whisk, an allusion to his ability to fly. The Bristol figure omits his sword but keeps the fly-whisk and scholar's robe.

About ten examples of this Bristol figure are recorded, including a number in museums.[4] They were simply made by pressing clay into a two-piece mould and the bases were left open underneath. All are apparently from the same mould, although in some instances the thick, opaque glaze masks much moulded detail. All are glazed just in white, although an example in the Victoria & Albert Museum has an additional wash of underglaze manganese on the base.[5] White figures lost popularity later in the 18th century and sometimes colouring was added to increase desirability. The Cheekwood example was probably enamelled in colours at a later date and has since been cleaned with corrosive chemicals, which have resulted in a semi-matt surface.

1. Geoffrey Godden, *Oriental Export Market Porcelain*, chapter 8, discusses the trade in white figures from China.
2. The first written record was a collection of anecdotes entitled *A Record of the Pure and the Anomalus* attributed to Tao Gu (903-970) as quoted in Paul R. Katz, *Images of the Immortal: The Cult of Lü Dongbin at the Palace of Eternal Joy* (Honolulu, University of Hawai'i Press, 1999) 54.
3. *The Vast Record of the Changeable Studio* by Wu Zeng (c.1127-1160) in Katz, 61.
4. Including the British Museum, the Museum of Worcester Porcelain, Bristol City Museum & Art Gallery, the Museum of Fine Arts, Boston and the Metropolitan Museum of Art, New York.
5. Illustrated by Geoffrey Godden, *Oriental Export Market Porcelain*, pl. 256.

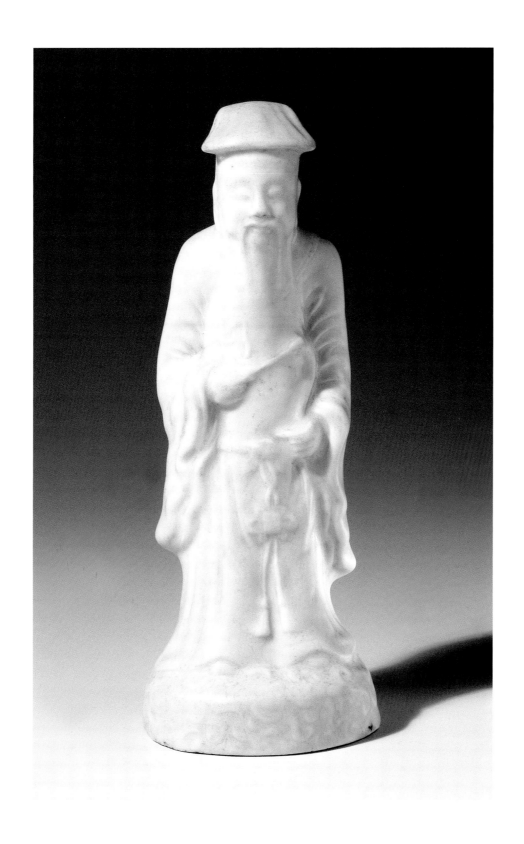

2. Bristol Porcelain Small Mug

Size: 11.2cm (4⅜in.) high
Date: c.1750
Mark: none

Provenance: formerly the J.W. Jenkins Collection.[1] Illustrated by John Sandon,
The Dictionary of Worcester Porcelain, p. 64 and by Dr. Bernard Watney, *English
Blue and White Porcelain of the 18th Century*, pl. 22c
Museum Purchase through the Ewers Acquisition Fund, the Tyne Acquisition Fund,
Dr. and Mrs. Robert W. Quinn and matching funds through the bequest of
Anita Bevill McMichael Stallworth, 1991.1

It is significant that this most unusual shape has no known parallel in Chinese porcelain. The Bristol and early Worcester factories chose not to compete with Oriental imports and instead painted Oriental blue and white designs on to their own shapes derived from English silver. It is likely this mug was inspired by an English metal prototype and was probably intended as a mug for drinking strong liquor. The distinctive round shape with its simple loop handle is an unusual shape for England in the mid-18th century. It harks back to the form of German salt-glazed stoneware mugs popularly imported into England in the 17th century and copied by English potters between 1680 and 1700.[2]

This shape is not moulded but individually thrown on a potter's wheel and then turned on a lathe. The neck rim and high foot show great skill on the part of the turner. Similar blue painting is found on Bow and Limehouse porcelain of roughly similar date and it is tempting to think London painters brought this style with them when they came to Bristol from Limehouse. A peacock feather motif painted along the length of the handle is certainly a direct link with Limehouse. We must remember, however, that this style of underglaze blue painting is copied directly from Chinese porcelain of the earlier 18th century. Landscape painting of this kind, known to Chinese scholars as the 'Master of the Rocks' style,[3] uses the curious perspective found on Chinese scroll painting. A mountainous landscape wraps around the pot's middle with a hut and bridge among trees and rocks. This manner of painting was totally alien to English art and it must have appeared very strange to the Bristol painter who, nevertheless, produced a most faithful copy of Chinese porcelain. The painting is viewed through the haze of the distinctive 'melting snow' glaze giving the image a misty appearance. This blurring of the fine detail is a result of the process of underglaze painting apparently practised at Bristol. The design was painted in cobalt oxide directly on to a lightly-fired porcelain body and it was then given a higher-temperature glaze firing.[4] Considering the difficulties, the detail seen on this mug at Cheekwood is unusually precise.

1. This is one of a pair of similar mugs formerly in the Jenkins Collection. The companion mug is now in San Francisco museum and is illustrated by Simon Spero, *The Bowles Collection of 18th Century English and French Porcelain*, fig 156.
2. See the catalogue of the Harriet Carlton Goldweitz Collection, Sotheby's New York 20 January 2006, pp. 59-61.

3. See Duncan Macintosh, *Chinese Blue and White Porcelain*, pp. 106-7. Master of the Rocks style developed in the 1660s and occurs on Kangxi (1662-1722) and Yongzheng (1723-35) export porcelain.
4. J. Sandon, 'Recent Excavation at Worcester, 1977-79' in ECC *Transactions*, Vol. 11, pt. 1, 1981, p. 9 and Branyan, French and Sandon, *Worcester Blue and White Porcelain*, pp. 7-9.

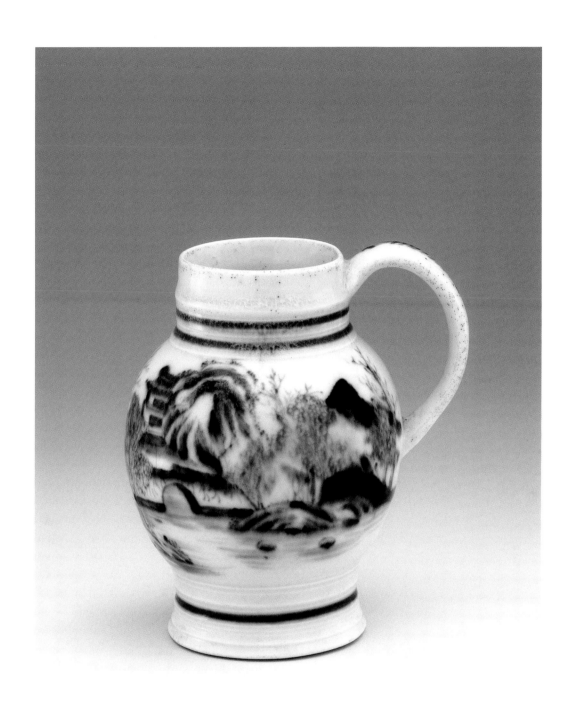

3. Pair of Cornucopia Wall Pockets

Size: 21.6cm (8½in.) tall
Date: c.1756
Mark: Workman's marks pseudo Chinese workman's mark
Gift of Mrs. Laird Smith, 1986.19.1

Worcester cornucopias were always made as matching pairs, the left- and right-hand examples being mirror images of each other. Only a few have survived with iron or lead liners from the period, but these show how they were used. The porcelain wall pockets were hung on a wall by means of suspension holes pierced in the flat backs. These would display either cut flowers or flowering bulbs grown in the metal liners. The price list of Worcester's London warehouse, c.1755-6, lists two sizes of cornucopias for sale at 2s.3d. and 2s.6d. each.[1] These will have been in blue and white. Most Worcester cornucopias were of a plain horn shape with moulded spiral decoration. The landscape moulding seen here is a rare and exciting alternative.

If Worcester's primary aim was to make products that were totally different from all other English porcelain, they succeeded with their cornucopias. The Chinese do not appear to have made any at this date, while examples from Bow, Derby, Vauxhall and other rival porcelain factories in England are also generally later in date, smaller and far less exciting than Worcester's finely potted specimens. Plenty of English pottery cornucopias survive from the middle of the eighteenth century, but it is far from certain which came first, saltglazed stoneware or Worcester porcelain examples.

Landscape modelling in relief is not a form of decoration associated with English porcelain, but this does occur in Staffordshire pottery. Teapots and cream jugs embossed with buildings, trees, sheep and cattle occur in redware, white saltglazed stoneware and creamware. These are associated with Thomas and John Wedgwood at the Big House in Burslem although it is likely that several makers produced similar moulded wares. Cornucopia-shaped wall pockets embossed with a landscape scene are known in Staffordshire stoneware too,[2] while others occur in green-glazed earthenware and so-called Whieldon underglaze colouring.[3] The porcelain versions made at Worcester depict a very similar building with cattle among trees. Scrollwork borders and flower sprigs by the points of the horn show that the Worcester and Staffordshire versions are clearly related. There was undoubtedly a link between some early Worcester modelling and Staffordshire saltglaze, suggesting that Worcester engaged craftsmen who had previously modelled for Staffordshire pottery. In the case of these cornucopias, however, the Worcester examples seem to pre-date the Staffordshire versions by at least a decade, so this is likely to be a case where Staffordshire potters copied Worcester and not the other way around.

The scrollwork moulded around the border of these Worcester cornucopias fits together very well with the painting in underglaze blue. This provides links with Worcester sauceboats of similar date, where shapes from English silver were combined with Chinese style decoration. The kind of trellis ornament in blue, seen here, is possibly derived from French ceramics from forty or fifty years earlier. Combined with the moulded rococo scrollwork, this decoration is uniquely Worcester and indeed these are a credit to the manufactory.

1. The price list is reproduced in John Sandon's *Dictionary of Worcester Porcelain*, p. 223
2. For a coloured saltglaze example in the Henry Weldon Collection see Leslie Grigsby's catalogue, fig. 61.
3. A green glazed pocket is in the Temple Newsam House Museum in Leeds; see Walton's catalogue, fig. 274. A Whieldon glazed example was in the Earle Collection

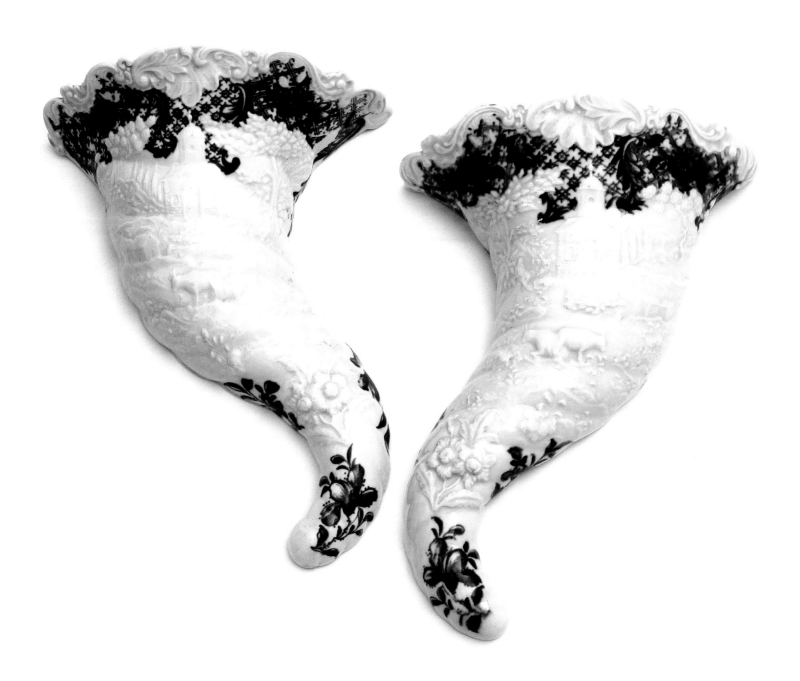

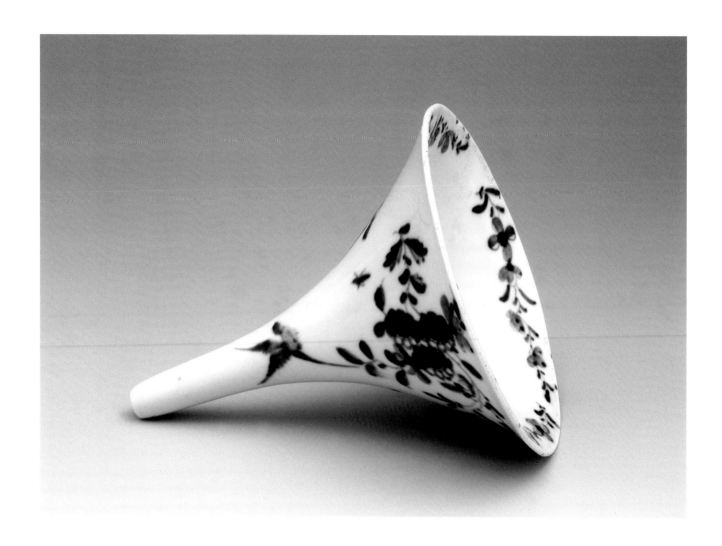

4. Wine Funnel

Size: 11.1cm (4⅜in.) high, 10.1cm (3⅞in.) diameter
Date: c.1753-55
Mark: Blue dots inside could be a form of workman's mark
Provenance: Peter Merry (Bridge House) Collection. Exhibited by Albert Amor Ltd, London, *The First Decade of Worcester Porcelain*, 1981
Museum Purchase through the bequest of Anita Bevill McMichael Stallworth, 1993.20

A funnel served as part of a household's utensils. Sturdy funnels, made of brass or painted tin with strainers inside, worked for everyday kitchen chores. Finer pieces made of silver, enamel or even glass enabled wine to be poured from a cask or jug into a decanter. A porcelain funnel such as this one from Worcester would have been too delicate for kitchen work and was probably reserved for showing off when expensive wine was decanted in the presence of guests. The practicality of a porcelain funnel remains in question and may account for the fact that few have survived from the 18th century. A silver funnel may have served as the prototype for this piece.

Worcester was the only English factory ambitious enough to attempt the manufacture of funnels in this elegant trumpet shape. They had to be individually thrown on a potter's wheel rather than moulded, and so it is hardly surprising that they occur in a number of different sizes, between 10.2 and 12.7cm (4 and 5in.)

long. Costly items to make, therefore, most Worcester funnels were decorated in enamel colours with chinoiserie figures or flowering rock patterns. Very few early blue and white examples are known and this funnel is therefore one of the greatest rarities in the Cheekwood Collection.[1] The overall design is delightfully simple. Much of the funnel's surface is left in the white, while on one side two birds fly above a small spray of daisy-like flowers. Four individual sprays form a border inside. Although they could only be stored upside down on a shelf, all known Worcester enamelled examples were painted so that the design would be the right way up when the funnel was being used. This blue and white funnel is an exception, for here the birds are seen flying correctly when the funnel is upside down. When the funnel was made it is clear that it was fired upside down on a bed of grit, some of which has adhered to the rim.

Most Worcester wine funnels are of so-called 'Scratch Cross' type dating from about 1753-55. A few are recorded with underglaze blue transfer-printed flowers, made more than a decade later, however.[2]

1. Simon Spero, *The Bowles Collection of Eighteenth-Century English and French Porcelain* states that fourteen polychrome funnels were known to the author whereas only four blue and white funnels survive. One of these is in the Bristol City Art Gallery and Museum, illustrated by Branyan, French and Sandon, *Worcester Blue and White Porcelain*, 2nd Edn, pattern I.E.50A.
2. One in the Zorensky Collection is illustrated by John Sandon and Simon Spero, *Worcester Porcelain, The Zorensky Collection*, fig. 651.

5. Feather-Moulded Coffee Can

Size: 5.8cm (2⅜in.) high
Date: c.1753-55
Mark: Workman's mark of a swastika shape
Museum Purchase through the Ewers Acquisition Fund, 1978.3.1

Cans of this type formed a staple product of the early Worcester factory. Produced in great numbers, these cans came in several basic shapes and were embellished with different moulded decoration to enhance the surface. The price list of Worcester's London warehouse,[1] undated but probably compiled in 1755-56, lists the sale of coffee cups or cans, 'ribb'd or wav'd', priced at 8 shillings per dozen. This corresponds with the waved design. The moulded 'waves' are actually part of a feather, for the matching coffee pot of this design shows the complete design of inverted peacock feathers, derived from English silver from the 1730s. The London price list confirms that coffee cans were sold by themselves and were not accompanied by matching saucers. Different handles could be mixed and matched with the various moulded patterns. Here a complex yet flat handle is placed at odds with the smooth curves of the body. The handle on this example is sharp and precise and the stepped base is also modelled with an unusual degree of care. Painted decoration consists of a simple garland of blue flowers and leaves around the rim. Most of these coffee cans were decorated in blue and white. The few polychrome examples that do survive seem mostly to have been enamelled outside the factory.

1. Reproduced by John Sandon, *Dictionary of Worcester Porcelain*, p. 223.

6. Two-Handled Sauceboat

Size: 21.5cm (8½in.) wide lip to lip, 24.8cm (9¾in.) long across handles
Date: c.1755
Mark: Workman's mark
Gift of Dr. and Mrs. E. William Ewers, 1981.9.5

Many English factories produced double-lipped sauceboats during the 1750s, often in Meissen rather than Chinese taste for this shape reflected the Continental fashion. Two-handled or double-lipped sauceboats are more often found in Continental ceramics than in English. During the 18th century dining in England became more intimate and the growing interest in French cuisine brought new customs and foods to the table.

Considering the enormous number of different single-handled sauceboat shapes and patterns made at Worcester, it is quite surprising that two-handled examples all follow just one form with hardly any variation in the modelling or painted decoration. Worcester double-lipped sauceboats came in three sizes. The monkey-like heads, which form decorative thumbrests on the handles, occur only on this rare largest size. The undulating shaped rim and delicate floral swags moulded in relief are unusually crisp, echoing the rococo sensibility of contemporary silver. A garland of finely modelled leaves encircles the body forming four medallions, each containing a painted scene. The centre is painted with a Chinese landscape with boats and fishermen, a scene commonly found on all three sizes of these two-handled sauceboats.

At 48 shillings per dozen (8s. each) these large two-handled boats were one of the most expensive items listed in Worcester's London warehouse in 1755-56.[1] They probably cost far more than Chinese double-lipped sauceboats which were imported to England at the time. Little wonder examples in this size are so rarely found today. The rarity is not just a question of price, though. Like many household objects, the sauceboat underwent physical changes as styles shifted. The two-handled form was already going out of fashion when Worcester produced them in the 1750s. By 1757 or so the factory had ceased their production.

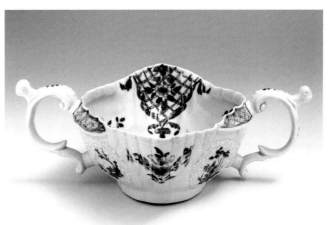

1. John Sandon, *Dictionary of Worcester Porcelain*, p.223.

7. Punch Pot and Cover

Size: 17.5cm (6⅞in.) high
Date: c.1754-55
Mark: Workman's mark of a letter T and two incised single strokes
Museum Purchase through the Ewers Acquisition Fund 1983.8.1

 The same shape as a teapot, the massive scale of this vessel identifies this as a punch pot, used for serving hot alcoholic drink. Punch pots are closely associated with the sport of foxhunting and a later Worcester example from c.1770 is recorded with a fox painted underneath the spout and the inscription 'Tally Ho'.[1] The advantage of Worcester's soaprock formula meant that it could be used to serve any hot liquid without cracking. In the 1750s tea was inordinately expensive, which meant that there would not have been a market for teapots of this size; strong liquor was far less expensive. In the 18th century hot punch was made using Arrack, a spirit distilled from sugar cane and rice, imported from India. This was mixed with sugar, lemons and lemon juice and hot water and flavoured with spices such as aniseed, nutmeg and cinnamon. Inside the punch pot the lemon fruit would float to the top and the spice residue would sink to the bottom. The position of the spout on the side of the pot meant that clear, warm spiced punch could be poured into glasses or cups. In winter, as the huntsmen gathered for the meet, stirrup cups filled from a Worcester punch pot would have been very welcome served in the saddle.

Worcester punch pots were individually thrown and turned on potters' wheels and their size and capacity varied considerably. During the mid-1750s the underglaze blue decoration on punch pots was mostly limited to a single pattern, known as the 'Zig-Zag Fence', or in a more elaborate version as the 'Two-Level Fence and Rock'.[2] These designs were used on tankards and other large vessels such as platters and punch pots. One curious feature of the punch pot at Cheekwood is that the reverse side of the vessel is painted with a complete mirror image of the whole design that appears on the front. On the spout is a carefully painted Chinese Daoist emblem or 'Precious Object'. This punch pot belongs to the so-called 'Scratch Cross' class of Worcester porcelain datable to c.1754-56. The base of this punch pot is marked with two incised lines, a form of workmen's tally markings that are not understood as yet.

1. Illustrated and discussed by R.L. Hobson, *Worcester Porcelain*, p. 130
2. Branyan, French and Sandon, *Worcester Blue and White Porcelain*, patterns I.D.12 and I.D.15.

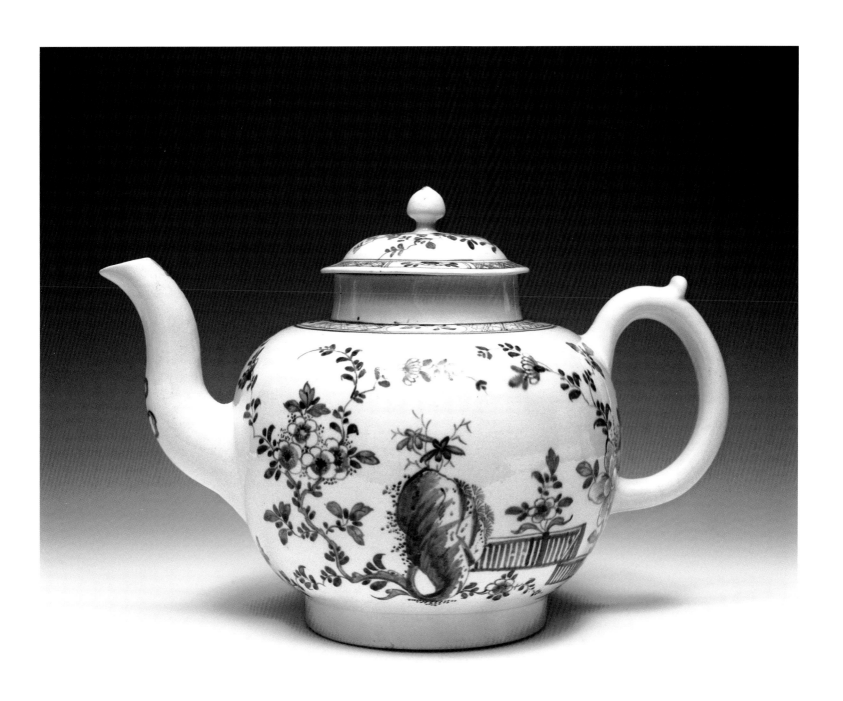

8. 'Dutch Jug' with Mask Lip

Size: 20.4cm (8in.) high
Date: c.1758
Mark: Workman's mark of the letters TF as a cipher
Museum Purchase through the Ewers Acquisition Fund, 1978.3.6

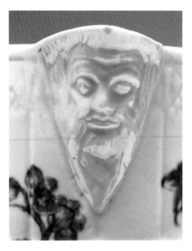

In February 1758 Benjamin Franklin was in England and purchased some Worcester porcelain to ship home to his wife. He described 'A large fine jug for beer, to stand in the cooler. I fell in love with it at first sight; for I thought it looked like a fat jolly dame, clean and tidy, with a neat blue and white calico gown on, good natured and lovely, and put me in mind of somebody.'[1]

In the 18th century this distinctive shape was known as a 'Dutch Jug'.[2] The origin of this name is unknown, but presumably these jugs enjoyed a ready market in Holland. These cabbage leaf moulded jugs came in a number of sizes and this is one of the smallest. Introduced at Worcester around 1754, most Dutch jugs from the 1750s were made without separate pouring lips (see catalogue no. 31). This is one of the earliest versions known where a moulded face of a bearded man forms the lip. Slits across the eyes of the mask face suggest he is sleeping, a distinctive feature seen only on Worcester mask jugs. This plain loop handle, with a leaf-moulded thumbrest at the top, occurs only on early examples and was replaced around 1758-60 by a triple scroll handle instead.

The moulding of overlapping cabbage leaves around the body gives these jugs a delightful feel when held, but for some reason Worcester's decorators largely ignored the moulding. In colours, or in blue, the scenic or floral painting bears no relationship to the leaf moulding beneath. The moulding also caused difficulties during the manufacture of blue and white Dutch jugs, as the glaze often dribbled down the modelled leaves and caused the blue painting to run. This example is unusually successful, for the painting of large individual flowers has not suffered any blurring at all. This design, called the 'Heavy Naturalistic Floral' pattern,[3] will have been copied from an engraved source which has not been traced. It illustrates the remarkable skill of Worcester's underglaze blue painters.

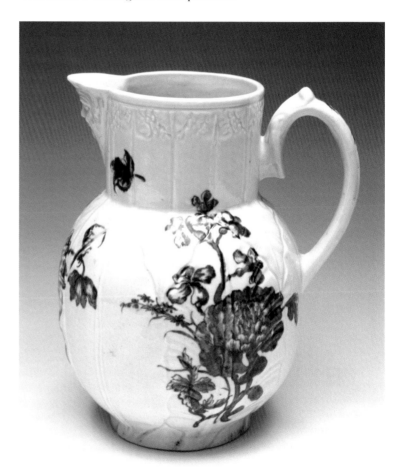

1. *The Complete Works of Benjamin Franklin*, New York, 1887, vol. 3, p. 6, quoted in Branyan, French and Sandon, p.10.
2. The price list of Worcester's London warehouse, c.1755-56, uses this name, illustrated by John Sandon, *Dictionary of Worcester Porcelain*, p.223.

Caughley 'Dutch Jugs' were sold by the Chamberlains c.1788-90.
3. Branyan, French and Sandon, *Worcester Blue and White Porcelain*, pattern I.E.25.

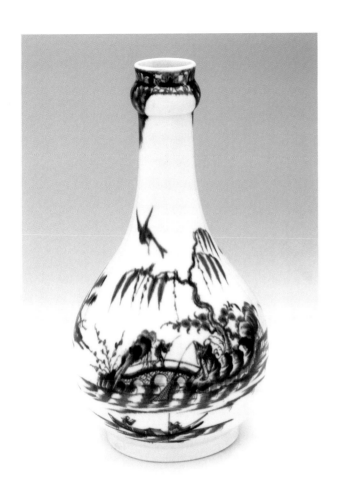

9. Water Bottle or 'Guglet'

Size: 25.6cm (10⅛in.) high
Date: c.1768-70
Mark: open crescent
Gift of Dr. and Mrs. E. William Ewers 1981.9.4

Filled with warm water, guglets were placed on washstands and were used to fill matching porcelain bowls. It is believed the name derives from the noise caused when water was poured from the narrow neck. During the 1760s Worcester replaced the flared necks of their earlier water bottles with the very narrow neck shape seen here, but while the small openings must have helped keep the water warm, they would have proved very difficult to fill. No wonder the fashion was short-lived and by the end of the 18th century open wash jugs had replaced the china water bottle.

By the late 1760s, when this example was made, mass production methods were replacing quality with quantity. Transfer-printing was now widely used at Worcester and, although some detailed painting was still carried out, it was laboured and very different from the free and spirited work that makes earlier Worcester blue and white so exciting. This bottle is heavy and thickly potted, and the glaze is indelicate, causing much of the detail to be lost. This is clearly illustrated by comparison with an unglazed example found by Henry Sandon during excavations on the Worcester factory site.[1] The pattern, known as 'The Willow Bridge Fisherman',[2] features figures on islands surrounded by water, appropriate subjects for the bottle's intended purpose.

1. Shown by Henry Sandon, *Worcester Porcelain 1751-1793*, pl. 17 and in Phillips' London auction catalogue of the Pinewood Collection, 31 October 2001, lot 45.

2. Branyan, French and Sandon, *Worcester Blue and White Porcelain*, pattern I.A.32. The matching basin combines the same two subjects into a single scene.

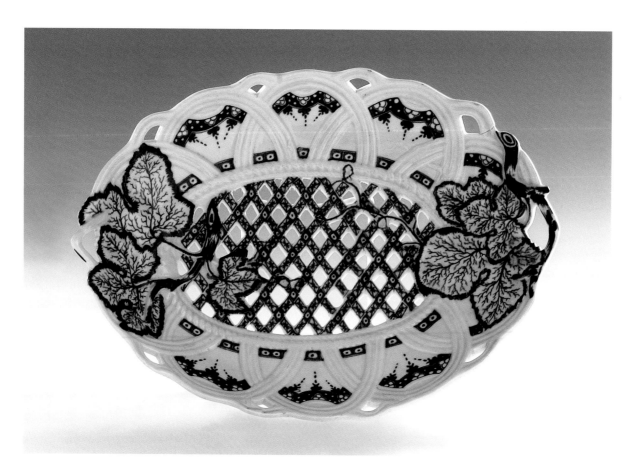

10. Pierced Fruit Dish or Drainer

Size: 29.6cm (11⅜in.) long
Date: c.1770
Mark: open crescent
Gift of Mr. and Mrs. Monroe Carell, Jr. 1987.6.1ab

Dishes moulded in the shape of straw baskets appear in 18th century ceramics and silver. These artificial baskets served as a decorative part of the dessert or dinner service and held breads, fruit and other delicacies. In view of the vine leaf moulding it is most likely these Worcester dishes were for draining fruit. They were manufactured using the same method as Worcester's round dessert baskets. The central pierced trellis pattern is not moulded but instead was drawn on the surface individually using some kind of ruler or maybe lengths of string. The holes were cut out one by one while the clay was still wet. This shape of dish with an arcaded trellis border and vine leaf handles was introduced at

Worcester c.1757 and was produced until c.1772 both in colours and in underglaze blue. A similar shape, previously made at Chelsea in the Red Anchor period, was itself copied from a Meissen dish of about 1750. Either could have served as the prototype for Worcester's version. Most dishes of this shape made at Worcester were not pierced. Meissen had made other shapes of moulded dish with pierced trellis patterns cut in the centre and these also accompanied dessert sets.

The dish illustrated here is one of a pair in the Cheekwood Collection. The handles, moulded as vine leaves and stems, are painted realistically with underglaze blue veins and edges. Only a small number of pierced Worcester dishes of this type are known, all dating from about 1770. They are recorded only in blue and white.[1]

1. For a similar drainer photographed with a waster from an un-pierced example of this shape, discovered in excavations of the factory site, see Henry Sandon, *Worcester Porcelain, 1751-1793*, pl. 124.

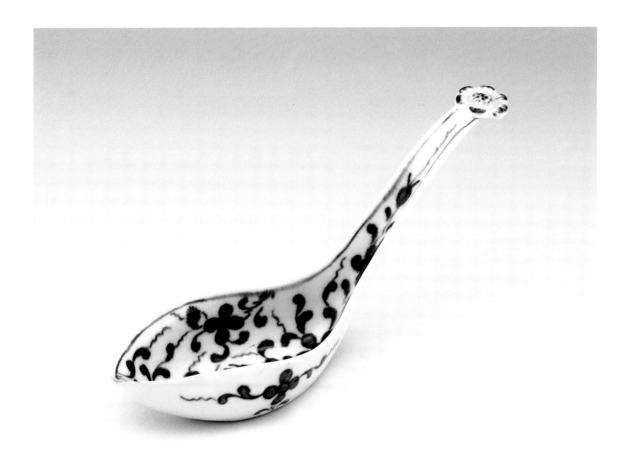

11. Small Spoon

Size: 13.9cm (5½in.) long
Date: c.1772-75
Mark: open crescent
Museum Purchase through the bequest of Anita Bevill McMichael Stallworth, 1994.11.1

This simple shape is well known today as a Chinese rice spoon, but in England in 1770 it is unlikely to have served the same function. This illustrates the widespread influence of Chinese porcelain shapes on English consumers. This form of spoon was used throughout South-east Asia for eating rice, although the examples imported into England in the 18th century were more likely to have been collected as curios. Rather than copy the shape of an English silver spoon, Worcester produced a faithful copy of this uniquely Chinese object. Its function remains unclear and collectors have speculated that it was used either for serving individual pickles or even as a caddy spoon or as a wine taster. Lowestoft and Bow produced a similar shape in blue and white porcelain. At Worcester production started around 1768 and continued to about 1785. Only a small number of patterns were used, of which this 'Maltese Cross Floral' design is the most popular.[1] Some spoons were pierced in the bottom of the bowl and perhaps these so-called sifter spoons were also used as egg drainers.

1. Branyan, French and Sandon, *Worcester Blue and White Porcelain*, pattern I.F.1.

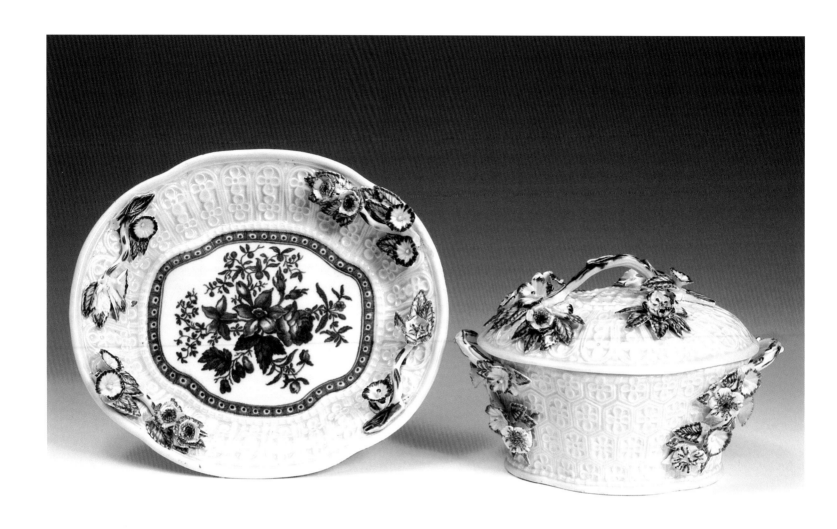

12. Covered Tureen and Stand

Size: The stand 24.7cm (9¾₆in.) long
Date: c.1768-70
Mark: Shaded crescent
Gift of Mrs. William J. Tyne 1988.25.2

This is a most unusual variant of a shape that is popularly known to collectors of Worcester porcelain as a chestnut basket. Normally the cover and stand of these chestnut baskets are pierced individually between each of the moulded panels and florets. This very rare example has no piercing whatsoever and instead this was probably intended as a form of tureen. The modelling is unusually crisp and, left just in white without any painting, the remarkable detail can be fully appreciated. The term chestnut basket is itself probably erroneous, for the 1769 Worcester sale catalogue[1] included several 'fine oval... cream-basons, pierced covers and plates' and these are likely to be the pierced version of this shape.

It is believed that John Toulouse introduced a totally new range of shapes when he arrived at Worcester from Bow around 1768. Many intricate moulded shapes appear for the first time around 1768-70 and many of

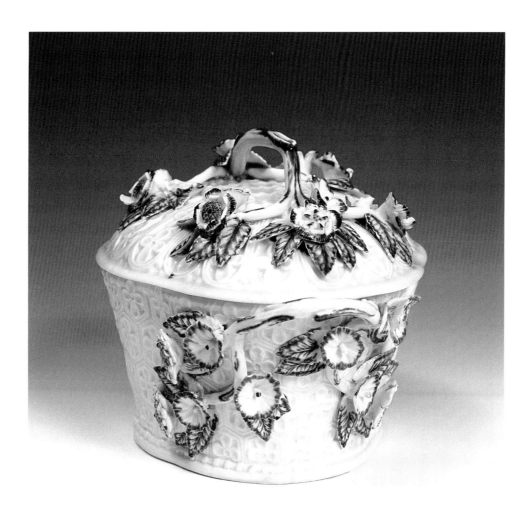

these were further decorated with finely modelled flowers. Although this tureen does not feature any of the so-called 'Hot Cross Bun Buds' found on pieces bearing his To or IT marks, the flowers and leaves on this tureen relate to Bow flower modelling and were probably made under the supervision of John Toulouse.[2]

The printed flower sprays used on the stand and inside the base of this tureen belong to the 'Rose-Centred Spray Group'.[3] By the time this piece was made, Worcester had mastered the technique of transfer printing in underglaze blue but they were still unable to print borders successfully. The cell border seen here around the centre of the stand is instead meticulously hand painted. Cream bowls with pierced covers and stands were also made at Caughley and at Lowestoft, both copied from the Worcester prototypes and printed with underglaze blue flowers. Derby made a range of covered bowls including some with related moulding, and some of these were occasionally left without piercing.

1. Quoted by H. Rissik Marshall, *Coloured Worcester Porcelain of the First Period.*
2. Further discussed by John Sandon, *Dictionary of Worcester Porcelain*, pp. 108 and 340.
3. Discussed by Branyan, French and Sandon, *Worcester Blue and White Porcelain*, pattern II.C.10.

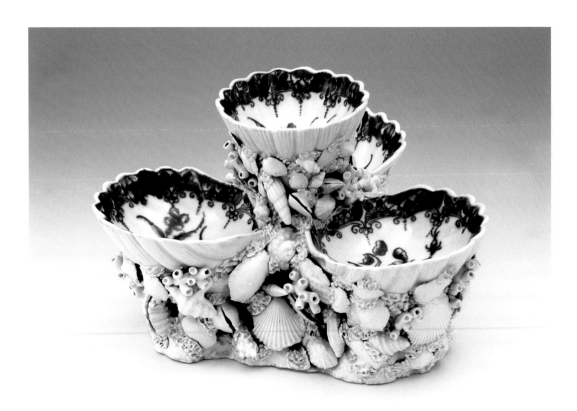

13. Shell moulded Pickle Stand

Size: 12.3cm (4⅞in.) high, 20.4cm (8in.) wide
Date: c.1765
Mark: None
Museum Purchase through the Ewers Acquisition Fund, 1978.7.3

A highly decorative centrepiece, this pickle stand evokes the deep love of shell-encrusted objects in the middle of the 18th century. Real seashells were seriously collected and wealthy estate owners dotted their gardens with grottoes filled with exotic shells. Shell collecting formed a popular and pleasant pastime, as expressed in a letter from Mrs Delany, companion to the Duchess of Portland. On a July day Mrs Delany worked on 'settling all my drawers of shells, sorting and cleaning them. I have a new cabinet with whole glass doors and glass on the side and shelves within, of whimsical shapes, to hold all my beauties.'[1] Shells, then, became part of visual culture and porcelain made an excellent medium for copying precious specimens.

Called 'pickle stands' in the eighteenth century, this tiered form was first produced at Bow around 1750 when a series of single shell-shaped dishes were joined together using individually cast porcelain shells embedded in simulated weed and coral. Worcester did not introduce the shape until later in the 1760s, probably due to the arrival of the modeller, John Toulouse who came from Bow.[2] Toulouse's subsequent career can be illustrated by the later introduction of shell pickle stands at Plymouth, Caughley and Chamberlain's Worcester. Shell pickle stands were also made at Derby and even by the fledgling American company, Bonnin and Morris, established in Philadelphia in 1770.

Worcester produced several sizes of pickle stand around 1768-72, in colours, in blue and white and in plain white versions. The small shells are strikingly realistic and some were undoubtedly cast from moulds made using real sea shells. The Cheekwood stand is an example of the middle size with one layer of three scallop shell pickle dishes surrounding a raised central dish, which was possibly used for salt. The underglaze blue pattern features rose sprays painted in a linear style and an intricate border only found on pickle stands.[3]

1. Letter of July 11, 1747, quoted by Rosalie Wise Sharp, *Ceramics: Ethics & Scandal*, p. 149.
2. John Sandon, *The Dictionary of Worcester Porcelain*, p. 326.
3. Branyan, French and Sandon, *Worcester Blue and White Porcelain*, pattern I.E.31.

14. Coffee Can

Size: 6.1cm (2⅜in.) high
Date: c.1765-70
Mark: Open crescent
Gift of Michael Ryan King in honour of Mrs. William J. Tyne, 1993.3

A cup with straight sides and no separate footrim was known in the 18th century as a can. Initially cans were not sold as part of tea and coffee sets with matching saucers and instead it was usual for coffee to be served in cups passed around on a silver tray. The wide bases gave the cans stability when served in this way. By the time this particular can was made, full matching tea and coffee sets were the norm. The service will have included saucers to accompany the teabowls, whereas it was still usual for coffee cans to be used without saucers. Indeed, they were sometimes used for a very different purpose, for hot toddies. Of course Worcester's soapstone formula guaranteed they would not break during use. A Worcester coffee can of rather earlier date is recorded inscribed in blue:

I drink up the liquor
Tho the cup is but small
And heres a good health
To Edmund Wall[1]

The pattern on this can is known as the 'Cannonball'. It was a popular pattern used for about thirty years beginning around 1755.[2] It was copied from contemporary Chinese Nankin export porcelain and is reminiscent of the so-called 'Three Dot' painted style used earlier at Bristol and at Worcester during the factory's first year of production. 'Floating rocks', a feature of formal Chinese landscape painting appear on the reverse of this can. These have become so stylised that later Worcester collectors thought that they resembled three cannonballs. Around the interior rim is a diaper border widely used on Chinese porcelain at this time and much copied at Worcester.

1. In the Museum of Worcester porcelain (formerly the Dyson Perrins Museum).

2. Branyan, French and Sandon, *Worcester Blue and White Porcelain*, pattern I.D.6.

15. Milk Jug from a Tea Service

Size: 10.1cm (4in.) high
Date: c.1770
Mark: Pseudo Chinese character mark
Gift of Dr. and Mrs. Roland Lamb, 1981.7.2

 The *Eloping Bride* makes an alluring name for this blue-and-white pattern copied directly from Chinese porcelain. The principal motif comprises two figures on a galloping horse. The forward figure turns and releases an arrow behind them. On the reverse of the jug are two other figures on foot – perhaps soldiers or courtiers. One holds a long spear. The name 'Eloping Bride' was given to the pattern by Victorian collectors of Worcester porcelain. While fun, this name is misleading, for the Chinese version actually depicts an Imperial hunting scene with attendant figures holding banners.

It is curious that the Chinese pattern Worcester chose to copy was not a contemporary design from 1770 but a pattern that had not been imported from China for something like forty or fifty years. The Chinese version occurs on teabowls and small plates or saucers made during the Kangxi and Yongzheng periods, around 1700-30. Worcester's version is carefully painted, but differs from most surviving Chinese prototypes. The figures resemble cardboard cut-outs, for Worcester have omitted the background detail of a simple landscape. Worcester used the pattern from about 1768-70. They chose to paint it only on their smallest size of teabowl and saucer, which is appropriate as the earlier Chinese originals were also very small. Other shapes in the Worcester teasets of this pattern are normal sized and include conventional teapots, covered sugar bowls and coffee cups. This milk jug would originally have had a cover with a modelled flower knop. A distinctive oval shape of spoon tray appears to have been created just for this pattern and a small number of other direct copies of earlier Kangxi and Yongzheng porcelain made at Worcester at this same time. The mark used at Worcester for this pattern alone is probably a fanciful copy of one of the Chinese character marks that were often used early in the 18th century.

16. Coffee Pot and Cover

Size: 21.6cm (8½in.) high
Date: c.1775
Mark: Open crescent
Gift of Dr. and Mrs. E. William Ewers, 1981.9.2

Worcester took inspiration for this coffee pot from Meissen rather than the Orient. Small cups moulded with fine vertical ribs known as 'reeding' had been made in the earliest years of the Worcester factory but had long since gone out of fashion. Around 1775 a new range of tewares was introduced with finely reeded bodies, apparently aimed at the Continental market. Some examples were enamelled with plants in purple or puce monochrome copied from the so-called *indianische Blumen* or 'Indian Flowers' decoration used at Meissen in the 1730s and '40s. Other Worcester reeded sets were painted in underglaze blue with border designs only, copied from early French porcelain or faience.

This coffee pot is decorated with a direct copy of a Meissen design, known in Germany as the '*Immortelle*' pattern. Named after an alpine flower, this pattern was first made at Meissen around 1730 and was also called '*Strohblumenmuster*' or 'Strawflower' pattern. This design enjoyed a long popularity, right through into the 19th century.[1] Many smaller German factories copied it and it has been estimated that the design was produced by fifty separate china factories in Europe. Because the pattern was so common, at the end of the 18th century it was referred to in Germany as 'bürgerliches Zwiebemuster' or 'Middle Class Onion Pattern', so called because copies by smaller china makers were cheaper than Meissen's best-selling 'Onion' pattern design also in blue and white. In England versions were also made at Lowestoft and Bow.

Worcester produced the pattern from 1775-85, always on finely reeded shapes. Unfortunately they found it difficult to prevent the glaze dribbling down the narrow moulded ribs and the result was serious blurring to the blue painting on many examples. Nevertheless, the factory must have enjoyed some success for Worcester pieces of the pattern are often discovered today in family collections in Holland and Belgium. Worcester chose shapes that suited the Continental taste. The handle on this coffee pot is an unusual shape similar to Meissen, and some rare covered coffee jugs are known in 'Immortelle' pattern, which are quite unlike vessels used in England.

Although coffee cups were usually included with standard tea services made at Worcester, coffee pots were mostly sold as a separate item. Presumably buyers preferred to use silver coffee pots, which were a symbol of status in many family homes. Worcester coffee pots are relatively uncommon, in total contrast to teapots which Worcester manufactured in enormous numbers. During the period 1760-90 there is relatively little change in the basic shape of Worcester coffee pots. Most have a high domed cover and a curving spout set low down on the baluster body. This 'Immortelle' pattern example has an unusually shallow cover, more suited once again to the Continental taste.

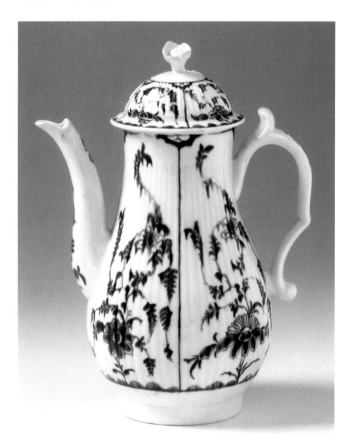

1. Robert Röntgen, *The Book of Meissen*, pp 255-6 discusses the many makers and the different names given to this pattern.

17. Miniature or Toy Tea Service

Size: The teapot 9cm (3⅝in.) high, saucers 9.5cm (3¾in.) diameter
Date: c.1776-80
Mark: Open crescents
Museum Purchase through the Ewers Acquisition Fund 1988.26.1

Miniature or 'toy' porcelain sets were made in various sizes to suit the taste of different buyers. In 1789, in notes to their supplier Thomas Turner at Caughley, the Chamberlain family complained that the miniature sets they had been sent were too small.[1] Most English porcelain factories made miniature tewares and, generally speaking, Worcester examples were larger than most. Even so they were never intended to be functional other than as playthings or novelties.

There is a subtle distinction between toys made for children to play with and toys intended for 'grown up' children to collect. Sets like this were just as likely to be placed in a display cabinet of curiosities rather than be given to a child to play tea parties with. In truth we shall never know if this set was ever used as a children's plaything. What we do know is that it was never a 'tradesman's sample' or 'apprentice piece'. There is a commonly held belief that anything produced in miniature was made as a sample to be carried around to shops by a salesman intent on taking orders for the full-sized object. This may have happened in the furniture trade, and some apprentice carpenters and joiners were asked to make tiny models to show off their skills, but this was not the case in the porcelain industry and there are many surviving records listing the making of 'toys'.

This set was made in the period following the retirement and death of Dr. Wall, and before Thomas Flight purchased the Worcester factory. This was a period of great change, marked by a general downturn in the quality of productions and a decline in blue and white especially. Contrary to these trends, however, this toy set is superbly potted. The thin porcelain is not cast in a mould and instead each piece was carefully turned on a lathe to shape the bodies, rims and feet before the application of separate handles and knops. It is a feature of most Worcester miniatures that they are more or less correct in scale and proportion to full sized tewares. From the photograph alone it would be very difficult to tell that you are looking at a miniature set at all, were it not for the oversized flower sprigs painted on each piece. These roses and leaf sprigs have not been scaled down from normal Worcester blue and white painting.

We know Worcester was making miniature tea sets by 1757 for this date appears on a set made for a little girl named Charlotte Sheriff.[2] During the 1760s a range of miniature pieces was made in the popular 'Prunus Root' pattern and the survival of three more or less complete sets of these in Holland indicates where Worcester saw their market.[3] Dutch families have a long tradition of collecting miniature or toy objects in silver and other materials. Worcester's smaller 'Prunus Root' pattern toys were replaced during the 1770s with these slightly larger items painted with formal flowers. During the following decade creamware and Staffordshire pearlware toys captured much of this market, while in porcelain it was the Caughley factory that led the way in the production of a wide range of toys and miniatures. Worcester examples from the 1770s are uncommon and this almost complete set at Cheekwood is a very rare survivor. There would originally have been six teabowls and saucers, however.

1. Quoted by Geoffrey Godden, *Caughley and Worcester Porcelain*, pp. 61-62.
2. John Sandon, *Dictionary of Worcester Porcelain*, pp. 310.
3. John Sandon, *op. cit.*, pp. 340-41.

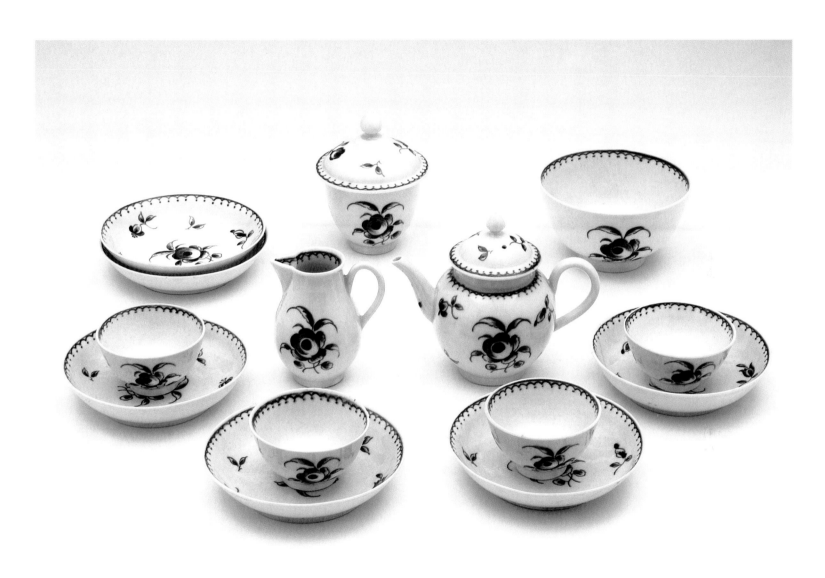

18. Bough Pot

Size: 22cm (8⅝in.) wide
Date: c.1765-68
Mark: Shaded crescent
Museum Purchase through the Ewers Acquisition Fund, 1978.4.2

In the 18th century ceramic flower containers came in various forms, sizes and materials. In England the fashion began with delftware. Flower bowls with pierced tops and the very popular delft 'flower bricks' were available in great numbers for tables and mantelpieces. Small holes at the top allowed for the placing of single cut flower stems. The pots could hold either fresh or artificial flowers, both of which were popular as decoration. Pots with larger holes accommodated flower bulbs such as hyacinths and tulips.

The shape popularly known as a 'bough pot' was produced at Worcester from the late 1750s until about 1780. Just two different models were available and these could be decorated in many different ways. The most lavish examples were made with scale blue grounds with panels of colourful fancy birds, while overglaze transfer-printed decoration was also used. The most frequently encountered versions are printed with flowers in underglaze blue. The Cheekwood example is moulded with three cartouches or panels, each filled with a printed

floral bouquet. As space fillers, smaller flower sprigs, narrow sprays and butterflies decorate the spaces in between the cartouches and the top. The larger bouquets combine elements from both the 'Pinecone Group' and the 'Rose-Centred Spray Group'.[1]

The shape of this pot is very much in the rococo taste with its asymmetrical shape, embossed scrolls and undulating surface. Worcester rarely produced such full-blown rococo shapes, which clearly looked to Continental prototypes. This form is not known from any other English porcelain factory. Pairs of Worcester bough pots survive together yet curiously only a single mould seems to have been used. You do not find 'mirror images' of the modelling as left- and right-handed examples. The back panel is pierced with two small holes which would have enabled owners to hang their bough pots on a wall in the same manner as a wall pocket or cornucopia. The level base is also designed for these to sit on a mantelpiece, however. The Worcester porcelain collectors Jeanne and Milton Zorensky owned a similar blue and white example within which they attempted to grow bulbs. Failure led them to conclude that these pots were really suited only for displaying cut flowers.[2]

1. Branyan, French and Sandon, *Worcester Blue and White Porcelain*, patterns II.C.10 and II.C.11, in particular p. 383 for a very similar bough pot.

2. Bonhams' catalogue of the Zorensky Collection, Part 2, 21 February 2004, pp. 6-7.

19. Teapot and Cover

Size: 14.3cm (5⅝in.) high
Date: c.1780
Mark: Shaded crescent
Museum Purchase through the Ewers Acquisition Fund, 1978.3.5

When this teapot was made Worcester's great invention — the process of transfer-printing on to porcelain — was no longer a closely guarded secret. Josiah Holdship probably developed the technique of transferring designs in underglaze blue around 1756-57. His process was perfected by 1760, but by the time he died in 1783 he had apparently lost most of his fortune. According to Martin Barr, he had failed to take prudent care, and this has been taken to mean that Holdship never properly patented his invention.[1] This Worcester teapot of c.1780 had to compete with new rival manufacturers in Shropshire, Liverpool and Staffordshire, all making cheap blue printed tewares.

Printing in underglaze blue had many commercial advantages. Once a copper plate was engraved, hundreds of 'pulls' or separate prints could be taken from it in a short amount of time. Good designs could be repeated time and again in a labour and cost effective manner. One great disadvantage was the difficulty in achieving fine detail. Underglaze printing was prone to run during the glaze firing and, to prevent this, copper plates for blue printing had to be engraved with thick bold outlines. This eliminated the delicate shading that was possible when prints were applied overglaze.

By the 1770s Worcester blue and white porcelain was competing head-on with cheaper imported teasets shipped from China. As a result, most of Worcester's blue-printed teaware was decorated in the Chinese taste. This teapot at Cheekwood bears a popular print known as 'The Mother and Child', depicting a seated Chinese woman with a child at her knee, flanked by ornate vases of flowers.[2] The print appears in an identical image on both sides of the pot. Small, individual flower prints decorate the spout and the lid. The deeply engraved lines necessary for underglaze printing have resulted in a strong image with a stark contrast between the figures and the white background.

Soon after this most successful teapot was made, Worcester's blue and white porcelain fell into a sharp decline. Difficulties with the printing process appeared in the 1780s,[3] and fierce competition from Staffordshire creamware potters, Caughley and Liverpool porcelain and Chinese export porcelain severely affected Worcester's market. By 1790 Worcester had abandoned the process altogether and focused instead on more expensive, coloured goods.

1. John Sandon, *Dictionary of Worcester Porcelain*, pp. 195-197.
2. See Branyan, French and Sandon, *Worcester Blue and White Porcelain*, pattern II.A.13. A rare version of this print appears with a third woman at the far right.
3. Henry Sandon, *Flight and Barr Worcester Porcelain*, appendix quoting from John Flight's diary.

EARLY WORCESTER COLOURED PORCELAIN

In its first year or two of production Worcester had trouble perfecting its blue and white, although from the outset its earliest enamelled porcelain was decorated to a remarkably high standard. In papers referring to the merger of the Lund's Bristol and Worcester porcelain manufactories in 1752, Worcester was described as a 'porcelain manufactory in imitation of Dresden ware', while Bristol was a 'porcelain manufactory in imitation of Indian China ware'. The East India Company had imported vast amounts of blue and white from China and this meant Bristol made only blue and white. Dresden on the other hand was associated with porcelain finely painted in colours, and this was Worcester's speciality.

Dresden (also known as Meissen) was only one of several influences on early Worcester painted porcelain. The exciting pieces at Cheekwood that date from the early 1750s are essentially Chinese in style, but working out the source of each pattern is not straightforward. The distinctive colouring used on eighteenth century Chinese export porcelain is mostly classified as either *famille verte* or *famille rose*. A cup and a bowl in the collection copy early Chinese *famille verte* with a bit of old Japan and Dresden thrown in. Meanwhile, *famille rose* colours decorate a cider jug in a popular pattern known as the 'Beckoning Chinaman'. The colouring of this jug seems to be Worcester's own invention however, as when it occurs on original Chinese porcelain this painted figure with one hand waving in the air, has been seen on *famille verte* vases. Much of the Chinese decoration on early Worcester is therefore 'Chinoiserie' inspired by, but not exactly copying, the porcelain of the Orient. A fine yellow ground jug at Cheekwood with Chinoiserie scenes in puce is more directly copied from Meissen of twenty years before.

By the mid-1760s a series of so-called Mandarin patterns were made as direct copies and replacements for Chinese *famille rose* teasets. Meanwhile the 'Imari' colouring from old Japan also proved popular. These Oriental patterns were sold alongside copies of Dresden flowers, birds and landscapes. Chelsea in London copied the same Dresden designs and Worcester was clearly influenced by these London porcelains too. In 1768 Worcester claimed that they had engaged 'the best painters from Chelsea &c' and these included John Donaldson and Jefferyes Hamett O'Neale. As well as copying a solid dark blue ground from Chelsea, Worcester made its own unique version of a blue background known as 'scale blue', the perfect ground to show off its 'fancy' or fabulous birds. A particularly fine scale blue vase can be seen at Cheekwood.

Worcester's very special invention, transfer printing in enamel colours, is particularly well represented in this collection, with two fine mugs and a remarkable punchbowl. Known at the time as 'Jet Enamels', Worcester's black printing was of superb quality, thanks to the engraving skills of Robert Hancock.

At the Worcester factory the enamelled decoration was often technically superb, but didn't always keep up to date with London fashion. Instead it was left to the Giles studio to follow the latest taste. Undecorated white Worcester porcelain was sold to James Giles, whose enamelling workshop in Soho copied the latest French porcelain from Sèvres as well as Meissen and Chelsea. Sèvres porcelain inspired both Giles and the Worcester factory to make a series of sumptuous new ground colours.

As fashions changed during the 1770s the Worcester factory should have taken their lead from Chelsea and Chelsea Derby in London. Instead, Worcester generally avoided the new Classical taste and stuck stubbornly to tradition. In this collection, a plate from the The Duke of Gloucester service represents Worcester's rococo porcelain at its best, but it was to be at least another decade before the factory received another royal order. When Dr John Wall retired in 1772, his old partner the apothecary William Davis remained at the factory's helm. Scale blue remained a staple product along with copies of Chinese and Japanese By the 1780s Worcester desperately needed new artistic direction, and they found this with Thomas and John Flight.

Opposite: Dessert plate decorated in the Giles workshop. See catalogue no. 48.

20. Early Coffee Cup

Size: 5.7cm (2¼in.) high
Date: c.1753
Mark: none
Provenance: The Cohen Collection; exhibited by Albert Amor Ltd in 1976, 1990 and 1992
Museum Purchase through the bequest of Anita Bevill McMichael Stallworth, 1992.16.1

This rare cup illustrates the many different influences Worcester combined together when creating its own unique style, for this was probably made during the first two years of production. The shape is probably borrowed from silver. Small silver cups were used for drinking coffee, their forms inspired by earlier Chinese porcelain 'capuchines', the name given to small coffee cups imported into England at the end of the 17th century. Worcester set out to create very individual shapes and this curious 'double ogee' base is quite unlike any other Chinese porcelain cups from the mid-18th century. This is one of the rarest forms of early Worcester coffee cup and very few examples are known.[1]

The decoration is Chinese in appearance, but the colouring is neither *famille verte* nor *famille rose*. These two distinct palettes of enamel colours used on Chinese export porcelain influenced most of the porcelain copied in England. Worcester took decorative elements from both China and Japan and mixed up the colouring to

create something special. The result could be compared with Meissen porcelain from twenty years earlier, where other Oriental patterns were somehow blended together in a similar way. It is unlikely the decorators at Worcester had seen any of these Meissen wares and instead this piece is pure and original Worcester decoration.

The main subject is an archaic bronze vase, which would have been revered as a precious object in China. Behind it and around the base of the cup are interpretations of Daoist 'Precious Objects' and emblems representing the Immortals. These motifs occur on earlier 18th century Kangxi porcelain, although of course their symbolism meant nothing to the painters at Worcester. Sprigs of formal Oriental plants conceal a beetle and a grasshopper. The iron red border inside the cup is in the style of Japanese *Kakiemon* porcelain, which was much copied at Chelsea. Gold highlights were used only sparsely on early Worcester and have been applied with considerable care.

1. A similar cup in the Kenneth Klepser Collection in Seattle is discussed by Simon Spero, *Worcester Porcelain, the Klepser Collection*, fig. 16.

21. Early Fluted Bowl

Size: 18.7cm-19.3cm (7⅜in.-7⅝in.) diameter, 7.8cm-8.2cm (3⁵⁄₁₆in.-3¼in.) high
Date: c.1753
Mark: A single incised line by the footrim
Provenance: formerly the Cohen Collection. Albert Amor Ltd, 1992. Illustrated by John Sandon,
The Dictionary of Worcester Porcelain, p. 15
Museum Purchase through the bequest of Anita Bevill McMichael Stallworth, 1992.16.3

21. Interior

This bowl reflects all the excitement of a porcelain factory in its infancy. At the same time it shows levels of sophistication that within a year or two would lead Worcester to great things. The porcelain body contains soaprock, Worcester's secret ingredient which gave it durability and the ability to withstand heat. It also meant the porcelain was unstable during firing and this bowl is misshapen and more than slightly askew. The shape is 'jolleyed' which means that it was made by pressing clay into a revolving mould. Worcester soon mastered this technique and was able to produce some of the crispest and most original moulding seen on early English porcelain. Shapes inspired by silver were reproduced with precision. The shape of this bowl, with thirty-six evenly spaced flutes, may have been copied from Japanese porcelain but it is more likely to have been based on a ribbed silver bowl.

The glaze has an even, slightly grey-green cast. This would not have matched the pure-whiteness of Japanese porcelain, nor Chelsea or Meissen, but it was ideally suited for reproducing Chinese porcelain. The palette used here for the enamelled decoration is essentially Chinese *famille verte* from the Kangxi period earlier in the 18th century. This bowl does not include the rose pink that had become a feature of contemporary Chinese *famille rose* porcelain, but most early Worcester porcelain combined the two palettes in a style of decoration that was unique to the factory. Patterns were inspired by China and Japan, blended together with elements borrowed from Meissen, Staffordshire white stoneware and English enamelled white glass. This bowl exhibits a restrained simplicity in its decoration of flowering leafy branches and tiny insects. Related decoration was used on the small, octagonal coffee cups, which Worcester made in large numbers, whereas larger scale items such as this bowl are rarely encountered.

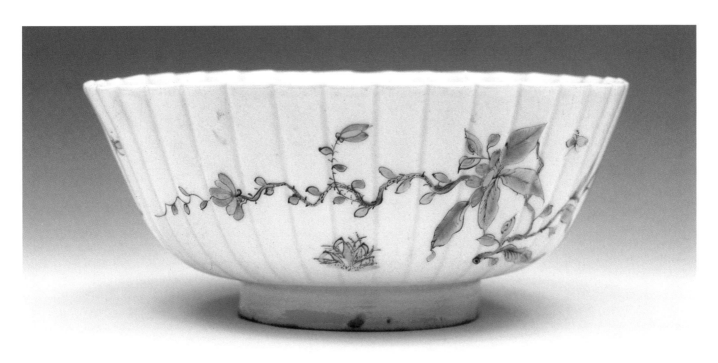

22. High-footed Sauceboat

Size: 6.4cm (2⅝in.) high
Date: c.1754
Mark: none
Museum Purchase through the Ewers Acquisition Fund, 1978.1.24

A wide range of fancy, moulded sauceboats was made at Worcester during the first five years of the factory. Collectors usually describe these as 'silver shape' and there is no doubt that the ultimate influence was English rococo silver from the 1740s. Exact matches are not easy to find, however, and it is likely Worcester's modellers were partly innovative as well as copyists. The price list of Worcester's London Warehouse, apparently dating from 1755-56, records that 'Sauce Boats, high footed' were made in three sizes, selling for between 14s. and 27s. per dozen.[1] Blue and white and coloured examples were made in a wide range of patterns. The enamelled versions were mostly in Chinoiserie style. Many were painted with a single standing Chinese figure, holding either a flower or a fan. Figures of this type have become known as 'Long Elizas'. The origin of the term is lost in the folklore of collecting although Long Eliza was apparently an anglicised version of the Dutch term *lange lijzen*

(meaning 'tall lady'). The bodies of Worcester high footed sauceboats were pressed from two-piece moulds, and they often have totally different modelling framing the panels on the front and on the reverse. Inside the lip of this sauceboat enamelled Daoist emblems add to the Chinoiserie theme, for these motifs have long lost their religious significance and are merely decorative instead.

In England in the 1750s a costly pair of Worcester porcelain sauceboats was much more than just a way to impress your dinner guests. A shortage of fresh meat meant meals were heavily salted as well as bland. Strongly flavoured sauces and gravies were essential to make meals palatable. In large households dining rooms were often a long way from the kitchen and cold food was another problem. Worcester sauceboats could be kept warm in the same way as silver examples, and so hot, richly flavoured gravy poured from such a vessel made a most welcome garnish.

1. See John Sandon, *Dictionary of Worcester Porcelain*, p. 223.

23. Leaf Sauceboat

Size: 18.6cm (7⅜in.) long
Date: c.1754-55
Mark: none
Museum Purchase through the Ewers Acquisition Fund. 1988.11.4

This sauceboat is in the shape of a cos lettuce, gently curving with a strongly modelled stalk looping to form an integral handle. The decoration of painted flower sprays combines European and Chinese styles in thick enamels. Surviving examples show that these leaf sauceboats were amongst the most popular shapes made at the Worcester factory during the 1750s. It is curious, therefore, than less than ten broken fragments of matching sauceboats have been found during numerous excavations on the factory site.[1] There are two possible reasons for this anomaly. The shape was apparently manufactured in large amounts during a relatively short time scale; also any examples that collapsed during the kiln firing didn't need to be thrown away on the factory site – misshapen leaf sauceboats looked perfectly natural to customers who enjoyed their rustic form. Other leaf-moulded sauceboats were made by most English porcelain factories, especially Longton Hall and Derby, but this precise shape appears to be unique to Worcester.

The decoration of enamelled flowers and insects is always finely executed. The colouring used on the Cheekwood example is unusual and shows the influence of earlier Meissen formal flower painting.[2] The surviving price list of

Worcester's London warehouse[3] shows that these were made in two sizes and originally sold for either 3s. or 3s.6d. each with enamelled decoration. It is significant that the London price list makes no mention of blue and white leaf sauceboats, as these were clearly aimed at the luxury end of the market. Only a handful of blue and white Worcester examples survive and all are poorly potted.[4]

Another example in the Museum of Worcester Porcelain shown with unglazed wasters from the factory site.

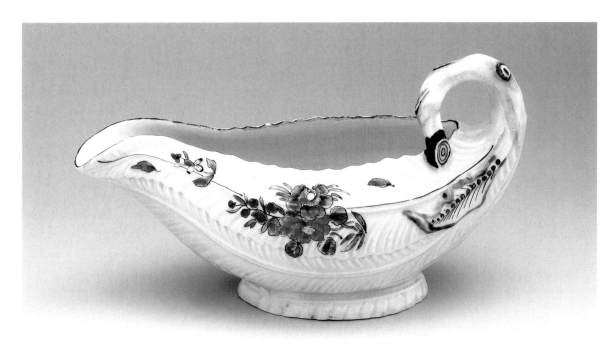

1. Discussed by John Sandon, 'Recent Excavations at Worcester', English Ceramic Circle Transactions, Vol. 11, pt. 1, 1988, p. 2.
2. See catalogue no. 32 for a jug with related enamelling.
3. Reproduced by John Sandon, Dictionary of Worcester Porcelain, p.223.
4. For an example from the Zorensky Collection see John Sandon and Simon Spero, Worcester Porcelain, the Zorensky Collection, catalogue no. 531.

24. Large Jug

Size: 17.9cm (7⅚in.) high
Date: c.1754-55
Mark: None
Provenance: formerly the Knowles Boney Collection
Gift of Mrs. William J. Tyne 1988.25.1

Jugs of this shape and size are often described as cider jugs, but they could just as likely have been used for beer, water or any other purpose. Curiously, the only jugs listed for sale in the Worcester factory's London warehouse price list, c.1755-56, are 'Dutch Jugs' which we know to be the leaf-moulded versions (see catalogue nos. 8, 31 and 32). Plain baluster-shaped jugs were, however, a staple product of the period, made in a limited range of sizes and with distinctive 'S'-shaped handles which have a slight thumbrest at the top. Thrown individually on a potter's wheel and turned on a lathe, these are usually somewhat thick and heavy for their size, and so call out for robust decoration. The 'Beckoning Chinaman' pattern lends itself perfectly to the shape.

The name is probably a Victorian invention by collectors amused at the theatrical pose of the portly Oriental who appears to be calling to a distant flock of birds, while a small boy dances at his side. The pattern is very much Chinoiserie. It is likely the Worcester factory created the design themselves by taking elements from earlier Chinese porcelain. Indeed, the main figure occurs on Chinese vases and dishes from the Kangxi period.[1] It is also possible that Worcester were influenced by earlier Meissen or Vienna porcelain. Johann Ehrenfried Stadler painted very individual Chinoiserie figures at Meissen during the 1720s and '30s and his cartoons closely resemble some Worcester patterns such as the 'Beckoning Chinaman'.[2] It seems far more likely that this style evolved at Meissen, Vienna and at Worcester quite independently of one another, but close parallels exist, especially in the nature of the enamels used. The floral design on the reverse of this jug is very different from Chinese *famille rose* and is strikingly reminiscent of the *indianische Blumen* style of Oriental flowers that were painted at Meissen a quarter of a century earlier.

These colourful, almost translucent enamels were used at Worcester from about 1753 and the 'Beckoning Chinaman' pattern was probably introduced a year or two later. The palette is close to that used on some Staffordshire white saltglazed stoneware as well as on early Longton Hall porcelain also made in Staffordshire. It is therefore possible that Staffordshire workmen brought this style to Worcester. The ground beneath the figures on this jug is washed in translucent green and heightened with dots of black enamel. This method of painting foregrounds, copied from earlier Chinese *famille verte*, was used extensively at Worcester during the 1750s. The 'Beckoning Chinaman' pattern varies greatly in the treatment of the painting by different artists and also in the composition. Sometimes the small boy is omitted. On some pieces, a woman holding a fan with a child by her side replaces the flower spray used here on the reverse of this jug. This version with the woman and child occurs on a series of fine Worcester fluted teapots. These were subsequently copied by Philip Christian's factory in Liverpool. Dr Knowles Boney, who previously owned the Cheekwood jug, collected Liverpool porcelain and thought this jug had been made there also. A Worcester origin is, however, no longer in doubt.

1. Worcester copied a figure painted on Kangxi *famille verte* porcelain. This shows one of the 'Eight Drunken Immortals of the Tang Dynasty', made famous in a poem by Du Fu.

2. The link is discussed by John Sandon and Simon Spero, *Worcester Porcelain, the Zorensky Collection*, p. 148, fig. 137, where a mug of this pattern is illustrated.

25. Butter Tub and Cover

Size: 14.1cm (5⅛in.) long
Date: c.1756-58
Mark: none
Gift of Mrs. William J. Tyne 1986.2.1ab

Usually known as a butter cooler, this rare Worcester object is more correctly described as a container for cool butter. The shape simulates a wooden tub, the staves held tightly together with bands of rope. Here the rope hoops are picked out in delicate yellow enamel, while other examples are known with pink hoops. The form is inspired by the shape of a butter churn used in the dairies of grand houses, where fresh butter was made every day. When butter was brought from the cold environment of the dairy into the warmer atmosphere of the house, condensation inevitably occurred. The moisture would have drained away through the holes in the porcelain tub.[1] Pierced butter tubs of similar form were made at Meissen around 1750 and Worcester appears to have copied these, or possibly an intermediary Chelsea example from the Red Anchor period. The flower painting seen here is in the Meissen style known as *deutsche Blumen.* Butter tubs pierced with rows of tiny holes were also made at Sèvres and related shapes occur also in silver. These pierced butter tubs would have needed a dish to catch any drained liquid and it seems curious that no matching porcelain stands are known.

Worcester fired lids and bases separately and, because their soaprock porcelain body was prone to distort in the heat of the kiln, this presented a problem when it came to matching up lids and bases afterwards. The covers that survive on Worcester butter tubs are rarely a perfect fit.

1. The function of an identical object is discussed by John Sandon and Simon Spero, *Worcester Porcelain, The Zorensky Collection,* p. 121, fig. 90.

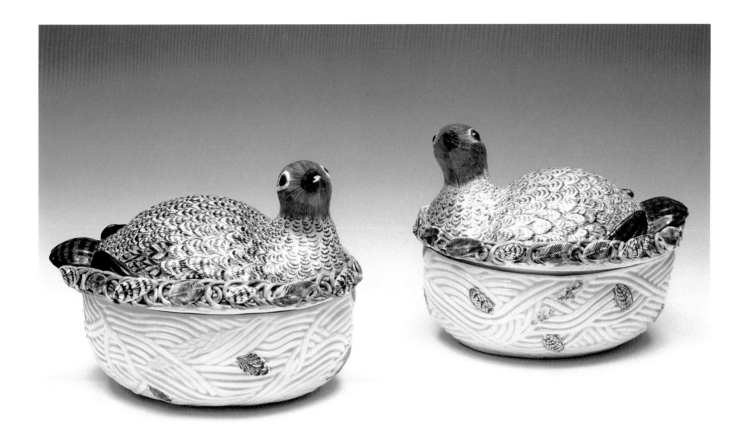

26. Pair of Partridge Tureens

Size: 16.8cm (6⅝in.) and 17.8cm (7in.) long
Date: c.1755-6
Marks: None
Gift of Mr. and Mrs. P.M. Estes, Jr., 1981.30.1

Described simply as 'Partridges' in the price list for Worcester's London warehouse, these tureens are recorded in two sizes. The Cheekwood examples are the larger versions, which sold for 5s. each in white and 8s. enamelled. The birds are decorated in a realistic fashion with plumage painted in shades of brown and red. They rest upon white porcelain nests woven with feathers. The rims of the 'nests' are edged with straw formed from spirals of clay resembling spaghetti, individually applied among feathers and moss. On smaller Worcester partridge tureens this straw band is applied to the bases, whereas on these rare large versions this rim of the nest is modelled as part of the lids, not the bases. In addition, a cut-out loop at one end of both the covers and bases provides openings for silver ladles, another feature found only on some of the larger Worcester partridges.

Tureens in the shapes of animals were just one part of the whimsy and illusion of the rococo style. Bulls' heads in Chinese porcelain, hens and chicks in Chelsea and lobsters of silver adorned tables and amused guests in the middle of the 18th century. Novelty tureens accompanied the dessert course when hosts would show off their wealth by decorating their tables in the most opulent manner. These Worcester partridges probably held sugar and cream to be served with a dessert of fruit. Worcester's rivals at Bow, Chelsea, Derby and Longton Hall all created partridge tureens in the 1750s. The ultimate source was most likely Meissen, although a wide variety of novelty tureens were also made in French faience. Worcester had problems with distortion when firing lids and bases separately and this is possibly why the factory was never fully committed to the idea of novelty tureens. Although Worcester made a large number of dishes in the shape of leaves, partridges and cauliflowers were the only naturalistic tureen shapes the factory attempted.

27. Covered Bowl or Écuelle

Size: 13cm (5⅛in.) diameter of cover
Date: c.1758-62
Mark: None
Provenance: Pitchford Hall, Shropshire, Christie's sale of the contents, 29 September 1992;
Simon Spero, exhibition catalogue 1993, fig. 28
Museum Purchase through the bequest of Anita Bevill McMichael Stallworth, 1993.24

Although this piece was possibly intended to be used as a sugar box, at Worcester this shape was usually made with a stand and is copied from a Meissen prototype. *Écuelle* is a French term for a covered bowl used for serving broth or soup, normally accompanied by a matching stand. This is a rare shape in Worcester porcelain. Examples are usually found painted with Meissen style flowers, either in colours or in blue and white.

This covered bowl formed part of an armorial set which passed down through many generations of an old Shropshire family. When the contents of Pitchford Hall were sold off in 1992, only a few pieces of the service survived, but all show the influence of Meissen. The baluster teapot was a Meissen shape, which was also made at Chelsea.[1] Just two cups and saucers remained. The teacup was a shape copied directly from Meissen and was marked with a copy of the crossed swords mark.[2] The 'Red Crabs' pattern is derived ultimately from Japanese Kakiemon, but once again by way of Meissen, where designs including this fanciful dragon were made c.1730. On this covered bowl an orange dragon circles through blue and yellow clouds over two comical crabs. Various insects and flowers dot the remaining white space. The pattern, without the added armorial, was apparently a standard factory pattern at Worcester, for it appears on teawares, Dutch jugs and some other moulded shapes from the late 1750s into the 1760s.

The Beauville family of Shropshire presumably requested this pattern and asked for Meissen shapes when they ordered a set bearing their coat of arms, a black shield with three stars and a chevron. The incorporation of the arms into the middle of the design, rather than

separating them from the pattern, is an unusual composition for English armorial porcelain, but curiously this is a feature sometimes seen on Meissen. As one of the few uniquely Meissen shapes that the factory had in stock, it is possible that for the Beauville service they substituted this small broth bowl in place of their normal sugar box. One other complete Worcester teaset is known, of similar date painted with Meissen style flowers where this same écuelle shape replaces the conventional sucrier.[3] The porcelain may have been 'old stock', from the mid-1750s, decorated just a few years later, for a bowl of the 'Red Crabs' pattern is recorded where the shape also appears to be much earlier than the decoration.[4]

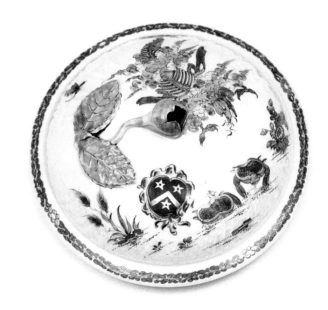

1. The teapot is now in the Art Institute of Chicago.
2. John Sandon and Simon Spero, *Worcester Porcelain, the Zorensky Collection*, p. 142, fig. 126.
3. Bonhams sale 12 September 2007.
4. John Sandon, *Dictionary of Worcester Porcelain*, p. 275.

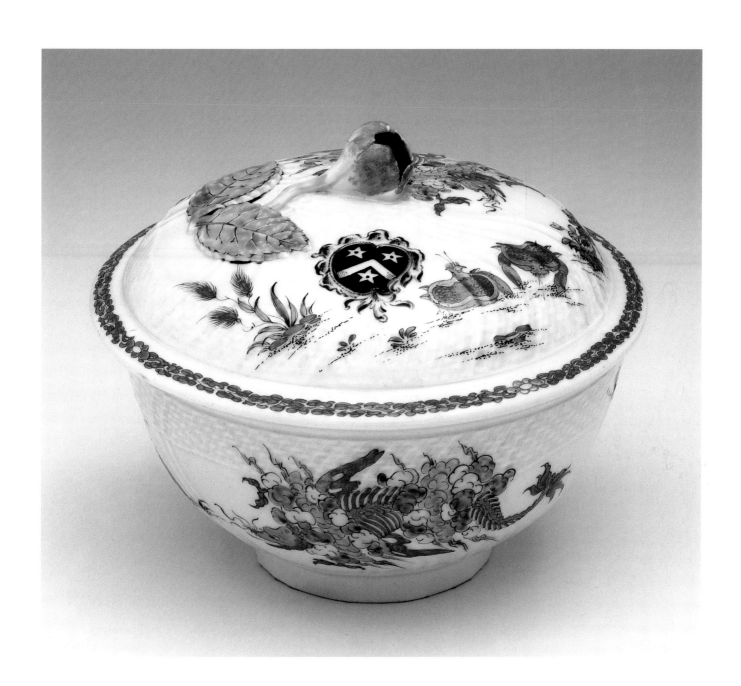

28. Dessert Dish

Size: 29.9cm (11⅜in.) wide
Date: c.1778
Mark: None
Published: Graham & Oxley, *English Porcelain Painters of the 18th Century*, exhibition catalogue, 1981
Gift of Mr. and Mrs. P.M. Estes, Jr., 1981.31.3

FABLES. 129

FABLE XXXIV.
The MASTIFFS.

G Van d'Gucht after John Wootton. 'The Fable of the Mastiffs'
from John Gay, Fables, 6th Edition. J. & R. Tonson and J. Watts,
London, 1746.

This dish is one of a distinctive group of dessert wares painted with animal subjects by an unknown painter. Previous attributions to Jefferyes Hamett O'Neale or Fidèle Duvivier are no longer accepted, for this is clearly not the hand of a master. Indeed, the naïve, almost amateur appearance of the painting gives this series its enormous charm. Within colourful, tight compositions, the animals are rendered in unnatural shades of lilac, rose, and blue. When human subjects are included these are awkwardly drawn with an almost cartoon-like quality. The painter derived his subjects from prints, although he simplified the compositions by removing foreground elements. Here the three men and three dogs have been placed in a standard Worcester porcelain green landscape vignette with vines at the base.

The source for the scene on the Cheekwood dish has been traced. The painter copied an illustration from an edition of John Gay's *Fables*. A copy of the 6th edition survives today in the archives at the Worcester porcelain factory, although it is very unlikely to be the same copy used in the 18th century.[1] The fable of 'The Mastiffs' is illustrated with an engraved scene signed by G Van d'Gucht after John Wootton (c.1683-1764). A successful artist of sporting subjects, Wootton provided thirty plates, mostly animals, for the *Fables*. William Kent supplied the remainder of the images. 'The Mastiffs' points out the consequences of interfering in the quarrels of other people. Two dogs are fighting when a third dog – representing England – enters the quarrel just to join the fray. Gay begins:

> Those, who in quarrels interpose,
> Must often wipe a bloody nose.
> A Mastiff, of true English blood,
> Lov'd fighting better than his food,
> When dogs were snarling for a bone,
> He long'd to make the war his own...

When the dogs' owners, a tanner and a butcher, see the English dog jump in, they are outraged by his interference and pull all the dogs apart. Cursing the English dog's presumption, dogs and men turn on the English dog and beat him. The fable may allude to Great Britain's engagement in the continuous European wars raging for most of the 18th century.

John Gay (1685-1732) was part of a circle of writers that included John Arbuthnot, Alexander Pope and Jonathan Swift. Gay achieved major success with his play *The Beggar's Opera*. In 1727 Gay published his first volume of fables and by 1782 more than fifty editions had been published. Books of illustrated fables, including the better-known Aesop's *Fables*, served as source material for a wide range of English ceramics.[2]

While J.H. O'Neale was at Worcester around 1769-70 he

painted entire dessert services with individual fables.[3] The Cheekwood dish belongs to a later series where animals are the principal subject matter. A few fables seem to have been included as additional decorative images, rather than as illustrations of poignant moral tales.[4] The painter used the same illustrated copy of Gay's *Fables* as the source for a plate now in the Ashmolean Museum Collection. 'The Elephant and the Bookseller' was also engraved by G. Van

d'Gucht, this time after William. Kent.

The neat, gold dentil pattern around the osier-moulded border, and the palette of colours, confirm that this dish was decorated at the Worcester factory. While the painter copied his figures and animals from a print, the treatment of the vegetation and the rocks and plants in the foreground suggest that he was trained at Worcester and was used to painting the famous Fancy Birds.

1. The volume at Worcester is John Gay, *Fables*, 6th ed. (London: J. & R. Tonson and J. Watts, 1746).
2. Jayne Elizabeth Lewis, *The English Fable: Aesop and Literary Culture, 1651-1740* (Cambridge: Cambridge University Press, 1996), p. 162. See also Leslie B. Grigsby, 'Aesop's Fables on English Ceramics', *The Magazine Antiques*, June 1994, pp. 868-877.
3. Discussed by H. Rissik Marshall, *Coloured Worcester Porcelain*, pp. 42-48.

4. Three pieces in the Ashmolean Museum are illustrated by H. Rissik Marshall, *op. cit.*, figs 507-511. Another in the Bowles Collection in San Francisco is illustrated in Simon Spero, *The Bowles Collection of 18th Century English and French Porcelain*, p.101. See also John Sandon and Simon Spero, *Worcester Porcelain, the Zorensky Collection*, fig. 221; Henry Sandon, *Worcester Porcelain 1751-93*, pl. 118; Franklin Barrett, *Worcester Porcelain*, pl. 83a; and F. Severne Mackenna, *Worcester Porcelain and its Antecedents*, pl. 135. A plate with a man and lion was in the Rous Lench Collection and four further pieces were in the Sir Jeremy Lever Collection, Bonhams 7 March 2007, lots 88-91.

29. Leaf Dish with Moulded Scroll Panel

Size: 18.8cm (7⅜in.) long
Date: c.1757-58
Mark: None
Provenance: Collection of Gladys L. Robertson, Toronto. Published: Meredith Chilton and
J.P. Palmer, *A Taste of Elegance: Eighteenth Century English Porcelain from Private
Collections in Ontario*, 1986, and Albert Amor Ltd, 1994
Museum Purchase through the bequest of Anita Bevill McMichael Stallworth, 1994.5

The Fox who longed for grapes, beholde with paine
The tempting Clusters were too high to gaine,
Griev'd in his heart he forc'd a careles smile,
And cry'd, they'r sharpe, & hardly worth my toyle.
Morall:
Young Debauchees to Beauty thus ingrate,
That vertue blast, they can not violate.[1]

One of the most popular of Aesop's fables, the 'Fox and the Grapes' derides the human predilection for rejecting the unattainable. Since the fox cannot reach the grapes, the grapes must be sour. This subject appears on this Worcester leaf dish beautifully painted in dark puce or purple. Numerous illustrated editions of Aesop's *Fables* were published in the 17th and 18th centuries and most of Worcester's customers would have been familiar with this imagery.

The central moulded panel shaped as an unrolled Chinese scroll is somewhat incongruous amongst otherwise European style decoration. The flowers painted in purple around the border are inspired by contemporary Meissen. Similar boldly painted individual blooms occur on a number of costly Worcester productions, such as the Dutch jug at Cheekwood, catalogue no. 31. Most coloured dishes of this shape are decorated in European rather than Chinese taste, whereas in blue and white the opposite is true. The central panels are normally painted or 'pencilled' in a single colour. Some were copied from contemporary prints and some of the subjects are repeated.[2] This shape probably corresponds with 'Fig Leaves' listed in the London warehouse price list selling in 1755-56 for 12s. per dozen.[3]

A Worcester plate, c.1778-80 with a different rendition of the same fable. R. David Butti collection.

IMAGE COURTESY OF BONHAMS

1. Aesop's *Fables.*, London: R. Newcomb for Francis Barlow (1666).
2. Another leaf dish identical to the Cheekwood example is in the Kenneth Maier collection in the Art Institute of Chicago.
3. John Sandon, *Dictionary of Worcester Porcelain*, pp. 218 and 223.

30. Panel moulded Creamboat

Size: 10.5cm (4⅛in.) long, 5.2cm (2¾₆in.) high
Date: c.1760-62
Mark: None
Provenance: Cohen Collection, exhibited by Albert Amor Ltd, 1992
Museum Purchase through the bequest of Anita Bevill McMichael Stallworth, 1992.16.4

A great fire threatened to destroy the Chinese port of Canton in 1743. English sailors under the direction of Commodore George Anson helped to stop it and, in gratitude, the city's merchants offered the Commodore a porcelain service of his own design. The admiral commissioned his ship's official artist, Piercy Brett, to create an appropriate design. Within a border of Anson's coat of arms and views of Wampoa and Plymouth, Brett created a fanciful yet symbolic scene for the centre of each plate. A garlanded breadfruit tree represented the hundreds of such trees dug up by Anson's sailors on Tenian island with the aim of establishing breadfruit plantations in the West Indies. To one side an altar of love stands beside a coconut palm, while doves, a bow and quiver and faithful hounds are further representations of love and home life back in England.[1] A series of engravings based on Brett's drawings made during the voyage were subsequently published[2] and these show that the Chinese porcelain service was indeed based on his painting of a breadfruit tree. Most of Anson's set still survives at his home, Shugborough Hall in Staffordshire, now under the protection of the National Trust.

The central design used for the Anson service became an established pattern available to all customers at Canton. At least twenty other armorial sets were made using the same motifs, while other tableware, vases and even snuffboxes were made without added arms or crests.[3] It is one of these other sets, without Anson's armorial, that inspired copies in Worcester porcelain. Known as the 'Valentine' pattern, the design was used for tea services from c.1756 to the early 1760s. It is most unusual for a teaware pattern to appear on a Worcester creamboat. Here elements of the 'Valentine' are painted within the moulded panels, while the associated scrollwork border is used inside. The altar and doves are placed among leafy sprigs, which formed part of the garland that decorated Anson's breadfruit tree.

Hexagonal or 'panelled' creamboats were first made at the Limehouse and Lund's Bristol factories before 1750. This version, bearing a later form of scroll-moulded handle was used c.1758-65 and features a crisply modelled geranium leaf embossed beneath the lip. In the mid-18th century cream was an expensive luxury and was served in fine silver or porcelain creamboats or small moulded jugs known as cream ewers.

A Worcester teapot painted with the 'Valentine' pattern, c.1758, from the Sir Jeremy Lever collection.

IMAGE COURTESY OF BONHAMS

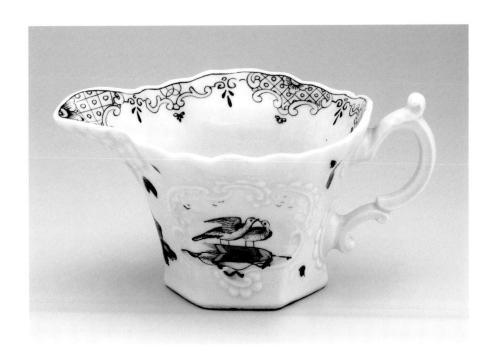

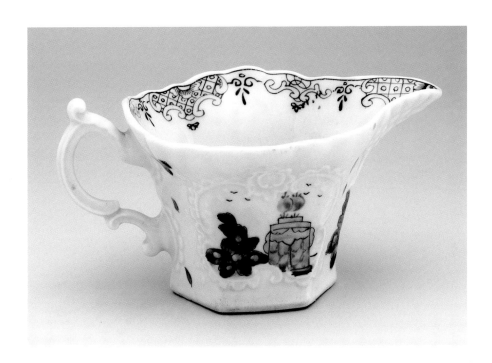

1. David. S. Howard, 'The British East India Company Trading to China in
Porcelain' in *Oriental Art*, Vol. XLV no. 1, 1999, pp. 45-52; also *Chinese
Armorial Porcelain*, pp. 46-48.

2. *Anson's Voyages*, published in 1748.
3 David S. Howard, *A Tale of Three Cities, Canton, Shanghai and Hong
Kong*, Sotheby's exhibition catalogue 1997, pp. 107-109, figs 128-129.

31. Leaf-moulded 'Dutch Jug'

Size: 20.3cm (8in.) high
Date: c.1757
Mark: None
Gift of Dr. and Mrs. E. William Ewers, 1981.9.2

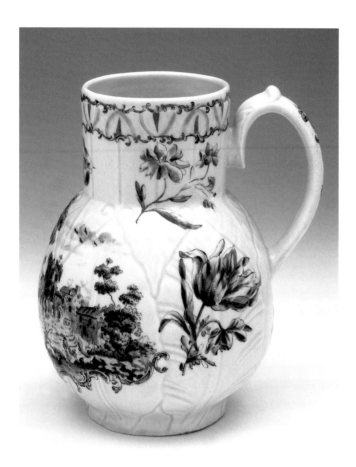

In order to keep up with fashions from the Continent, the Chelsea porcelain factory engaged artists from Tournai and borrowed a collection of new Meissen porcelain for their craftsmen to copy. Sprimont, Chelsea's proprietor, had his finger on the pulse of the latest London taste. A hundred miles away in Worcester things were very different. There is no evidence to suggest Worcester engaged any artists who had any experience of the Continent proper. Their idea of Meissen porcelain painting was second-hand. They had possibly seen some Chelsea and some Longton Hall copies of Meissen. Their painters were most likely Staffordshire saltglaze decorators or had been glass enamellers in Birmingham. As a result, before 1756 Worcester hardly deviated from Oriental decoration.

By 1757 Worcester had made a conscious decision to encompass Continental ideals. They obtained Chelsea vases that were themselves copies of Meissen. Worcester's 'Mobbing Bird' pattern vases were based on shapes and patterns made at Chelsea probably a year before. They could not be more different. Meissen and Chelsea painted real birds in real trees; Worcester did not quite reduce them to the level of cartoons, but they certainly gave them a provincial look. Worcester's 'Meissen' painting is as individual as their chinoiserie figures.

This is a splendid example of Worcester's 'Dutch Jug'. It is clearly Continental in style, but it is not a direct copy of Meissen. The shape is unique to Worcester. Following old stoneware or pewter traditions there is no pointed lip, yet it still functions as a jug and pours surprisingly well. The decoration is ornate and typically ignores the moulded cabbage leaves. Purple rococo borders and flowers frame a large central scene with two men fishing and a shepherd driving his flock towards a ruined church and a distant village. The figures are not the main subject, though. The buildings and the trees dominate the picture. Smoke puffs from the house chimneys. Behind the ruins the village is thriving.[1]

So where did Worcester get their inspiration? It is not Meissen, nor Chelsea. The composition is reminiscent of South Staffordshire (Bilston) enamels, which is understandable in view of the proximity to Worcester. An odd lid formerly in the Godden and Zorensky Collections provides a different clue.[2] Asked to make two covers to sit on top of a pair of bottle coolers from Vincennes, the forerunner of Sèvres, Worcester carefully copied the buildings on the French originals, but used their own Worcester palette of colours instead. These buildings on these odd covers are distinctly similar to the buildings on the jug at Cheekwood.

1. The decoration on a related Dutch jug is discussed in Bonhams' catalogue of Important Worcester Porcelain, the R. David Butti collection, 10 May 2006, lot 53.

2 See Geoffrey Godden, *Godden's Guide to European Porcelain*, pl. 7, and Bonhams' sale of the Zorensky Collection, part 1, 16 March 2004, lot 33.

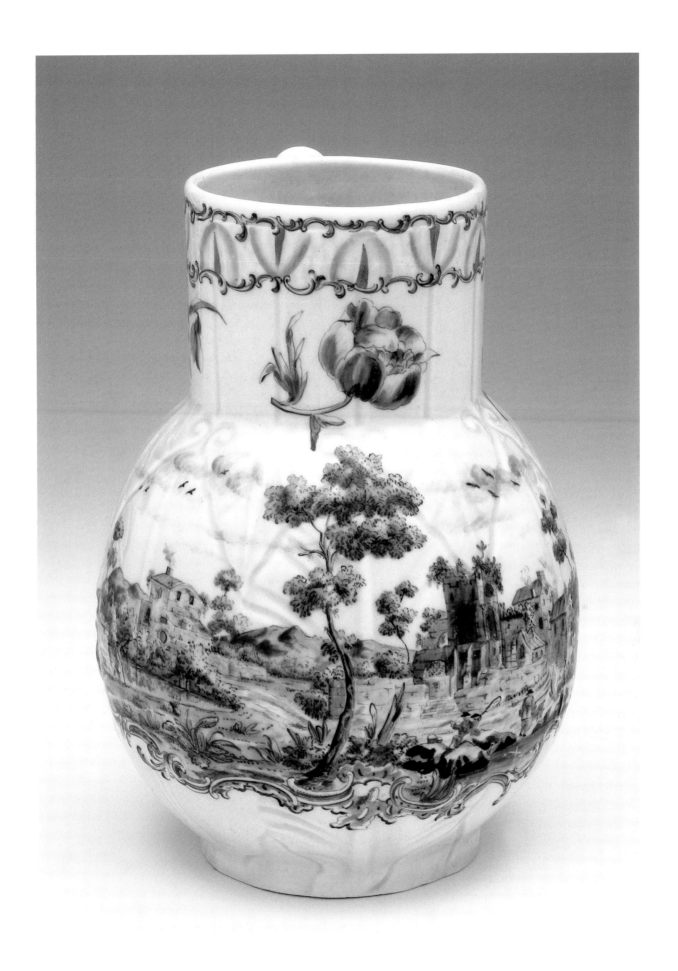

32. Large Mask Spouted 'Dutch Jug'

Size: 27.5cm (10¹³⁄₁₆in.) high
Date: c.1760
Mark: None
Gift of Mr. and Mrs. Robert K. Zelle 1993.12

It is hard to imagine a better illustration of the uniqueness of Worcester porcelain. This large jug, impressed with cabbage leaves, required great skill to shape and fire. The form was a speciality of Worcester alone. Around 1760 the simple loop handle previously used on Dutch jugs (seen on catalogue nos. 8 and 31) was changed in favour of this triple scroll handle, which provides strength and almost invites the owner to pick it up. By this date all Dutch jugs had mask spouts, the pointed beard mirroring the sharp point of the lip. The face on this example is particularly well decorated and full of character, wide awake and crowned like Neptune in brilliant gold.

The Chinoiserie painting is astounding. A different scene appears on both sides of the jug, with further scenes in the smaller panels. The painting style is very similar to some of the best blue and white Worcester porcelain and therefore it is highly likely that the painter of this jug also painted in blue and white. The sources of very few of Worcester's Chinoiserie designs are known. 'The Ladies' Amusement', a wealth of printed imagery compiled by London publisher Robert Sayer, included some related Chinoiserie scenes. The central part of one of these, a fanciful riverscape after Jean Pillement titled 'Chinese Landscape', appears to be the source of one Worcester blue and white pattern,[1] and so it is probable Worcester's blue painters were aware of Pillement's work. This Anglo-French artist was a master of the genre and his paintings and prints of Chinoiserie subjects were very influential.[2]

Comparison with an almost identical jug in the Zorensky Collection[3] strongly suggests that Worcester used a printed source for these scenes. The panels on the Cheekwood and Zorensky jugs appear at first sight to be identical, but close comparison shows many subtle differences in details and in the treatment of the enamel. They may even be the work of different painters. It is unlikely that the painter or painters responsible copied one jug from the other. It is much more likely that prints or drawings on paper provided the designs for both jugs and the decorators made subtle changes as they copied the pictures.

Jugs of this pattern were made in different sizes and smaller mugs, both cylindrical and bell shape, are known. All place the puce Chinoiserie panels on a yellow background. In most cases the yellow proved to be problematical. This jug is a very pale yellow colour, resulting in an unintentional subtlety. It appears that the colour was fired at too high a temperature and partially burnt away in the kiln.[4] The distinctive shapes of the reserved panels suggest Worcester were copying Meissen. Flower sprigs scattered upon the yellow ground also suggest the influence of Meissen's *indianische Blumen*, but true to form, Worcester have adapted these to include a touch of Japanese Kakiemon. These are Worcester's own Japanese flowers instead, in a style that was to become much more important at the factory a decade later.

1. See Branyan, French and Sandon, *Worcester Blue and White Porcelain,* pattern I.B.8.
2. Maria Gordon-Smith, *The Influence of Jean Pillement on French and English Decorative Arts,* published in *Artibus et Historiae,* no. 41, 2000.
3. John Sandon and Simon Spero, *Worcester Porcelain, the Zorensky Collection,* fig. 262.
4. See catalogue no. 33 in this book for further comments on Worcester yellow grounds.

33. Moulded 'Junket Dish'

Size: 22.3cm (8¹³⁄₁₆in.) diameter
Date: c.1762-65
Mark: None
Museum Purchase through the Ewers Acquisition Fund, 1981.9.8

This shallow bowl with a moulded interior is usually called a junket dish, although the original function is unclear. A sweetened mixture of soured cream and curds, junket is better known today as 'curds and whey'. It required a textured surface to help it to set and it is likely Worcester created these modelled dishes for the purpose. Variations on this basic shape were produced at Worcester from c.1758 until 1780, although it is more likely that later examples were used for serving salad.[1] The earliest shape, seen here, has three moulded cartouches reserved on a ground of bead-like basket weave. Most surviving examples occur in blue and white, with Chinese scenes or flowers painted in the panels. Others, as here, had panels of Meissen style flowers in colours reserved on a yellow ground.

Yellow grounds on porcelain were highly prized but difficult to achieve. Meissen had perfected a wonderful yellow ground by 1730 and in turn Sèvres mastered the technique, although examples are rarely found. English porcelain factories had tremendous trouble producing an even, strong yellow ground. Chelsea, during the Red Anchor period, achieved some success but the result was usually pale and insipid. Derby and Longton Hall both used yellow grounds during the later 1750s, although these tend to be messy and uneven. Worcester had attempted a yellow ground as early as 1754-55 on a series of oval potting pots[2] but in the few surviving examples the colour is very uneven and in one instance so pale as to be almost non-existent. These experiments failed and the factory does not appear to have tried again until c.1757.

A yellow ground Dutch jug with the arms of the 14th Countess of Errol, who died in 1758, shows that this ground colour was in use at Worcester before this date.[3] Early examples from 1758-62 reveal how the factory continued to experience great difficulty with the colour. Some junket dishes of this same shape and design are known where the ground colour appears to have over-fired and burnt away almost to nothing.[4] Within a few years, however, Worcester proved that they could create a really strong and even yellow ground. The yellow on the junket dish at Cheekwood is moderately strong and successful. Some others are known with a lurid, almost egg-yolk yellow, but these tend to be the exception. Worcester continued to develop its yellow ground and some jugs and vases from 1765-68 achieved a good strong depth of colour. These are great rarities, though, and, realising their limitations, Worcester seems to have given up the challenge. It was to take another twenty years for a reliable yellow ground to be perfected in England, this time at Derby.

A great many specimens of Worcester porcelain bearing yellow grounds can now be exposed as fakes. The practice of 'redecoration', adding desirable coloured grounds to plain pieces of early Worcester, became commonplace during the 19th and early 20th century. It is important to examine all yellow ground pieces for signs of re-firing at a later date, and also to note aesthetic inconsistencies. During the 18th century Worcester found that border designs in purple or puce were a successful way to frame a yellow background. Nearly every known example of genuine Worcester yellow ground decoration combines these colours in some way. The puce scrollwork highlighting the cartouches on this junket dish confirms its authenticity.

1. John Sandon, *Dictionary of Worcester Porcelain*, p. 212.
2. Bonhams' sale of the Zorensky Collection, part 3, 22 February 2006, lot 7.
3. Research by H. Rissik Marshall, further discussed by Simon Spero, *Worcester Porcelain: The Klepser Collection*, p. 87.
4. Bonhams' sale, 7 December 2005, lot 111.

34. Cauliflower Tureen and a Leaf Dish or Stand

Size: Tureen 11cm (4⅜in.) wide, Leaf dish 21.3cm (8⅜in.) long
Date: c.1757-60
Marks: None
Museum Purchase through the Ewers Acquisition Fund 1983.10.5

Tureens formed as cauliflowers were made at Meissen, Chelsea and at Longton Hall, but, whereas these factories made a great many other plant and vegetable-shaped tureens, Worcester's only other venture into this genre was the partridge tureen (see catalogue no. 26). The modelling is so realistic it is tempting to think Worcester created this tureen by taking a mould from an actual cauliflower. They used press-moulding to cast this vessel which is remarkably thin. Considering the difficulty Worcester usually encountered with distortion during firing, this is a remarkably successful product, for the cover on the Cheekwood tureen fits perfectly. The florets of the cauliflower are left just in the white, for the colour of Worcester's plain glaze is most appropriate. The leaves are enamelled with simple washes of light and dark green to add to the very realistic appearance.

Worcester made cauliflowers from c.1757, the earliest examples sometimes left in plain white. Around 1760 a small number of cauliflowers were further decorated with transfer-printed butterflies, either in black or coloured in over black printed outlines.[1] These match printed butterflies on small leaf dishes and it is likely these cauliflowers and leaves were sold together, the dishes forming stands. It is far from certain whether the earlier plain cauliflowers were sold with similar stands. Leaf dishes like the example seen here survive in far greater numbers than the cauliflowers, suggesting the leaves were sold by themselves as dessert dishes. The cauliflower and leaf dish at Cheekwood do complement each other remarkably well, however.

1. Henry Sandon, *Worcester Porcelain 1751-1793*, pl. 35 for an example in the Museum of Worcester Porcelain.

35. Sweetmeat Dish with 'Blind Earl' Moulding

Size: 16cm (6⅜in.) wide including handle
Date: c.1758
Mark: None
Museum Purchase through the Ewers Acquisition Fund, 1983.10.1

This is an early example of one of Worcester's most popular moulded shapes, a form introduced in the late 1750s. The leaves and rosebuds are raised slightly from the surface, while their stalks meet to form an applied branch handle at one side. A very similar shape of dish was made at Chelsea around 1755-57 during the Red Anchor period, and it is probable Worcester copied Chelsea. Rare examples are also known from Bow and from Derby, all probably copied from the same Chelsea prototype.

Cheekwood's version is painted in realistic colours with delicate shading on the leaves and careful delineation to represent tiny thorns. Chelsea and Longton Hall both made a speciality of *trompe l'oeil* work, forming all manner of dishes out of plants, leaves and flowers. These dishes decorated 'dessert' tables, where novelty was an important part of the visual display. Known as 'sweetmeat dishes', these would have served candied confectioneries. Worcester experienced difficulties making moulded plates and dishes and they rarely achieved the same crisp modelling seen on leaf dishes made by their competitors. However, this rose-leaf moulded dish did enjoy a long life at Worcester and a version was still in production two centuries later. During the 1760s dishes of this shape were made at Worcester to match many popular teaware patterns. It is likely these were sold as accompaniments to teasets and, in the case of these teaware versions, the painted decoration pays no attention to the underlying moulding.

Named the 'Blind Earl' pattern, this design has a romantic tale attached to its development. According to tradition, the Earl of Coventry, blinded in a hunting accident, asked the Worcester factory to make a design he could feel. It is nice to think of the Earl brushing his fingertips over the raised leaves and buds to enjoy this pattern but, like so many stories, part of it at least is apocryphal. The Earl did not suffer his accident until some time later, probably in 1780 – over two decades after the pattern first appeared. A Worcester set of this design made by Flight, Barr and Barr does remain in the Coventry family, however, and it is likely the pattern earned its name a result of the production of this set in the 1820s or '30s.

36. Oval Dish or Stand (one of a pair)

Size: 19.2cm (7%6in.) wide
Date: c.1770-72
Mark: Pseudo Chinese characters within a tramline oval
Museum Purchase through the Ewers Acquisition Fund, 1983.10.3-4

Queen Mary II was an obsessive collector of Japanese porcelain in the 17th century, and she was not alone. Royalty and nobility across Europe competed to acquire the limited amount of Japanese porcelain that trickled through the trade routes of Dutch, Chinese, and English merchants. English collectors, such as the Earl of Exeter at Burghley House,[1] filled their homes with the latest Japanese porcelains. Trade with Japan slowly increased and by the early 18th century, cargoes of 'Imari' porcelain were regularly imported into Holland in particular. The Japanese Imari palette comprises red, orange, gold and a limited use of other colours combined with a deep, intense underglaze blue. The name comes from the port of Imari in Japan through which most of the shipments passed. The trade was short-lived, however. During the 1730s Japan severed its trade links with Europe and by 1740 all exports of Imari porcelain had ceased.

By the time English porcelain was discovered in the middle of the 18th century Japanese porcelain had become the most precious of commodities. Collectors paid generous sums to dealers in curios for any old Japanese wares that were available. This valuable market spurred the new English factories into making copies of any old Japanese porcelain they could borrow. Chelsea and Bow both copied Japanese porcelain extensively. Initially Worcester chose not to compete with the two London factories, and it was not until the late 1760s that Worcester started to make Japanese patterns in earnest.

By 1765 porcelain makers in China had flooded the export market with their own copies of Japanese Imari patterns, in a softer palette than before. Worcester began to make two very different Imari styles. One was copied from contemporary 'Chinese Imari'. The other was known as 'old Japan,' and was quite literally copied from patterns made in Japan in the glorious days sixty years before. This pair of 'Old Japan' stands at Cheekwood faithfully reproduce a Japanese pattern from the early

18th century.[2] These formed stands for a popular shape of oval tureen or potting pot, although the pattern takes no account of moulded rococo cartouches underneath. Panels reserved in the border take the shape of chrysanthemums, or else 'mons', which are a kind of family badge or emblem of rank worn in Japan to signify status. Curiously Worcester usually marked this pattern with Chinese, rather than Japanese characters, using symbols based on Imperial Chinese reign marks.

We know from entries in Worcester's sale catalogue of 1769 that 'Brocade' and 'Mosaic' were contemporary names for some of these patterns, but from the porcelain surviving today it is hard to tell which patterns the catalogue entries refer to. The 1769 sale[3] included sets described as 'Old Rich Mosaic Japan Pattern' and collectors have assumed that this entry refers to the pattern shown here. An unfinished Worcester saucer dish formerly in the Zorensky Collection[4] is decorated with just the underglaze blue portion of the 'Old Mosaic' pattern. This shows how the pattern was created and helps to explain why it was so costly at the time.

1. Gordon Lang, *The Wrestling Boys*, Japanese porcelain exhibition at Burghley House, 1983
2. John Ayers, Oliver Impey, J.V.G. Mallet, et. al, *Porcelain for Palaces: The Fashion for Japan in Europe 1650-1750*, pp. 225 and 291, illustrates a Japanese dish and a Worcester copy, both in the Victoria and Albert Museum.
3. This sale took place at Christie's on December 14 1769.
4. Bonhams sale of the Zorensky Collection, part 3, February 2006.

37. Plate in Chinese Style

Size: 22.3cm (8⅞in.) diameter
Date: c.1765-68
Mark: None
This plate illustrated by John Sandon,
Dictionary of Worcester Porcelain, p. 244
Museum Purchase through the Ewers Acquisition Fund, 1989.17.1

In May 1763 the *Oxford Journal* wrote in praise of Worcester porcelain. The article tells us that '...services of Chinese porcelain may be made up with Worcester so that the difference can not be discovered'.[1] The Worcester factory was certainly prepared to copy any porcelain made in the Orient, but here their publicist claims that their matchings are so precise that they cannot be distinguished from the original. This seems a bit of an exaggeration.

This plate is as close as you can get to a Worcester copy of a Chinese original. The prototype is a Chinese plate made around 1700. This style of decoration and palette, known today as *famille verte*, was popular during the reign of the emperor Kangxi (1662-1722).[2] Named after the dominant green shades, the palette also includes other colours – red, blue, yellow and purple. *Famille verte* enamels are translucent and, to emphasise this, they were usually highlighted or outlined in black. Early in the 18th century, Chinese *famille verte* porcelain was extensively exported to Europe and the style was heavily copied, at the time as well as later.

This pattern, a basket of flowers within a green ground border, is taken directly from a Chinese *famille verte* plate from 1700-20. When this copy was made, in the mid-1760s, plates of this plain shape were very much out of fashion. Yet in order to match the shape as well as the decoration of this Chinese original, Worcester have returned to a shape of plate that they had not made since their first few years.

But what would Worcester's customers have thought when they put this copy alongside the rest of the original Chinese set? The shape would be the same, but the Worcester plate would immediately seem heavy. Chinese *famille verte* plates would have been much more thinly potted. The pattern is faithfully reproduced, but the palette is very different. Worcester's translucent green is their own version of *famille verte* and no doubt this was as close as they could get, but it is not quite right. The glaze on the Worcester plate seems creamy, lacking the crisp, blue-grey tint that distinguishes *famille verte* porcelain from the Kangxi period. Finally, Worcester chose to add gold highlights to their plate. One thing the Chinese enamellers could not master during the Kangxi period was gilding on to porcelain. When it is present on *famille verte* porcelain, Chinese gilding tends to be thin, whereas the Worcester factory's gilding is typically thick with a warm colour and texture.

This is a direct copy of a Chinese plate, but not a 'replacement'. There is a subtle difference. If this had really been made to replace broken plates from an existing Chinese porcelain set, it would probably have stood out like a sore thumb. Instead, this is a Worcester copy of the kind of Chinese porcelain plate that had not been imported into England for something like forty or fifty years. Worcester probably made plates like this for collectors, perhaps to hang on their wall along with other precious old artefacts from the Orient. This is probably why no other shapes are known to match Worcester plates of this sort. Worcester did not commence the production of large-scale dinner or dessert services until five years later and then they used modern, rather than old-fashioned, shapes and patterns.

1. May 1763 *Oxford Journal*, quoted in Branyan, French and Sandon, *Worcester Blue and White Porcelain*, page 16.

2. Julie Emerson, Jennifer Chen, and Mimi Gardner Gates, *Porcelain Stories: From China to Europe*. Seattle and London: Seattle Art Museum with University of Washington Press, 2000, 127.

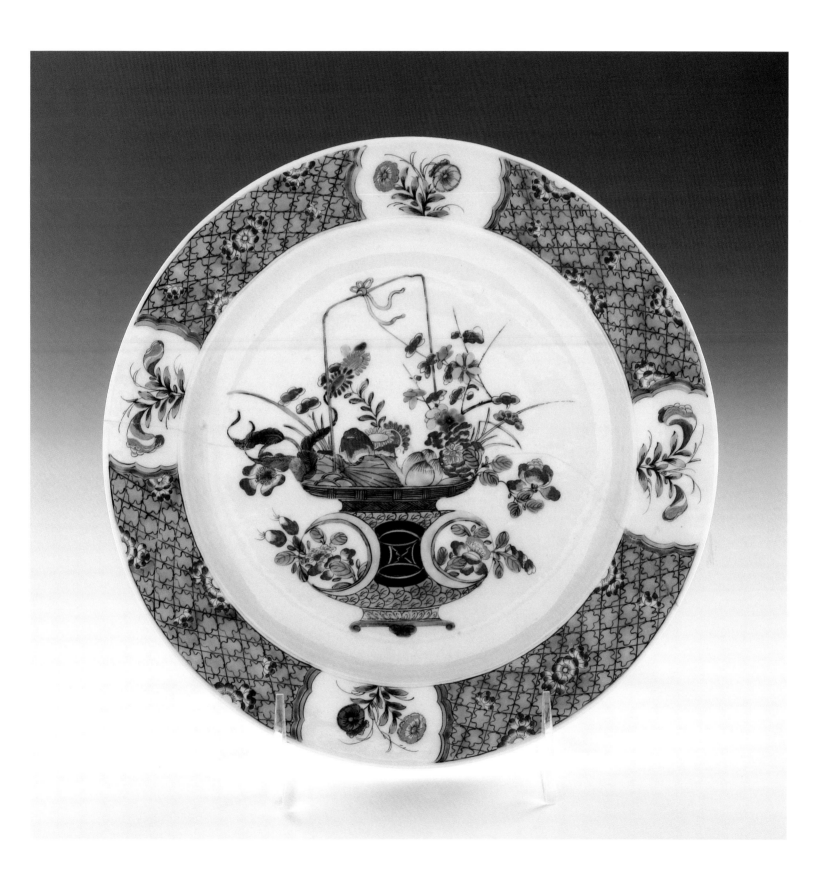

38. Teapot in 'Mandarin' Style

Size: 13cm (5⅛in.) high
Date: c.1768
Mark: None
Museum Purchase through the Ewers Acquisition Fund 1978.3.10

This small Worcester teapot reproduces the most popular form of decoration on Chinese *famille rose* porcelain made for export. In the 18th century Europeans were clearly fascinated by the curious imagery and humorous antics of the figures painted on their Chinese teasets. Massive orders were sent to the factories in China where the painters were able to draw upon an infinite repertoire of figures and compositions. The subjects were probably borrowed from Chinese literature, folklore and even theatre, although any meaning they had to the Chinese decorators was lost on the customers far away in England. In the design copied on to this Worcester teapot, one figure holds a Chinese ceremonial wand known as a Ru-i sceptre, while his companion holds a peach, symbolising longevity. To British families these Chinese figures were no more than cartoons that inspired amusing conversations over the tea table.

By the 1760s Worcester had perfected the porcelain teapot. Customers trusted them in the knowledge that they would not crack during use. Full tea services no doubt sold well, but there was an even greater demand for Worcester's teapots by themselves. We can presume this from the numbers of Worcester teapots that survive today. Teapots with copies of Chinese figure patterns survive in quite considerable numbers, while in proportion there are far, far fewer jugs, sugar boxes and cups and saucers. The round shape is a simple yet perfect design, for the spouts pour evenly with barely a dribble, while the lid stays in place even when the last drops of tea are expelled. This example has the unusual feature of a forked tip on the spout.

Chinese figures painted on *famille rose* teasets were known in the 18th century as 'Mandarin' patterns. In Holland two sorts were described – 'Gentleman's Mandarin', enriched with fancy gilding, and 'Peasant's Mandarin' in the simple style seen here. Worcester 'Mandarin' pattern teapots usually bear a different scene on the front and on the reverse, while the teapot lid always repeats one of the subsidiary motifs used on the teapot.

39. Teapot and Cover

Size: 14.5cm (5⅝in.) high
Date: c.1768-72
Mark: Square seal mark
Gift of Mr. and Mrs. P. M. Estes, Jr., 1983.9.1

This Worcester teapot merges two popular Japanese patterns produced through the 1770s. The first component is the extraordinary bird from the Sir Joshua Reynolds pattern. No evidence survives to explain the relationship between this pattern and its artist namesake, Sir Joshua Reynolds (1723-1792), although it can be presumed that a set decorated with one version of the pattern was passed down to a descendant of the great painter. It is possible that this pattern corresponds to the 'fine old pheasant pattern' listed in the catalogue of Christie's 1769 Worcester sale.[1] A bird with long tail feathers rests upon a turquoise tree. The bird is a derivation of a Japanese porcelain '*Kakiemon*' pattern showing a phoenix, known in Japanese as *ho-o*. In England this inevitably became known as a ho-ho bird.

Worcester first made a version of the Sir Joshua

Reynolds pattern in the mid-1750s. This *Kakiemon* motif originated in Japan around 1700 and was copied at Meissen, Chantilly, Chelsea and elsewhere. Worcester reintroduced the pattern many years later, around 1768. Three different versions were made. One placed the Kakiemon design alone on a white background on fine dessert sets, the plates of Meissen shape. On other dessert wares, the ho-ho bird in the centre is dramatically framed by a solid underglaze 'wet' blue border.[2] On teasets matching this teapot, the bird fills the blank panels between wide underglaze blue stripes. These deep blue bands are reserved with red chrysanthemum 'mons'. This design element is taken from the 'Queen's' pattern, a name that also appeared in the 1769 sale catalogue. The many variations of the 'Queen's' pattern normally have fine Japanese style flowers in the reserves. The Joshua Reynolds version is rather more dramatic and shows Worcester's ability to make up its own patterns by combining different Oriental sources.

1. H. Rissik Marshall, *Coloured Worcester Porcelain of the First Period*, p. 84.

2. See the auction catalogue of the Zorensky Collection part 3, Bonhams London 22 February 2006, lot 166

40. Hexagonal Vase and Cover

Size: 38..5cm (15⅛in.) high
Date: c.1767-69
Mark: Square seal mark
Gift of Mrs. William J. Tyne, 1982.22

Sets of towering vases sat atop japanned cupboards, mantels and wall brackets in wealthy homes during the reign of William and Mary. An avid porcelain collector, Queen Mary purchased sets of Japanese covered vases for her apartments in the royal palaces. Some late 17th century examples still survive at Hampton Court Palace and, as a result, large Japanese hexagonal vases matching Queen Mary's are known to collectors today as 'Hampton Court Vases'.[1] Decorated in the *Kakiemon* palette, these were copied at Meissen thirty years later and at Chelsea around 1750. Worcester rarely copied Japanese and Chinese porcelain exactly, preferring to adapt designs to their own individual styles. When Worcester first decided to make large hexagonal vases around 1760, they took the same basic Japanese form but elongated the bodies and added a longer neck and wider flange to the cover. The shape was transformed. Initially Worcester made these only in blue and white, painted with a much altered version of the Japanese *Kakiemon ho-o* birds used on the original Hampton Court vases.[2] Five years later blue-ground versions appeared at Worcester, and what a contrast.

Worcester apparently produced the shape in four different sizes. They were made by pressing thin slabs of clay into moulds, but many distorted or collapsed slightly during the kiln firing. As a result, the actual height of Worcester's hexagonal vases can vary greatly, even between matching pairs. To reflect the importance of this impressive shape, most were decorated with a very rich and costly pattern. In particular these were used to showpiece Worcester's innovative use of underglaze blue grounds.

Scale blue is almost certainly Worcester's own invention. The influence was the new 'Gros Bleu' grounds from Sèvres, and in particular adaptations used on rococo vases made at Chelsea. Chelsea's underglaze blue ground, known as *Mazarine*, was thick and uneven

and 'bled' heavily. Worcester tried out different methods of preventing this blurring which spoilt the effect of solid underglaze blue grounds. The old Chinese method of powder blue was one answer, but a more ingenious and pleasing effect was discovered, probably about 1766-67. The increased use of underglaze blue transfer-printing meant that there was a surplus of blue and white painters at the Worcester factory. Some of these were put to work providing 'scale blue' grounds on teasets and vases. To create the scale pattern, a thin wash of cobalt was applied to the background area to be covered, and then individual scales were painted by hand on top of this wash using a more-concentrated cobalt. Although time-consuming to execute, the result was a huge success for the factory and scale blue is now synonymous with 18th century Worcester porcelain.

Scale blue served as the background for so-called 'mirror-shaped' panels, the white cartouches resembling the gilded frames of rococo mirrors. After glazing, these fine hexagonal vases were passed to the best painters who specialised in 'Fancy Birds'. Worcester's exotic birds are crazy and very individual. Many different hands were employed to paint birds on scale blue vases and tea and dinner sets. Collectors have attempted to classify different kinds of bird painting. This vase is a most splendid example of the so-called 'Agitated Birds' that appear on earlier blue ground productions at Worcester. Loosely derived from Chelsea bird painting, these fantastic creatures are unique to Worcester. The peacock-like specimen on the vase at Cheekwood is quite exceptional, as is the use of colourful rococo scrollwork at the bottom of the main panels, a feature not seen on later scale blue vases. The fanciful insects, used to fill the remaining smaller panels on this vase and cover, are of a type also unique to the Worcester factory. Gold completes the pattern, framing the panels with a more restrained rococo ornament.

There is no doubt that originally this vase was just one half of a magnificent pair. Sadly nobody knows what became of the companion vase.

1. John Ayers, Oliver Impey, J.V.G. Mallet, et. al., *Porcelain for Palaces: The Fashion for Japan in Europe 1650-1750*.

2. Branyan, French and Sandon, *Worcester Blue and White Porcelain*, pattern I.C.19.

41. Heart-shaped Dessert Dish

Size: 28.3cm (11⅛in.) wide
Date: c.1772-75
Mark: None
Gift of Mr. and Mrs. William Tyne, Jr. 1984.3

This design shows influences from both of the principal Continental porcelain factories. Spiral festoons of formal garden flowers are derived from Meissen, especially border patterns used during the Academic or 'Dot' period (1763-74). The green ground, on the other hand, is derived from Sèvres, copying the so-called '*pommes verte*' or apple green developed during the 1750s. Green ground colours were very difficult to achieve in 18th century porcelain. Meissen failed to develop a successful apple green colour and produced instead rather curious turquoise and vibrant lime-yellow colours. In England Chelsea, Derby and Bow each enjoyed only limited success, creating very messy results.

Worcester produced a very distinctive green enamel early in the 1770s. Thick and opaque, it proved difficult to control during the kiln firings. This dish shows the problems Worcester experienced. The green is mottled and pitted, particularly in the upper left hand part of the dish. The irregular shape of the border suits the rococo taste, but is partly the result of the green having run and dribbled. A feature of Worcester's green enamel is that it would not take gilding on top. The gold scrollwork on this dish is ingeniously placed to frame the green edge without overlapping it at all. This design is known as the 'Marchioness of Huntley' pattern, after the second wife of the 10th Marquis who sold a dessert service of the pattern in 1882. There is no doubt that many separate sets of this pattern were made during the 1770s, for tea, dinner and dessert. It is likely the ground colour was known in 18th century England as 'Pea Green'.

Because of the technical problems, an apple green ground was apparently produced at Worcester for only a short time, probably between 1769 and 1775. Today, Worcester's apple green decoration is a highly contentious subject and few experts can agree about what is genuine and what is fake. There is no doubt that a very large number of pieces bearing this ground colour were decorated at a later date. The difficulty is deciding which, if any, are authentic examples of 18th century decoration. Specimens with apple green borders only, such as the 'Marchioness of Huntley' pattern and various patterns with central sprays of 'Spotted Fruit' are in almost every case accepted as totally authentic. On the other hand, the use of apple green as a ground colour for panels of flowers or 'Fancy Birds' is shrouded in controversy. Indeed, some authorities do not accept any such pieces as genuine 18th century decoration.

42. Armorial Saucer Dish

Size: 19.2cm (7%6in.) diameter
Date: c.1772
Mark: None
Provenance: Simon Spero, *English Porcelain and Enamels,* 1994, catalogue no. 22
Museum Purchase through the bequest of Anita Bevill McMichael Stallworth, 1994.16

In 1365, during the reign of Edward III, the Worshipful Company of Plumbers received their Grant of Ordinances to form a London livery company. In the 14th century a plumber was a freeman engaged in making gutters, pipes, furnaces, belfries, roofing tiles and cisterns, primarily working with lead.[1] Craft guilds were formed in the Middle Ages as organisations of tradesmen. Their primary purpose was to regulate the practice of a particular craft. Each trade had its own coat of arms along with events, rules, and a guildhall as its social hub.[2] It is possible the teaset of which this dish formed part was commissioned for use in the guildhall.

These arms were granted to the company in 1588. They are formed of tools of the craft – two soldering irons, a cutting knife, a shaver, two sounding leads, a Jacob's staff and a water level on a shield. The crest is a fountain upon which stands the patron saint, St. Michael the Archangel,

holding a sword and balance. The arms are faithfully copied on to this dish, but the painter made a few crucial errors. The motto should read 'Justicia et Pax' but on the Worcester service it appears incorrectly with a second 't' in Justicia. St. Michael's wings are also omitted. A full tea service of this design was made at Worcester. This saucer-shaped dish is one of the two plates that came with the set, used for cakes or bread and butter.[3]

Around the spirited rococo cartouche, formal flowers are painted in a distinctive enamel called 'dry blue'. Whereas underglaze blue was widely used, all porcelain makers had difficulties developing bright blue colours that could be used satisfactorily on top of the glaze. The Worcester factory favoured this vivid blue enamel that was applied thickly and does have a 'dry' appearance. Dry Blue often appears in conjunction with Worcester armorial decoration.

1. *Short History of the Worshipful Company of Plumbers,* London: Order of the Court, 1988. Lt. Col. R.J.A. Paterson-Fox and Mr. Alec Moir of the Worshipful Company of Plumbers have assisted with the identification of these arms and the history of the Company.
2. From 1639-1863 the Plumbers' Guildhall was located in Chequer Yard, Bush Lane, London.

3. The other saucerdish from the Plumbers' service is in the H. Rissik Marshall Collection in the Ashmolean Museum, illustrated by Franklin Barrett, *Worcester Porcelain,* pl. 48a.

43. Plate from the Duke of Gloucester Service

Size: 22.8cm (9in.) diameter
Date: c.1770
Mark: A crescent in gold
Gift of Mr. and Mrs. P.M. Estes, Jr. 1991.4

This is one of the most recognised Worcester services, with lush fruit, colourful insects and gilded rococo scrolls. The service was made for William Henry, Duke of Gloucester (1743-1805), younger brother of King George III. Duke William died without children and so on his death most of his personal effects passed to another brother, Adolphus, Duke of Cambridge. Adolphus thus inherited the Worcester service, together with a similar service made at Chelsea a decade earlier. Both sets remained in the family of the Dukes of Cambridge until 1909 when they were auctioned at Christie's in London.[1] Because of this inherited ownership, the Chelsea set had become known as the 'Duke of Cambridge Service', but it only entered the Cambridge family in 1805. Both sets, Chelsea and Worcester, had been made for the Duke of Gloucester and it is clear that one inspired the other.

A few pieces from each set remained in the family of another descendent of the Duke of Cambridge[2] and one of these Chelsea plates is illustrated here for comparison. When William, Duke of Gloucester ordered his dessert set from the Chelsea factory, probably in 1764-65, he chose a new shape of plate that had been created in 1762 for a service to be given by George III and Queen Charlotte to the Queen's brother, the Duke of Mecklenburg-Strelitz. The border of each plate was embossed with rococo scrollwork forming panels which contained painted insects. The centres were painted with groups of flowers, fruit, and vegetables.

Eight or ten years later the Duke of Gloucester wanted a new dinner service to match his dessert set, and this time he went to Worcester rather than Chelsea.[3] There can be no doubt that painters at the Worcester factory were provided with samples of the Chelsea set to copy. They did not, however, simply make replacements. They didn't make moulds to copy the precise shapes of the Chelsea plates, for example. Instead they imitated the outlines of the Mecklenburg-Strelitz moulding by painting the border with scrollwork panels in 'dry blue' enamel and gold. The insects in these border panels are Worcester insects, the sort seen on their scale blue vases (see catalogue no. 40). The fruit and foliage painted in the centres is inspired by the Chelsea set, but, instead of the somewhat muddy colours used at Chelsea, Worcester used their own rather more vibrant palette of almost translucent enamels. Every piece in the service was painted with a different composition, even though a relatively small number of fruits and berries were used throughout the set. The Cheekwood plate bears a combination of strawberries, raspberries, cherries, gooseberries, plums and blackcurrants.

The result is simply fantastic. As the first royal service commissioned from Worcester, the Duke of Gloucester service surpassed all previous factory work in its refinement and luxury. To reflect this, they marked every piece with pride, using a crescent mark in gold. Sadly, something like fifteen years passed by before the Worcester factory was honoured with its next major royal commission.

A Chelsea plate from the set made for William, Duke of Gloucester, c.1764-65. IMAGE COURTESY OF BONHAMS

1. Sold by Christies' in London, 8 June 1904.
2. Sold at Bonhams, 7 December 2004, lots 291-296.

3. The Chelsea factory was still operating under the ownership of William Duesbury of Derby.

44. Pair of Turkish Figures

Size: 12.8cm (5in.) and 12.9cm (5⅟₁₆in.) high
Date: c.1768-72
Marks: None
Provenance: the Peter Merry (Bridge House) Collection, sale at Phillips London 26 May 1993
Museum Purchase through the bequest of Anita Bevill McMichael Stallworth
in honour of Dr. and Mrs. E. William Ewers and Mrs. William J. Tyne, 1993.4.1-2

In 1753, Horace Walpole derided the changes in table decorations with the introduction of porcelain figures. Walpole explained, 'Jellies, biscuits, sugar plumbs [sic] and creams have long given way to harlequins, gondoliers, Turks, Chinese and shepherdesses of Saxon china. But these, unconnected, and only seeming to wander among groves of curled paper and silk flowers, were soon discovered to be too insipid and unmeaning. By degrees whole meadows of cattle, of the same brittle materials, spread themselves over the whole table'.[1]

The porcelain figures described by Walpole were Saxon China, or Meissen in other words. Imports from Germany were great luxuries in England in the 1750s and, to satisfy the passion for table decoration that Walpole ridiculed, the china factories at Bow, Chelsea, Derby and Longton Hall devoted much effort to making copies of Meissen figurines, as well as many new subjects of their own.

Worcester concentrated on the manufacture of teawares and chose not to compete with other factories by making porcelain figures. With one possible exception, no figures were made at Worcester until 1768-70. Indeed, T. Falconer, a visitor to the factory in 1766 wrote, '...they have not yet debased [the Worcester manufactory] by making vile attempts at human figures, but stick to the usefull [sic]'.[2]

The introduction of figure making probably coincided with the arrival at Worcester of John Toulouse, an experienced craftsman from Bow. The pair of Turks at Cheekwood are unmarked, but other examples are recorded impressed with initials, either IT or To, which are

believed to be the personal marks used by John Toulouse while he was at Worcester. They are very much in the style of figures made at Bow a decade earlier and were made in the same way using press-moulding. When Capt. Roche visited Worcester on 21 October 1771 he wrote that 'They make very fine figures or ornamental china, it being done much better and also cheaper at Derby: here they are obliged to mould it, but there it is cast, which is ten times as expedicious [sic]'.[3] Derby figures from 1771 are definitely superior and by this date Worcester's Turks would have seemed decidedly old-fashioned. The Turks stand on simple green mound bases applied with a few sparse flowers. In contrast, most contemporary Bow and Derby figures were mounted on elaborate rococo scroll bases. No wonder relatively few Worcester figures were made and all are such rarities today.

The image of a Turkish sultan and fine lady evoke the richness of the East. They also tell the story of trade. In 18th century England Turks were associated with coffee, since the beverage originated in that region. Many coffee houses were identified by the sign of a Turk's head, and likewise Turkish Baths were notorious in London for their association with the sex trade. This pair of figures are meant to look exotic and they are decorated with remarkable richness of colour. The female companion wears a robe of turquoise, or *bleu celeste*, trimmed in ermine over a flowered gown. The male Turk wears similar embroidered robes and holds a curving scimitar. The use of gilding, bright ground colours and careful painting make these rich products indeed.

1. Horace Walpole, *The World*, 8 February 1753 as quoted in Howard Coutts, *The Art of Ceramics: European Ceramic Design 1500-1830*, p. 99.
2. From a letter discovered by C.W. Dyson Perrins and quoted by F. Severne Mackenna, *Worcester Porcelain and its Antecedents*.
3. Capt. Joseph Roche, R.N., extracts from his journal published in *Notes and Queries*, February/March 1917.

45. Tea Canister and Cover

Size: 14.2cm (5⅝in.) high
Date: c.1772-75
Mark: None
Gift of Mr. and Mrs. Charles W. Atwood, 1993.11

Tea canisters stored loose, blended tea-leaves and presented a decorative addition to the tea table. They should not be confused with tea caddies, which are boxes made of wood or other materials used to store and mix different types of tea. Fine Meissen tea services from the 1720s-30s included decorative tea canisters and canisters were provided as additions to many Chinese export porcelain teasets.[1] Worcester started to make tea canisters around 1760-62, but throughout the 1760s their inclusion in a tea service was very much of an exception rather than the rule. Even during the 1770s, the period from which most examples survive, a canister was not included with every set. The simple shape of a plain oval, favoured by the Worcester factory, changed little over twenty years.

Some have moulded flutes, reeding or, in a few instances, chrysanthemum moulding. Only a few Worcester canisters can be dated later than 1780 and the plain oval shape was not continued into the Flight period. Worcester oval canisters always had a neat domed lid with a flower finial (although in the present example the flower knop is a replacement).

With the exception of a few overglaze transfer-printed designs, the decoration on Worcester canisters conforms to popular teaware patterns. The Cheekwood canister is decorated with a well-known although curious pattern, for the flowers are in the style of Chinese Export porcelain, while gold rococo cartouches are loosely derived from Meissen. This pattern would have been relatively inexpensive, and is also aesthetically pleasing.

1. For more information on the development of the tea canister see *Tea Trade and Tea Canisters*, Stockspring Antiques exhibition catalogue, 2004.

46. Coffee Cup, Teabowl and Saucer

Size: saucer 11.5cm (4½in.) diameter, cup 6cm (2⅜in.) high, teabowl 6.8cm (2¹¹⁄₁₆in.) diameter
Date: c.1760
Marks: None
Published: John Sandon, *The Dictionary of Worcester Porcelain*, page 342
Anonymous gift in honour of Mrs. William J. Tyne 1988.5.1-3

To have created an entire tea service with such a splendid rococo armorial device would have been enormously costly if hand painting had been used. Similarly, to have engraved individual copper plates to print a unique armorial on every piece would have been complicated and expensive. Instead, the decoration on this 'trio' is an ingenious combination of both printing and painting. The fancy rococo cartouche on each piece is printed in a single colour, rather in the manner of an engraved bookplate.[1] The coloured arms within the cartouche are hand-painted. The result is a personalised armorial teaset with plenty of detail at a realistic cost. The arms and crest painted on this set are those of Wilson impaling Langton.[2] In heraldry

'impaling' is the joining of two coats of arms on one shield. Other sets were made at Worcester with the same printed cartouches and different painted arms.[3]

The subsidiary decoration on these pieces comprises popular prints from Worcester's considerable supply of engraved imagery. Printed on the reverse of the bowl and the cup is a version of the design known as 'The Tea Party'. Robert Hancock and his pupils created many variations of this popular scene, all showing a man and a woman in fashionable dress enjoying tea in a garden. The versions here are reduced to fit within the limited space available. The swan printed within the interior of the teabowl is merely a space-filler.

1. Bookplates were often engraved with a coat of arms and were used frequently as models for Chinese armorial porcelains. See David S. Howard, *A Tale of Three Cities, Canton, Shanghai and Hong Kong*, Sotheby's exhibition catalogue 1997, fig. 52, and Geoffrey Godden, *Oriental Export Market Porcelain*, pp. 204-5.
2. Other pieces from this set are illustrated by H. Rissik Marshall, *Coloured Worcester Porcelain of the First Period*, plate 11a and by Joseph M. Handley, *18th Century Transfer-Printer Porcelain and Enamels*, fig 7.1.
3. See John Sandon and Simon Spero, *Worcester Porcelain, the Zorensky Collection*, fig. 500, p. 385, for a similar cartouche with the arms of Marke of Liskard.

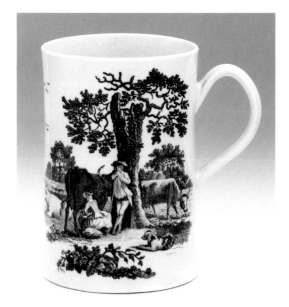

47. Transfer Printed Mug

Size: 14.8cm (5¹³⁄₁₆in.) high
Date: c.1765
Mark: None
Museum Purchase through the Ewers Acquisition Fund, 1977.12.71

On 13 July 1770 Lady Shelburne recorded her visit to the Worcester factory in a long diary entry. Her descriptions of the production methods are amateur but fascinating, and include a note about printing: '...Some of their China is painted with a Pencil, Others by Copper Plate, but they made a secret of that Method, and will not let any body see it done'.[1]

As the printing technique was a closely-guarded secret, there are no contemporary accounts of exactly what went on. There are two schools of thought concerning the printing process used at Worcester. We know the design was engraved into a smooth sheet of copper and they had to transfer the design to the porcelain. One method was to ink the plate and pick up the image on a thin sheet of tissue-paper. This paper 'pull' was then rubbed on to the surface of the mug, transferring the ink. Alternatively the engraved lines were filled with oil and a bat of a glue-like substance was used to transfer the design in tiny droplets of oil. The colour was then dusted on to the surface of the mug as a fine powder that adhered to the oil.

It used to be assumed the paper method was used, but some mugs of this type suggest the opposite. On the images seen here, the trees appear thick, heavy and jet black, while the milkmaids and animals are far more detailed. This is more likely the result of stretching or smudging of the glue bat.

Whichever method was used, transfer printing permitted the factory to reproduce the same image on hundreds of objects. Called 'Jet Enamels', customers did not regard Worcester's printed porcelain as in any way inferior to hand-painted decoration. The artistry of skilled engravers and the talented hands who applied the prints ensured Worcester's printed wares were every bit the equal of painted productions.

Subjects for Worcester prints came from a wide-range of published sources and popular prints. The two idyllic scenes that appear on the Cheekwood mug were frequently used together. Both images are taken from larger landscape prints. '*Rural Lovers*' shows a gentleman addressing a milkmaid as she stands under a tree, a scene copied from a 1760 print by Francis Vivares of a painting by Thomas Gainsborough. '*Milking Scene*', the second image where the maid is milking the cow, is part of a 1759 print by Luke Sullivan titled *A View of Woobourn in Surry* [sic], *the seat of Philip Southcote, Esqr.*[2]

1. Lady Shelburne's full account appears in J.V.G. Mallet, 'Lady Shelburne's visit to Worcester in 1770', E.C.C. *Transactions*, Volume 11, Part 2, 1982, pp-109-111.

2. For the sources for both images see Joseph M. Handley, *Eighteenth Century English Transfer-Printed Porcelain and Enamels*, p. 71

48. Dessert Plate decorated in the Giles Workshop

Size: 19.6cm (7¾in.) diameter
Date: c.1768-70
Mark: A large anchor painted in red enamel
Museum Purchase through the Ewers Acquisition Fund, 1983.8.2

The 'Fancy Birds' painted in the atelier of James Giles are instantly recognisable. They first occur on Chinese porcelain enamelled in London at Kentish Town, where the Giles family worked as independent china decorators. The Giles workshop probably started painting exotic birds around 1756, on white Chinese porcelain painted in London.[1] Giles' enamelling on Chinese porcelain was contemporary with the 'Red Anchor' period at Chelsea. The first bird painting by Giles on Worcester porcelain, c.1762-65, was also inspired by Chelsea,[2] but by the time this dessert plate was painted there were other influences too.

While still drawing on the Chelsea style, Giles became heavily influenced by the latest Meissen porcelain of the 'Academic' or 'Dot' period (1763-74). Observing the new Continental style of painting on imports from Dresden, Giles changed his palette, preferring instead brighter colours and bold, wide brushstrokes. This type of decoration has become known to collectors as the 'Wet Brush' style, a very appropriate name for the painter literally loaded his brush with enamel pigment. The whole essence of the painting is speed. The painter did not labour over the plumage and instead the painting has a spontaneity that is totally different from the more-detailed 'Fancy Bird' painting executed at the Worcester factory. Giles redefined the imaginary creatures. Compared with Chelsea or Worcester, Giles' 'Fancy Birds' are more expressive and exuberant. This is seen not just in the painting of the birds, however. The rocks and vegetation also show higher colouring and a more formal treatment. Giles' ripe fruit isn't real, but it jumps off the plate. The insects associated with the 'Wet Brush' style of painting are perhaps the most defining feature. Once seen they are never forgotten, for they are both terrifying and fun at the same time.[3]

At the time this plate was produced, Giles had a contract to decorate Worcester porcelain in his London studio. He proudly claimed in 1767 that he was the Worcester manufactory's 'Enamelling Branch...in London' and Giles was also in direct competition with Chelsea, nearing the end of its 'Gold Anchor' period (1758-70). It is curious, therefore, that the plate at Cheekwood bears a copy of the old Chelsea mark of a red anchor, rather than a fake Meissen crossed swords mark which might have been more appropriate.

1. Gerald Coke, *In Search of James Giles*, p. 87.
2. For a full tea service see John Sandon, *The Dictionary of Worcester Porcelain*, colour pl. 47

3. For a recent review of Giles' decoration on Worcester porcelain see Stephen Hanscombe, *James Giles, China and Glass Painter*.

49. Mug with Shakespeare Print

Size: 12.7cm (5in.) high
Date: c.1769-72
Mark: None
Gift of Dr. and Mrs. E. William Ewers, 1981.31.2

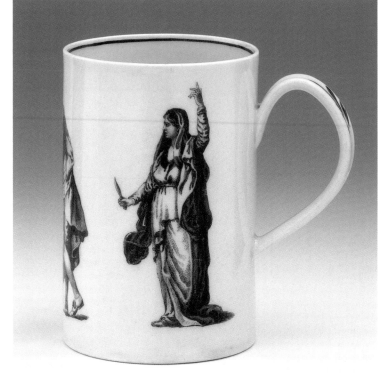

In 1769 David Garrick, the most famous actor of his century, orchestrated a grand Jubilee dedicated to William Shakespeare. The Stratford-upon-Avon festival drew national acclaim and encouraged a revival of Shakespeare's plays. Due to the success of the Jubilee and his own performances, Garrick became synonymous with Shakespeare. The precise chronology is unclear, but it is likely that a series of Worcester mugs bearing this print of Shakespeare were issued to celebrate the 1769 Jubilee at Stratford.[1] The special productions to be used at Stratford were probably bell-shaped mugs with the added feature of a gold rim, never normally used on

Garrick Between Tragedy and Comedy, Edward Fisher (1722-1785) after Sir Joshua Reynolds (1723-1792)
No date. Mezzotint (1st state)
Yale Center for British Art, Paul Mellon Fund

82

printed pieces. On these the black printed figure of Shakespeare was flanked by figures of Fame and Minerva, re-issued from earlier commemorative mugs.

The same print of Shakespeare was subsequently printed on to cylindrical mugs. On these the figures of Minerva and Fame were replaced by two new female allegories. The source for these is a painting by Sir Joshua Reynolds titled *Garrick between Comedy and Tragedy*, painted in 1761.[2] In Reynolds' work the actor is flanked by the Muses. Worcester used these same Muse figures, *Comedy* with a mask and *Tragedy* with her dagger, and placed them either side of Shakespeare, his likeness derived from his monument in Westminster Abbey.[3]

Prints of Reynolds' painting *Garrick between Comedy and Tragedy* were widely popular. The image even travelled to France where George Colman saw it in Paris. In 1765 Colman wrote to Garrick, 'There hang out here

in every street, pirated prints of Reynolds' Picture of you...'.[4] Worcester's adaptation of the Reynolds' painting and the Shakespeare monument drew upon popular culture and appealed to an audience already familiar with the painting. The Worcester print remained in use through the 1770s. In general, transfer-printing proved an excellent medium for capturing images of famous people or events. Worcester also produced mugs bearing the likenesses of King George III, Queen Charlotte, and Frederick, the King of Prussia, as well as naval and military commanders.[5]

Most Worcester overglaze printing was in black. A muddy purple colour or a dark pink (known as puce) were occasionally used. Red or russet-brown had been used earlier on porcelain printed at Bow, although this colour was very seldom used at Worcester. The Cheekwood Shakespeare mug is a great rarity, therefore.

1. Norman Stretton Collection, Phillips auction catalogue 1 February 2001, lot 46.
2. Joseph M. Handley, *Eighteenth Century English Transfer-Printed Porcelain and Enamels*, p. 71 discusses the source
3. In 1740-41 Peter Scheemakers sculpted the Shakespeare monument after a design by William Kent.

4. George Colman to David Garrick, 1765 cited in Nicholas Penny, ed., *Reynolds*. New York: Harry N. Abrams, Inc., 1986, p. 207.
5. Joseph M. Handley, *op. cit.*

50. Hunting Punchbowl

Size: 28cm (11in.) diameter, 12.2cm (4⅜in.) high
Date: c.1775-78
Mark: None
Gift of Mr. and Mrs. P.M. Estes, Jr. 1988.24

Imagine this bowl full of punch as the centrepiece of a jovial celebration following a day spent hunting. Once the bowl had been emptied, the merry huntsmen would gather around and sing the popular songs referred to in the decoration. The music for a song 'Away to ye Cops...' hangs from hunting trophies, used as ornament between four border panels showing dead game that might have been taken during the day, including deer, wild boar, hares and other game. The rococo ornament smothering the border includes hunting slogans such as 'The farmer with Pleasure beholds him dead' and 'Speed Falls to, sickens, he dyes [sic]'. All around the outside of the bowl runs a foxhunting scene with mounted huntsmen, grooms and beaters all in pursuit of a fox. Refilled and emptied once again, the revellers could observe in the very centre of the bowl the scene of 'The Kill', their quarry captured and held above the baying hounds.

The main decoration is taken from a popular series of hunting pictures of the day. In this case James Seymour's painting *'The Chase'* has been adapted from part of an engraving by Thomas Burford.[1] Worcester produced this print in different versions designed to fit around smaller or larger bowls. This is one of the largest sizes recorded and includes extra figures around the bowl not seen on smaller punchbowls.[2] This most elaborate border decoration is also used only on the larger bowls. A splendid punchbowl such as this was included in the Worcester factory's sale in 1769, listed in the catalogue as 'A Beautiful Bowl, with a fox chase, jet enamelled'.[3] The landed gentry of 18th century England who enjoyed the sport of hunting in all of its guises could afford to use Worcester porcelain and so the popularity of hunting prints is hardly surprising.[4]

The centres of Worcester bowls were vulnerable to wear, especially when used for punch. The overglaze black prints often fade or rub off and gold rims, when present, also suffer from wear during use. The punchbowl at Cheekwood is a rare survivor in remarkable condition and as such illustrates the wonderful detail Worcester were able to achieve, once they had mastered the art of transfer printing.

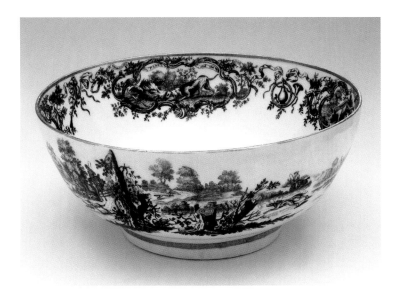

1. See Cyril Cook, *The Life and Work of Robert Hancock*, item 42 and Joseph M. Handley, *18th Century English Transfer Printed Porcelain and Enamels*, item 2.48.
2. The Norman Stretton Collection, Phillips sale 21 February 2001, lot 56.
3. Quoted by R.L. Hobson, *Worcester Porcelain*, p. 168.
4. See Gordon and Sally Guy-Jones, *'The Hare Chase'*, E.C.C. Transactions, Vol. 15, pt. 3.

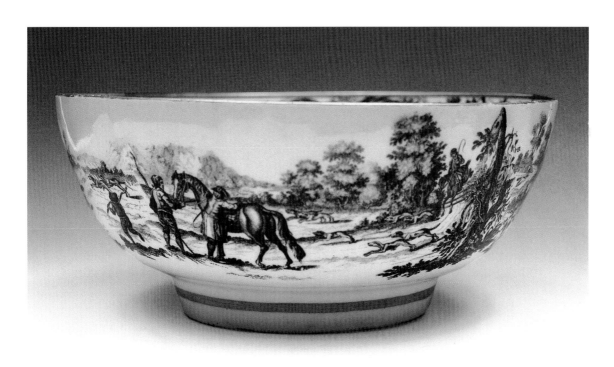

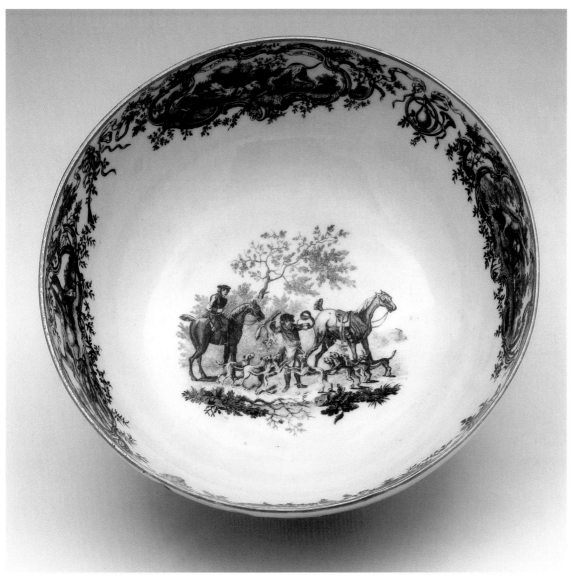

51. Teacup, Coffee Cup and Saucer with Armorial Decoration

Size: saucer 12.7cm (5in.) diameter
Date: c.1772-74
Mark: None
Gift of Mr. and Mrs. P.M. Estes, Jr., 1986.14.1-3

The workshop of James Giles made relatively few armorial services, which is surprising in a way as there ought to have been a ready market for such sets in London. Chinese porcelain services with owners' coats of arms meant a very long delay as customers' orders were sent to far away China. Giles advertised in 1767 that 'Ladies and Gentlemen may depend upon having their Commands executed immediately, and painted to any pattern they shall chuse [sic]'.[1] The Calmady family from Langdon Hall near Plymouth chose not to wait and commissioned a tea and dinner service enamelled in the Giles workshop. The family arms are painted prominently on every piece, with only a simple border of a green vine with red berries weaving around a single gold line.

The Calmady arms called for a bright blue background and this meant using a form of 'Dry Blue' enamel over the glaze. Plain areas of blue enamel were difficult to achieve in the 18th century, especially at Worcester. Designs that include a lot of overglaze blue were normally the work of outside decorators, although in the case of armorial designs the Worcester factory attempted their own version of a dry blue ground. The tone of blue on the Calmady service is Giles' slightly muddy blue colour, rather than the more violent 'Dry Blue' colour used on sets decorated at Worcester.[2] The flower sprigs painted on the side of the cups in this trio are curious, quite unlike any others found on Worcester porcelain, further pointing to a Giles origin, but the gilding on the handles, in a pattern of graduated dots, provides the biggest clue that this set was decorated in the Giles workshop.

Instead of a motto painted on a ribbon beneath the arms, the initials of the original owner of the teaset *WC* appear on each piece. It may have been made for Captain Warwick Calmady (1711-1788), a relatively undistinguished officer in the Royal Navy, or else the set was made for his illegitimate son, also named Warwick, born in 1753. Warwick Calmady Junior married his cousin, Pollexfen and this service could have been commissioned for their wedding. After Warwick Jnr. died in 1780, Pollexfen Calmady remarried and this service descended through her family until it was sold in May 1985 at Bearne's salerooms. A rectangular platter is now in the Maier Collection at the Art Institute of Chicago and a teacup and saucer was in the Zorensky Collection.[3]

1. John Sandon, *Dictionary of Worcester Porcelain*, p. 177.
2 For Worcester factory-decorated armorials using 'Dry Blue' see Bonhams' catalogue of the Zorensky Collection, Part 3, 22 February 2006, lots 107 and 108.

3. John Sandon and Simon Spero, *Worcester Porcelain 1751-1790, the Zorensky Collection*, fig. 454.

52. Dessert Dish decorated in the Giles Workshop

Size: 26.6cm (10½in.) wide
Date: c.1772-74
Mark: crescent painted in underglaze blue
Museum Purchase through the Ewers Acquisition Fund 1988.11.2

With the growing popularity of the neo-classical style, 18th century collectors clamoured for antique vases and their reproductions. Producers such as Josiah Wedgwood looked at antique vases and engravings of vases as sources for new shapes. One source was the 1746 book, *Première Suite de Vases antiques d'après Saly et autres* which included thirty engravings of vases drawn by the French artist, Jacques Saly (1717-1776). Saly had drawn ancient vases during his travels in Rome. Both William Chambers and Robert Adam, the style leaders, owned copies of Saly's seminal work. Another copy was certainly available to the painters at James Giles' workshop, for some of Saly's vases were copied on to plates and dishes.[1]

Decorated in the atelier of James Giles, this dish can be identified from an entry in the catalogue of the sale of some of Giles' stock in 1774. This auction included a dessert service 'elegantly painted with different vases and an ultramarine blue border, enriched with chased and burnished gold, 24 plates, sundry compoteers and 5 baskets'.[2] Many examples of this exciting pattern survive, suggesting that several services must have been made.[3] The design is the epitome of the neo-classical taste. The solid underglaze 'Wet Blue' border is embellished with grapevines in tooled gold inspired by the *Ciselé* gilding used at Sèvres. In the centre a single, dramatic stone urn is garlanded with coloured flowers.

The immediate inspiration for this set is probably Chelsea or Chelsea-Derby porcelain of c.1770. Decorators at Chelsea understood the new neo-classical taste and combined borders of palmettes with painted urns. The Worcester factory was far behind the latest London taste, however, and in the 1770s their decoration remained stubbornly rococo. By contrast James Giles, as a china dealer in London, followed the latest fashion and was quick to realise that the designs of Wedgwood and Adam represented the future. The lavish gilding would have made this set one of Giles' most expensive stock patterns in 1774. Giles was in competition with Wedgwood in London, though. Perhaps the solid blue ground was too closely associated with Sèvres, however, for Giles' fashionable neo-classical porcelain failed to save his workshop from bankruptcy two years later.

Giles' dessert service listed in the 1774 auction included five baskets. These would have been oval with curved sides pierced with overlapping circles and applied twig handles.[4] In the collection at Cheekwood is a matching basket, but this was made at the Flight factory in Worcester around 1790, produced as a replacement to match an earlier Giles-decorated dessert set.

1. Timothy Clifford discovered the connection between Saly's engravings and Giles' porcelain. See Timothy Clifford, *Some English Vases and Their Sources, Part 1*. E.C.C. Transactions, Vol. 10, Part 3, 1978, p. 169. A basket matching this dish is illustrated.
2. Included in the fifth day of sale, 25 March 1774, quoted by Gerald Coke, *In Search of James Giles*, p. 139.
3. For a similar plate see Simon Spero, *Worcester Porcelain, the Klepser Collection*, p. 136. Other related pieces are illustrated by Gerald Coke, op. cit., p. 219 and Stephen Hanscombe, *James Giles, China and Glass Painter*.
4. Two baskets are shown by John Sandon, *Dictionary of Worcester Porcelain*, p. 245

53. Vase and Cover enamelled in the Giles Workshop

Size: 15.5cm (6⅛in.) high
Date: c.1770
Mark: none
Museum Purchase through the Tyne Acquisition Fund with matching funds through the bequest of Anita Bevill
McMichael Stallworth, 1990.8

The sensational background colours developed at Sèvres were enormously influential. Most English porcelain factories attempted their own versions with different degrees of success. The most stunning of the French colours was a bright turquoise, known at Sèvres as *bleu celeste*. This had been perfected at Vincennes by 1753 but it was many years later before a reasonable copy was available in England. Chelsea led the way around 1760-62, while Worcester introduced its version later in the 1760s. When Worcester held their important auction in London in 1769, they proudly listed the availability of a 'sky blue' enamel.[1] This was initially incorporated into small panels in the border of a popular teaware pattern now known as

'Jabberwocky'.[2] By 1770 Worcester had perfected their sky blue, or turquoise, enamel and used it as a solid, all-over ground colour. In London, the Giles workshop introduced their version more or less simultaneously with the Worcester factory. Giles preferred to use the French name and the sale of part of Giles' stock in March 1774 included a number of sets decorated in 'blue celest and gold'. The Giles and Worcester factory versions are virtually identical and it is necessary to look for other clues to tell the two apart. The pattern of the gilding on the handles tells us that the vase at Cheekwood was enamelled in the Giles workshop. Instead of picking out the modelling of the scrollwork in gold, Giles' decorators have used their trademark pattern of graduated gold spots. A similar pattern of gold dots can be seen on the armorial cup and saucer (catalogue no. 51) and on many other Giles-decorated porcelains.

In the absence of additional decoration, solid turquoise ground colours are curiously monochromatic. The Worcester factory used solid turquoise for the entire surface of teasets, with only gilded lines as embellishment. The Cheekwood vase shows that the Giles workshop in London also used their turquoise ground with gold line rims only. In addition, however, Giles used the turquoise ground colour as a background for reserved panels containing more sophisticated patterns.[3] Turquoise was used as a ground colour for just a very short time at Worcester and after 1775 it only occurs as part of border designs once more.

Vases decorated in the Giles workshop are rare. This shape of vase with fancy scroll handles coincides with the arrival at Worcester of John Toulouse and the introduction of a range of elaborate new shapes.[4] It would originally have been one of a pair or more likely part of a garniture of three or five vases. In England in 1770 the decorative effect of such a set would have been fairly shocking.

1. Quoted by John Sandon and Simon Spero, *Worcester Porcelain 1751-90, the Zorensky Collection*, p.211.
2. See John Sandon and Simon Spero, *op. cit.*, fig. 297.
3. A celebrated set was made with 'harlequin' panels, every reserve showing a different pattern; see Stephen Hanscombe, *James Giles, China and Glass Painter*, fig. 23.
4. Simon Spero and John Sandon, *op. cit.*, chapter 11.

54. Mug with Painted Landscape

Size: 14.9cm (5⅞in.) high
Date: c.1782-85
Mark: crescent in underglaze blue
Museum Purchase through the Ewers Acquisition Fund, 1986.4

By the middle of the 1770s London fashion demanded new styles of porcelain decoration suited to the neo-classical taste. The market leader was the Chelsea factory, now owned by William Duesbury of Derby and known today as Chelsea-Derby. Austere symmetry replaced rococo frivolity. The all-over underglaze blue grounds that Chelsea and Worcester had made famous were suddenly old-fashioned. As Derby had never mastered a solid 'mazarine' blue, Duesbury was very happy to replace these blue-ground patterns with a bright blue border design instead. Chelsea-Derby made elegant blue-bordered table-ware, the blue enamel rims hung with husks, classical heads and trophies suited to the new neo-classical fashions.

The Worcester factory failed to react fast enough to changes in London taste. Worcester's own blue-bordered patterns did not appear until 1780, at least five years after Chelsea-Derby had shown the way. Worcester still had trouble firing overglaze blue enamel and instead continued to use underglaze blue for their borders. A new range of fluted shapes had become popular, copied from France, and this caused problems for Worcester as their blue borders tended to dribble and run down the flutes. Worcester was happier using plain shapes and this mug is typical of their elaborate productions from the 1780s.

The overall design is an attempt at the neo-classical, with symmetrical fruit festoons and a turquoise chain border framing the main panel, features copied from Chelsea-Derby. The gilding around this panel is still rococo in style, however, and seems incongruous. The landscape painting is Worcester's version of a new style of 'picturesque' painting popular in England. Derby employed Zachariah Boreman and other artists to introduce a totally new treatment of landscape painting, inspired by English watercolour painting of the day. Worcester landscapes are very different from the much more subtle style of Derby painting. The panel on this mug follows the ideals of English 'Picturesque' painting. The primary subject is not the village in the centre distance, but instead it is the broken fence in the foreground and the slanting tree to one side that catch the viewer's attention. The village with its church steeple fades into the background under a cloudy sky. Instead of the new style of painting Zachariah Boreman brought to Derby, it is possible to see in this Worcester landscape painting the influence of the earlier Chelsea artist Jefferyes Hamett O'Neale, who worked at Worcester for just a short time around 1770.

This mug falls within a group of Worcester wares from the 1780s associated with the names of Lord Henry Thynne and the Earl of Dalhousie. Both titled families owned sets of Worcester porcelain decorated with landscape panels and blue borders, which were sold in Victorian times.[1] The patterns feature bright underglaze blue borders, rich gilding and central oval panels painted with imaginary landscapes. Many variations exist, for the style continued in production for more than a decade. Cylindrical mugs were made in many different sizes and some have survived in graduated sets of three showing that they were sometimes conceived and sold in this way.

1. For discussions about the names given to these Worcester services see Simon Spero, *Worcester Porcelain, the Klepser Collection*, and H. Rissik Marshall, *Coloured Worcester Porcelain of the First Period*, fig. 1101.

55. Heart-shaped Dessert Dish

Size: 26.5cm (10⁷⁄₁₆in.) wide
Date: c.1785-90
Mark: crescent in underglaze blue
Gift of Mr. and Mrs. P. M. Estes, Jr., 1985.1

The 'Hop Trellis' patterns are synonymous with Worcester porcelain. In the 18th century Worcester was a major hop-growing area, but the name is sadly apocryphal. The berried garlands certainly do not depict hops and instead the origins of this pattern lie in rural France, not Worcestershire.

Whereas Meissen was the major influence on Worcester porcelain decoration during the 1750s and '60s, for the following two decades it was Sèvres, not Meissen, that provided the inspiration for so much of Worcester's output. English taste in general borrowed heavily from the artistry of the courts of Louis XV and Louis XVI. The formal gardens at Versailles provided the backdrop to so much of the artistry of the Sèvres factory. Plants were trained to twist and grow among formal trellises and these inspired decorators at Sèvres during the 1750s to create some very inventive patterns.

This Worcester 'Hop Trellis' pattern dish was made a quarter of a century after the same pattern first appeared at Sèvres, although in England in the 1780s this was still highly fashionable. The origin is French rococo, but formal patterns like this suited the fashion for neo-classical symmetry. The pattern is known in Chelsea-Derby porcelain from the early 1770s and James Giles in London painted several different 'Hop Trellis' designs between 1770 and 1774. The Worcester factory did not make their 'Hop Trellis' patterns until the later 1770s and indeed many pieces in this style, such as this dessert dish, date from the 1780s. By this time the care taken over the decoration at Worcester had declined. The gilding, for example, is not as in intricate on this dish as on earlier blue-bordered pieces such as the landscape painted mug, catalogue no. 54. The bright blue border uses the purer source of cobalt oxide introduced in the middle 1780s and this contrasts well with the bright turquoise border around the centre of the dish. This turquoise ground is painted with a design of tiny pebbles known as *caillouté*, another decoration popular at Sèvres.

'Hop Trellis' patterns were made at Worcester for about fifteen years, mostly on teawares of the fluted 'French' shape. Dessert services of the pattern are uncommon. This set would originally have contained four dishes of this shape, alongside four each of shell-shaped, square and oval dishes, a pair of tureens for sugar and cream, a centrepiece and either twelve, eighteen or twenty-four plates.

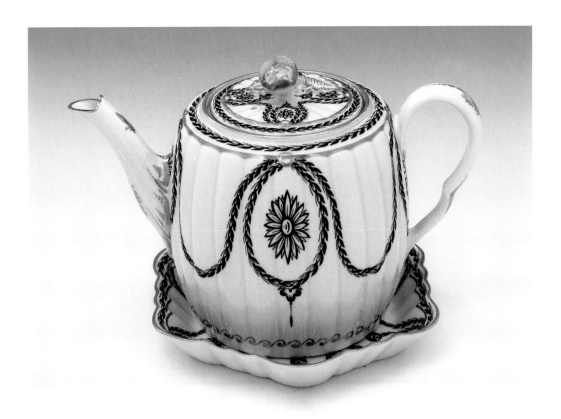

56. Teapot, Cover and Stand

Size: teapot 12.8cm (5in.) high, stand 13.8cm (5⅞in.) wide
Date: c.1782-85
Mark: none
Gift of Mrs. William J. Tyne, 1986.2.2

Customers in the 18th century chose their porcelain tableware to match the architecture and furnishing of their home. Leading designers conceived complete interiors and it is easy to imagine this teapot used in a neo-classical room in the Adam taste associated with the architect brothers, whose name is synonymous with this taste in England. Although simple, the pattern is very finely executed. The pattern of husks and paterae is loosely derived from ancient Rome by way of the ornamental plasterwork and furniture inlay so popular in Georgian England at this time.

Although we think of this kind of teapot as coming from the 'First Period' at Worcester, it was most probably made during the Flight period after 1783. Thomas Flight had been the London agent for the Worcester factory and it is possible he encouraged the production of designs such as this in an attempt to stem the decline of

the ailing factory. The Giles workshop and the Chelsea-Derby factory, both in London, had used versions of this pattern a decade earlier, and so although Flight was keen to introduce modern and fashionable patterns, when this teapot was made it was perhaps already outdated. The shape, derived from Sèvres, had been made at Worcester from around 1775 and suits the pattern well. This design was made in gold only, or in a combination of gold and black as shown here. This teapot features honey gilding which is slightly textured and not nearly as bright as the London gilding used at the Giles workshop and on Chelsea-Derby. An identical teapot was in the Zorensky Collection,[1] while a complete tea service of this shape and pattern survives together in the Worcester Porcelain Museum and from this it is possible to imagine how a room must have looked in the 1780s furnished with a full equipage of this design.

1. See John Sandon and Simon Spero, *Worcester Porcelain 1751-90, The Zorensky Collection*, fig. 230.

57. Armorial Dessert Dish

Size: 26.2cm (10⅜in.) wide
Date: c.1789-90
Mark: none
Museum Purchase through the Ewers Acquisition Fund, 1983.8.3

Although this service is more or less contemporary with the set made for the Duke of Clarence (catalogue no. 60), these sets represent two entirely different tastes. While the royal service was in the latest French style, the dessert set made for the Reverend Bostock was already old-fashioned by 1789. It does, however, mark a turning point in the factory's fortunes.

The arms of Bostock impaling Rich are placed in the centre of a floral chaplet within swags of ripe fruit hanging from an outer border. This band of rich underglaze blue is heightened with three different patterns of gilding. The gilding is very bright and represents almost the first use at Worcester of the new technique of mercury gilding. This method used mercury as a medium to mix with the gold instead of honey, which had been used previously. This new process was introduced to Flight's Worcester factory by Mrs. Charlotte Hampton who was invited to Worcester in 1789.[1] According to John Flight's diary, the defection of the Chamberlain family – who left to set up their own rival china works – left Flight's without any experienced gilders.[2] Charlotte Hampton had probably worked previously for Flight's china shop in London. She arrived in Worcester in May 1789 and introduced the new process immediately. Mercurial gilding gave a brighter, flatter look compared with the textured appearance of honey gilding.

The Reverend Charles Bostock, of Roos Hall in Suffolk, married Mary Frances Rich in June 1783. Revd. Bostock inherited the Rich family name on the death of his father-in-law in December 1790 and he was elevated to Sir Charles Rich, Baronet in July 1791. As the arms on this dish omit a baronet's coronet, the set must have been made some time between May 1789 (the first use of mercury gilding) and December 1790 (the death of Lieut-General Sir Robert Rich).[3] The set is today widely distributed among collections, including a tureen and ladle in the Harris Masterston Collection in Houston

1. Harry Frost,writing in the *Handbook of the International Ceramics Fair,* 1992, pp. 34-39.
2. John Flight's diary, quoted by Henry Sandon, *Flight and Barr Worcester Porcelain.*

3. John Sandon and Simon Spero, *Worcester Porcelain 1751-90, the Zorensky Collection*, p. 293 and fig. 360, for an identical heart-shaped dish from the service.

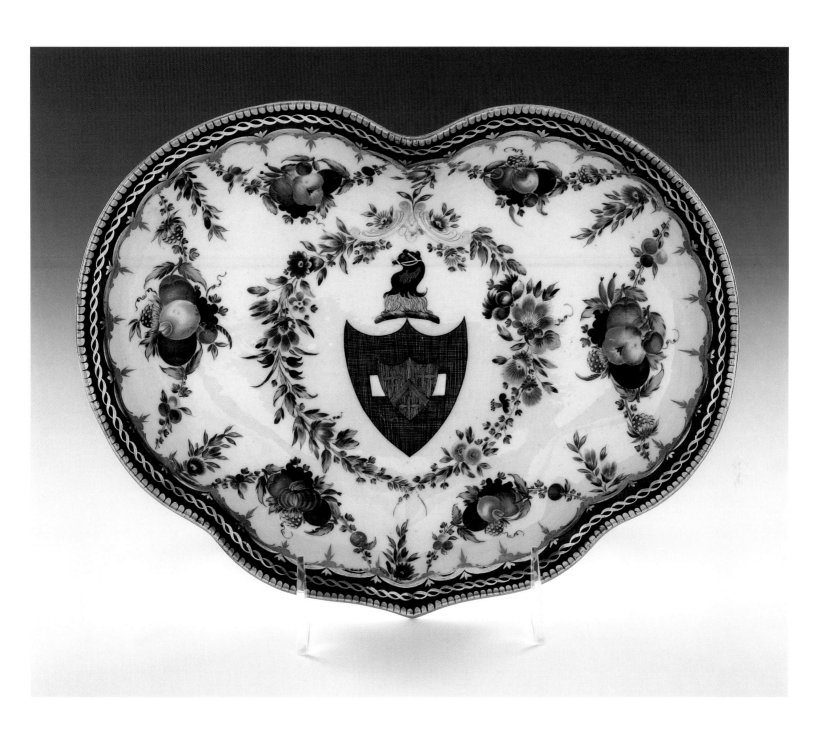

THE FLIGHTS AND THE BARRS

The visit of George III in 1788 gave the Flights a much-needed fillip. When Thomas Flight bought the Worcester porcelain factory five years before he acquired a moribund business lacking direction. Flight was the company's London agent and he bought the factory for his two young sons. Joseph and John Flight took control in 1784 and 1788. They had an uphill struggle as the aging kilns caused huge problems and the works foreman was defrauding them. The final nail in the coffin came when the Chamberlain family set up their own rival factory in Worcester. The Chamberlains had been in charge of painting at Flight's and took most of their best decorators with them. They even took over Flight's old shop in Worcester High Street. Things couldn't get any worse.

The King gave John Flight some much-needed advice. George III and Queen Charlotte ordered a set of china in an old blue and white Chinese design within a gold edge. The King thought it looked refreshingly modern and an icepail of the pattern at Cheekwood reveals why. Renamed the 'Royal Lily' pattern, this pointed the factory in a new direction. On King George's recommendation, Flight's opened a new London shop at 1 Coventry Street. John Flight travelled to Paris and ordered fashionable French porcelain to sell in the shop. John engaged new modellers and decorators and introduced modern French designs to Worcester. He also abandoned cheap blue printing and made a conscious decision. From now on every piece of Flight porcelain would be of the highest quality, finished off with the best gilding.

One royal order leads to another. In 1789 the King's son, the Duke of Clarence ordered an armorial dessert service in the French taste. Then in 1791 the Flights let off fireworks in Worcester to celebrate another important order from the Duke of Clarence, a dinner set known as the 'Hope Service'. Plates from both of these services are at Cheekwood and are a tribute to John Flight's achievements during his tragically short career. He died in July 1791, before the Hope service was completed.

To continue in business Joseph Flight needed help and in 1792 Martin Barr became the senior partner in the new firm of Flight and Barr. Quality was the most important criteria, boosting the firm's reputation. This was very much a family affair and when Martin's son, Martin Barr junior, was old enough to become a partner, the name of the company was changed in 1804 to Barr, Flight and Barr. A lavish assortment of porcelain from this period can be seen at Cheekwood and visitors are overwhelmed by the rich colours and sumptuous gilding. An entire dinner service startles the eye, while for sheer quality of workmanship an armorial jug made for George III cannot be surpassed.

When Martin Barr senior died in 1814, his other son George joined his brother and the firm became Flight, Barr and Barr. Only the highest quality was good enough for the Barrs. They believed the British government intended to create a national porcelain factory along the lines of Sèvres or Vienna. While petitioning for Government patronage, Martin and George Barr insisted every piece of their porcelain was finely finished and edged in the best gold. They are supposed to have told their decorators 'We want you to consider this as jewellery – we wish you to take all possible pains'. The high price almost didn't matter. Some of the best china painters of the day were engaged, including Thomas Baxter and William Billingsley, great artists whose work is represented in the collection at Cheekwood

Martin Barr's taste never deviated from Etruscan and Classical ideals for this was the style he so admired from the Continent. Flight, Barr and Barr never received the King's special backing, but their devotion to these ideals has left us a glorious legacy. The Stowe service, made for the Marquis of Buckingham, is without doubt the most extravagant set of porcelain ever made in England. The tureen from the Stowe Service is far and away the highlight of a great collection of armorial porcelain at Cheekwood.

Opposite: Jug made for George III. See catalogue no. 69.

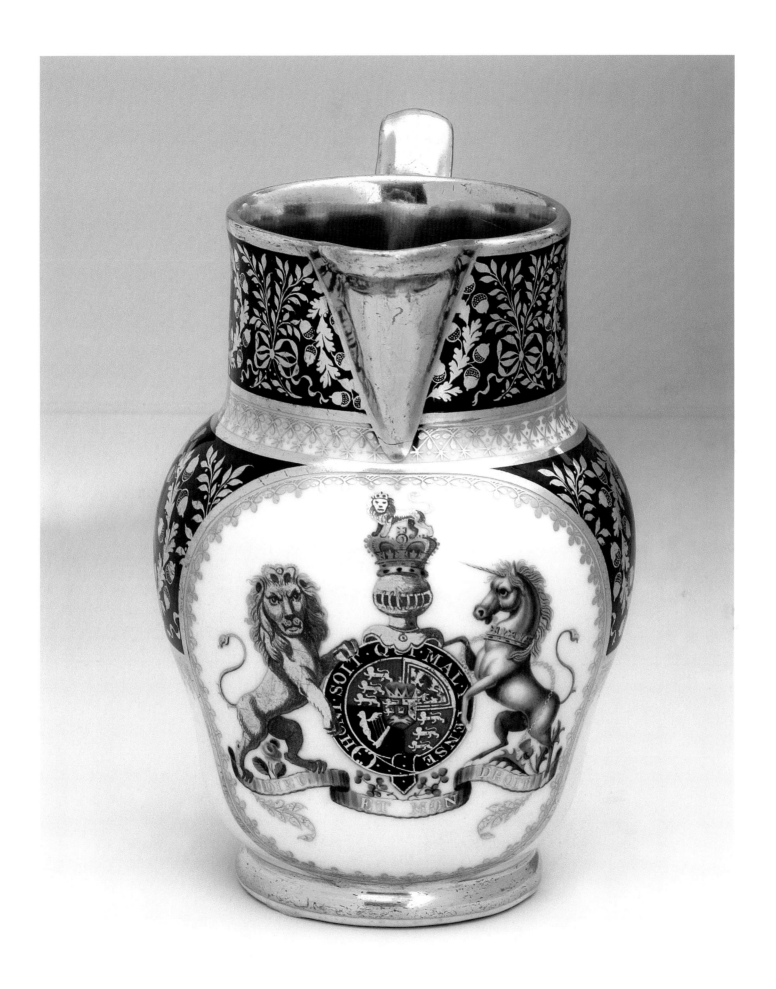

58. Bell Pull

Size: 5.4cm (2⅛in.) long
Date: c.1785-90
Marks: None
Provenance: the Peter Merry (Bridge House) Collection
Museum Purchase through the bequest of Anita Bevill McMichael Stallworth, 1994.11.3

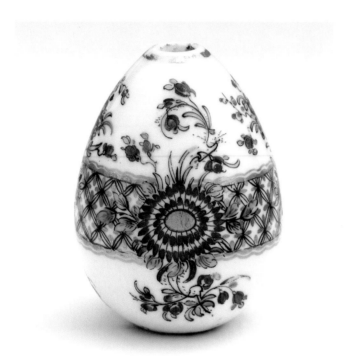

Bell pulls hung from a cord or wire that rang a distant bell to call the servants. From period images, 18th century bell pulls were cords similar to those found on curtains and often ended in large tassels.[1] Over time, the bell cord itself became an item of ornament as it flattened into a broad strip that could be heavily embroidered with abstract patterns or full-blown flowers.

In the 18th century ceramic bell pulls were usually the shape and size of an egg, although other baluster or vase shape examples are known.[2] They served both as a handle and as a weight to keep the bell cord taught. The fashion for weighted bell pulls seems to have originated in England around 1780. They were made in porcelain for only a short time, from around 1780-95, at Flight's factory and those of their rivals, Derby and Chamberlain. The Chamberlain account books list the shape as 'bell handles' or 'bell rope balls'. In 1791 a Chamberlain bell handle cost 4s.6d.[3] Pottery bell pulls were made in jasperware by the Wedgwood factory, finely finished with relief decoration.[4]

It is difficult to distinguish between Flight and Chamberlain egg-shaped examples since bell pulls were unmarked. The few surviving examples are all decorated with rich Japan patterns, including some with underglaze blue bands known as the 'Queen's Pattern'.[5] The Cheekwood example is attributed to Flight's factory on the basis of the smooth glaze and the enamel colours used. The pattern is inspired by the many fanciful designs of old Japan, copied at Worcester from c.1768 until the 1780s.

DECEMBER. DECEMBRE.

1. A mezzotint by Robert Dighton the elder (1752-1814) entitled 'December', published in 1784 by Carington Bowles, shows a bell pull in use. Illustration courtesy Winterthur, Bequest of H. F. Du Pont 64.892.12
2. John Sandon, *Dictionary of Worcester Porcelain*, p. 65, illustrates a different shape of Flight bell pull mounted as a vase, an ingenious use of the object.
3. For more information on bell pulls in Chamberlain price lists see Geoffrey Godden, *Chamberlain's Worcester Porcelain*, pp. 218-219. Godden suggests that Caughley may have supplied the shape to the early Chamberlain factory.
4. For a Wedgwood jasperware example see Elizabeth Bryding Adams, *The Dwight and Lucille Beeson Wedgwood Collection at the Birmingham Museum of Art*, p.258.
5. A Chamberlain example is illustrated by Geoffrey Godden, *op cit*, p. 219. A waster with cobalt stripes, probably from the early Flight period, was found during excavations on the factory site, see John Sandon, 'Recent Excavation at Worcester 1977-1979', E.C.C. *Transactions*, Vol. 11, Part 1, 1981.

59. Ice Pail with Cover and Liner

Size: 27.5cm (10⅞in.) high
Date: c.1795
Mark: none
Museum Purchase through the Ewers Acquisition Fund, 1983.6

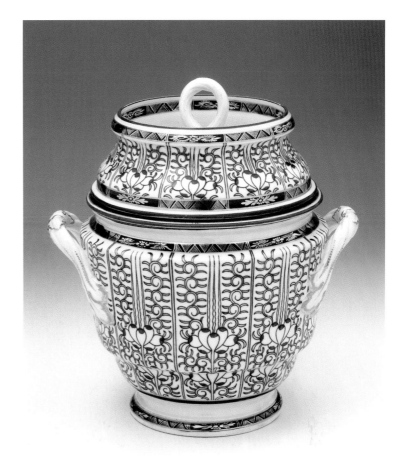

An ice pail kept sorbets and ice creams cold by sealing them between two layers of ice held in the base and lid. This form was developed at Sèvres in 1759, known as a *seau à glace*.[1] Ice pails consist of three parts: the body, liner and lid. The 'U'-shaped liner was embedded in crushed ice in the base while further ice was packed into the bowl part of the lid. The pieces had to fit exactly and thus ice pails proved challenging objects to make. Worcester introduced the ice pail into production probably around 1775 or 1776, although all 18th century examples are rare.

Ice cream was considered a great luxury as well as a delicacy. In addition to expensive ingredients such as sugar and cream, the most costly part was the harvesting and storing of ice. This required the labour of estate workers in winter to collect ice from frozen ponds and pack it into a special building known as an ice house. It was a demonstration of wealth to serve ice cream to your guests in elegant porcelain containers.[2] Only the most expensive dessert service included a pair of ice pails as an optional extra.

This ice pail bears a very popular underglaze blue pattern called 'Royal Lily', a design of highly stylised lilies dating back to the Ming dynasty in China. Blue and white Chinese porcelain with the 'Lily' pattern was exported to Europe during the Kangxi period around 1700. At Worcester the pattern first appeared around 1775-80 and it was subsequently used on a most extensive range of shapes. The pattern combines underglaze blue with red enamel and gold borders and frequently an iron-red or brown rim was added to imitate the appearance of the Chinese originals. The simple 'Lily' pattern was elevated to its royal status in 1788 following the visit to Worcester of King George III and Queen Charlotte. No record remains of the King's purchases from Flight's factory, but these certainly included the 'Lily' pattern. A few examples have been noted marked with a crown over a crescent in gold and it has been suggested these came from the King's original order. By the following year the pattern was already known as 'Royal Lily' for this name appears in the order books of the rival Chamberlain workshop when they sold their version of the pattern in 1789.[3] Worcester's 'Royal Lily' pattern remained popular throughout the 19th century and even into the 20th century. It was copied by a number of other factories including Coalport and Spode.

1. Howard Coutts, *The Art of Ceramics: European Ceramic Design 1500-1830*, pp. 117-118.
2. For information on the history of ice cream and desserts, see Wendy A. Woloson, *Refined Tastes: Sugar, Confectionery, and Consumers in Nineteenth-Century America* (Baltimore and London: The Johns Hopkins University Press, 2002).
3. Geoffrey Godden, *Caughley and Worcester Porcelain*, pp. 44-45.

60. Royal Armorial Plate

Size: 24.3cm (9⅝in.) diameter
Date: c.1789-90
Mark: Flight with a crown and crescent painted in underglaze blue
Published: John Sandon, *Dictionary of Worcester Porcelain*, col. pl. 22
Museum Purchase through the Ewers Acquisition Fund, 1988.13

Less than a year after receiving the honour of a Royal Warrant from King George III, Flight's Worcester factory was asked to make its first royal armorial service. The order came not from the King but from his fourth son, William Henry, Duke of Clarence, who became Flight's most important patron. In 1789 H.R.H. Prince William was awarded the Order of the Thistle, the highest honour in Scotland. He was also given the title Duke of Clarence and St. Andrew. In celebration the Duke commissioned a set to be decorated with the Order of the Thistle, together with the Order of the Garter that had previously been awarded to him. No English porcelain maker had ever been asked to create such a set and the design must have been a considerable challenge to Joseph and John Flight, especially as their firm was at this time struggling to overcome enormous difficulties.[1]

The commission was for a dessert service of shaped fruit dishes, small plates and tureens for sugar and cream.[2] Surmounted by a ducal coronet, the Duke of Clarence's own version of the royal arms appears on a central shield within the Order of the Garter bearing in gold the motto, 'Honi soit qui mal y pense' (Shame on him who thinks this evil). Wrapping around the garter is the green ribbon of the Order of the Thistle. The badge of the order, showing St. Andrew as patron saint, hangs beneath the arms and links a spray of laurel and an oak branch to form a victor's wreath. The oak branch is symbolic of the British Navy, chosen because Prince William was a Rear Admiral. The prince was sent into the Navy at the age of thirteen in 1778 and served in many engagements until his retirement from active duty in 1789.

The border of this scalloped plate is truly unique. Two ribbons, one in blue for the Order of the Garter and the other green with gold thistles for the Order of the Thistle, twist together to form a chain. Within the reserves are painted delicate sprigs of roses and thistles. At the four points of the compass are the badges from both orders. On the left is a Garter star, while the Order's patron saint, St. George, slays a small dragon at the top. On the right is a star for the Order of the Thistle and at the bottom of the plate St. Andrew is shown holding his diagonal cross.

With no precedent in English porcelain, it is hardly surprising that the Flights looked to France for inspiration. John Flight had visited France in March 1789[3] and ordered Paris porcelain from the Angoulême manufactory for sale in their London shop. The composition and colouring resembles Parisian porcelain of the day. The workmanship is outstanding. John Flight had complained in his diary for June 1789 about difficulties the firm had experienced with firing underglaze blue.[4] This plate uses underglaze blue for the Order of the Garter and this has fired evenly and remains clear.

This service must have impressed the Duke of Clarence, for two years later he rewarded the Flight factory with a larger and far more important order (see catalogue no. 61, the 'Hope' Service). The firm was also honoured, many years later, with an order for a coronation service, for in 1830 the Duke of Clarence became King William IV. The patronage of the royal family aided the revitalised factory in becoming a popular source for luxury porcelain.

1. The Chamberlain family left Flight's employment in 1789 taking all of their best decorators and gilders. See catalogue no. 57.
2. The set was first discussed by R.W. Binns, *A Century of Potting in the City of Worcester*, pp. 105-6.

3. Henry Sandon, *Flight and Barr Worcester Porcelain*, p. 25.
4. Quoted by Henry Sandon, *op cit*, p. 26.

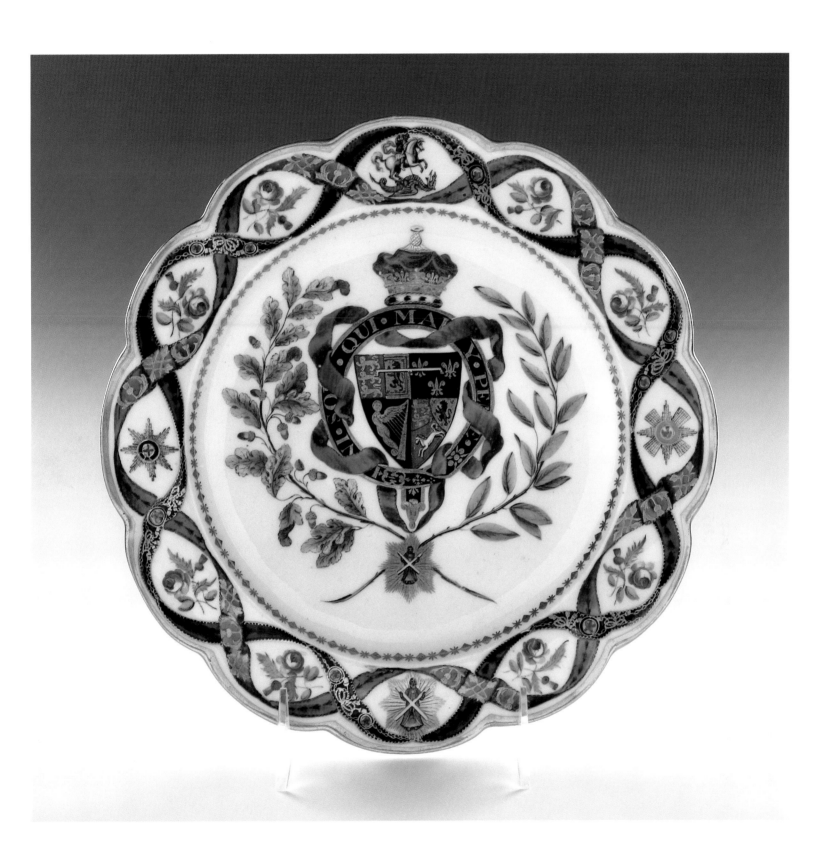

61. Plate from the 'Hope' Service

Size: 24.6cm (9¹¹⁄₁₆in.) diameter
Date: 1790-92
Mark: Flight with a crown and crescent painted in underglaze blue
Museum Purchase through the Ewers Acquisition Fund, 1983.8.4

A royal service meant important publicity for its maker and so there was fierce competition between porcelain manufacturers to win such a major order. When the Duke of Clarence wanted a new dinner service, as was the custom of the day he put the commission out to tender. Representatives of the Derby and Worcester manufactories were invited to submit specimen plates and costings. The Flight factory had completed an armorial dessert service for the Duke just two years earlier, but they still needed to convince their patron that this much larger dinner service was within their capabilities. They were, after all just starting to regain their footing with new leadership, and were battling against new competition from the Chamberlain factory in Worcester.

John Flight recorded in his diary in January 1790:

We used our two best painters last week to make some very fine designs for the Duke of Clarence, we have already completed 3 plates and I have sent them to London. One is a gold arabesque design, another the figure of Hope, the other of Patience.[1]

A few days later on 24 January John Flight added:

Apart from the two plates mentioned.... We have made two others with figures, Peace and Plenty. H.R.H. Duke of Clarence has decided on the Hope design with the decoration that we put on the Peace plate, he has ordered a table service that will amount to more than £700 sterling. He has given us a year in which to complete it. Last Monday we had a grand illumination here on the day of the Queen's birthday, which made a lot of noise. Everyone says that it was the best thing of that sort that has ever been seen here. We have also published the order

that the Duke of Clarence has given us and these two things help much in providing subject for gossip in society on the success of these transactions and our progress.[2]

A specimen plate from the Derby factory has survived,[3] showing that Flight's were not alone in providing samples to the Duke of Clarence. In February 1791 William Duesbury, owner of the Derby factory, wrote to Lord Rawdon to say how unhappy he was that the order had gone to Flight's.[4]

The Duke of Clarence Service is in the French taste, heavily influenced by the fashion for the neo-classical that was so much in vogue. A dark underglaze blue border is richly gilded with paterae, gadroons and stars in a strict pattern. The monochrome paintings of 'Hope' that appear on every piece in the service were the work of a painter only recently employed by Flight's. John Pennington was an excellent artist who had worked for Josiah Wedgwood as an enameller in London.[5] On 12 July 1789, John Flight recorded in his diary:

My Brother [Joseph Flight] has exten'd into an agreement with Pennington, a very clever painter in London. We heard he was [engaged] to Chamberlain & this made us first wish to have him. C[hamberlain] had applied to him but he preferred our offer. I expect him on Tuesday.[6]

John Pennington specialised in painting in monochrome or *en grisaille*, in sombre tones of sepia or brown. The full centre of each piece depicts a young woman, always on a rocky shore or in a bay looking out to sea. Each figure is in a slightly different pose, but all are accompanied by an anchor that identifies her as the allegorical figure of 'Hope'. One of the three Christian virtues, this personification of Hope with an anchor was well established by the 18th century.

In 1789, the year the Duke retired from naval duty and

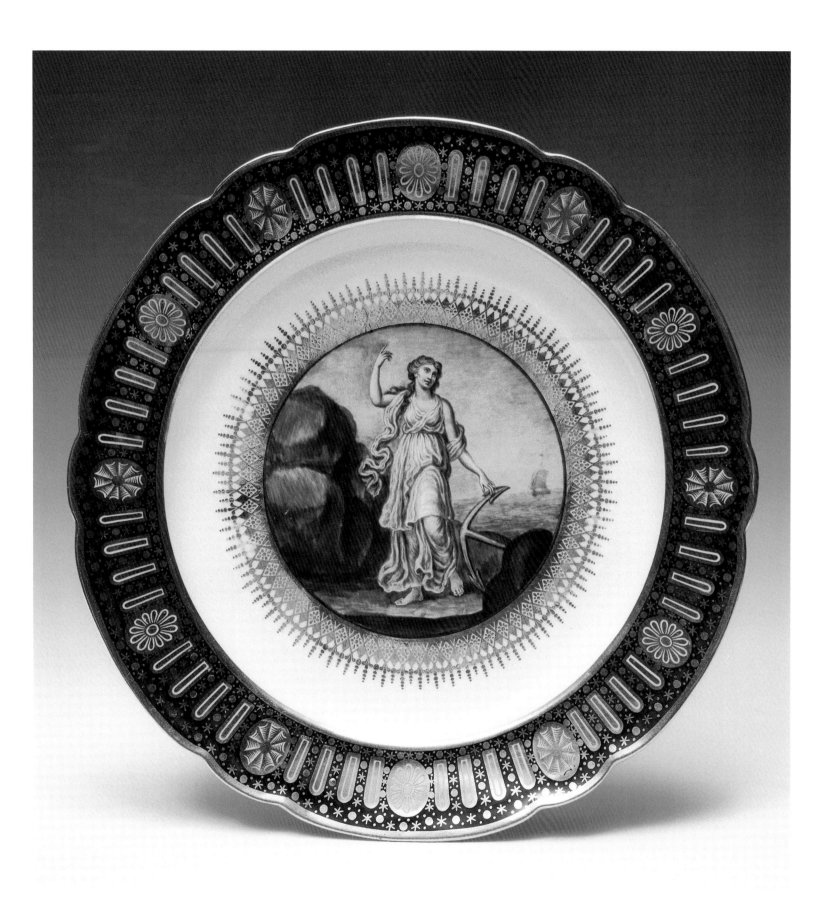

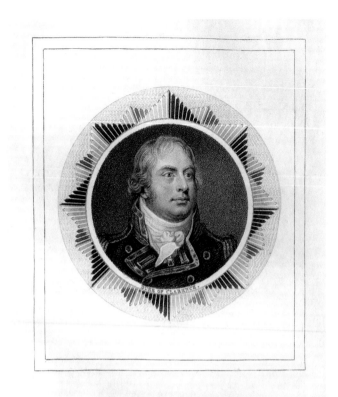

HIS ROYAL HIGHNESS
WILLIAM HENRY DUKE of CLARENCE,
BORN AUG.t 21 1765.

From *George The Third, His Court and Family*, published by
Henry Colburn & Co., 1821.

With a single painter responsible for so many scenes, the time given of one year to complete the set was ambitious. Even so, Flight's were only slightly late with their delivery. On 13 April 1791 John and Joseph Flight advertised in a Worcester newspaper that the nearly completed service was available for view and invited ladies and gentlemen to come and see it. It was usual for china makers to place an important service on display in the factory's showroom before delivering it to the customer, as Josiah Wedgwood had done with his celebrated 'Frog' service made for Catherine the Great. There is no record of what the Duke of Clarence thought of the 'Hope' service, but he did return to the factory in 1830 when he ordered an even more lavish set from Flight, Barr and Barr. In due course the 'Hope' service passed to the Earl of Munster and a significant part of it was sold at Christie's in the 1970s. This is now in a private collection in England, while other pieces are in many museums around the world.

ordered his service, Erasmus Darwin (1731-1802) published a poem entitled '*Visit of Hope to Sydney Cove, new Botany-Bay*'. Darwin's words almost perfectly match the sentiments of this plate. He wrote:

> Where Sydney Cove her lucid bosom swells,
> Courts her young navies, and the storm repels,
> High on a rock amid the troubled air
> Hope stood sublime, and waved her golden hair;
> Calmed with her rosy smile the tossing deep,
> And with sweet accents charmed the winds to sleep...[7]

1. Quoted by Henry Sandon, *Flight and Barr Worcester Porcelain*, p. 230.
2. Henry Sandon, *op. cit.*, pp. 230-1.
3. Identical in design to the Worcester set but with a central figure of 'Griselda', perhaps representing Patience. This was sold at Bonhams, 7 June 2002, lot 31.
4. Henry Sandon and John Twitchett, *Collectors Guide Magazine*, March 2002, p. 32.

5. For Wedgwood's relationship with Pennington, see F.A. Barrett and A.L. Thorpe, *Derby Porcelain*, London: Faber & Faber,1971.
6. Quoted by Henry Sandon, *op. cit.*, p. 223.
7. Roger Lonsdale, ed., *The New Oxford Book of Eighteenth Century Verse* (Oxford: Oxford University Press, 1984,) p. 761.

62. Milk Jug

Size: 12.4cm (4⅞in.) high
Date: c.1800-05
Mark: incised B with a small cross
Gift of Mr. Robert Woolley in honour of Mrs. William J. Tyne, 1988.31.3

This jug for milk, or possibly cream, would have accompanied a very lavish tea service. The all-over decoration is what is known as a 'Japan' pattern. Flight and Barr made many luxuriant, exotic designs that fall under this umbrella name today, but you would never find anything quite like this decorating any porcelain made in Japan. *Imari* or *Arita* porcelain from the Orient has served as the inspiration for a style that is instead far more brilliant. Underglaze blue stripes divide the surface into three vertical panels filled with stylised ornament in bright overglaze enamels. Birds, fences, rocks, peonies and other exotic plants crowd every inch of space. The heavy use of gold sets this apart from any Japanese prototype. Old Japanese *Imari* porcelain did include gold, but Japanese gold is thin and ineffective. By contrast, Worcester's gilding was rich and bright, giving a sumptuous appearance to the overall design. This pattern proved popular at Flight's factory and continued in production for about twenty years.[1]

'Japan' patterns were produced side by side with formal neo-classical patterns, for the factory gave its customers plenty of choice. Japan patterns appealed to customers who had a taste for the exotic. The same shapes were available in every kind of decoration and in this case this jug form is based on classical rather than Oriental traditions. English porcelain designers closely followed silver shapes. Flight and Barr kept up to date with changes in fashion and this milk jug shows how the shape of silver and ceramic jugs progressed after 1800. The fashion of the time called for oval forms with straighter and taller sides. The lip is pronounced while the handle is flattened with a bold loop at the top.

1. Compare catalogue no. 78, a dish of similar pattern by Barr, Flight and Barr. A Flight, Barr and Barr teacup and saucer also at Cheekwood is illustrated by

John Sandon, *Dictionary of Worcester Porcelain*, col. pl. 57. This has an additional initial G of its original owner.

63. Breakfast Cup and Saucer and an Eggcup

Size: Cup 6.6cm (2⅝in.) high, saucer 15.4cm (6⅛in.) diameter, egg cup 6.1cm (2⅜in.) high
Date: c.1800-04
Marks: Incised B on cup and eggcup only
Museum Purchase through the Ewers Acquisition Fund, 1979.10.1ab-2

'Barr's Orange' is a wonderful colour. This distinctive background was introduced around 1800 and has been known as 'Barr's Orange' within the Worcester factory since at least the end of the 19th century. Named after Joseph Flight's partner in the business, the colour would certainly not have been developed by Martin Barr himself, for he was no chemist. Barr was a draper by profession and joined the business to provide financial help and marketing experience.

In England during the Regency period the fashion for rich, plain backgrounds led many porcelain factories to perfect new strong ground colours. Bright orange grounds were widely popular, at the Coalport and Spode factories in particular and also at Chamberlain's factory in Worcester (see catalogue nos. 91 and 94 in this catalogue). The 'Barr's Orange' used at Flight's factory is a deep shade of salmon. It is not as vibrant as the orange colour used by most other makers, and it is this softness of tone that sets it apart. No other factory perfected an orange colour that fired consistently smooth and even.

Worcester's 'Barr's Orange' made an excellent background for fine gilding. On this large cup and saucer gold pendent leaves and borders spill down over the ground colour and frame the armorial panel. A customer has chosen a pattern from stock and asked for his crest and motto to be painted within the reserved panels. The same gilded pattern occurs on other coloured grounds and is known with different family crests. Here the unidentified crest of a lion's paw grasping a clover is painted *en grisaille* and bears the motto 'Re E Merito'. These pieces formed part of a breakfast service. In breakfast sets the cups are much larger than normal teacups and other, additional shapes are often included such as jam or preserve pots, muffin dishes and eggcups. A dessert service matching this in every respect was made a few years later during the Barr, Flight and Barr period, and replacements for this were subsequently made by Spode.[1]

1. A set of Barr, Flight and Barr and Spode plates was sold by Sotheby's in New York, the Doris Duke Collection, May-June 2001, lot 628.

64. Pot-pourri Vase and Cover

Size: 25.2cm (9⅞in.) high
Date: c.1792-95
Mark: Incised B and painted script 'Flight & Barr Worcester Manu's to their Maj's'
Previously illustrated by John Sandon, *Dictionary of Worcester Porcelain*, p. 40
Gift of Mr. and Mrs. William J. Tyne, Jr. in memory of Mr. Jack C. Massey, 1992.5ab

Towards the end of the 18th century the fashion for large classic style fireplaces called for sets of vases to decorate them. At the same time advances in gardening and the cultivation of flowers demanded new containers to display cut specimens. This was the age of the porcelain bough pot. This vase may have sat between two semi-circular bough pots as a garniture, or else could have served a similar purpose by itself, for the cover is pierced with a series of small holes, each of which could display a single cut bloom.

Worcester had used yellow grounds as decoration up until about 1770 but gave up because of the technical difficulties they presented (see catalogue nos. 32 and 33). Around 1790 the Derby factory perfected the use of a rich yellow ground and a similar colour was also made with much success at Pinxton. Both Flight and Barr and Chamberlain at Worcester attempted the colour in the mid-1790s. This wonderful vase shows that Flight's technical ability was now the equal of any manufacturer in Britain, for the yellow ground is truly incredible, a vibrant canary colour. Clearly they still had some problems in firing a yellow ground, as the vase has some black specks from the kiln affecting the yellow enamel, but these hardly detract at all.

On the large, flat surface, a black-ground panel is painted with extraordinarily realistic flowers in overglaze enamel. These flowers are far removed from the fruit and flower swags seen on the Bostock Service dish of just a few years earlier (see catalogue no. 57). In 1789 Joseph Flight attracted to Worcester John Pennington, a leading figure painter from London. When tendering for the 'Hope' service, John Flight mentioned that specimen plates had been painted by their two best painters.[1] It is likely that, in addition to John Pennington, Flight had engaged another painter from London, perhaps this flower painter, whose work occurs only on early Flight and Barr period pieces.

This bouquet of overlapping aster, peony and tulip is very Continental in style and is reminiscent of the botanically accurate sprays painted on Sèvres, Paris and Vienna porcelain of the time. The style focuses on naturalism with each petal carefully delineated and special attention is given to depth in the composition. The choice of a black ground to contrast with the yellow is nothing short of masterful.

Alongside the realism of the flower painting, the shape seems rather rigid with formal flutes and gadroons. The scroll handles and oversized finial lack the elegance that the decoration deserves. This suggests that at this period the factory did not fully understand ornamental production. Flight's chose to concentrate on the manufacture of tableware instead and made relatively few vase shapes.

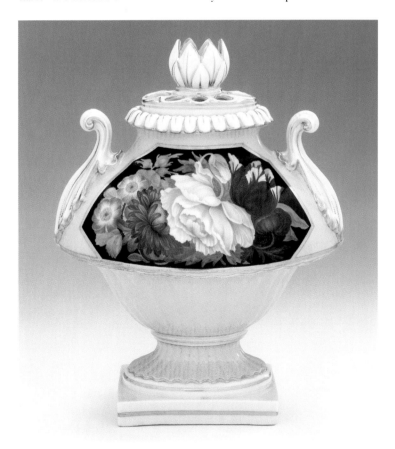

1. See catalogue no. 61, quote from John Flight's Diary.

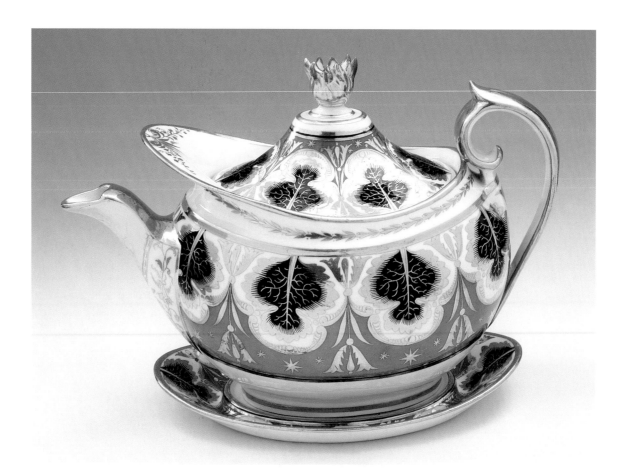

65. Teapot, Cover and Stand

Size: 26cm (10⅛in.) total length
Date: c.1805-10
Mark: none
Museum Purchase through the Ewers Acquisition Fund, 1978.1.20

During the Barr, Flight and Barr period the factory never cut any corners. Every piece was finished to the highest specifications and nothing but the best would pass muster. This teapot is superbly potted. First, it is surprisingly light with a handle that invites you to pick it up and pour. The flame that forms the knop on the cover is an intriguing feature that also invites you to want to pick up the lid and see how it feels. The cover fits like a glove and doesn't slip when the pot is tilted towards the most elegant spout which rises from beneath an exaggerated lip, like a ship's prow. The stand has a raised platform in the centre on which the pot sits with classical elegance, and this design also means that the decoration on the stand is not rubbed at all, even after two hundred years.

Basically this is perfection in porcelain. Barr, Flight and Barr knew exactly where it wanted to be artistically; it produced some of the best teawares in Britain, decorated to the highest standards. The pattern on this teapot almost jumps from the surface, and it is clearly intended to be as eye-catching as possible. The combination of underglaze blue leaves with the popular 'Barr's Orange' ground (see catalogue no. 62) works well together, but, as with so much Flight's Worcester porcelain, it is the gilding that makes all the difference. The finest gold trims the edges, covers the spout and finial and runs in swags over the ground colour. Although the overall composition consists of relatively simple elements, the resulting teapot exemplifies the Regency style which in England in 1805-10 was anything but restrained. Admiring this single piece, it is easy to forget that originally this was just one part of a complete service for tea and coffee, and this teapot was meant to be used for brewing a pot of tea.

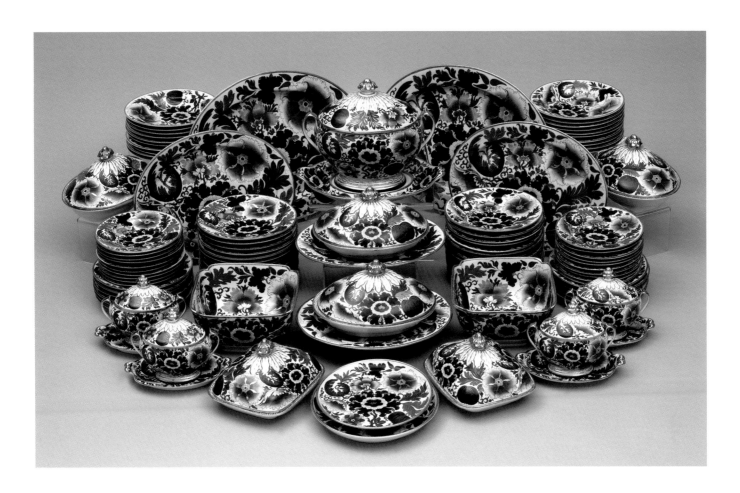

66. An Extensive Dinner Service

Sizes:
Soup tureen with cover and stand, the stand 36.5cm (14⅜in.) wide
Four rectangular vegetable dishes and covers, 23.7cm (9¾in.) wide
Four oval vegetable dishes, 27.7cm (10¹⁵⁄₁₆in.) wide
Four sauce or dessert tureens with covers and stands, the stands 24.2cm (9½in.) wide
Five pairs of platters, ranging in size from 50.7cm (19¹⁵⁄₁₆in.) to 30.8cm (12⅛in.) wide
Two square salad bowls, 23.8cm (9¾in.) wide
Two cheese stands, 27.3cm (10⅝in.) and 24.8cm (9¾in.) diameter
Forty dinner plates, 23.6cm (9⁵⁄₁₆in.) diameter
Twenty soup plates, 23.9cm (9⁷⁄₁₆in.) diameter
Twenty dessert plates 20.7cm (8⅛in.) diameter
Date: c.1805-10
Marks: Impressed BFB and crown on most pieces
Gift of Dr. Roland Lamb in memory of his wife, Florence Cheek Lamb, 2001.9.1-107

Just imagine the scene. It is 1810 and the cream of society has gathered in the ballroom of a grand townhouse, invited by a host most anxious to impress. To the summons 'Dinner is served', the guests are led to the dining room. Double doors swing open and there set out on the vast table, in all its glory, is a new dinner service from Barr, Flight and Barr. In the centre of the table the soup tureen stands like a great classical urn. Once the guests are seated, with military precision staff ladle soup on to plates and place one in front of each guest. Waiting in the wings further staff are putting the finishing touches to more than a dozen great platters, each piled high with a different entrée. Empty dinner plates replace the soup plates as the entrées arrive in procession. The lids of the vegetable tureens are lifted to reveal further steaming secrets,

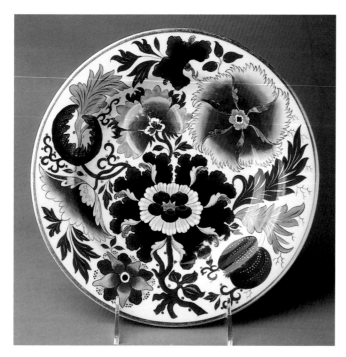

while open square bowls are heaped high with salad. Dinner is served in a fashion called *à la française* wherein all the tureens, covered vegetable dishes and platters are prearranged on the table. Guests then help themselves to the dish nearest to them. For a faraway dish, a servant would retrieve the desired platter. This method had its drawbacks. In 1817 the Prince of Wales, later King George IV, gave a dinner *a la française* with over one hundred hot dishes that included thirty-six entrées. As one guest complained:

> Meaning to be very polite [the servants] dodge about to offer each entrée to the ladies in the first instance; confusion arises, and whilst the same dishes are offered two or three times over to the same guests, the same unhappy wights have no options of others.[1]

The staff move quickly, stacking high the used plates and empty dishes as the entrée courses give way to dessert. Further platters arrive with towering puddings and jellies, which the guests pile on to their smaller dessert plates. Flat round stands with exotic foreign cheeses provide a further course to round off the meal.

If everything has gone to plan, the guests return to the ballroom full of admiration for their host and praise for the Worcester factory whose porcelain they had just enjoyed. Without adequate preparation and plenty of rehearsal, however, the result could so easily have been pandemonium. One wonders how many dinner services of expensive porcelain were devastated as staff crashed into one another, piles of plates toppling over and tureen lids sent flying. On one occasion when the King of Denmark entertained at dinner with the priceless 'Flora Danica' set of Copenhagen china, many pieces were broken in a single night. Accidents are generally good for the porcelain industry but this is not something a lover of antique Worcester porcelain likes to think about.

The dinner service at Cheekwood was given to Dr. and Mrs. Roland Lamb of Nashville who regularly used it to entertain. Great care was always taken, and thankfully it survives in remarkable condition. Dinner services varied in their content depending on the customers' needs. This set by Barr, Flight and Barr includes tureens for soups, vegetables and sauces, all of which survive as pairs, as do the platters of which there are five different sizes. Single items include a salad bowl, a fish drainer and matching platter, a low tazza for cheese and a very large platter moulded with a gravy well to catch the juices. There are forty dinner plates, twenty dessert plates and twenty soup plates.

No factory lists or pattern books survive from Flight's factory and so we do not know any names given at the time to patterns such as this. It is possible that this is what some other factories referred to as an 'Indian' pattern. As Chinese porcelain was imported by the East India Company, copies of Chinese export patterns were sometimes known as 'Indian' rather than Chinese. When patterns mixed bright colours with underglaze blue they were often called 'Japan' patterns instead (see catalogue no. 78). The pattern on the Lamb service at Cheekwood includes as a central motif, a magenta flower with a turquoise heart which is similar in shape to flowers found in the classic Chinese export pattern known as 'Tobacco Leaf'. There is unlikely to be a single source for this Barr, Flight and Barr design, however. The service is most likely an original Worcester composition made up of elements from a number of contemporary patterns based on old Oriental porcelain.[2] Motifs such as the rust red pomegranates and leaves and the pink and turquoise flower do occur separately on other pieces of Worcester porcelain, but this is the only complete dinner service of this type known to have survived together.

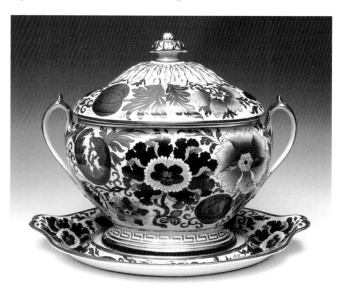

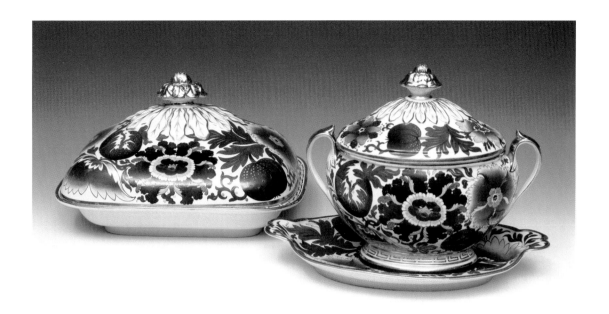

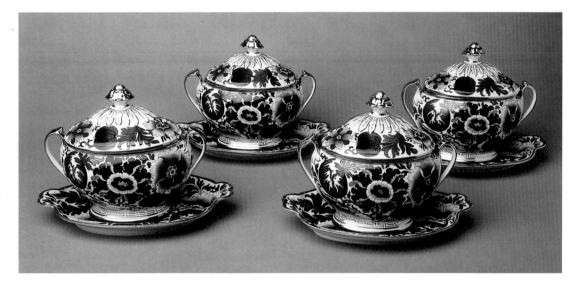

1. Abraham Hayward, *Biographical and Critical Essays* (1859), 'The Art of Dining;, p.405.
2. See Henry Sandon, *Flight and Barr Worcester Porcelain*, pl. 90, for a plate with another 'India' pattern in related taste.

Thomas Rowlandson (1756-1827). A Meal at Squire Worthy's, n.d. Watercolour on paper. Tate Gallery, London.

A more modest dinner table is set *a la française* with a tureen and covered dishes like those in this service. Numerous servants, pictured at right, enabled their employers to perform such elaborate dinners.

PHOTOGRAPH TATE, LONDON 2007

67. Plate with Outside Decoration

Size: 23.4cm (9¼in.) diameter
Date: c.1810
Mark: Impressed BFB and crown
Museum Purchase through the Ewers Acquisition Fund, 1990.5

When studying Worcester porcelain, it is hard to interpret the role played by outside decorators. Aside from James Giles, whose work is relatively well known, there are many other odd forms of decoration from different periods that simply do not 'fit in'. It is easy to assume that anything uncharacteristic must be the work of an independent enameller, but such assumptions can be dangerous. This plate, and its companion in the Cheekwood collection, is crudely painted in what might be deemed an 'amateur' style. The gilding, on the other hand, is of very good quality.

Poor painting such as this is very unusual on Flight's porcelain. A clue to the fact that this plate was not painted at the factory is the presence of 'spit-out', black speckling on the underside indicating the plate was enamelled some time after glazing. It also has no painted factory mark, just an impressed stamp, which would be unusual for a lavish production decorated at Worcester. Since its inception the Worcester factory had supplied blank porcelain to outside decorators, but once they had their own retail shop in London this practice stopped. Providing competitors with high quality blank porcelain bearing impressed Worcester factory marks made no sense at all.

In London early in the 19th century were a number of independent china enamellers who bought undecorated porcelain for enamelling. The best-known London workshop was the studio of Thomas Baxter in Gough Square. Because Baxter later worked at Worcester there is a common misconception that he painted on Worcester porcelain while he was in London. This is not the case. Baxter mostly used white Coalport porcelain and some from Paris.

If, as seems likely, this is the work of an independent London enameller, where did the blank Worcester plate come from? It could have been 'old stock', rejected during the Flight, Barr and Barr period because of the out of date BFB impressed mark, but this seems unlikely. Sometimes porcelain with simple decoration was cleaned using grinding or acid to remove tiny flowers or limited gilding, providing a blank surface for 'redecoration', but there is no evidence for this here. With unsigned pieces such as this plate, the decorator and his or her purpose must remain mysterious, for this plate simply doesn't add up.

While the origin of the plate is a puzzle, the decoration is even more mysterious. The central human-like figure with a towel over the left shoulder attempts to step out of a rhomboid frame enclosed in a red circle. This is surrounded by eight panels with an animal inside each; badly drawn, these appear to be a winged horse, dog, elephant, fox, lion, deer, pig and warthog. The pagan symbolism doesn't match any known zodiac. It is possible the centre may be based on a drawing of a Roman mosaic. The border decoration includes panels of mythological beasts that defy interpretation. A companion plate at Cheekwood places further beasts within a formal pattern of Celtic inspiration. Maybe there was once a 'harlequin' set of these plates, each more bizarre than the last. The naïve decoration creates an intriguing puzzle if nothing else.

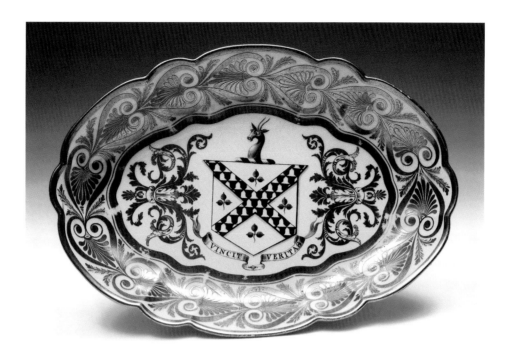

68. Oval Dessert Dish

Size: 27.8cm (10 15/16in.) wide
Date: c.1805-10
Mark: full printed Barr, Flight and Barr mark in brown, impressed BFB and crown
Museum Purchase through the Ewers Acquisition Fund, 1988.11.6

John Prendergast-Smyth ordered two sumptuous services from the Barr, Flight and Barr factory around the same time. The first service shares a similar gilded border to this dish, although instead of an armorial centre the set was a 'Harlequin'. Each plate or dish was finely painted with a different subject including landscapes, birds, animals, shells and figures of all kinds.[1]

This large serving dish from the second service features a gilded classical border of formal palmettes and gold foliage on a white ground. In the centre further intricate gilded scrollwork flanks a coat of arms with a prominent red cross at its centre. These are the arms of the Prendergast family, one of the oldest English families living in Ireland; they arrived there in the twelfth century. Born in 1741, John Prendergast-Smyth was the son of Charles Smyth and Elizabeth

Prendergast Haman, daughter of the 1st Baron Gort. Through his mother, John was the heir to Thomas Prendergast, 2nd Baron Gort and he assumed the name upon his uncle's death in 1760. John Prendergast resumed the surname Smyth in 1785. He was created Baron Kiltarton of Gort in 1810 and Viscount Gort six years later. Only one year after his elevation, Prendergast-Smyth died and his estates passed to his sister's son. Since this service does not bear a baron's or viscount's coronet, John Prendergast-Smyth probably ordered it before 1810.

Lavish armorial services without a coloured ground are unusual. This dish does, however, illustrate the power of fine gilding used by itself. The classical design is executed with mathematical precision and provides a stunning frame around the coat of arms. In today's marketplace fine gilding is undervalued. It is therefore worth remembering that this set would have been enormously expensive when it was made; indeed, it will have cost Prendergast-Smyth just as much as his other service with the hand painted scenes.

1. Eight plates and two tureens from the painted service are illustrated by Henry Sandon, *Flight and Barr Worcester Porcelain*, p. 77, pls 60 and 61.

69. Jug made for George III

Size: 14cm (5½in.) high
Date: 1805-10
Mark: painted crown and factory name in puce listing London address and royal patronage
previously illustrated by John Sandon, *Dictionary of Worcester Porcelain*, col. pl. 46
Museum Purchase through the Ewers Acquisition Fund. 1984.26.6

This jug bears the full royal arms of King George III. It was apparently ordered in 1805 and so this was not the first time the king had commissioned porcelain from the Flight factory. Compared with previous orders, this set is far more lavish and costly, however, and in terms of quality the workmanship shown here cannot be surpassed. In 1788, the royal family stayed in Worcester for several days when the king attended the Music Meeting. George III honoured Flights with a surprise visit to their shop. John Flight recorded..

...the Sovereign and his family honou'd us with a visit, totally unexpectedly and came in without any form as a common person wou'd.... They behaved exceedingly familiar and affable, ordered a good deal of china.[1]

The King and Queen toured the factory in a more formal manner a few days later. John Flight requested and received the firm's first royal warrant, giving them permission to name the factory as 'Manufacturers to their Majesty's.' The Queen and Princess Royal ordered more porcelain[2] and the King encouraged Flight to open a retail store in London. The royal patronage transformed the ailing Flight factory into a highly successful venture, and so the Flights and Barrs had every reason to be thankful to their monarch.[3]

Possibly due in part to the King's poor health, it was not until sixteen years later that George III ordered two new royal services from the factory. The first had a rather reserved design with a so-called 'Barr's Orange' ground covered with gilding and the King's cipher GR beneath a crown.[4] The second service was most likely ordered in 1805 but additional pieces continued in production over the next decade. This very extravagant service bears the monarch's full coat of arms as shown on this jug. The ground is a deep underglaze cobalt blue with gilded oak leaves and acorns between sprays of laurel. The oak branches probably represent the British Navy (ships were mostly made from oak). As the order for this service in 1805 coincided with Britain's naval triumph at Trafalgar, the branches take the form of a victor's wreath around the King's cipher, the initials GR beneath a crown. The gilded border also features the emblems of the Union of the British Isles—a small bouquet of rose, thistle and shamrock.[5]

The royal arms are executed with a remarkable attention to detail. The face of the lion is captured with particular care. Applying enamel detail on top of bright gold is an especially difficult technique. This jug is also thinly potted, suggesting that it was made with a great sense of pride, as befits a royal service. The use of solid gilding inside is exceptional. The patriotic workmen at Barr, Flight and Barr will also have been aware of the continued significance of the firm's Royal Warrant. Most of Flight's George III service remains in the Royal Collection and the royal family has never sold pieces. Examples like this jug are likely to have been 'specimens' kept back by the factory for display in its shops or works museum. A number of specimens from major services were sold following the death of R.W. Binns in 1900.

1. John Flight's Diary quoted by Henry Sandon, *Flight and Barr Worcester Porcelain*, p. 218-219. The royal visit occurred on August 6, 1788.
2. See the 'Royal Lily' icepail, catalogue no. 59.
3. John Flight took the King's advice and opened a new London shop. John Flight noted in his Diary: 'This visit we expect as does everybody else will be of great advantage to our Manufactory and my brother and self began to think of improving the opportunity...'; see Henry Sandon, *op. cit.*, p. 219

4. Henry Sandon, *op. cit.*, p. 19, middle row right.
5. Following the Act of Union in 1800, these emblems were widely adopted. The leek of Wales did not feature as Wales was not acquired by England through conquest.

70. Pair of Griffin Candlesticks

Size: 16.2cm and 16.4cm (6⅜in. and 6⁷⁄₁₀in.) high
Date: c.1804-13
Marks: none
Museum Purchase through the Ewers Acquisition Fund, 1982.4.1-2

The griffin is a mythical creature with the body of a lion, neck of a snake and head and wings of an eagle. The image figured in ancient Greek art and the beasts were sacred to Apollo. The revival of classicism returned many ancient animals to the design world. In 1759 William Chambers published *A Treatise on the Decorative Part of Civil Architecture*. Chambers' designs for 'various ornamental utensils' included a tall, lean griffin supporting a candle nozzle. Josiah Wedgwood's well-known griffin candlesticks, dramatically cast in black basalt, were introduced around 1770.[1]

The Worcester griffin candlesticks are very different in form from William Chambers' and Wedgwood's models. The design source Worcester used is not known, but it is likely the inspiration came from France. The Parisian porcelain factories took many classical subjects, including figures and animals, and cast them in porcelain, either in unglazed white biscuit or smothered with gold. The intention was to imitate ormolu which is gilded bronze. You could be mistaken for thinking these Worcester griffins are made of ormolu covered in pure gold. Their lions' manes, wings and paws have been carefully shaded to imitate bronze, while the bases pretend to be slabs of polished marble. Such deceipt could go too far and so, just to make sure their customers realised these really were made of porcelain, Barr, Flight and Barr left the candle nozzles in white.

Other English china makers, notably Spode and Coalport, made griffin candlesticks, but these were generally smaller without tall plinths.[2] The Cheekwood pair is not marked, which is rather surprising in view of the quality of the decoration. Other examples are known with impressed Barr, Flight and Barr marks, however, and so the attribution is not is doubt.[3] In another instance, the same mould for the griffin was used as the base for a centrepiece where four griffins support a dish or a flat tray, the beasts decorated in gold and bronze as on this pair of candlesticks.[4]

The griffins sit upon plinths painted all around to imitate finely veined grey marble. One side of each plinth is painted with the image of a dead bird. The painting is exquisitely detailed although the subject seems incongruous to the rest of the object. Why choose dead birds as an illustration? Comparison with other factory painting of feathers, shells and flowers in highly realistic styles may provide an answer. A keen interest in the natural world induced many people to collect specimens. Perhaps these realistic illustrations reminded the owner of other intellectual pursuits.[5] The painter responsible for these bird panels is not known. William Doe, who is listed as a painter of 'natural birds, feathers, insects &c',[6] had barely started his apprenticeship at the Flight factory when these candlesticks were made. Also, Thomas Baxter, who taught William Doe, was still painting in London at this time.[7]

1. See Margaret Legge, *Three Centuries of Wedgwood*, Australian museum catalogue, fig. 40.

2. Vega Wilkinson, *Spode-Copeland-Spode: The Works and its People 1770-1970*, pl.12.

3. See a pair of candlesticks sold 26 October 2002, Sotheby's New York, Lot 1636.

4. See 8 September 1993, Phillips London, Lot 390.

5. An identical dead goldfinch appears on a Barr, Flight and Barr inkstand sold by Phillips in London, 10 December 1997, lot 417.

6. William Chaffers, *Marks and Monograms on Pottery and Porcelain*, detailing an interview with Solomon Cole and listing painters at Flight, Barr and Barr.

7. See Henry Sandon, *Flight and Barr Worcester Porcelain*, p. 93, for a plate with dead birds erroneously attributed to Thomas Baxter.

71. Inkwell

Size: 14.5cm (5¹¹⁄₁₆in.) wide
Date: c.1804-5
Mark: elaborate Barr, Flight and Barr mark painted in script, incised B
Gift of Mr. and Mrs. James Fowler in memory of Mrs. John O. Fowler, 1993.7

Prior to the 1800s the Worcester factory produced few inkwells. At the time of Barr, Flight and Barr inkwells became a more standard product in a few distinctive forms. This basic shape came originally from French porcelain and variations were made by a number of English factories. This example is roughly crescent shape with two pockets attached at its back corners. These pockets held pounce, a fine absorbent powder (such as powdered charcoal) that was sprinkled over paper to prevent the ink from smudging or spreading. A moulded head forms the top of the handle that bisects the piece at the back. On top, a well for ink sits in the centre with three holes for quill pens around it. The lid that would originally have sat over the inkpot is lacking from this example.

For decoration, the pounce pockets are left in white and gold and the main body is painted as black marble veined with white and pale rose. At this time there was a growing interest in geology and a popular hobby involved collecting polished specimens of exotic marbles, usually set into patterns to form tops of tables. The panel on the front of the inkwell is finely painted with a landscape. The scene is not identified underneath, which is probably just as well as it is likely to be imaginary. The Derby china factory had established a fashion for sets of porcelain painted with a different named scene on each piece, but the painters never travelled to see the views for themselves and the titles usually mean very little. Instead a 'Picturesque' composition would be created in the mind of the factory painter. On this inkwell panel the sheer cliff may have been inspired by a print of the celebrated 'tor' near Matlock in Derbyshire, but much licence has been taken and the row of stepping-stones in the foreground is a total invention of the Worcester painter, quite out of scale in such a river but making a pleasing composition.

The mark of an incised B together with a painted Barr, Flight and Barr mark places this inkwell at the very beginning of the Barr, Flight and Barr period, the decorators using up existing stock bearing the earlier incised mark used up until 1804.

72. Dessert Plate

Size: 21.6cm (8½in.) diameter
Date: c.1810-13
Mark: full Barr, Flight and Barr printed mark in brown, impressed BFB and crown, and painted title
Gift of Mr. and Mrs. James Fowler, 1978.1.28

Landscape painting on British porcelain rose in popularity at the end of the eighteenth century. This ran parallel to a growing appreciation of the natural world and the countryside around Britain. After the publication of Reverend William Gilpin's books of sketching tours through the island, gentlemen became travellers and amateur artists, taking to the roads with sets of watercolour paints in search of 'Picturesque' views. With such a mood prevalent, realistic landscape views proved a good decorative idea for porcelain.

This plate comes from an extensive dessert service where each piece would be painted with a different scene. In neat red script on the back this is named as 'View near Lymington, Hampshire'. The craftsman at the Worcester factory who painted this set would not have been in a position to travel himself and so the scenes were not based on his own sketches drawn from life. The views derive instead from engravings in one of the many popular picture books that illustrated other people's tours around the country. The location listed on the back is unimportant. This may have been based on a real tumbledown cottage in Hampshire, but much artistic licence will have been used, both by the engraver of the source print as well as by the painter at Worcester. Customers just wanted a set of pretty plates and the original owner of this set would not have specified which views should be chosen. The factory painters selected them at random as they turned the pages of their travel books.[1]

The Barr, Flight and Barr mark shows this plate was made before 1813 and, as such, it is somewhat ahead of its time. Instead of a classical pattern of gilding around the centre, the gold scrollwork and dots revive the taste of rococo. This style of porcelain decoration came back into fashion during the 1820s. Prior to that it was gradually introduced in London and in particular appears on the beautiful porcelain made at Swansea. William Billingsley was at Worcester during the Barr, Flight and Barr period before leaving in 1813 to establish the Swansea chinaworks.[2] Billingsley painted flowers while at the Flight factory (see catalogue no. 77), but no landscapes by him are known. The view of Lymington on this plate is very unlikely to be the work of Billingsley himself, but the green and brown palette used, and the treatment of weed-like roots to frame the bottom of the composition, suggests the painter responsible had worked alongside William Billingsley and had learnt mannerisms from the master.

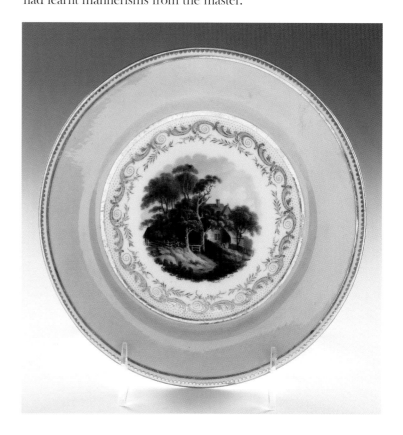

1. See Henry Sandon and John Twitchett, *Landscapes on Derby and Worcester Porcelain*.

2. John Sandon, *Dictionary of Worcester Porcelain*, pp. 66-7.

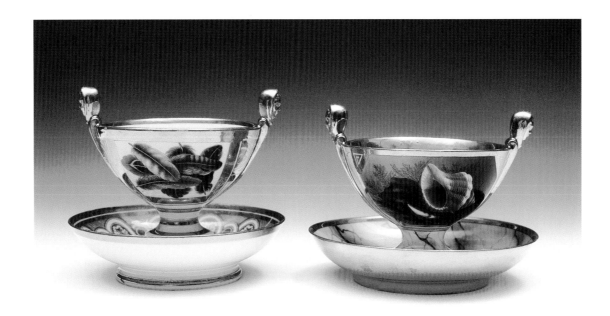

73. Two Cabinet Cups and Stands

Size: cups 10.5 and 11.7cm (4⅛in. and 4⅝in.) high, stands 14cm and 13.3cm (5½in. and 5¼in.) diameter
Date: c.1804-10
Marks: Full Barr, Flight and Barr marks painted in script, feather-painted cup and stand also with incised B marks
Feathers cup gift of Mr. Robert Woolley in honour of Mrs. William Tyne, 1992.29.3;
shells cup gift of Mrs. William J. Tyne, 1990.10.2

This curious shape is based on the form of an ancient Greek wine cup. Worcester's version was probably adapted from a French porcelain prototype from Sèvres or Paris. Cabinet cups were basically vessels without function. You would not have served wine or any beverage in these cups and instead they were intended to be placed in, or on, a display cabinet as objects of artistry in their own right. In the reign of George III the finest new porcelain of the day was collected just as antiques are collected nowadays. These cabinet cups would have appealed to connoisseurs, for their painted subjects show other forms of collectors' items.

Collecting exotic sea shells from around the world was a popular and expensive hobby of wealthy English ladies and their long-suffering husbands (see catalogue no. 74). Stuffing birds and collecting birds' eggs was likewise a pastime enjoyed by the aristocracy. Sportsmen used to shoot all kinds of bird species that we would regard as garden friends today. Young boys would be taught to recognise the plumage and individual feathers of different game birds. It is possible to imagine a father showing his son this Worcester porcelain cup as a test, to see if he can identify all the different specimens. The feathers are, after all, painted with incredible accuracy.

The shell panel on this other cabinet cup is most likely the work of Samuel Smith. He served his apprenticeship at the beginning of the Barr, Flight and Barr period and a number of superb signed pieces from 1806-7 allow his shell painting to be identified.[1] The treatment of the weed in the background on this cabinet cup at Cheekwood closely resembles a signed jug by Samuel Smith, although on the cup the shells are painted with less surety. William Doe is known to have painted feathers in the Flight, Barr and Barr period,[2] but he would have been too young to be the feather painter who decorated on Barr, Flight and Barr porcelain. The lack of an ascription to any named artist does not, however, detract from the beauty of work.

1. John Sandon, *Dictionary of Worcester Porcelain*, p. 311 and col. pl. 77.
2. William Chaffers, *Marks and Monograms on Pottery and Porcelain*, quoting Samuel Cole, a painter at Flights.

74. Large Etruscan-shaped Vase

Size: 35.6cm (14⅜in.) high
Date: c.1807-13
Mark: full Barr, Flight and Barr mark painted in script
Gift of Mrs. P.M. Estes, Jr. in memory of her husband, Mr. P.M. Estes, Jr., 1992.10

This monumental vase combines two of the factory's highest achievements during the Regency period. Barr, Flight and Barr introduced some of the best neoclassical shapes, following the lead of French porcelain and appealing to the strong market for all things antique. Wealthy patrons collected ancient Greek and Roman art on the Grand Tour and modelled their homes after ancient columned temples. This vase embodies many of the trademark elements of a classical object from its urn shape to its animal paw feet. The dramatic, angular handles attach with satyr head masks at the bottom. Solomon Cole described in his memoir the later Flight, Barr and Barr partnership's attitude to vase design and decoration:

> ...knowing that the Etruscan shapes presented a greater amount of plain surface than any other, [they] had the good sense to adopt them, being desirous of introducing as much art as possible into their manufacture...
>
> ...While these Etruscan shapes are classical and severe in form, they may be also said to be complex, always having handles, and great skill being required in their production; while ornaments without handles, however elegant in form, cannot please in the same degree, because they can be produced by a more simple means, *viz.*, by the thrower on the wheel in clay or the turner in wood.[1]

Cole also made another good point in his description. Not only did the shape of an object need to be pleasing, but the decoration must match or exceed it in good taste and design. It was the painting that determined the ultimate value of the object. The simple shape of this vase is overwhelmed with expensive and fine decoration. The ground colour is painted to imitate finely polished marble veined with darker and lighter streaks. Pure, burnished gold has been lavishly applied to the base, rims and handles, with a central border of fine classical ornament. Even the interior of the vase is gilded, with a fishnet pattern that complements the subject of the principal, reserved panel.

The entire front is painted with a complex still life of seashells spilling across a shelf. The unlikely positioning of sprigs of seaweed and coral serves to break up the severe outline of the shell specimens, while the background is dramatically shaded from light to dark. This type of shell painting was a speciality of the Flight factory. The fashion for painting realistic shells on to porcelain probably started in Paris and was introduced at Worcester during the Flight and Barr period around 1802. It reached its apex during the Barr, Flight and Barr and early Flight, Barr and Barr partnerships. Looking at this vase, there can be no doubt that Worcester's painters used real shells to copy on to their porcelain. The compositions may have been inspired by published engravings of specimens from collectors' books or design books, but the shells themselves are too realistic to have been copied from coloured-in prints. On one occasion, when the Worcester painter Thomas Baxter worked on a magnificent cabaret set, he titled his shell panels on the reverse 'Shells from Nature'.[2]

Many painters were responsible for shell decoration at Flights and at Chamberlains, and they clearly had different abilities. The work of three distinctive hands can be identified, two of these from signed pieces.[3] Thomas Baxter painted shells and other still-lifes on a series of fine Coalport plates while he was in London between 1801-1807 (see catalogue no. 81). His shell work at Worcester occurs only on Flight, Barr and Barr productions and is distinguished by the use of stippled shading. Samuel Smith painted shells on a series of signed apprentice pieces.[4] The very delicate manner in which he painted the background seaweed on these enables some of his unsigned work to be attributed (see catalogue no. 73).

A third, most accomplished hand used a different,

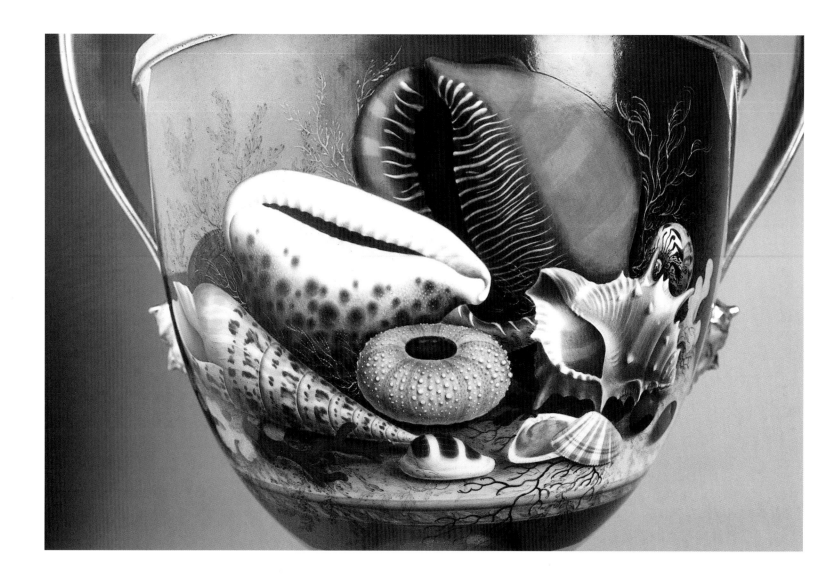

distinctive technique to paint delicate seaweed in the background of his compositions. The filaments of his weed form into tiny oval clumps, painted using brushstrokes that end in thicker daubs of colour. No signed specimens exist, but the identity of this painter can be suggested by a process of elimination. In his memoir quoted above, Solomon Cole told William Chaffers that the artist John Barker excelled in painting shells. In his catalogue of the Worcester Porcelain Works Museum, compiled in the 19th century, R.W. Binns attributed a number of shell painted pieces to Barker. In the absence of further evidence, it is likely that this third, highly skilled painter of shells was John Barker. If so, the vase at Cheekwood is a superb example of his work.

1. Solomon Cole, a former painter at Flights, was interviewed in the 1870s by William Chaffers. His account appeared in Chaffers' *Marks and Monograms on Pottery and Porcelain.*

2. Illustrated by John Sandon, *The Dictionary of Worcester Porcelain*, p. 62.

3. John Sandon, 'Shell-decorated Worcester Porcelain', *The Magazine Antiques*, June 1992, pp. 946-955.

4. A fine jug and goblet is illustrated by John Sandon, *Dictionary of Worcester Porcelain*, col. pl. 77.

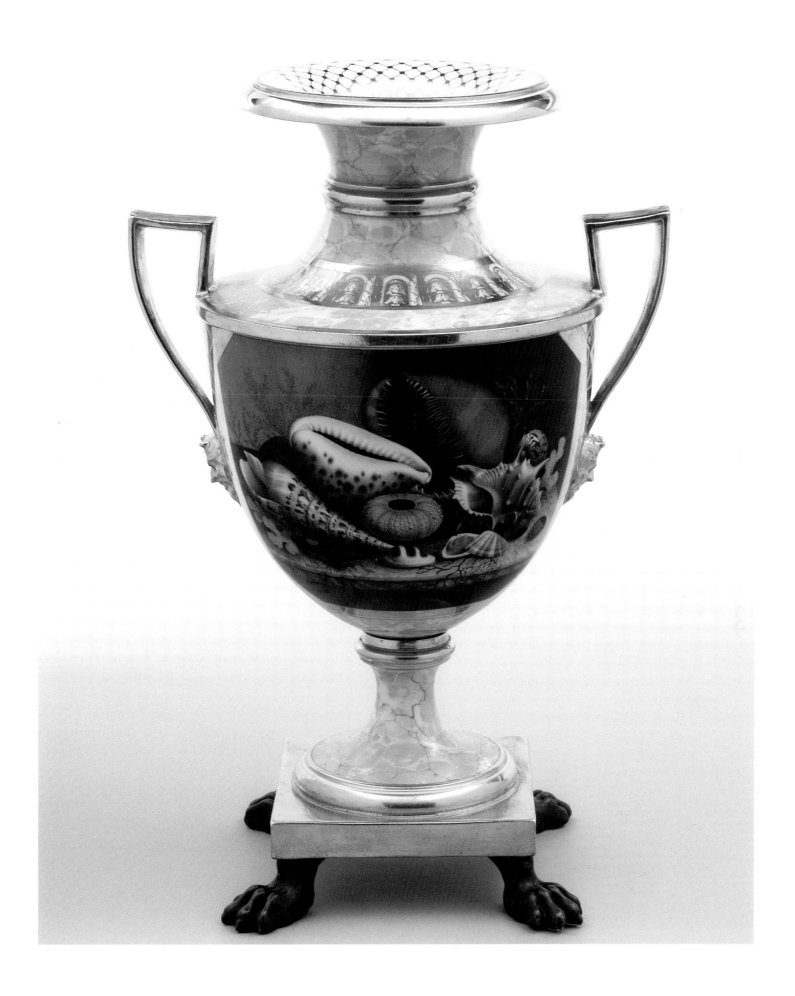

75. Dessert Plate

Size: 20.4cm (8in.) diameter
Date: c.1810
Mark: full printed Barr, Flight and Barr mark, impressed BFB and crown
Gift of Dr. and Mrs. E. William Ewers, 1984.26.3-4

Although the technique had been invented at Worcester, exploitation by pottery manufacturers in Staffordshire cheapened the reputation of transfer-printing. The firm of Flight and Barr believed in excellence above all else and saw printing as an inferior alternative to hand decoration. All forms of printing were discontinued around 1795. After a gap of about fifteen years the attitude of the firm changed slightly. While Flights remained staunch opponents of underglaze blue printing, they saw nothing wrong with printing itself as an art form and welcomed a new invention that produced the subtle decoration known today as bat printing. The difference between bat prints and previous overglaze transfer prints was the use of a stipple effect of tiny dots to create shaded areas, instead of engraved lines. Under strong magnification the surface of this plate is formed of thousands of tiny red dots, creating something like the same visual effect as a photograph in a newspaper.

The printing process itself was similar to a technique used at Worcester during the 1750s and '60s, except that instead of using thin paper to transfer the design, a glue bat was used instead. The process begins with a sheet of copper into which the pattern has been engraved or etched. Oil is sluiced on to the copper plate and then the excess is rubbed away, so that oil only remains within the engraved lines or dots. A slab of semi-solidified glue roughly half a centimetre (a quarter of an inch) thick is cut to the correct size and this glue 'bat' is pressed on to the copper plate. When carefully peeled away, tiny droplets of oil adhere to the bat. This is then pressed down on to the surface of the porcelain and, when removed, the glue bat leaves behind the drops of oil. A fine powdered colour is then dusted over the surface and adheres to every droplet of oil, revealing the complete pattern in all its delicacy.

Solomon Cole described to William Chaffers his memories of life at the Flight factory fifty years before. He told how all the painters at the factory were men and that

women were only employed to burnish the gilding. He added:

> The only other female employed was Mrs Lowe, who had a room to herself, and was engaged principally in printing the names of the firm in a circular form on the back of each rich and important piece, and occasionally printing shells and figures, as already described, in one colour, sometimes in a grey tint, and at others in a warm self colour.[1]

Bat printing was only practised at Flights for a brief time between 1810 and 1820, and for a relatively small number of different patterns. Shell subjects were printed on dessert services, usually in black or sometimes in brown or red.[2] Shells were one of the factory's most prestigious forms of painted decoration, and the compositions of their shell prints were clearly related to Flights' painted subjects. It is interesting to note that two of the finest Worcester shell painters, Thomas Baxter and Samuel Smith, also produced engravings for printed books, although there is no evidence that either was responsible for the etching of the copper plates used for these shell prints.

1. William Chaffers, *Marks and Monograms on Pottery and Porcelain*.
2. R.W. Binns reproduces this same print in his history of the factory as an item 'much used in decorating China'. See R.W. Binns, *A Century of Potting*, 2nd ed., London: Bernard Quaritch, 1877, pl. 11.

76. Pair of vases or jardinières

Size: 15.5cm (6⅛in.) high
Date: 1805-10
Mark: painted crown and factory name Barr, Flight and Barr in puce script with details of royal patronage
Museum Purchase through the Ewers Acquisition Fund. 1978.4.4ab

Around borders of tiny gold polka dots, bands of colourful feathers are painted with meticulous care. The rich orange ground is *semé* with golden starbursts. Feather painting was one of the grandest and costliest achievements of the Flight factory. Each feather can be identified by actual species – mostly popular game birds. These vases would have appealed to sportsmen, as well as their wives and daughters. In Georgian England aristocratic ladies gathered shells, plants and many other specimens for their collectors' cabinets. Real feathers were pasted into albums in overlapping formal patterns. The Worcester painter has

thought carefully about the layout of his feathers, as each vase in this pair is a perfect mirror image of the other, the specimens matched feather for feather.

This shape first appeared around 1800, influenced by Paris. Most porcelain jardinières of the period were made in two sections with detachable bases. Flights chose instead to make their jardinières as single pieces with integral bases, and they are also narrower than those of most competitors. The pots could have contained cut flower specimens as well as growing bulbs. The ground colour is known today as 'Barr's Orange', a term that was in use in Victorian times, although its origin is not recorded. Other factories used a rich orange ground at the beginning of the 19th century and these vases should be compared with the Chamberlain pen tray also painted with feathers, catalogue no. 94.

77. Dessert Plate

Size: 20.5cm (8⅛in.) diameter
Date: 1808-13
Mark: Full printed Barr, Flight and Barr mark, impressed BFB and crown
Museum Purchase through the bequest of Anita Bevill McMichael Stallworth 1993.8

This plate formed part of a dessert service with a different flower painted on each piece. The rose painted in the centre is remarkably realistic and is clearly the work of a skilled artist. In the late summer of 1808 the finest flower painter of his day arrived in Worcester looking for work. William Billingsley had failed in his attempts to make porcelain at Torksey and, faced with bankruptcy, he fled to Wales pursued by creditors. Unable to find financial backing at that time to establish a china works at Nantgarw, he was virtually destitute when he sent word to Barr, Flight and Barr asking for a small advance to pay for his journey to Worcester. Therefore, by remarkable good fortune, Martin Barr was able to employ an amazingly skilled painter for wages '...not any more at present than the common hands'.[1]

In time William Billingsley improved his conditions and assisted Barr, Flight and Barr in developing a new china body. In the meantime, though, it is likely that Billingsley worked as a painter at the factory from October 1808 until at least 1810 or 1811. Indeed he probably painted intermittently until he left Worcester suddenly and without notice in November 1813, returning to Wales once more.[2]

No signed work exists from Billingsley's time at Worcester, but it is possible to compare paintings on Barr, Flight and Barr with work he previously executed at Derby or Pinxton and later at Swansea. A small number of dessert services from the period 1808-12 appear to have been painted by Billingsley himself with a different single flower on each piece.[3] Attributing flowers to Billingsley is often controversial, mainly because his work was so influential. Any other flower painters working at Barr, Flight and Barr would have watched in awe as the master worked, and no doubt they would have learnt to paint as he did. The plate at Cheekwood, strongly believed to be painted by Billingsley, depicts his most popular subject of a single rose spray. When viewed close up the painting seems to lack detail, and yet it has an impressionistic quality that makes the flower and leaves seem so real you can almost smell their fragrance from the middle of the plate.

1. Sarah Billingsley's letter to her mother, quoted in full by Henry Sandon, *Flight and Barr Worcester Porcelain*, p. 67.
2. Henry Sandon, *op. cit.*, gives a full account of Billingsley's time spent at Worcester and the attempts made by Barr, Flight and Barr to pursue him after he left. His complete career is discussed by W.D. John, *William Billingsley*.
3. One is illustrated by John Sandon, *Dictionary of Worcester Porcelain*, col. pl. 9, and another was sold by Bonhams London, 8 June 2005, lot 333.

78. Oval Dessert Dish

Size: 28.4cm (11¾in.) long
Date: 1813-14
Mark: Full printed Flight, Barr and Barr mark and impressed BFB and crown
Gift of Mr. and Mrs. P.M. Estes, Jr. 1983.9.2

The decoration of this dish spans two periods of the Worcester factory. The porcelain was cast during the Barr, Flight and Barr period and stamped with the BFB initial mark. The dark blue portion of the design would have been applied soon afterwards and the dish glazed and fired to seal this part of the pattern underneath. By the time the colouring was completed, and before the dish went on to be gilded, Martin Barr senior died in November 1813 and the firm changed its name. The factory mark of Flight, Barr and Barr was applied at this time. This mark will have been of the type added by Mrs Lowe who '...had a room to herself and was engaged principally in printing the names of the firm in a circular form on the back of each rich and important piece...'.[1]

A service of this pattern would have been sufficiently rich and important to be deserving of the factory's special printed mark. Although decorated with a 'stock' pattern made for a considerable period, this would have been a very costly set in view of the many processes involved in its creation and the lavish use of gold. The design is a 'Japan' pattern, inspired by the '*Imari*' designs imported a century earlier from the Arita region of Japan. Imari was so called because it had been imported to the West via the port of Imari. The patterns known by this name feature dark underglaze blue combined with red and orange enamel and gilding. When other colours such as green and purple are used in addition, the term 'Japan Pattern' is generally applied, but there are no hard and fast rules and it is clear that china sellers in Regency England did not all use the same terminology.

Japanese porcelain had not been imported into Europe since the 1730s, when Japan imposed on itself isolation from international trade. Collectors, especially in Holland, adored the bright colours of old Japanese porcelain and bought copies made in England. Some of the best Japan patterns were made at Worcester and Derby, although many other porcelain makers produced their own versions. In Staffordshire pottery makers such as Mason's used similar Japan patterns on their Ironstone wares.

The pattern on this dish was first used during the Flight and Barr partnership around 1800.[2] Far removed from any specific Japanese prototype, a pagoda, a bridge and a fence have become so stylised that they are little more than geometric shapes, while plants are unrecognisable within the flowering jungle. Perspective doesn't matter. The purpose is to present the viewer with overwhelming richness. This is accomplished by the use of brilliant gold throughout, including a border design which is nearly solid gold. All this gold had to be polished or 'burnished' by hand. At the Flight factory, the young ladies whose job this was worked in a room fifty feet (15m) long.[3] They worked from seven in the morning until seven at night for the relatively small wage of just 3s.6d. a week.[4]

1. From Solomon Cole's memoir published by William Chaffers, *Marks and Monograms on Pottery and Porcelain*.
2. A milk jug is illustrated by Henry Sandon, *Flight and Barr Worcester Porcelain*, p.52.
3. Solomon Cole's memoir, *op. cit.*
4. Sarah Billingsley's letter to her mother, quoted by Henry Sandon, *Flight and Barr Worcester Porcelain*, p. 67.

79. Dessert Plate

Size: 21.8cm (8⅝in.) diameter
Date: c.1816
Mark: Printed Flight, Barr and Barr mark
Museum Purchase through the bequest of Anita Bevill McMichael Stallworth, 1993.23

It is mystifying that the company responsible for commissioning and importing so much armorial porcelain from China should ask an English manufacturer to produce a service bearing the company's coat of arms. In 1816 the Honourable East India Company commissioned Flight, Barr and Barr to make a dinner, dessert and tea service bearing a most impressive rendition of the East India Company's arms.

Founded in 1600, the Honourable East India Company monopolised Britain's Far Eastern trade for more than two centuries. The company originated as a group of London merchants buying stock in risky ventures importing valuable spices from the South Pacific. Starting with the tiny nutmeg, the company slowly aggregated lines of trade stretching into India and China. In a way, the company set the foundation for the British Empire as economic interests drove it to establish stations and towns near exotic commodities. During the 18th century the East India Company's operations were on a vast scale, their imports from China dominated by tea and porcelain.

By the time of this Worcester porcelain service, however, the Company had lost its coveted monopoly in most regions as new corporations pushed for a share of the market. Free trade proponents in Great Britain argued that the Company was not doing enough to sell British exports in foreign markets. Greatly reduced in size, the Company slowly became an antiquated institution.[1]

It is certainly to Worcester's credit that the service from Flight, Barr and Barr was superior to any decorated porcelain available from China at this time. The border design is unusual for Worcester, and no doubt this was chosen by the East India Company, The pink border hung with loose bouquets of pink roses may be a reference to the *famille rose* porcelain that the Company formerly imported in such quantity. For the matching tea service made by Flights, the roses in the border were replaced with golden acorns, alluding to the ships of oak that carried out the Company's trade. The gold scroll design that outlines the border is an

early revival of the rococo taste, in contrast to the severe neo-classical styles that dominated most of the Flight factory productions. The coat of arms in the centre is finished to perfection. The lion supporters and crest have been painted in brown enamel on top of gold, a difficult process because gold required a lower firing temperature than most enamel colours. The gilding is most likely to be the work of John Bly.[2] The only evidence for this is Bly's work on the William IV service fifteen years later, but, according to Solomon Cole, Bly '...excelled in shading the gold in arms, and was unequalled in giving a natural expression to the lion in the royal arms or wherever it occurred...'.[3]

The East India Company ordered other armorial sets from Flights' competitors. A service was made by the Spode factory and a very much larger order was given to Chamberlain's in Worcester. Over four years, Chamberlain's received commissions to make over seven thousand pieces of porcelain for the East India Company, their orders worth a total of £4,190.4s.[4] Many pieces of the Chamberlain sets survive to this day in India, suggesting the services were made for use in the East India Company's offices overseas.

1. Morse, *The Chronicles of the East India Company, trading to China 1635-1834.*
2. See John Sandon, *The Dictionary of Worcester Porcelain*, p. 142
3 Solomon Cole's Memoir published in William Chaffers *Marks and Mono-*

grams *on Pottery and Porcelain* and repeated by Henry Sandon, *Flight and Barr Worcester Porcelain*, p. 103.
4. See Geoffrey Godden, *Chamberlains Worcester Porcelain*, p. 130 and pls. 160-161.

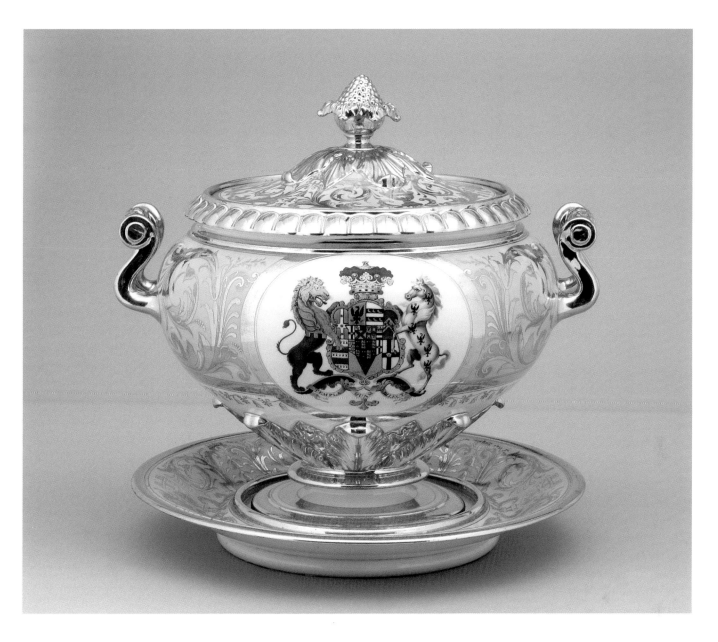

80. Soup Tureen, Cover and Stand

Size: 28cm (11in.) high
Date: 1813-14
Mark: Full Flight, Barr and Barr circular printed mark, impressed BFB and crown
Gift of Mrs. Wayne T. Delay and William T. Delay in memory of Wayne Tilden Delay, 1988.2

With the death of his father in February 1813, Richard Temple-Nugent-Brydges-Chandos-Grenville became the very rich 2nd Marquess of Buckingham and owner of the magnificent Stowe estate. The Grenvilles started as a gentry family and built their fortunes on a combination of investment and strategic marriages. With each wealthy wife, the family annexed estates in Buckinghamshire, Somerset, Cornwall, Jamaica and Ireland, often with elevations to the peerage. As a result, the 2nd Marquess's inheritance totalled about 39,000 acres (15,795 hectares) of land with a yearly income of £53,000.[1] The Marquess already possessed a significant fortune through his marriage to Anna Eliza Brydges, heiress to the Duke of Chandos.

Unlike his father, the 2nd Marquess was not generally popular with his contemporaries. In 1804 Reverend Powell wrote that the young man was not so agreeable as his father having great pride and a manner less pleasant.[2] Others considered the heir as proud, arrogant and, above all, extravagant. His greatest interest resided in collecting art and he avidly bought books, paintings, sculptures, prints, furniture and ceramics.[3]

Although the family owned sets of Chinese and French porcelain, the new Marquess ordered a further dinner service just a few months after his father's death. He selected Flight's Worcester factory for the commission. The company had just undergone its own name change after the death of Martin Barr, which accounts for the impressed BFB initial marks and printed Flight, Barr and Barr occurring together on most pieces of the service. The 2nd Marquess ordered over 186 pieces, each with his full coat of arms and elaborate gilding. The resulting service is considered one of the finest produced at the Flight factory and indeed the equal to any other armorial set made in England. The original order included two soup tureens, of which the Cheekwood example is one. Raised on its own separate stand, the shape epitomises the classical or Etruscan taste that Flight, Barr and Barr understood so well. The same shape was also used for smaller sauce tureens in the service. The pale salmon ground colour is not as vibrant as the 'Barr's Orange' favoured by the factory a decade previously (see catalogue

no. 76). This delicate colour forms the background for outstanding ornament drawn out in gold on every piece. Stylised antique urns and lyres appear at each point of the compass while swirls of acanthus leaves fill the remaining space. The quality of this workmanship is simply breathtaking, reminding us that Flights' gilders were not simply craftsmen but artists of the highest calibre in their own right. The amount of gold expended on this dinner service reflects the sheer wealth of the Marquess, for the knop of this tureen, the handles and the rims are all coated in solid gold.

The purpose of the ground colour and gilding was to frame the coat of arms placed at the centre of every plate and dish, and mounted on the front of each tureen. The family history and numerous aristocratic marriages meant that the arms of the 2nd Marquess and his wife were complex, to say the least. Just how much quartering was it possible to squeeze on to a single shield? Flights' decorators had a massive task on their hands. Every shield was a work of art in its own right, not to mention the painting of the lion and horse as supporters – and the coronet and motto too. The factory records are lost and so we don't know how much this set cost. In today's terms the expense would be simply astronomic, but in 1814 money was no object to the Marquess of Buckingham.

When the service arrived at Stowe it joined everything from antique Roman statues to stuffed birds in the cluttered treasure house. Stowe and its collections stood as the physical symbol of the family's ambitious claims to aristocracy. In 1822 the Marquess was elevated as the 1st Duke of Buckingham and Chandos, a long cherished goal

Platter (also in the Cheekwood collection).
Mark: crown and BFB impressed. Date: 1813-1814. Size: 41.6cm (16⅜in.) long. Credit: Gift of Mrs. Hugh Stallworth 1979.4.1

for the family. A year later, when his grandson was born, the Duke celebrated lavishly with a week-long christening party. Each night at dinner, over one hundred guests sat down to dinner, perhaps with this service on the table.

All this grandeur hid a dreadful secret – the Duke was selling off his estates to fund his lifestyle. His son, Richard Plantagenet, followed his father's bad habits and put further financial strain on the estates and family. In 1839, when the first Duke died, the Grenville family quickly fell deeper into decline. The 2nd Duke continued to make disastrous investments forcing his son, Richard, to attempt to save as much of the inheritance as possible. Against his father's delusionary arguments, Richard had to liquidate the holdings of many family houses including the symbol of their prestige, Stowe. The sale at Stowe in 1848 both shocked and enthralled aristocratic society and thousands of visitors attended the preview. Christie's sale lasted for an incredible forty days.

Newspapers lamented the degradation of the estate as the family was exposed to public scrutiny. Lord Macaulay commented in *The Times* on the scandal of the 2nd Duke of Buckingham's bankruptcy, 'An ancient family ruined, their palace marked for destruction, and its contents scattered...Stowe is no more...'.[4]

Following the 1848 sale, the 3rd Duke of Buckingham and Chandos bought back eighty-two pieces of the Flight, Barr and Barr service. These were sold once again at a sale at Stowe in 1921. Further parts of this set were auctioned by Sotheby's in 1974 and 1987.[5] Today the magnificence may be scattered around the world, but the ambitions of the Marquess of Buckingham remain for all to see at Nashville, radiating from the Stowe Service tureen, the greatest porcelain treasure at Cheekwood.

Sir William Beechey (1753-1839). Richard Temple-Grenville, First Duke of Buckingham and Chandos, n.d. Oil on canvas. The Governors of Stowe School
IMAGE COURTESY OF STOWE SCHOOL PHOTOGRAPHIC ARCHIVES

1. John Beckett, *The Rise and Fall of the Grenvilles: Dukes of Buckingham and Chandos, 1710 to 1921* (Manchester and New York: Manchester University Press, 1994), p.81.
2. John Beckett, *op. cit.*, p.100.
3. Sale catalogues for Stowe survive and present an insight into the family's collections. For example, see *Stowe Catalogue, priced and annotated by Henry Rumsey Forster*. London: D. Bogue, 1848 in the Winterthur Library.
4. Thomas Woodcock and John Martin Robinson, *Heraldry in Historic Houses of Great Britain* (London: The National Trust and New York, Harry N. Abrams, 2000), 169.
5. Sotheby's New York, 16 October 1987, the dramatic catalogue illustration, including the Cheekwood tureen, is reproduced by John Sandon, *Dictionary of Worcester Porcelain*, col. pl. 79.

81. Cabinet Cup by Thomas Baxter

Size: 7.8cm (3⅙in.) high
Date: 1814-16
Mark: Flight Barr & Barr, Royal Porcelain Works, Worcester, London House, 1 Coventry St., written in
black script by the artist
Gift of Dr. and Mrs. Vernon H. Sharp in memory of Mrs. Lorene Dandridge Sharp, 1979.1.4

'Some men say an army of horse and some men say an army on foot and some men say an army of ships is the most beautiful thing on the black earth. But I say it is what you love.'

Sappho[1]

A Greek poet and musician, Sappho lived in Mytilene, a city on the island of Lesbos, from around 630 BC. Little is known of her life apart from scraps of verse surviving in books assembled at Alexandria, Egypt, while references to her work appear in the writings of other ancient authors. Delving into themes of love and deep emotion, Sappho's poetry experienced a revival in the late eighteenth and early nineteenth centuries as new translations were published in German, French and English. A somewhat idealised visual image of Sappho appeared in paintings and prints and her name became a synonym for female literary and artistic achievement.[2]

Thomas Baxter was well versed in the classics. His own book, *Outlines of the Antique,* included in the introduction his view that 'It is to the Greeks that we owe nearly all that is elegant or dignified in art'. He studied Greek vase painting and his painted figures adapt perfect classical poses. For this cup's portrait of Sappho, however, Baxter has not copied any published source. Here is his own composition and within its theme of ancient love poetry is a secret passion the artist returned to time and again.

On this cup Thomas Baxter has painted a portrait of Emma Hamilton. The picture is strikingly similar to a sketch believed to be by Lawrence in the British Museum[3] and to another portrait of Emma by J.J. Masquerier engraved by Wm. Say and published in 1806 (reproduced here). Baxter made many sketches and drawings of Emma of his own from life, for he visited her a number of times between 1802 and 1804.[4] She invited actors, artists and writers to keep her company at Merton while Nelson was away at sea and her beauty clearly had a profound impression on the young china painter from London. Baxter painted Emma on porcelain in various guises. The most celebrated piece is a Coalport plate now in the Victoria and Albert Museum. Painted in 1806, it is based on a sketch of Emma as Britannia that Baxter had drawn at Merton a few years before.[5]

Nelson's death left Emma heartbroken and it is poignant that Baxter chose to paint Emma as Sappho at the same time as her melancholia brought about her own sad death in January 1815. Thomas Baxter arrived in Worcester in 1814 and remained there for two years. He painted for Flight, Barr and Barr and also ran his own china painting school next to

Lithograph by Wm. Say after J.J. Masquerier's portrait of Emma Hamilton, published in 1806

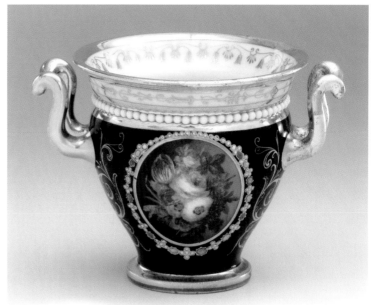

the cathedral. Baxter was an all-round 'decorator' and was skilled at modelling, gilding and jewelling. It is believed that the jewelling on this cup is Baxter's own work. While at Flights in 1815 he modelled portrait medallions, including one of Nelson, framed with similar jewels applied from brightly coloured enamel set in gold. The flowers painted on the reverse of this cup show how Baxter could tackle any subject with equal accomplishment. The factory name on the bottom and title of Sappho in neat upper-case writing on this cup belong also to the hand of Thomas Baxter, who always titled his subjects in black.[6] The simple classical shape appealed to his artistry and would originally have come with a matching saucer-like stand. Similar jewelled cups by Baxter are known with portraits of King George III and the Duke of Wellington, but to this artist Emma remained his greatest heroine and lost love.

1. Anne Carson, *If Not, Winter: Fragments of Sappho* (New York: Alfred A. Knopf, 2002), 27.
2. For example, when artist Angelica Kauffman painted actress and poet Mary Robinson's portrait the artist titled it *The British Sappho*. Gill Perry, '"The British Sappho": Borrowed Identities and the Representation of Women Artists in late Eighteenth-Century British Art', *Oxford Art Journal* 18, no. 1 (1995), pp. 44-57.
3. J.T. Herbert Baily, *The Life of Lady Hamilton*, opp. p. 48.
4. An album of sketches drawn by Thomas Baxter at Merton is preserved in the National Maritime Museum.
5. John Sandon, *The Regency Decorators of Worcester*, International Ceramics Fair and Seminar Handbook, 1991.
6. An identical portrait of Sappho, titled in black, was painted by Thomas Baxter on one of a pair of Flight, Barr and Barr cabinet cups from the Howells Collection, sold by Bonhams 9 March 2005, lot 219. The companion cup titled 'Saint Cecilia' also probably depicted Emma Hamilton.

82. Visiting Card Tray

Size: 21.8cm (8⅞in.) diameter
Date: c.1835
Mark: Full printed Flight, Barr and Barr mark and script title 'Superb Lily'
Museum Purchase through the Ewers Acquisition Fund, 1978.4.5

Dainty porcelain baskets with carrying handles had a very specific function in homes where status was taken very seriously. Paying calls and leaving calling cards at residences cemented social relationships while at the same time distinguishing class. Guests would announce their arrival by placing their calling card on the card tray sitting on a table in the hallway. The butler or another member of staff would then convey the card on its basket to the lady or gentleman of the house. Calling cards could also be displayed as a point of pride, along with invitations to a ball or other prestigious social events. In the novel *Vanity Fair*, written in 1847-8, the wily governess Becky Sharp attempts to impress her guests with her rising status by placing the Marchioness of Steyne's and Countess of Gaunt's cards in 'a conspicuous place in the china bowl on the drawing-room table, where Becky kept the cards of her visitors'.[1]

Flight, Barr and Barr favoured this shape during the 1830s. The shallow dish is raised upon three gilded paw feet and a twisted handle arches over the top. The basket is very thinly cast and the handle feels delicate, and so one hopes that the handle was used more for decoration than for actually carrying the basket around the house.[2] When Flight, Barr and Barr merged with Chamberlains in 1840, this shape continued in production for at least another decade.[3] The interior is moulded with a border of overlapping leaves radiating to the rim and enamelled with a bright green ground. A gold zigzag separates the leaves from the central image, a grand orange lily with stems and buds.

Identified on the reverse, the flower is the Superb Lily, a native plant of the Eastern United States. Images of this flower were published in two influential botanical source books. Many china factories owned copies of *Curtis's Botanical Magazine*, a monthly journal that provided an inexpensive source of floral images. The illustrations in Robert John Thornton's *Temple of Flora* (published as a book in 1807) were far more decorative, placing the plants in garden settings. Books of botanical illustrations were readily available at this time and served as design sources for many ceramic decorators. (See the Chamberlain botanical tureens, catalogue no. 107.)

1. William Makepeace Thackeray, *Vanity Fair: a novel without a hero*, intro. by Joanna Trollope, 1st ed., NY, Random House, 2001. page 507.
2. Henry Sandon, *Flight and Barr Worcester Porcelain*, pl. 168, shows another example painted with a subject from literature.

3. Geoffrey Godden, *Chamberlain-Worcester Porcelain*, p. 231, records the production of 'card racks' in the 1820s. He also illustrates as pl. 201 a basket of this form dating from 1840-1850.

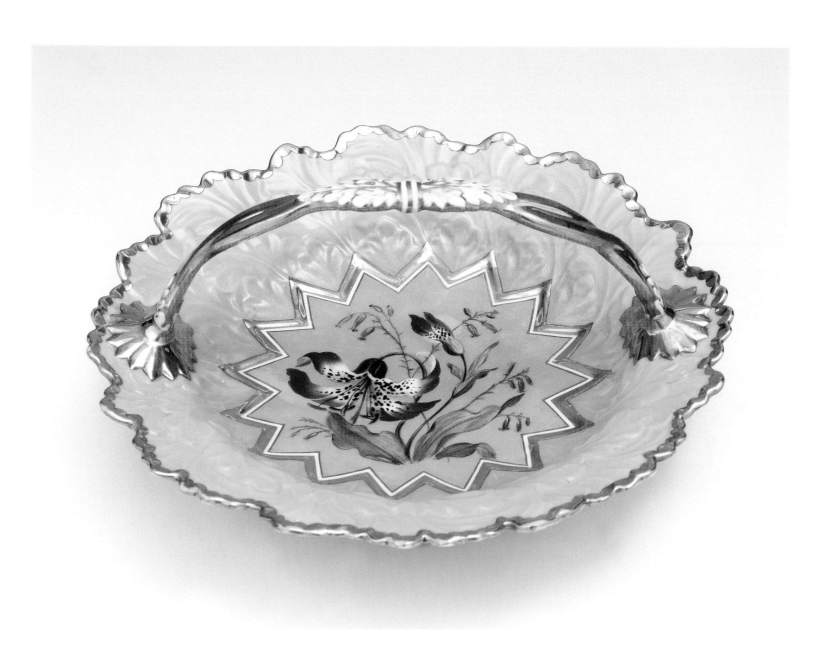

83. Pastille Burner in the Shape of a Cottage

Size: 15.8cm (6¼in.) high
Date: c.1835-40
Marks: Full Flight, Barr and Barr mark in script painted inside
Gift of Dr. and Mrs. Robert W. Quinn, 1988.27

Before the construction of enclosed sewers, most cities suffered from appalling sanitation. Open sewers emptied directly into the rivers and at times the stench was simply unbearable. Even within gentrified homes there was no central plumbing or refrigeration and this meant everyday odours posed a strong concern for homeowners. Pastille was one option for masking smells. Sweet smelling resins were combined with different plants and gum tragacanth to make a dry paste which could be shaped into a cone around a rudimentary wick. When lit, the pastille smouldered and issued a perfumed smoke much like burning incense. Household inventories from at least the seventeenth century record containers for pastille in Great Britain. The burners came in various shapes and materials including brass, silver, earthenware and porcelain.[1]

In the first half of the nineteenth century several British factories turned out pastille burners designed as rustic cottages with working chimneys to release the smoke. The idea was to remind city dwellers of the pleasing air of the countryside. The earliest date from around 1810-20, made from Staffordshire earthenware known as pearlware, and are shaped as a half-timbered cottage with a thatched roof and central chimney. By the 1830s the fashion for porcelain cottages became widespread. The advantage was that they could also serve as a nightlight, the glow from the burning candle shining softly though the windows. Most were made by small china factories in Staffordshire and the makers cannot be identified. The principal china factories of England generally avoided such frivolities, but a few examples show that cottage pastille burners were made by Spode, Coalport and Samuel Alcock and Company.[2]

Chamberlains in Worcester made at least four different models, the first recorded as early as 1813. One particularly elaborate Chamberlain version was listed as a 'Swiss Cottage' in 1829.[3] Flight, Barr and Barr's only

known cottage shape was larger than most other markers and relatively plain in general outline. The rectangular house has gothic windows and a neat thatched roof with tiny gable windows. The cottage originally sat upon a mounded base, which mimicked a lawn, but this base is sadly missing. Three examples have been recorded where the roof is painted to simulate thatch, while the Cheekwood cottage is the only one known with a gilded edge around a white roof. A cottage garden of painted flowers, including hollyhocks and a rosebush, frames the doors and windows. This use of hand painting is unusual, for cottages from most other factories were encrusted with modelled flowers.

Dainty cottage pastille burners were very much part of the new fashion inspired by Dresden that swept through the English porcelain industry in the 1820s-30s. This new rococo taste is typified by the name 'Coalbrookdale' used by the Coalport factory for their flower-encrusted porcelain. For some reason Flight, Barr and Barr chose to ignore the Dresden or Coalbrookdale style completely and stuck instead to traditional classical themes.

1. Donald L. Fennimore. *Metalwork in Early America: Copper and Its Alloys. from the Winterthur Collection.* Winterthur, DE: Winterthur Museum, 1996. p. 348.

2. See Robert Devereux. 'English Porcelain Pastille Burners: Cottages, Castles, Churches and others', pp 187-196, E.C.C. *Transactions,* Vol. 16, Part 2, 1997.
3. Geoffrey Godden, *Chamberlain-Worcester Porcelain,* pp. 272-3.

84. Inkstand

Size: 27.5cm (10⅞in.) long
Date: c.1825-30
Mark: Full Flight, Barr and Barr mark painted in script with titles 'Worcester' and 'Malvern'
Museum Purchase through the Ewers Acquisition Fund, 1978.4.3

A functional object for use on a desk, this is also a highly decorative ornament and a souvenir of a visit to Worcester. One panel is painted with a view of the city, showing Worcester Cathedral and the River Severn. It is interesting to notice how the painter has cheated and bent the perspective around so that the background shows the church spire of St. Andrew's and the outline of Flight, Barr and Barr's china factory, not normally visible from this side of the cathedral. The other panel shows the nearby spa town of Malvern, where visitors would go to drink and bathe in the pure water that springs from the Malvern Hills.

This inkstand was made around 1830 and is one of the few instances where the firm has attempted to produce something that is modern. The classical patterns and shapes favoured by Flight, Barr and Barr didn't blend naturally with the gentle, feminine style of the rococo revival. The scrollwork cartouches framing the painted scenes are slightly rococo and the feet have gentle scroll moulding, but that is about as far as it goes. The inkwells are shaped like classical urns and a mask head on the handle is decidedly Roman. The gilded 'gadroon' rim takes inspiration from classic architecture and silver from a century before. Flights' interpretation of the rococo revival was never more than half-hearted. The bright lime green colour and the painted insects reflect, in a way, the new Continental taste that by this time had impacted on so much art and design in England. The designers at Flight, Barr and Barr must have seen the very different porcelain Coalport, Minton and Rockingham were making at this time, as well as Chamberlains and Graingers in their own city of Worcester. Clearly they felt that they knew their customers and Flights kept on making the classical designs they had always relied upon. R.W. Binns, writing his history of the factories in 1865, gives an explanation for their actions. Flights seriously believed that the British Government was going to appoint a national china factory along the lines of Sèvres, Meissen or Berlin. For this reason they believed every production should be manufactured to the highest standards of workmanship and expense. Flight, Barr and Barr followed these ideals instead of following popular fashion. Most collectors of their porcelain today are rather glad they did.

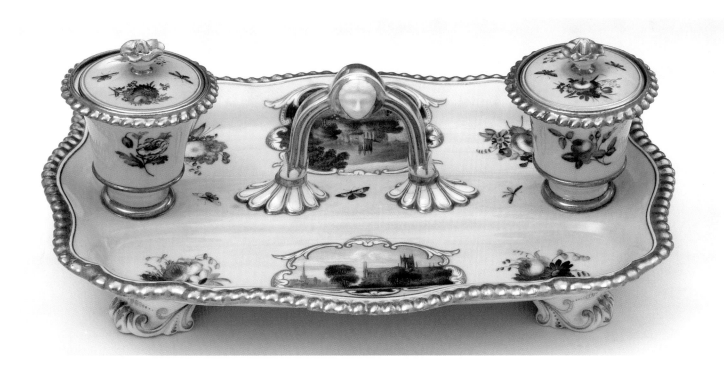

85. Shell-shaped Dessert Dish

Size: 20.2cm (8in.) wide
Date: c.1825-35
Mark: impressed FBB and crown
Gift of Mrs. William J. Tyne, 1990.10.4

The Puller family ordered at least two surviving services from the Flight, Barr and Barr factory. This scalloped dish was part of the dessert service. It bears the family crest, a falcon with a laurel branch standing on a cap, within a salmon border covered in gold vermicelli. Favoured by the Worcester factories, *vermiculé* or vermicelli gilding takes its name from the pasta which shapes itself into similar squiggly lines.[1] A design first used in Paris, this pattern was simple to execute and is likely to have been the work of apprentice gilders. The second service made for the Pullers, a dinner service, also bears the family crest and a salmon coloured border but lacks the extra gilding.

Both services were probably made between 1825 and 1835, but they do illustrate the difficulty in dating Barr, Flight and Barr porcelain. Their classical shapes remained in production for a long time and, while other factories moved with fashion and introduced new fancy, rococo forms during the 1830s, Flights were still making the same basic shapes and patterns in 1840 that they had made a quarter of a century earlier. Sir Christopher Puller was born in 1774 and became Chief Justice of Bengal. When he died in 1824 his son, Christopher William Giles Puller (1807-1864), inherited the family estates. This inheritance could have spurred the commissioning of new household goods and so the set may date from 1824. It is more likely, however, that the set was ordered in 1831 when Christopher Puller married Emily Blake. The set would have appeared somewhat old-fashioned in England during the reign of William IV, but Flight, Barr and Barr stuck rigidly to their old styles and their porcelain no doubt appealed to customers who liked tradition.[2]

1. For information on the use of vermicelli gilding see John Sandon, *Dictionary of Worcester Porcelain*, p. 354.

2. Other shapes from the service, including an ice pail, are illustrated by Henry Sandon, *Flight and Barr Worcester Porcelain*, pl. 176.

86. Pair of Oval Dessert Dishes

Size: 30.9cm (12⅛in.) long
Date: c.1825-35
Mark: FBB and crown mark
Museum Purchase through the Ewers Acquisition Fund, 1978.1.21ab

Worcester's fine old 'Fancy Birds' remained a popular device well into the Flight, Barr and Barr period. On this pair of dishes from a dessert service, like their 18th century counterparts the birds still wear bright plumage but now they reside in more realistic landscapes and stand on firmer earth.[1] This style came to be called 'Davis's Birds' after the man believed to develop them.

Solomon Cole, reminiscing about the old factory, talked about two painters of 'Fancy Birds', George Davis and Charles Stinton. Solomon noted: 'George Davis, usually called Dr. Davis, added his brilliant colouring in the rich plumage of his birds'.[2] Davis worked at the Chamberlain factory from its inception, and had previously worked for Thomas Flight. The earliest porcelain strongly believed to be his work dates from c.1780.[3] When the Chamberlains set up on their own in Worcester, George Davis accompanied them. The Chamberlain archives reveal that he was highly paid as a painter, and was referred to as 'Mr. Davis' suggesting he may have led the painting department. Numerous Chamberlain pattern descriptions refer to Davis by name, further strengthening his assumed leadership position.[4] The records of Davis' career with Chamberlains contains gaps, however, when it is believed that he worked for the rival firm of Flight, Barr and Barr and as an independent decorator.

'Dr. Davis' perfected the 'Fancy Bird' painting style, but he was not the only artist to execute it. Solomon Cole mentioned Charles Stinton at Flight, Barr and Barr also working in the same vein. Stinton was part of the remarkable family of painters that worked for generations as decorators at Worcester. Unfortunately, Charles Stinton did not leave any signed pieces so the extent of his work cannot yet be identified. Furthermore, other junior painters are likely to have completed this work since 'Fancy Birds' were popular and in high demand. As a result, the 'Fancy Birds' painted on the Cheekwood dishes cannot be definitely attributed to a single painter.

The remainder of the decoration on these dishes was the work of the gilding department. Golden tendrils spread towards the central image on each dish and, like the vermicelli design seen on catalogue no. 85, this pattern of gold weed was easy to execute and an effective means of covering larger, plain areas. Called 'seaweed gilding' today, this gold pattern enjoyed widespread popularity among factories from around 1800 to 1840. Named *rich gold sprayage* at Flight, Barr and Barr, the Chamberlains called it *gold bramble* while at Derby this was listed with the unbecoming name *dead spray*.[5]

1. Three pieces from a similar service are recorded illustrated by Henry Sandon, *Flight and Barr*, p. 150.
2. Memoir of Solomon Cole, told to William Chaffers, *Marks and Monograms on Pottery and Porcelain*.
3. See John Sandon and Simon Spero, *Worcester Porcelain, the Zorensky Collection*, fig. 368.
4. For information on George Davis' career at Chamberlains, see Geoffrey Godden, *Chamberlain-Worcester Porcelain*, pp. 192-4.
5. Catherine Beth Lippert. *18th century English Porcelain in the Indianapolis Museum of Art*, 1987, pp 247.

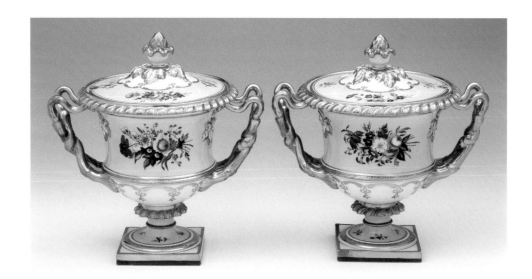

87. Pair of Dessert Tureens and Covers

Size: 22.5cm (8⅞in.) high
Date: c.1830
Marks: Impressed FBB and crowns
Gift of the Horticultural Society of Middle Tennessee, 1988.8

Around 1771 a monumental Roman marble vase surfaced in an archaeological excavation at Tivoli, near Hadrian's Villa. Sir William Hamilton, the eminent collector and British diplomat, exported the vase from Italy to England and placed it in the collection of his nephew, the Earl of Warwick. The vase was regarded as an exemplary specimen of Roman art and its image appeared in many publications on antiquities, making it instantly recognisable. Smaller copies in stone, bronze or silver appeared everywhere and in due course the shape of the Warwick vase influenced a whole generation of designers.

Few china makers copied the shape of the Warwick vase exactly, for the masks and trophies ornamenting the original were far from elegant.[1] Instead, the basic campana form of the body and the entwined handles were adapted to form vases, tureens, icepails and wine coolers, the shape issued with or without lids according to function and fashion. Some factories such as Coalport included a modelled border of vines, loosely based on the Roman original. Flight, Barr and Barr had always favoured plain classical shapes and felt the vines were superfluous.

Flights' plain Warwick Vase shape first appeared around 1815, for in the Worcester Porcelain Museum is a relatively small version painted by Thomas Baxter.[2] This open-topped vase is raised on a somewhat incongruous pedestal with moulded columns. A few years later Flight, Barr and Barr re-modelled their standard dessert service to incorporate the fashion for fancy gadrooned rims. They took the Warwick Vase form for the tureens and ice pails, replacing the rim modelling with the gadroon pattern seen here. The shape continued in production until the 1830s and icepails of this form were included in the service made for King William IV. The company also produced the same basic body shape with less elaborate, rams' head handles set on the lower body only.[3]

The Cheekwood pair could easily be mistaken for purely ornamental vases. Their function is revealed by the recesses in the lids to accommodate a ladle, for one would have served sugar and the other cream. The square plinths replaced the need for a separate stand that usually accompanied tureens from dessert services. The painting of flowers on a green ground will have matched the rest of the service. Painting directly on top of an enamel ground colour was a difficult process. Like so much Flight, Barr and Barr porcelain, in terms of technical achievement these tureens cannot be faulted.

1. The Chamberlain factory made the Warwick vase complete with modelled heads and vines. See Geoffrey Godden, *Chamberlain-Worcester Porcelain*, pl. 295.

2. Illustrated by Henry Sandon, *Flight and Barr Worcester Porcelain*, pl. 110. Baxter was at the factory only between 1814-16.
3. See Henry Sandon, *op. cit.*, pl. 123.

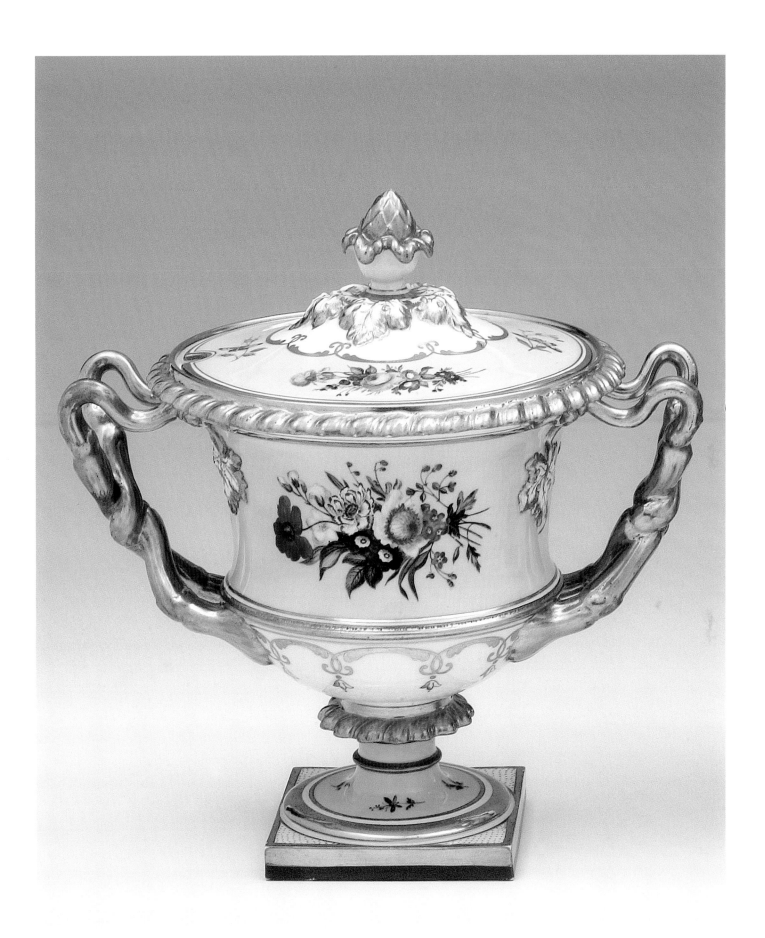

THE CHAMBERLAINS AND THE GRAINGERS

Robert Chamberlain was apprenticed as a 'pot painter' at the very start of the Worcester factory, probably in 1752-53. His son Humphrey followed in his father's footsteps and by the 1780s the two Chamberlains were the most senior decorators. All other painters and gilders at the factory worked under Humphrey and Robert Chamberlain's immediate direction. Following the sale of the factory to Thomas Flight, the Chamberlains took advantage of the situation and set up their own, break-away business. They initially decorated Flight's porcelain as before but then in 1788 they moved to new premises and took all their decorators with them. To rub salt in Flight's wounds, the Chamberlains even took over Flight's old shop at 33 High Street, Worcester. They were refurbishing the premises in August 1788 when King George III and Queen Charlotte paid an unexpected visit.

The Chamberlains started out buying 'blank' undecorated white ware from Worcester's rivals at Caughley, but by 1791 the Chamberlains were producing their own porcelain. They employed former colleagues to help them, people like John Toulouse, a veteran modeller from Worcester who had worked at Bow at least thirty years before. Decoration inevitably followed Worcester traditions, especially rich-looking Japanese and Chinese patterns such as 'Dragon in Compartments' and 'Finger and Thumb', seen on a full tea service at Cheekwood. These colourful patterns proved popular and profitable.

The Chinese dominance of the armorial porcelain market was coming to an end and the Chamberlains saw a huge opportunity. Chamberlain's soon became a well-known name in this niche market, their reputation fuelled by some special customers. Lord Nelson visited the Chamberlain factory in 1802 and ordered a set of 'Japan' pattern tableware all with his coat of arms. Sadly Nelson died at Trafalgar before the set was completed but it brought fame to the maker. In 1815 another naval hero, Sir James Yeo, ordered an even more extensive set with his crest and motto. Both Commodore Yeo and Nelson chose border patterns from stock. Other customers bought sets with their own family crests within the same popular border patterns.

With a shop in Worcester Chamberlain's supplied a local market with souvenirs painted with views of the city. Outlets in other spa towns and resorts forwarded orders to Worcester. Many original Chamberlain factory order books survive in the Worcester Porcelain Museum and these help identify some of these special commissions. A presentation loving cup at Cheekwood combines a painted view of Oxford with an imaginary coat of arms, two specialties of the Chamberlain factory and a great piece of social history.

These factory archives provide background information on an inkwell in the Cheekwood collection made for the Marquis of Abergavenny. This is painted by Humphrey Chamberlain junior, the son of Humphrey Chamberlain, the factory owner. The younger Humphrey was aged twenty-two in 1813 when he worked on the Abergavenny service, the factory's most important single commission. Humphrey junior's brother Walter was also a painter as well as manager of the Chamberlain factory during more difficult times in the 1830s. Changing markets and competition in Worcester brought economic hardship and forced the two great rivals of Chamberlain's and Flight, Barr and Barr to merge. In 1840 they formed a single factory trading as Chamberlain and Company.

Just as the Chamberlains had left the employment of Flight's factory to set up on their own, a separate porcelain manufactory in Worcester was established by two Chamberlain painters. Thomas Grainger was taken on as an apprentice by his uncle, Robert Chamberlain, in 1798. Soon after completing his apprenticeship in 1805, Thomas Grainger left to set up his own factory in partnership with John Wood. Production probably began in 1806. Grainger's copied many productions from their two main Worcester rivals but, instead of targeting the luxury end of the market, Grainger's preferred to compete with Coalport and other porcelain makers in Staffordshire for a share of the popular tea and dinner set market. This policy worked, for the Grainger factory survived for longer than either Flight's or Chamberlain's. Grainger's factory was bought by Royal Worcester in 1889 and finally closed in 1902.

Opposite: Plate. See catalogue no. 97.

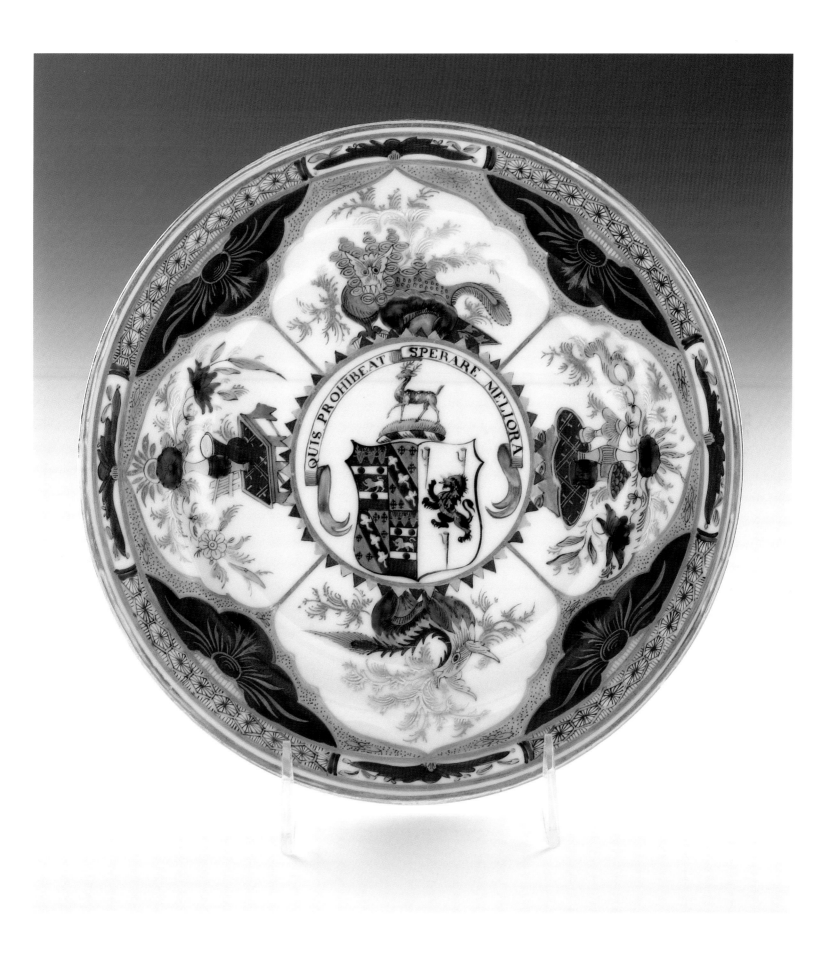

88. Dessert Tureen, Cover and Stand

Size: the stand 21.5cm (8½in.) long
Date: c.1795-1800
Mark: none
Gift of Michael Ryan King in memory of Susan Ivie Davis, 2006.1

Most products of a porcelain factory conform to its own house style and can be identified on stylistic grounds even without a maker's mark. The shape of this tureen matches others supplied with marked Chamberlain services and in this case no other manufacturer is known to have made this shape. The appearance of the body and glaze is consistent with other Chamberlain porcelain of the period, and so there is not any doubt as to the attribution. The decoration, however, is quite unlike other known Chamberlain tablewares of the period, which means it was either a special commission or, more likely, was made as a 'matching' for an existing service made elsewhere. Matchings, or replacements, were an important part of a porcelain factory's output. In the case of this tureen, the appearance of the border pattern and the starburst surround to the gilded cipher panels suggest that Chamberlains have made a matching for a Chinese export porcelain service made just a few years previously.

In the Victoria and Albert Museum are two Chinese porcelain 'pattern plates' dating from c.1790 and bearing the name of the Canton merchant Synchong.[1] Each plate shows four different border designs and the shapes of two different cartouches containing initials drawn in gold as ciphers. The border designs are individually numbered. Plates like these were used by china dealers in England or possibly in the United States. Customers would select their favourite border and cartouche and their order would be sent to Synchong together with a drawing of their desired family cipher. Many months later, the completed service would arrive on a trading ship from Canton and the owner would proudly take delivery of a personalised dinner set. Border no. 21 on one of Synchong's pattern plates is very similar to the design on this Chamberlain tureen.

If the customer had an accident and broke part of their precious set, or even if some pieces were damaged on the journey from Canton, there was not a lot they could do about it. To get a replacement piece painted in China would take a great deal of time. It was easier to commission an English china factory to make a copy. A number of makers specialised in such matchings, the Derby and Spode factories in particular. Occasional entries in the Chamberlain order books mention patterns produced to copy samples provided by the customer. The identity of the family with the initials HH is not known, but their Chamberlain tureen would have matched the rest of their Chinese porcelain service almost exactly. Chamberlains have purposely used a soft, thin kind of gold for the border, so as to match the appearance of the gold on the Chinese original. The shape is Chamberlains' own, however. It is possible the original Chinese dinner service did not contain dessert tureens and the family simply wanted to upgrade to the latest fashion and ordered Chamberlain dessert wares to match.

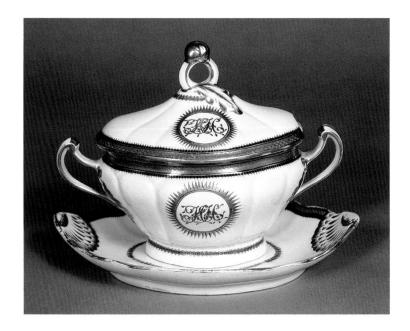

1. Illustrated by Geoffrey Godden, *Oriental Export Market Porcelain*, pl. 21.

89. Chocolate Cup, Cover and Stand

Size:12.5cm (4¹⁵⁄₁₆in.) high
Date: c.1805
Mark: Chamberlains Worces'r Warran'd 263 painted in purple
Museum Purchase through the Ewers Acquisition Fund, 1983.10.6

Chocolate was a luxurious beverage and was served in a specially designed cup with a lid. Chocolate was made with hot milk, mixed and heated on a stove, unlike tea which was normally served and drunk at the tea table. As teacups were filled from a teapot and the beverage drunk straight away, the cups did not require a cover to keep the contents hot. Chocolate cups, on the other hand, were often filled in the kitchen and needed to be carried through the house to their recipients. A wide saucer-like stand allowed the servants a firm grip, while a tightly fitting cover kept the chocolate hot and prevented spillage.

Elaborate covered chocolate cups developed on the Continent and became popular in England around 1770. They did not accompany normal tea and coffee sets and today most survive just as single items or as pairs. Significantly, you find very few chocolate cups in blue and white, for the drink was only served in homes that could afford the extravagance of chocolate. This rich example was made at the Chamberlain factory and the Chamberlain account books of the time provide further evidence that chocolate cups were generally decorative rather than utilitarian objects. Most were sold as a single object or as a pair, and they often bore expensive decoration such as finely painted views or figure subjects.[1] In more formal patterns they seem to have been sold as sets and when Nelson ordered his extensive 'Japan' pattern breakfast set in 1802 it included six chocolate cups of this form, although with plain bodies rather than with spiral or 'shanked' moulding as seen here.

The pattern number, 263, is recorded in the factory pattern list as 'India blue, red & gold'. China makers were confused by the origins of much Oriental porcelain and it is difficult to classify the terminology they used. The presence of underglaze blue, red and gold means this is primarily an 'Imari' design, although the added green could determine this as a 'Japan' pattern.[2] The pattern is actually derived from a Chinese original which was itself inspired by 'Old Japan'. It is of a type known to Oriental collectors as a 'Pseudo Tobacco Leaf' pattern, for the overall effect conjures up images of a well-known Chinese Export pattern called 'Tobacco Leaf'. Chamberlains possibly copied their pattern 263 from the New Hall porcelain factory where a very similar pattern was made. At Chamberlains this pattern was also available for tea, dessert and dinner services. The factory mark underneath the lid includes the abbreviated word 'Warranted'. This simply means that the porcelain was warranted not to crack when used with hot drinks such as chocolate.

1. Geoffrey Godden, *Chamberlain-Worcester Porcelain*, pp. 233-234. Godden shows a similar 'shanked' shape although with different handles and saucer rim.

2. See catalogue nos. 62 and 78 for information on Worcester 'Japan' patterns.

90. Beaker or Tumbler

Size: 8.8cm (3⁹⁄₁₆in.) high
Date: c.1800-05
Mark: None
Museum Purchase through the Ewers Acquisition Fund, 1988.11.7

Small tapering cups, also called tumblers, could be both utilitarian and decorative objects. The Chamberlain account books show that these were sold according to capacity, for they are listed in quarter-pint, half-pint and pint sizes. Tumblers were decorated with all manner of painted subjects, ranging from classical figures to animals and landscape views.[1] Small tumblers were usually sold as pairs and were often accompanied by a matching jug. This tumbler has a rich yellow ground covering half of the surface, while the remainder is taken up with a painted view of Worcester from the south-west. This tumbler would probably have been sold in Chamberlains' china shop in Worcester High Street, where local views would have found a ready market.

Painted in black *en grisaille*, the cathedral is viewed from across the River Severn. A number of small boats on the river show a curious failure in perspective, however. Chamberlains employed painters of widely differing abilities, and for some mass-produced local souvenirs the highest quality painting was not all that important. It is interesting to compare the view on this beaker with another Worcester souvenir, the Flight, Barr and Barr inkstand, catalogue no. 84. The view on the beaker is from the other side of the river and so the background correctly shows the spire of St Andrew's church. However, the Chamberlain painter has deliberately omitted the frontage of Flight and Barr's china factory, which would be clearly visible from this angle.

1. Geoffrey Godden, *Chamberlain-Worcester Porcelain*, pp. 290-291. In pl. 376, Godden illustrates another tumbler painted with the same view.

91. Teapot, Cover and Stand

Size: 18.4cm (7¼in.) high, 25cm (9⅞in.) maximum length
Date: c.1803-05
Mark: None
Gift of Dr. and Mrs. Robert W. Quinn, 1988.18

Some customers believed in getting value for their money. Spending a huge sum on a teaset, they expected every inch to be crammed with decoration, and this is certainly the case here. The owner's family crest, complete with their initials, nestles in a band of painted flowers. Around the border is a formal gilded pattern and a rich orange ground is smothered with further intricate gilding. If the primary purpose of a new tea service was to impress your guests, this full teaset must have taken their breath away.

Around 1803-06 Chamberlains introduced a new form of oval teapot which they called *Dejeune* shape.[1] This elegant shape was based on a smaller version designed as part of a cabaret or déjeuner set on a tray. The teapot has a domed lid, a pronounced shoulder and a slight belly near the base. The clip handle shape is unique to the factory, while the spout has a fluted base derived from repoussé fluting used on silver teapots. The flower painting is unlike most other Worcester floral decoration. The individual, finely painted garden flowers resemble paintings by William Billingsley on Derby and Pinxton porcelain, suggesting that the artist responsible for this teapot was aware of the work of Billingsley and may previously have worked alongside him. When this teapot was made, Billingsley was struggling with

his failing porcelain venture at Torksey or working on his own as an independent decorator at Mansfield. In July 1799 Billingsley had purchased a small amount of white Chamberlain porcelain which would have been decorated at Mansfield. As this teapot is unmarked, there is a very slight possibility that it was painted in Billingsley's workshop. Tempting though this theory is, the gilding links to other Chamberlain porcelain decorated at Worcester so it is far more likely that this was painted by a Chamberlain decorator who had seen the work of Billingsley.

The crest appears in the centre of the stand, on both sides of the teapot and on the lid. Each crest is painted above a gold monogram JMM. The crest – a Moor's head in profile rising from a ducal coronet – may be that of the Moore family, the Earls of Drogheda. Chinese export mugs and jugs with the family's full coat of arms and the initials JM survive from c.1780.[2] The initials have not been linked to any senior member of the Moore family at that time. Charles Moore, 6th Earl Drogheda, married Lady Anne Seymour in 1766, but their son did not bear the initial M. The monogram could belong to one of their four unidentified daughters, or another candidate is a cousin descended from a younger son of the 1st Viscount Drogheda. John Moore of Drumbanagher, Co. Antrim, married Mary Stewart in November 1781 and their initials may constitute the gold JMM.

1. Geoffrey Godden, *Chamberlain-Worcester Porcelain*, p.113.

2. See David Sanctuary Howard, *Chinese Armorial Porcelain*, 1974, p.632.

92. Tray from a Cabaret

Size: 41.8cm (16½in.) wide
Date: c.1795
Mark: impressed letter T
Gift of Mr. and Mrs. Reese L. Smith, 1984.1

This tray illustrates most graphically how far the Chamberlain factory had progressed within just a few years of their first porcelain production. In terms of artistic design it is quite amazing. The shape and decoration looks to the Continent and mirrors the finest achievements of Meissen, Vienna or Paris. Beautiful flowers are painted *en grisaille* or in other words in delicate shades of grey. These flowers may be in monochrome, but they are rendered with complete botanical accuracy. They are as real as any growing in the botanical gardens at Cheekwood. In contrast to the delicate shading, every leaf and petal has been outlined against a ground of solid, burnished gold. In a proud reserve in the middle of the tray is the cipher and coronet of the original owner.

The initials are hard to transcribe and sadly there is no surviving record or family history to identify for whom this was made. At this time Chamberlains had three main competitors for the top end of the porcelain market in England: Flight and Barr, Derby and Pinxton. The latter two specialised in making cabaret sets. Four or five years previously the Derby factory had made a cabaret painted by William Billingsley with coloured flowers on a gold ground[1] and to date no Worcester porcelain had come close to matching such workmanship or artistic brilliance.

Soon after they began to make their own porcelain, Chamberlains engaged an experienced modeller who had previously worked at Worcester twenty years before. John Toulouse was responsible for the figures of Turks at Cheekwood (catalogue no. 44). The Chamberlain archives show that during the 1790s Toulouse worked as a potter at Chamberlains during the day and earned considerable overtime as a modeller.[2] It is likely he created the mould for this tray and he was also responsible for casting this example, as scratched on the reverse is his personal mark of a letter T. This would originally have formed the base of a 'déjeuner' or cabaret set, with a matching teapot, sucrier, jug and two cups and saucers. The teapot was probably the same shape as the richly decorated example, catalogue no. 91 in this catalogue. In April 1794 Chamberlains supplied Lady Hurd with a costly déjeuner and their estimate lists the tray as costing more than all the other pieces added together.[3]

Solid gold grounds were naturally costly. The practice of using gold in this way originated at Augsburg around 1720 and thereafter enriched some of the finest Meissen and other Continental porcelain. In England Chelsea used gold as a background for flower painting around 1765 and this decoration was revived at Derby. Early in the 19th century solid gold grounds occur on Coalport flower-painted services, the gilding possibly added in London. Solid gold grounds were used very rarely at Worcester. Gold is, of course, prone to wear and such lavish decoration was impractical on porcelain that was likely to be used regularly. This cabaret was made to show off the wealth of its original owner and was probably kept locked away in a display cabinet or even in its own fitted box. As a result the gold is not rubbed at all and this makes it all the more remarkable.

1. See Anthony Hoyte, The Charles Norman Collection, supplementary catalogue, pp. 66-67.
2. Geoffrey Godden, *Chamberlain-Worcester Porcelain*, pp. 208-9, discusses at length the career of John Toulouse and weighs up the evidence from the Chamberlain archives.
3. Geoffrey Godden, *op. cit.*, p. 238.

93. Tea and Coffee Service

Sizes:
Teapot, cover and stand, the teapot 18.4cm (7¼in.) high
Sugar box and cover, 14.4cm (5¹¹⁄₁₆in.) diameter.
Milk jug, 14.1cm (5⅝in.) high. Slop bowl, 19.7cm (7¾in.) diameter
Bread and butter plate, 19.7cm (5¾in.) diameter
Six teacups, coffee cups, and saucers, the saucers 13.8cm (5⅜in.) diameter
Date: c.1802-05
Mark: inscribed in gold under the sucrier lid 'Chamberlains Worcester No 276',
some cups and saucers with 276 in red or puce enamel
Gift of Mrs. William J. Tyne, 1992.14.1-14

In the archives of the Chamberlain factory pattern number 276 is listed as 'India, Thumb and Finger'.[1] Little imagination is needed to see why the decorators at the Worcester factory chose to call this design 'Thumb and Finger'. The pattern is known on Chinese export porcelain from the late 18th century, one of a series of rich designs made in China to copy 'Old Japan'.[2] What is far from clear is the meaning to the Chinese of the dark blue shapes that make up this distinctive feature within the design. Are these rocks or tree roots, maybe, from which springs the luscious vegetation?

The pattern was bold but easy to execute, and the decorative effect was stunning. It could be sold for a high price, and it was therefore a profitable pattern for the Chamberlain factory who sold many teasets, dessert services and even full dinner sets.[3] Rival factories such as Coalport and Spode made the pattern also, although it is impossible to tell which factory made it first.

The basic composition of a complete tea and coffee set or 'equipage' remained unchanged from the 18th through to the 19th centuries. Cheekwood's partial service numbers twenty-four pieces: teapot with cover and stand, sugar box with cover, milk jug, slop bowl, bread and butter plate, six teacups, six coffee cups, and six saucers. A basic service from Chamberlains would originally have included two plates for bread and butter and probably twelve each of the teacups and saucers. Matching saucers for the six (or sometimes twelve) coffee cups were not considered necessary since it was assumed a household would never serve coffee and tea at the same time. Similarly it was assumed a well-to-do family would own a silver coffee pot, for porcelain coffee pots very rarely survive with sets of this kind.

By the early 19th century it became usual for some of the major porcelain manufacturers to mark their products with their name underneath the base. The Chamberlains were proud of their porcelain teasets and wanted their customers, and, more importantly, their customers' guests, to know who made the chinaware they were enjoying. Instead of writing their name underneath the bases, where they would not be seen, Chamberlains marked their teasets only on the insides of the lids of the teapot and sugar box. As each guest lifted the lid of this sugar box to help themselves to the sugar, the name 'Chamberlains Worcester' was revealed for all to see.

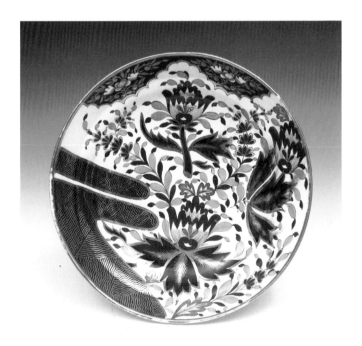

1. The full pattern list is quoted by Geoffrey Godden, *Chamberlain-Worcester Porcelain.*
2. See catalogue nos. 66 and 78 in this catalogue where the terms 'India' and 'Japan' are discussed.

3. See Geoffrey Godden, *op cit,* p. 111 and John Sandon, *Dictionary of Worcester Porcelain,* pp. 158-9.

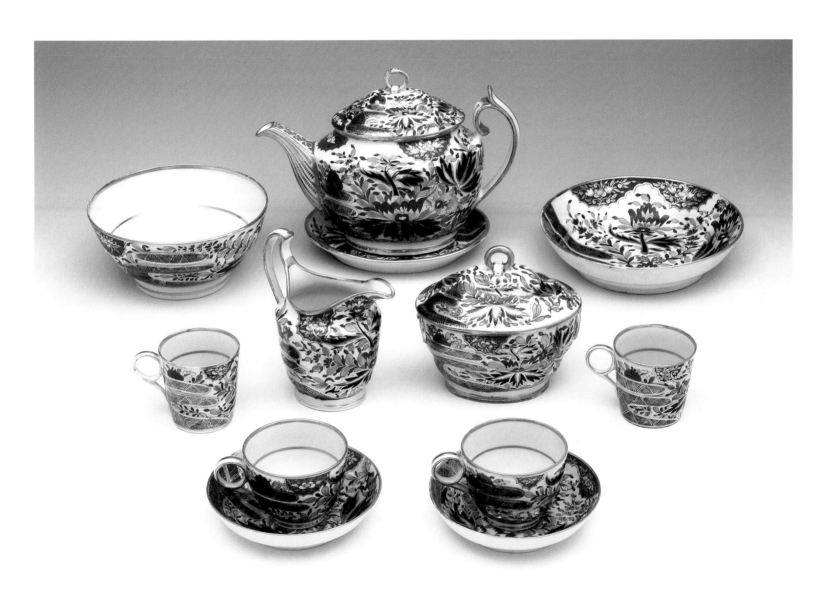

94. Pen Tray

Size: 30.8cm (12⅛in.) long
Date: c.1812-14
Mark: Full Chamberlains mark including royal patronage painted in neat script
Gift of Ms. Estelle Shook Tyne in honour of her mother, Mrs. William J. Tyne, 1993.25

Chamberlains
Worcester
Manufacturers to their
Royal Highnesses
The
Prince of Wales
&
Duke of Cumberland

A pen tray was a most elegant object to place on your writing desk. In the 18th century, and into the Regency period, most inkwells included holes into which quill pens were somewhat precariously placed. Separate pen trays would seem to have been a natural progression, but the idea never really caught on and all examples in English porcelain are rare. Instead the pen tray eventually became an integral part of many fancy inkstands (see the Flight, Barr and Barr example, catalogue no. 84).

Two basic forms of Chamberlain pen trays are recorded. One was a slightly awkward shape with an opening at one end from which the quill protruded. The other was on a grand scale with eagle handles in the finest Etruscan or classical style. Quill pens were made from a single feather. Chamberlains clearly felt that painted feathers were therefore a most appropriate subject, for a number of pen trays are known with this most desirable decoration. The factory order books include the sale in February 1813 of '1 Pentray, grey ground, feathers and gold bead, £2.2s.0d.¹ At a cost of two guineas this was indeed a luxury item. The example at Cheekwood was probably identical with its pebble gilding and gold bead pattern border, apart from an orange ground instead of grey.

This orange ground is Chamberlains' version of the ground colour now known as 'Barr's Orange', used by their rivals Barr, Flight and Barr. A pair of Flights' jardinières (catalogue no. 76) also combines this colour with feather painting. Comparison shows that, although Chamberlains' feather decoration was perfectly competent, Flights' feather painting was generally superior in detail and delicacy. At Chamberlains the records show that feather painting was in use as early as 1807,² whereas Flights probably introduced the decoration a year or two earlier.

It is necessary to look closely at the mark on this pen tray to realise that Chamberlains' name and details are hand painted rather than printed. Beautifully written with a pen, this mark lists the names of the Prince of Wales and the Duke of Cumberland. The Prince's brother, the Duke of Cumberland, ordered a major service from Chamberlains in 1806, the year before the Prince of Wales honoured the firm with a visit. In the interests of self-promotion, the firm chose to celebrate this patronage for many years to come. Flights had been granted a royal warrant from George III and Queen Charlotte and claimed to be china makers to Their Majesties and the Royal Family. The rivalry between the King and the Prince of Wales was almost as fierce as the rivalry between the two Worcester factories. In due course, Flight, Barr and Barr were also able to add the patronage of the Prince of Wales to their factory marks (see catalogue no. 78).

1. Geoffrey Godden, *Chamberlain-Worcester Porcelain*, p. 274.

2. Geoffrey Godden, *op. cit.*, p. 179.

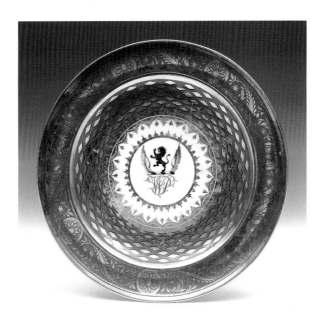

95. Small Plate

Size: 18.4cm (7⅛in.) diameter
Date: c.1800-05
Mark: Chamberlains Worcester in purple script
Gift of Mr. Robert Woolley in honour of Mrs. William J. Tyne, 1988.31.5

Chamberlains produced some of the finest gilded English porcelain. For this lavish service made for the Pierrepont family, the central roundel is the only spot of white left on the plate. It bears the painted crest of a black lion between two wings with the monogram WP in gold. The crest identifies the family, and while the Pierrepont surname was shared by the Dukes of Kingston, it has not been possible to identify the original owner any further.

While one might suppose that such an exuberant design would be unique, two other armorial services are know utilising exactly the same pattern.[1] We can therefore conclude that the Pierreponts chose this design after looking through pattern plates displayed in a china shop. At this time Chamberlains did not have their own London premises but instead used an agent, Asser and Co. in Covent Garden, where a wide range of their porcelain was proudly displayed.[2] Customers would choose from sample plates which would be labelled with the price of a whole service. Generally this meant the more gold used the more expensive was the service.

The pattern selected for this service uses a background of deep orange, which was highly fashionable at the time. A radiating pattern of graduated gold diamonds serves to focus the eye on the central crest. These diamonds were first drawn in red enamel on top of the background and then individually shaded in pure gold. Around the border of the plate a highly-skilled gilder has drawn a pattern of classical leaf scrolls and stars alternating with formal paterae. The result shows how gold alone could construct a multifaceted design, as long as every component was to scale and perfectly in line. It is incredible to realise that the decorators did not use any kind of printed or stencilled outline. Instead the gilder drew the pattern individually on every plate using a compass and dividers, along with a special tool for marking out segments of equal size on a circular plan.[3]

The Chamberlain family had headed the gilding department at the Flight factory before leaving to form their own company. It is not clear how many gilders were employed, as they were listed under the forty-seven painters.[4] We do know that by 1800 Chamberlains employed sixteen young women as burnishers. Their job was to polish every precious inch of gold and leave it gleaming. Nothing short of the very best finish would satisfy the firm's wealthy clients.

1. Geoffrey Godden, *Chamberlain-Worcester Porcelain,* pp. 87 and 90 illustrates two armorial services with the same decoration.
2. R.W. Binns, *A Century of Potting in the City of Worcester,* p. 151.
3. The portrait of Thomas Baxter in the Victoria and Albert Museum shows him holding such a tool.
4. Geoffrey Godden, *op. cit.,* p.73.

96. Square Dessert Dish

Size: 20.8cm (8⅛in.) wide
Date: 1815-19
Mark: Printed Chamberlain's Regent China mark
Museum Purchase through the Ewers Acquisition Fund, 1978.9.1a

During a brief moment of peace in 1815, Royal Navy Commodore Sir James Lucas Yeo ordered a breakfast, tea and dessert service from the Chamberlain factory. He selected from stock the popular border pattern number 298 which had been one of Chamberlains' staple products for more than a decade. The porcelain was to be the new pure white 'Regent China' body. The dark blue border included panels of 'Japan' style flowers and ornate gilding. To this pattern was to be added Yeo's personal crest, painted within the insignia of the Order of the Bath complete with the Order's motto, 'Tria Juncta in Uno'. The cost of hand painting these crests on every piece was greater than the cost of the rest of the decoration and gilding put together.[1]

The Commodore wanted this very special porcelain service to celebrate his achievements in the service of his country. Born the son of a navy victualling agent, James Yeo entered the Royal Navy at the age of ten in 1792. He served

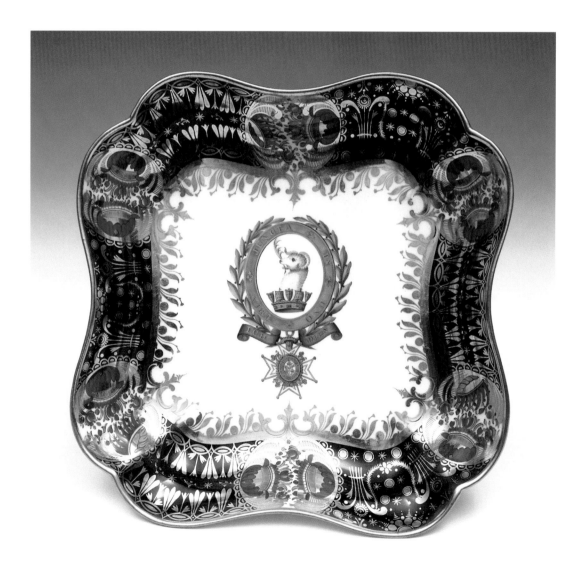

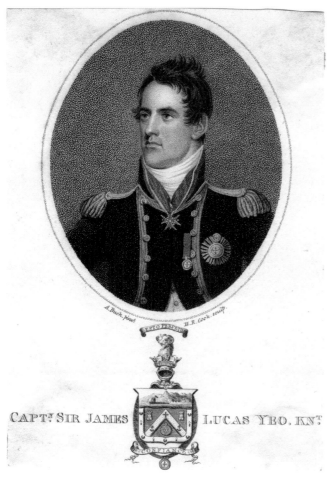

Sir James Lucas Yeo by Henry R. Cook after Adam Buck, stipple engraving, published 1810.

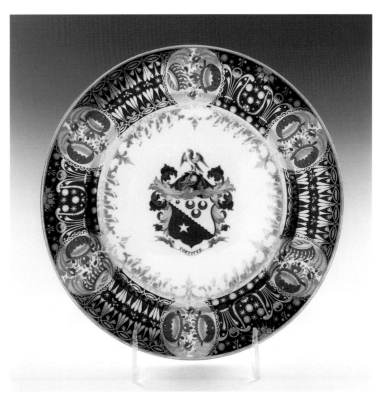

A Chamberlain plate also in the collection at Cheekwood uses the same border pattern, no. 298, as the Sir James Yeo set. Instead it bears arms attributed to the Turner family.

Gift of Michael Ryan King in honour of Dr. and Mrs. E. William Ewers 2004.2

with distinction in the wars against France and earned the post of commander by the age of twenty-one. In 1809, while patrolling the coast of Brazil, Yeo joined with Portuguese forces to defeat French privateers off the island of Cayenne. This action resulted in the surrender of French Guiana, the last French colony in South America. In gratitude, the Prince Regent of Portugal appointed Yeo as a Knight of the Order of San Bento d'Aviz and when Yeo returned to England King George III elevated him as a Knight Commander of the Order of the Bath with a grant of his own coat of arms.[2] The arms, the crest of which appears on this service, incorporated the medal of the Order of Bath into the design.

With the outbreak of war with the United States in 1812, Sir James Yeo took command of the naval forces on the Great Lakes. After peace was declared in 1814 he returned to England and it was at this time, in 1815, that Yeo placed his order with Chamberlains. Later the same year he embarked on a new assignment to oppose the slave trade off the coast of West Africa. While working in Jamaica he contracted fever and died on 21 August 1818 on the return voyage to England. Although the order had been placed three years before, Sir James was never able to dine off his lavish porcelain. The complexity of the design meant that at the time of Yeo's death the Chamberlain service was still unfinished. The Worcester factory finally completed the order in 1820 and sent their invoice to his estate.

1. For the full order and other information see Geoffrey Godden, *Chamberlain-Worcester Porcelain*, p. 117.

2. Robert Malcomson, *Lords of the Lake: The Naval War on Lake Ontario, 1812-1814*, Annapolis MD: Naval Institute Press, 1998, pp. 115-118.

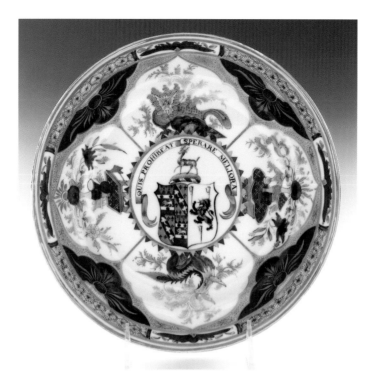

97. Plate

Size: 24.1cm (9½in.) diameter
Date: 1796-97
Mark: None
Gift of Michael Ryan King in memory of Mrs. William J. Tyne 2004.1

To celebrate their marriage at St. Marylebone on 24 October 1796, Thomas Parker and Elizabeth Palmer commissioned a fabulous dinner service bearing their conjoined coats of arms. The wealth that paid for such a set came from the wife's side of the family, for Thomas John Parker was merely a tenant at Canbury House in Kingston, Surrey. In great contrast, Elizabeth Peters Washington Palmer had grown up in the magnificent Whitton Place in Middlesex, her family's lifestyle financed by plantation interests in the West Indies.[1]

The arms of Parker impaling Palmer appear in the centre of every piece of an extensive dinner service from the Chamberlain factory. The pattern chosen was one of the most extravagant designs of the day. Listed in the Chamberlain archives merely as 'Dragon in Compartments', this pattern had started life on Chinese porcelain during the Kangxi period more than seventy years before. A copy of a *famille verte* design of c.1720, the pattern was first used at Worcester around 1768-70. Subsequently both the Flight and Chamberlain factories used the design extensively, as did Coalport and many

other English makers. Indeed, the popularity of the pattern resulted in a most curious situation. Around 1800 Chinese decorators in Canton re-introduced the pattern, copied from English porcelain which was itself copying an old Chinese design.

It is hard to interpret the meaning of the fantastic beasts that appear in two of the panels around the border of this plate. Neither are strictly dragons, and the alternative name of 'Kylin' pattern sometimes given to this design is probably closer to the old Chinese imagery. Although many factories used the pattern at different times, Chamberlains seem to have favoured it the most, using the most splendid colours in their particular rendition. In view of the pattern's popularity, it is surprising in a way that relatively few families chose to add their armorials to sets of 'Dragon in Compartments'. Perhaps they felt that the overpowering border took away from the importance of the coat of arms. Thomas Parker's place in society was greatly enhanced by his marriage and so he had no such reservations in choosing the most outrageous pattern to reflect his new-found status.[2]

1. Several pieces of Chamberlain porcelain are known painted with views of Whitton Place.

2. Sixty-two pieces of the service were sold by a descendant at Phillips London on 5 and 6 June 1991, lots 547-565.

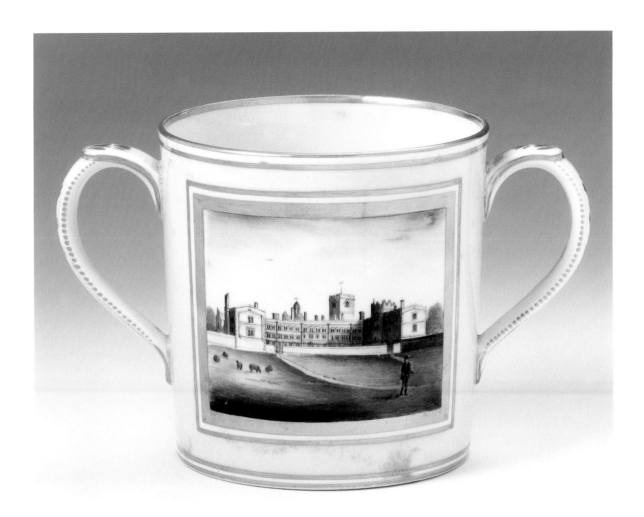

98. Two Handled Mug or Loving Cup

Size: 18.3cm (7⅛in.) high, 11.6cm (4½in.) diameter
Date: December 1809-February 1810
Mark: Chamberlain's Worcester
Museum purchase through the bequest of Anita Bevill McMichael Stallworth, 1992.23

This amazing souvenir tells the story of three friends at college and their enjoyment of fine punch. No piece of porcelain at Cheekwood is better documented, for the original order for this mug survives in the Chamberlain factory archives. Commissioned in December 1809, this cup bears an imaginary coat of arms dedicated to the drinking of punch. On the reverse, a view of Jesus College, Cambridge is painted *en grisaille*.

The imaginary coat of arms celebrates the most popular mixed drink at the time. A traditional Indian drink, punch had been introduced to Britain by returning sea captains in the mid-seventeenth century. Derived from the Hindi word *panch* meaning five, punch calls for five ingredients: rum or brandy; water or green tea, sugar, spice, and citrus juice. Each gentleman had his own recipe and the ingredients changed according to taste and pocketbook. The shield here shows a porcelain punch bowl flanked with rum and brandy bottles and topped with three lemons. Above the shield, the crest is an arm toasting a glass, while the motto 'Another and Another Yet' calls for two more bowls full of punch. For supporters, Cupid represents love and the infant Bacchus celebrates drinking. The Bacchic boy sits atop a cask of arrack.

This costly Indian spirit made from the fermented sap of palms was the basis of most fine punch recipes. The arrack cask bears the initials of the college, JCC, as a golden cipher. Beneath all of this, a further motto dedicates the scene to 'Le Ponche et Les Dames' (Punch and Women).

The Chamberlain order book for Boxing Day, 26 December 1809, records a somewhat complex order for three fine porcelain mugs:[1]

> Edward Hibgame, Esq, Jesus College Cambridge
> '1 Mug 2 Handles with Yellow ground & Gold border Caricature Arms on one Side & Jesus College on the other, price at 31/6.
> Rev. H W Hill, Stone near Kidderminster
> 1 Mug, same as dlittol, ordered by Mr Charles Hill, Dennis House near Stourbridge, by 6th February
> Mr C Hill, Dennis House, nr. Stourbridge
> 1 Mug 1 handle yellow gnd. & view of Jesus College in front ... view to be sent

Research has been able to identify the three men referred to in the factory order book.[2]

Edward Hibgame had arrived at Jesus College on 18 May 1793 as an ordinary student, studying under Mr. Plampin and Mr. Newton. He received his Bachelor's degree in 1798 and after gaining his Master's degree in 1801 he remained at the college as a Fellow. Hibgame was ordained as a deacon in 1814 and as a priest in 1815, finally leaving the college in 1831 to take over the parish of Fordham

Charles and Henry Hill were the sons of Thomas Hill, Esq. of Dennis Park, Old Swinford near Stourbridge in Worcestershire. Charles was privately educated before he went to Jesus College on 19 February 1805. He was a Fellow-Commoner, which meant that because his family could afford to pay higher fees he was allowed to dine with the Fellows at high table. Charles studied with Dr. Clarke, Mr.Caldwell and Mr. Brooke.

His brother, Henry William Hill, was also born at Dennis Park and educated in Stourbridge. He studied first at Worcester College, Oxford, before his admittance to Jesus College, Cambridge, on 24 November 1804. He subsequently entered the priesthood and was already working as a rector at Stone when his brother placed the order with Chamberlains at the end of 1809. The Reverend H.W. Hill subsequently served as rector of Rock, Worcestershire, from 1812 until his death on 4 April 1840.

The Hill brothers may have been studying theology in training for the priesthood, but this did not stop them enjoying college life to the full. The Cambridge colleges were notorious for their drinking clubs where the sons of gentlemen would drink fine wine and punch rather than ale and cider. It was perfectly natural for masters and fellows at the colleges to socialise with the students. No doubt Mr Hibgame drained many punchbowls with the young Hills, and it was probably during a lively drinking session that one of them sketched the idea for this imaginary coat of arms.

Completed in little over a month, the costly mugs were possibly used by their recipients in February 1810 at a celebratory drinking session at the college. It is not known if this cup belonged to Henry Hill or Edward Hibgame. The use of these mugs may have set a precedent for future students, as another Chamberlain mug with the same view, this time with a white ground rather than a yellow ground, remains at Jesus College, given by a former member in 1991. The view of the college is copied from a print by R. Harraden, but the decorator at Chamberlains copied the image incorrectly, depicting the buildings as stone rather than as brick. The paintings of Cupid and the Infant Bacchus are particularly accomplished and are probably the work of Humphrey Chamberlain Jnr. Aged just eighteen when this mug was ordered, he was already acknowledged as the company's finest figure painter; indeed, two years earlier he had proved himself by painting the historical figures on a fruit set made for the Prince Regent. In 1814 Humphrey Chamberlain returned to the theme of Cupids for the panel on Lord Nevill's inkstand, catalogue no. 100.

1. Chamberlain's Order Book, 1808-1819, p. 44. This is preserved in the Museum of Worcester Porcelain.

2. Dr. Frances Willmoth, the Archivist at Jesus College, Cambridge, has provided much valuable information, based on notes compiled by Arthur Gray, a former Master of the college.

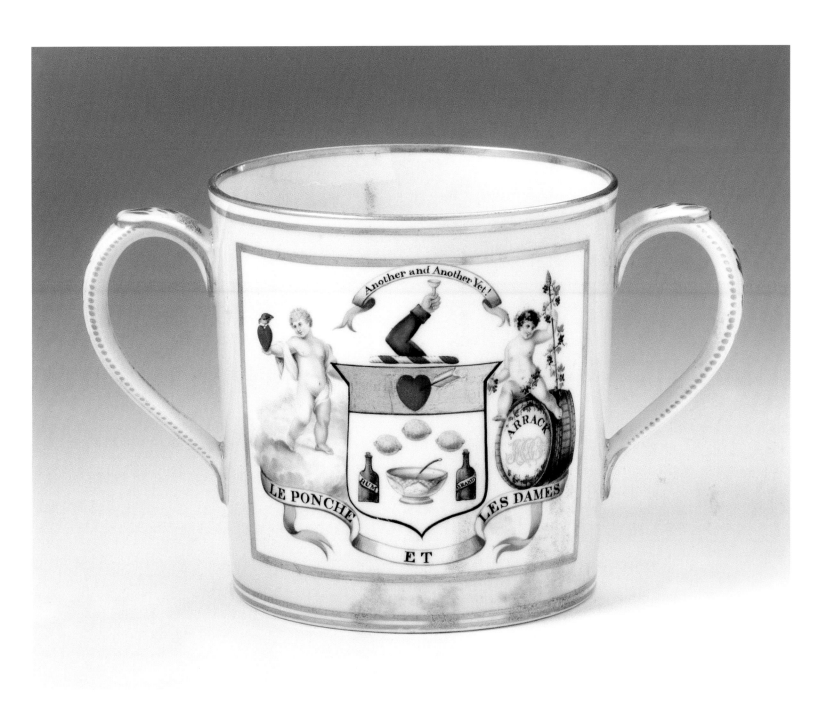

99. Platter with armorial decoration

Size: 36.4cm (14⅜in.) wide
Date: c.1806-13
Marks: Chamberlains Worcester, poorly written in red script
Gift of Dr. and Mrs. Roland Lamb, 1981.7.1

The British Army in Egypt by Anthony Cardon, after Philip James de Loutherbourg, stipple engraving, published 1806. This image of senior British officers includes Sir John Doyle.

©NATIONAL PORTRAIT GALLERY, LONDON

Sir John Doyle, fourth son of an Irish gentleman, enjoyed a distinguished military career that took him from the forests of South Carolina to the deserts of Egypt. In 1801 a British expeditionary force of 17,000 men landed in Egypt, under the leadership of General Sir Ralph Abercromby.[1] A veteran of the American Revolution and other Continental campaigns, Doyle was in command of the 87th Regiment of the Royal Irish. Their duty was to oust a branch of Napoleon's army that had controlled Egypt since 1798 and threatened British interests in the Middle East and India. Victories came swiftly and the British forces soon accepted the surrender of the French. For his distinguished service in the campaign Doyle, who had volunteered for this duty, was made a baronet in 1805. With the baronetcy, Doyle received permission to add soldiers as supporters to his coat of arms, as well as an extra crest of a horseman.[2]

To celebrate his elevation to the baronetcy and the granting of his new arms, Doyle commissioned a dinner service from Chamberlains in Worcester. From entries in the factory account books, it would appear the set was ordered in 1806 but not invoiced until 1814.[3] Sir John Doyle's new, full coats of arms were to be painted on every piece of the dinnerware within what was appropriately described as an 'Etruscan border'. In addition a tea and coffee set was ordered, just with crests and wreaths. The order included four platters each of 25.4cm (10in.), 30.5cm (12in.) and 35.6cm (14in.). This platter measures just over 35.6cm (14in.) wide and represents Doyle's greatest adventure. Two soldiers in full uniform serve as supporters on either side of the shield. One soldier clasps a French flag with LYBIA and EGYPT written upon it. Beneath the arms the Latin motto on the ribbon intones 'Fortitudine Vincit' or 'He conquers by fortitude'.

1. Michael Clodfelter. *Warfare and Armed Conflicts: A Statistical Reference to Casualty and Other Figures, 1500-2000.* 2nd ed. Jefferson, NC and London: McFarland & Co., Inc., 2002, p. 115.

2. *The Times*, 14 August 1834, p. 3 col. D. Death of Sir John Doyle (obituary).
3 In the Chamberlain's factory books from 1808-1819 there is an entry copied from an older 1806 book for Lieutenant General Sir John Doyle. The order was invoiced on 6 May 1814.

159

100. Inkstand

Size: 21.8cm (8½in.) maximum width, 12.3cm (4¹³⁄₁₆in.) high overall
Date: 1813-14
Mark: Chamberlains Worcester painted beneath a coronet
Museum Purchase through the Ewers Acquisition Fund with matching funds from the bequest of Anita Bevill
McMichael Stallworth, 1990.7

On 28 July 1814 a Chamberlain employee neatly recorded the extensive list of porcelain shipped to Lord Nevill, Marquis of Abergavenny.[1] The order had taken much longer than the original four months requested by the customer in June 1813.[2] Chamberlains' decorators had spent a whole year completing one of their most lavish commissions — an armorial breakfast, dinner, and dessert service, every piece with a rich orange ground and fabulous gilding. In addition, the Abergavenny crest of a bull's head was painted on every piece.

Lord Nevill also ordered ten additional rich ornamental objects to be painted by the factory's best painter. These were meant to complement the tableware, but at the same time these pieces represent a leap into another dimension in terms of ceramic achievement. A set of seven vases, a pair of massive 'Grace' mugs and this inkstand, were all to have pale orange grounds with large blank spaces to serve as canvases for Humphrey Chamberlain's paintings. The son of Humphrey Chamberlain, Snr. and the nephew of Robert Chamberlain, Humphrey Jnr. had started to paint at a young age and exhibited extraordinary skill.[3] His

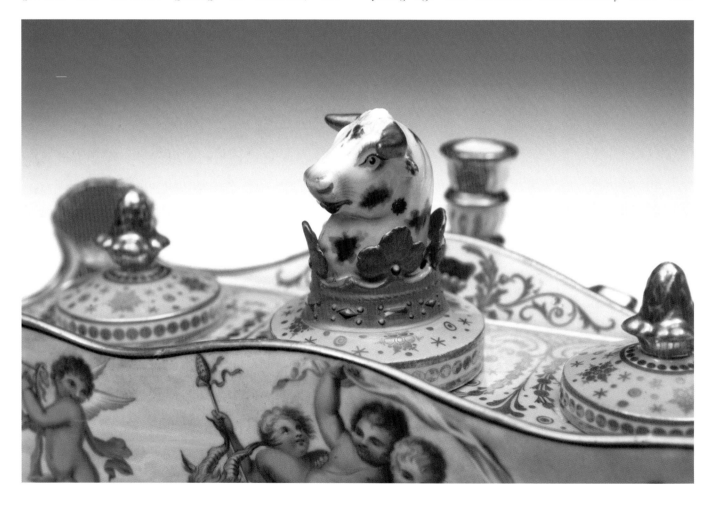

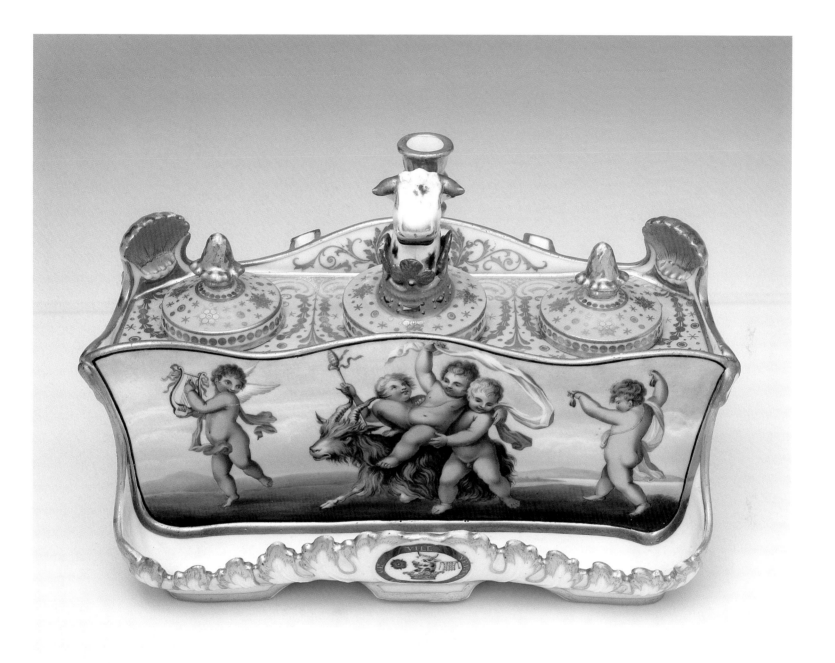

technique was very unusual in the field of English china painting. Humphrey Jnr. used the 'oil and dust' method to apply a fine powdered ceramic colour. Delicately shaded colour adhered to the oil resulting in a remarkable smooth texture without any evidence of brushstrokes.

Lord Nevill chose the subjects he wanted painted on his 'ornaments'. A set of seven vases, in graduated sizes, were to be painted with scenes from Shakespeare's plays.[4] A

pair of mugs with classical allegories titled 'The Power of Love' and 'Bacchante' were extraordinarily expensive at £42.[5] The 'figures' chosen for the inkstand were putti taken from Roman mythology. Five small children and a goat dance across its front; the first child plucks a harp and the last child rings finger cymbals; two other children support a third child balancing on the goat's back. This musical celebration honours Bacchus, the Roman god of wine, for one putto holds a symbolic staff called a thyrsus,

an emblem associated with the god and his followers. Putti and goats appeared in artists' renditions of Bacchic festivals from antiquity to the eighteenth century.

The inkstand itself is also an achievement of the modeller. The undulating surfaces form a complex outline that sweeps the eye around the piece. Three inkwells with covers sit in the stand. Usually the finials on the covers of inkwells are purely functional knops allowing the lids to be lifted. The central well on Lord Nevill's inkstand is surmounted by something far more decorative and significant – a modelled bull's head. This miniature sculpture is the Marquis' family crest, rising from a gilded coronet. The original order in the Chamberlain factory account books includes a charge of three guineas for 'moddels [sic] for Crest'. This creative use of the Nevill coat of arms has precedents in silver where wealthy families had their armorial supporters and crests adapted as handles and finials on special commissions. In addition to this inkstand, this modelled bull's head was used also on the covers of the tureens in Lord Nevill's Chamberlain dinner service.[6] This touch shows that no expense was spared on this important commission.

Left. The original entry in the Chamberlain factory account books listing the porcelain ordered by Lord Viscount Nevill from the Chamberlain archives preserved at the Museum of Worcester Porcelain. IMAGE COURTESY OF BONHAMS

Opposite, above. A soup tureen from Lord Nevill's dinner service. Note the crest of a bull used as the finial on the cover, matching the inkstand at Cheekwood (sold at Bonhams 6 June 2007).
IMAGE COURTESY OF BONHAMS

Opposite, below. Two views of the central vase from the 'Rich Set of Regent Ornaments' that formed part of the Abergavenny order in July 1814. The painting by Humphrey Chamberlain Junior is a Scene from Shakespeare's *Henry VIII*.
IMAGE COURTESY OF BONHAMS

1. The original order is reproduced by John Sandon, *Dictionary of Worcester Porcelain*, p. 247.
2. Discussed by Geoffrey Godden, *Chamberlain-Worcester Porcelain*, pp. 101-102.
3. John Sandon, *op. cit.*, pp. 98-99. See also catalogue no. 98.
4. For the central vase see Geoffrey Godden, *op. cit.*, col. pl. 8. This was sold by Bonhams 7 June 2006. A pair of smaller beaker vases are in an English private collection.
5. Now in the Worcester Porcelain Museum, illustrated by Geoffrey Godden, *op. cit.*, pl. 332.
6. Sold by Bonhams 6 June 2007, illustrated here for comparison.

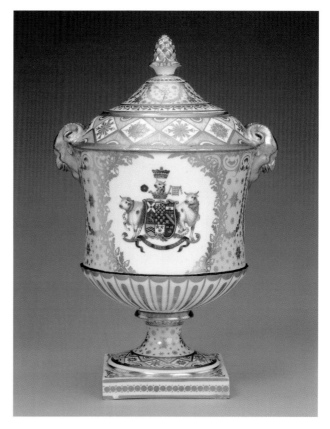

163

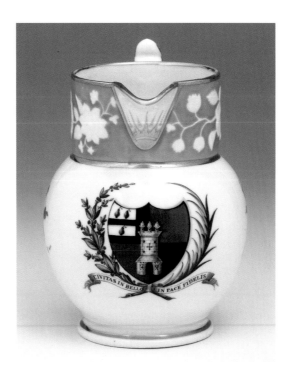

101. Jug with the Worcester Civic Arms

Size: 13.7cm (7in.) high
Date: c.1815-20
Mark: none
Museum Purchase through the bequest of Anita Bevill McMichael Stallworth 1994.2

This Chamberlain jug is decorated with the arms of the Corporation and the City of Worcester. It is unlikely to be a mere souvenir of a visit to the city and was probably for civic use, although sadly there is no record of the original order. The Latin motto included in these arms translates as 'Citizens faithful in war and peace'. Worcester had earned its reputation as the 'Faithful City' for its support of the King during the English Civil War. The first porcelain jugs produced at Worcester for the City Corporation were made in 1757 and these are still housed in the city's Guildhall.[1] This Chamberlain jug is less elaborate, but was still made with plenty of civic pride.

This jug is made from Chamberlains' 'Regent China' body. Named after the Prince Regent, this fine, glassy porcelain is beautifully white and durable, for the body and glaze were fired together at a high temperature. One unfortunate disadvantage of this manufacturing technique was that the glaze hides much of the moulded detail. The flower sprays embossed on both sides of the neck of this jug are indistinct and only stand out because of the use of a blue background. The combination of white relief decoration and a blue ground had become famous because of Josiah Wedgwood's jasperware but, whereas Wedgwood and other potters applied white sprigged decoration on top of a blue stoneware ground, the Worcester porcelain version used on this jug was made by moulding the flowers and background all in one. A finely ground powder of cobalt oxide was mixed either with water or sticky oil and painted around the outline of the moulded flowers. This cobalt powder reacted with the glaze, turning blue with only slight running or smudging.

Chamberlain archives show that the 'Emboss'd' decoration was popular from around 1812. The version used on this jug occurs on standard tea and dessert services.[2] An alternative moulded border of 'Union' sprigs was made a year or two later, embossed with roses, thistles and shamrock, the emblems of the Union of the British isles.[3] The moulded flowers and the rose and anemone painted on the sides of this jug do not relate to the city of Worcester and are just decorative instead.

1. Discussed by John Sandon, *Dictionary of Worcester Porcelain*, p. 118.
2. Geoffrey Godden, *Chamberlain-Worcester Porcelain*, pp. 113-116 and pls. 132-133.
3. Godden, *op. cit.*, p. 116 and pls. 131 and 155.

102. Painted plate

Size: 21.4cm (8⅜in.) diameter
Date: c.1818-19
Mark: printed factory mark within a crowned wreath, including New Bond Street address, also painted title 'Czarina and Maria' very neatly written in red
Museum Purchase through the bequest of Anita Bevill McMichael Stallworth, 1993.9

The Reverend William B. Daniel published his three volumes entitled *Rural Sports* after 1801. Illustrated by artist John Scott, the books outlined the history and practice of country sport in England. The set proved very popular and was reissued in a number of other editions. The Chamberlain factory in Worcester owned a set of *Rural Sports* and used this as the source for painted subjects on their porcelain. In 1814, for example, Thomas Box of Buckingham ordered four mugs decorated with 'Fox & Terrier', 'Brown & White Pointer', 'Setter & Black Grouse' and 'Greyhounds'.[1] These titles relate to engraved plates in Daniel's books. The use of this influential source book is confirmed by the inscription on the back of this plate, and other mentions of the name *Rural Sports* in Chamberlains' record books.[2]

The Chamberlain factory frequently drew upon the illustrations in *Rural Sports* as a source for sporting subjects.[3] One example is this Cheekwood plate painted with two greyhounds and inscribed on the reverse 'Czarina and Maria'. The Revd. Daniel devoted chapters to dogs where he reviewed their ancient history, their habits and their great loyalty. He sprinkled historical and wondrous tales of dogs throughout the book. Daniel discussed greyhounds in relevance to the sport of coursing. Coursing, 'an amusement much in vogue', showed the amazing speed of the dogs by sending two after a hare. Rightly outlawed today as a cruel bloodsport, at the time the emphasis was more on the chase than the death of the hare. Among famous English dogs Daniel retold the story of Czarina and Maria, two hounds from the same distinguished bloodline. Czarina 'ran forty-seven matches in Norfolk and Yorkshire with uninterrupted success'. Her eight puppies later became acclaimed racers themselves.[4]

The plate may have formed part of a dessert service, each plate or dish painted with a different scene from *Rural Sports*. It is more likely, however, in view of the unusually thick and heavy potting, that it was simply a 'cabinet plate', a single specimen of fine workmanship to be displayed by a collector or by a sportsman. This scene of Czarina and Maria was a popular choice of the Chamberlain painters. It appears on the lid of a Chamberlain snuff box now in the Museum of Worcester Porcelain and in July 1818 Chamberlains sold '1 Quart jug, fine painting, Greyhounds running, vide Daniels-Rural sports £3.3s.0d'.[5]

1. Worcester Archives, Chamberlain's, London Order Book, 1814-1822, entry for 12 November 1814.
2. Chamberlain's, London Order Book, 17 August 1817, an order for H. Cornwall, Esq. '1 Quart jug Fox & Terrier rural sports vide Daniels, 3-3-0; 1 do. "Fox & Hound" do.'
3. For more examples from *Rural Sports* used on other ceramics see J.C. Holdaway, 'The Influence of 18th Century Naturalists in Ceramic Decoration', E.C.C. *Transactions*, Vol. 12, Part 1, 1984, pp. 1-5.
4. William Barker Daniel, *Rural Sports*, Vol. I., London: Longman, Rees & Orme, 1807, p. 395. For more on the use of sporting subjects see Tim Holdaway, 'The Sporting Magazine as a Source of Ceramic Design', E.C.C. *Transactions* Vol. 17, Part 2, 2000, pp. 303-311.
5. Chamberlain archives, quoted by Geoffrey Godden, *Chamberlain-Worcester Porcelain*, p. 258.

103. Large Vase and Cover

Size: 40.3cm (16in.) high
Date: c.1820-30
Mark: Chamberlains Worcester and New Bond Street address in red script painted inside cover
Gift of Mr. and Mrs. Rufus Fort, Jr. in memory of Dr. and Mrs. Rufus Fort, Sr. through funds provided
by exchange 2004.14

This most impressive vase provides an interesting contrast between the two Worcester rivals. Classical shapes dominated the products of both factories, Flight, Barr and Barr in particular. Chamberlains didn't produce as great a variety of vase shapes, but at times could be just as ambitious. On this vase the modelling of the griffin handles and the applied ring of simulated pearls around the neck rim show clearly the influence of Flights. These features also illustrate how Chamberlains could achieve almost the same quality as Flights when it really tried. The detail of the leaf moulding around the shoulder, however, is not as accomplished as Flights' would have been. Also the formal gilded decoration is not nearly as precise as seen on the best Flight factory wares. Finally, it is the control of the ground colour that lets this vase down. Misfiring has caused kiln specks and blackening, mainly around the marbled foot, a manufacturing defect that Flight, Barr and Barr would simply never have allowed. In spite of these minor criticisms, this Chamberlain vase is still a fabulous piece of porcelain, epitomising English Regency taste.

The Chamberlain factory archives record the introduction of this shape.[1] Vases were normally referred to as 'ornaments' and in 1814 the factory sold '2 new shape ornaments, griffin handles'. Griffins were mythical beasts which were part eagle, part snake and part lion (see catalogue no. 70). The handles on this vase do indeed combine a bird's head and wings with the neck of a snake,

although it is understandable that in another Chamberlain order book written in the same year a different description was used. '1 new ornament 15 inches. Dragon head, maroon & gold, with flowers all round' sold for twelve guineas, a considerable sum at the time.

This example has a finely painted flower panel on both sides and two smaller panels in between. The painting is similar to a style of flower painting on Flight, Barr and Barr around 1815 which can be identified as the work of Thomas Baxter.[2] After a period spent painting at Swansea, Baxter returned to Worcester in July 1819 and worked at Chamberlains for two years until his death in 1821. During this period he supervised the painting department at Chamberlains and is known to have painted flowers.[3] This vase could possibly be by Thomas Baxter, or else by an artist who was trained by this very gifted teacher.

1. Extracts from the Chamberlain records quoted by Geoffrey Godden, *Chamberlain-Worcester Porcelain*, p. 299.
2. See a vase illustrated by John Sandon, *Dictionary of Worcester Porcelain*, p. 47 and a signed mug illustrated *by Henry Sandon, Flight and Barr Worcester Porcelain*, pl. 94.

3. Baxter's career at Chamberlains is discussed by Geoffrey Godden, *op. cit.*, pp. 185-186.

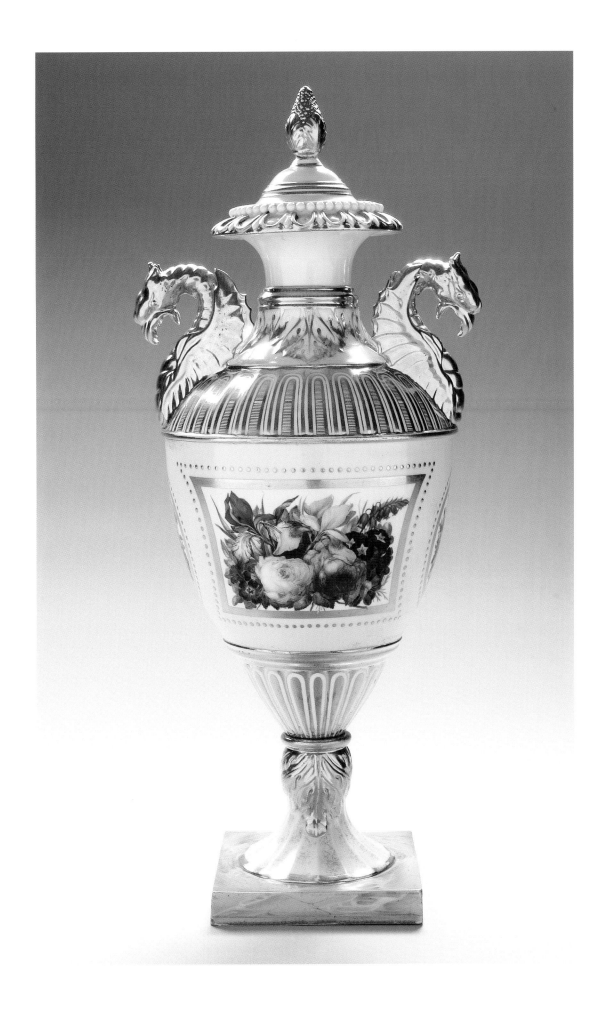

104. Plate decorated by C. Hayton

Size: 21.6cm (8½in.) diameter
Dated: 1821
Mark: inscribed in red script 'Hampton Court Herefordshire C. Hayton. 1821'
Museum Purchase through the bequest of Anita Bevill McMichael Stallworth, 1993.18.3

This plate is a rare example of an independently painted plate made with the full blessing of the Chamberlain factory. The distinctive moulded gadrooned edge, known as 'Baden' shape, leaves no doubt this is Chamberlain porcelain, although instead of a Chamberlain factory mark it is inscribed on the reverse with the name of the painted view and signature C. Hayton. 1821. Mr. and Mrs. C. Hayton of Moreton, near Hereford, purchased blank Chamberlains' porcelain, decorated it, and returned it to the factory for firing and gilding. As independent decorators the Haytons signed and dated their work on the reverse – a practice not generally permitted among factory artists.

Some porcelain makers were happy to provide blank white porcelain to firms of independent china painters as a significant part of their business.[1] Other factories preferred to protect their reputations and wanted full control of the decoration that appeared on their porcelain. In view of the competition between the three main Worcester manufactories, it is hardly surprising that the larger independent decorating workshops in Worcester, Doe and Rogers and Sparks, were obliged to buy most of their blanks from Coalport and Staffordshire.

It is difficult, therefore, to interpret the business arrangement that the Chamberlain factory had with the Haytons. The factory archives show that between 1821 and 1825 they bought white porcelain and also paid for gilding and burnishing.[2] Invoices quoted by Geoffrey Godden show that the Haytons paid one guinea for 'Burnishing and burning 6 plates' and 3s.6d. for 'Gilding,

burnishing & burning a gadroon Baden (shape) 8 inch plate'. Floral sprays and views of country houses signed by C. Hayton occur on Chamberlain and other Staffordshire porcelain.[3] The painting style is reminiscent of landscape painting seen on Flights' porcelain and William Chaffers listed a C. Hayton working for Flights,[4] and so the artist may have received training at the other Worcester factory before setting up on his own. Working from their home in Herefordshire, the Haytons naturally favoured local views. The Hampton Court depicted on this plate is not the well-known royal palace in Middlesex but another residence of the same name not far from Moreton in Herefordshire where the Haytons lived.

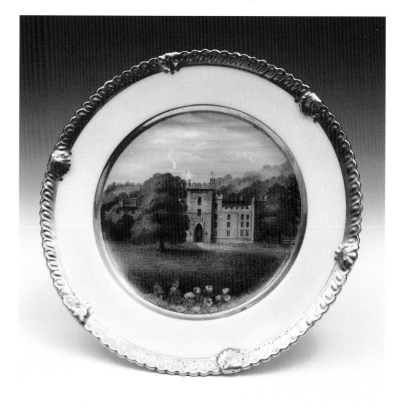

1. The Coalport factory specialised in supplying blanks and even produced their own printed price lists.
2. Quoted by Geoffrey Godden, *Chamberlain-Worcester Porcelain*, p. 201.
3. J. Sandon, *Dictionary of Worcester Porcelain*, p. 194, illustrates a pair of Staffordshire chocolate cups signed by C. Hayton.
4. Henry Sandon, *Flight and Barr Worcester Porcelain*, p. 20.

105. Lion Paperweight

Size: 10.8cm (4⅛in.) long at the base
Date: c.1824
Mark: Chamberlains Worcester in red script
Provenance: formerly Geoffrey Godden
collection and illustrated in his *Chamberlain-Worcester Porcelain*, pl. 346
Museum Purchase through the Ewers Acquisition Fund, 1988.26.2

The Chamberlain factory had made animal ornaments from the 1790s and a wide range of dogs and other animal models such as mice, cats and rabbits were made in the 19th century. Most were purely decorative but, unlike other Chamberlain animals, the base of Cheekwood's white lion is weighted, suggesting that it had a more specific purpose. The Chamberlain factory records confirm both the function and date of manufacture. In May 1824 the factory sold '2 Lion paper presses, pink & gold at 6s.'.[1]

To many people the word paperweight conjures up an image of a coloured glass sphere. The millefiori glass paperweight or *'presse-papier'* was invented in France in the 1840s, although paperweights go back much earlier in date than this. An ornamental weight kept papers and letters organised on top of a desk and also had another important use. Many documents written on parchment were stored rolled up. Reading and sorting a number of rolled-up documents could be a frustrating and chaotic business as the rolls curled themselves up again. Paperweights helped to sort out the jumble. The first ornaments created specifically for the purpose were made from heavy metal, bronze or stone. In 1802 the Prince of Wales bought for five guineas a present for his mistress, Mrs Fitzherbert: 'a Paper Weight formed of Statuary Marble surmounted by an Ormolu Figure of a Dog'.[2]

Porcelain paperweights were made in France and Germany, especially in Paris from about 1800. It is very likely that Chamberlains have made a direct copy of a French lion paperweight. It could have graced the desk of an academic or scholar, for the lion is Egyptianesque, influenced by the art of ancient Egypt. In England in 1824 this would have been quite expensive at six shillings and very few Chamberlain 'paper presses' seem to have been made.

1. Quoted by Geoffrey Godden, *Chamberlain-Worcester Porcelain*, p. 271.
2. Invoice in the Royal Archives reproduced in Bonhams auction catalogue of Continental Ceramics, 18 May 2005, p. 41.

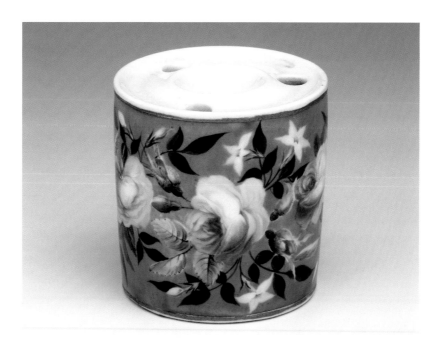

106. Small Inkwell

Size: 6.6cm (2⅝in.) high
Date: c.1820-25
Mark: Chamberlains Worcester in red script
Gift of Mr. and Mrs. P.M. Estes, Jr. 1989.16.2

This small drum-shaped inkwell, prettily painted with roses, may have been used by the lady of the house to write her letters or even to maintain the household account ledgers. This small inkwell has a central, glazed conical aperture for the ink and this is surrounded by three holders for quill pens. Chamberlains' fine glassy porcelain proved impervious to ink, giving them an advantage over many other makers of English porcelain at the time, for bone china inkwells tended to stain during use. Blue enamel applied overglaze as a background was particularly susceptible to deterioration caused by ink and it is possibly for this reason that the decoration on this Chamberlain inkwell includes an underglaze blue ground instead. The ground had to be painted first, leaving blank reserves in the shape of the flowers and some of the leaves. These were painted in later after glazing. This technique avoided problems with the blue enamel, but it does mean that the flower painting is rather stiff, for the painter had to fit the roses entirely within the shaped reserves.

To prevent messy spillage during use, some Chamberlain drum-shaped inkwells were made with separate saucer-like stands. In December 1821 the factory sold '2 small inks and stands at 12s.' and in April of the sale year '1 saucer ink, roses etc' sold for one guinea.[1]

1. Entries from the Chamberlain account books quoted by Geoffrey Godden, *Chamberlain-Worcester Porcelain*, p. 251.

107. Pair of Dessert Tureens and Covers

Size: 21cm (8¼in.) high
Date: c.1818-25
Mark: Chamberlains Worcester with New Bond Street address in red script under the covers, the bases with titles of the flower specimens
Gift of Mr. and Mrs. Paul V. Callis and Dr. and Mrs. Robert W. Quinn, 1992.3-4

Pyramidal Heath from *Curtis's Botanical Magazine.*
IMAGE COURTESY OF THE NATIONAL AGRICULTURE LIBRARY, USDA

This looks like a grand pair of vases for a mantelpiece, although the holes to accommodate ladles cut into the rims reveal that this pair originally formed part of a very grand dessert service for serving fruit. One of these vase-shaped tureens would have contained powdered sugar and the other would have held cream, both costly commodities served only in the grandest houses. Each matching plate and shaped dish would have been painted with a different botanical specimen. The complete dessert set displayed in its entirety would certainly have impressed all household guests.[1]

By the 1810s publications containing fine, hand-coloured botanical illustrations were readily available to gardeners, scientists and artists. One of the most successful plantsmen, William Curtis, published the first issue of *The Botanical Magazine, or Flower Garden Displayed* in 1787.[2] This influential periodical featured coloured illustrations of plants with a description of their origins and instructions on cultivation. In order to attract subscribers, Curtis focused on popular plants currently available to English gardeners. The series served as a good resource for porcelain design, at the Derby factory in particular where botanical dessert services were made in the 1790s.[3] Chamberlains copied Derby botanical services around 1798-1800 and subsequently made widespread use of this kind of decoration.[4]

These tureens are Chamberlains' 'Baden' shape with gilded, gadroon moulded rims and rich underglaze blue borders. The flower specimens are copied from volume 9 of *The Botanical Magazine* issued in 1797, although this service was not painted until two decades later. Both sides of the bodies are hand painted with a highly detailed individual specimen. A script mark on the base identifies each plant. Both tureens depict on one side the lanky Scarlet-Flowered Cyrilla, while the other sides depict the pink Pyramidal Heath and the blue star-like Phlox.[5]

1. For a selection of dishes from an identical dessert set see Geoffrey Godden, *Chamberlain-Worcester Porcelain*, pl. 153.
2. The magazine remained in publication until 1983. See Wilfrid Blunt and William T. Stearn, *The Art of Botanical Illustration*, Suffolk: Antique Collectors' Club in association with The Royal Botanic Gardens, Kew, 1994, pp. 211-212.
3. Peter Brown, 'Derby Porcelain: The Work of Floral and Botanical Artists, 1790-1805' in *The Magazine Antiques*, June 2003.
4. A part set of Curtis's *Botanical Magazine* survives in the Museum of Worcester Porcelain although this is unlikely to be the same set that was used at Chamberlains' factory.
5. Some of these illustrations come from Volume IX of Curtis's *Botanical Magazine*. The Pyramidal Heath appears on p. 366 and one version of the Scarlet-Flowered Cyrilla is on p. 374.

108. Child's 'Toy' Plate

Size: 7.7cm (3¾in.) diameter
Dated: 1830
Mark: inscribed in puce script 'Victoria September 1830' and marked 'Chamberlains Worcester'
Museum purchase through the bequest of Anita Bevill McMichael Stallworth, 1994.3.1

When King William IV ascended the throne in July 1830, his eleven-year-old niece, Princess Victoria, found herself as the heiress presumptive. Her father, Edward, Duke of Kent, the fourth son of George III had died in 1827 and no other legitimate heirs survived. The line of succession wasn't totally clear-cut, however, and Victoria's mother the Duchess of Kent needed to convince parliament and the British public that her daughter was the rightful heir. In order to launch the young princess into her public role, the Duchess orchestrated a series of excursions around the country.

From August to October 1830 Princess Victoria and her mother spent ten weeks in Malvern to improve their health. During their stay they also visited Worcester, paying visits to the main sites of the city including the porcelain factories and the cathedral. Substantial orders for porcelain had been placed with Chamberlains in the young princess's name as early as May 1828, when she would have been just nine years old, and in November 1828 Princess Victoria was invoiced by the Chamberlains for 13s. worth of 'trinkets'.[1] To celebrate the princess's visit to Worcester in 1830, Chamberlains issued commemorative miniature plates bearing a royal crown and the initial V, within an apricot border with white and gold flowers. Some of these plates were marked just with the factory name on the reverse, while others were additionally inscribed 'Victoria September 1830'.[2]

The purpose of these miniature plates is uncertain. One survived in an American collection with a matching miniature sucrier from a child's teaset painted with a view of Malvern,[3] so it is possible this formed part of a set

presented to the princess to mark her visit. It is believed the miniature plates are far more than simple playthings for the little princess, however. The Duchess of Kent was forceful and manipulative and engaged in intense lobbying to convince parliament as well as the royal court that her daughter was the only legitimate heir to the British throne. Plates like these would have made appropriate gifts from a young princess to anyone who might have been in a position of influence at Court.

Seven years later Victoria did indeed become queen. She was still just eighteen years old. The patronage she had given to Chamberlains as a young princess was seemingly forgotten, however, and valuable orders for royal porcelain generally went to other manufacturers, Minton in particular. It would not be until the 1850s when Kerr and Binns of Worcester received a significant order to make porcelain for the Queen.

1. Orders from Princess Victoria are listed by Geoffrey Godden, *Chamberlain-Worcester Porcelain*, p.141.
2. For a similar plate and more information on the Princess's visit see *The Richardson Collection of Irish Political and British Royal Commemoratives*, Bonhams' sale catalogue, 9 February 2000, lot 106
3. Sold at Sotheby's New York c.1995

109. Saucer-shaped Dish

Size: 25.4cm (10in.) diameter
Date: c.1820
Mark: printed Chamberlains factory mark in black including New Bond Street address
Museum purchase through the bequest of Anita Bevill McMichael Stallworth, 1994.10.1

This is a most extraordinary production from a leading English porcelain manufactory. It is a direct copy of Chinese porcelain, but the Oriental prototype is not the conventional export ware found in England. Instead this design is associated with Chinese porcelain made for the Islamic market. Sets of circular bowls and saucer-shaped dishes decorated in this style are found throughout the Middle East, including India, Turkey and even into Russia.

It is most unlikely that Chamberlains produced sets of these saucer dishes for general sale. Instead this was probably made as a special order to make replacement pieces for an existing Chinese set. How such a set came to be in England around 1820 is hard to explain. It is therefore more likely that the commission came from overseas. The Chamberlains had an arrangement to supply porcelain to Griffiths Cooke & Co. in Madras, India, and through this agency supplied dinnerware to important customers including the Honourable East India Company in 1817-18 and the Nabob of the Carnatic in 1820.[1] This Lotus pattern is certainly a type of decoration that would have been in use in India at this time. The delicate shading of the lotus petals, using opaque *famille rose* enamels, encircles a flowering peony plant in gold with iron red enamel tracery. The shape of saucer dish would also have suited Middle Eastern rather than European customers. The quality of Chamberlains' decoration would have compared very favourably with the Chinese prototypes and a dish such as this would have impressed their agents and customers in Madras.

1. Chamberlains' trade with India is discussed by Geoffrey Godden, *Chamberlain-Worcester Porcelain*, pp. 130 and 135.

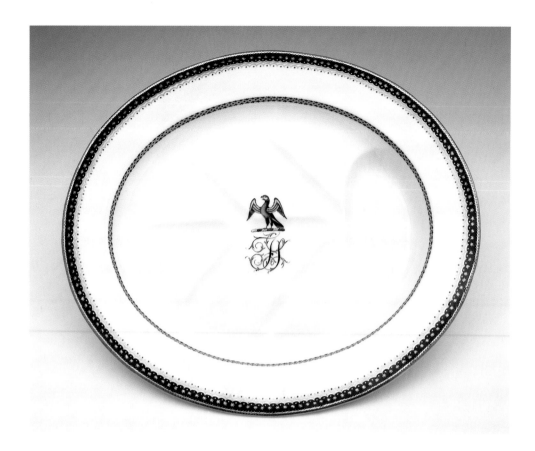

110. Meat Platter with 'Gravy Tree'

Size: 50.4cm (19⅞in.) wide
Date: c.1820-25
Mark: None
Gift of Dr. and Mrs. Benjamin H. Caldwell, Jr. in honour of Dr. and Mrs. E. William Ewers, 1979.1.3

Massive in scale and simplicity itself, this dish looks very different from other richly decorated Chamberlains' productions at Cheekwood. It formed part of a dinner set for use in a very grand home, but it would be from the domestic set used every day, rather than the best chinaware used when entertaining.

This dinner set came from China originally, probably at the end of the 18th century. An English family would have sent a drawing of their crest and initial to merchants in Canton and a year or two later their dinner service would have been delivered. Possibly there were no large platters with the Chinese set, or else the biggest dish could have been broken and so a replacement piece was ordered not from China but from Chamberlains in Worcester.

The dish is a precise copy of the Chinese pattern, with a simple but distinctive border design in blue enamel and gold. As it is an exact copy, it is difficult to date the replacement dish, but it was probably made some time between 1815 and 1830. It is made from Chamberlains' 'Regent China' body and this means it is beautifully white and also hard wearing. It also means that this dish would have looked whiter and cleaner than the rest of the Chinese set.[1]

This shape of platter is popularly known as a 'Tree Dish' or else as a 'Well and Tree Platter', for it is modelled with a depression at one end. This was designed to catch juices which would drain from a joint of meat and run down the branches of the tree-shaped indentation to collect in the gravy well. Most larger 19th century dinner sets included one or two 'tree dishes'. Because such sets were made to be used, few dishes survive in such good condition as this most impressive platter.

1. See catalogue no. 88 in this catalogue for an earlier Chamberlain tureen also made as a replacement for a Chinese set.

111. Shaped Dessert Dish

Size: 29.1cm (11⅞in.) wide
Date: c.1840-45
Mark: Chamberlain & Co. Worcester painted in brown script
Museum Purchase through the Ewers Acquisition Fund, 1978.2.1

As we marvel at the sumptuous ornamental porcelain and very special armorial sets made by Chamberlains and Flight, Barr and Barr, it is easy to forget that the largest output of any china factory was dinner, dessert and tea sets for more ordinary, everyday use. Neglecting this side of their production contributed to the decline of the two great Worcester factories, forcing them in 1840 into an unlikely alliance trading as Chamberlain and Co.

A pleasing pair of dishes at Cheekwood shows a factory desperate to move with the times. During the 1820s and '30s Chamberlains and Flights had both blindly pursued an obsession with classical traditions and had failed to keep abreast with changes in fashion. They had both introduced tableware with new gadroon-moulded rims before 1820, but these were mostly combined with rather formal borders and painted centres. Their main rivals, English china factories such as Coalport, Minton, Ridgway and Alcock, looked to new styles in porcelain, especially rococo designs from France and floral-encrusted wares from Dresden. This is what the British public wanted in the 1830s.

While dessert services in such patterns were standard productions of English porcelain factories, they would still have been relatively costly, used in well-to-do middle class homes. The painting of 'Fancy Birds' had played a major part in the productions of all the Worcester factories since the 1760s. The colourful birds painted in the panels on this dish are very much Worcester species, evolved from Dr. Davis' birds (see no. 85) and very different from the old French Sèvres style birds painted by Thomas Randall and his followers at Coalport.[1]

This Worcester dish with its fancy gadroon moulded rim, rococo scroll handles, sky blue ground and panels of birds could easily be mistaken for Coalport or Minton, for these firms made identical designs during the 1830s.[2] By the time Chamberlain and Co. produced their version up to a decade later, the style was no longer new. Indeed, gadroon rims were old-fashioned by the 1840s. This dish exhibits misfiring to the glaze and there is some discoloration and deterioration noticeable in the sky-blue ground colour. These faults echo the serious underlying problems suffered by Chamberlain and Co. and so this service would have done little to turn the factory's fortunes around.[3]

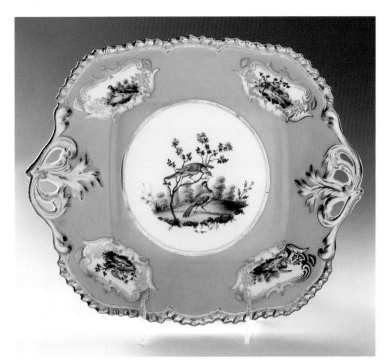

1. Michael Messenger, *Coalport*, pp. 225-228.
2. Related styles are featured in Geoffrey Godden's books *Coalport and Coalbrookdale Porcelains* and *Minton Pottery and Porcelain of the First Period*.

3. Geoffrey Godden, *Chamberlain-Worcester Porcelain*, pl. 209, illustrates a Chamberlain and Co. cup and saucer with identical decoration matching this dish, on a shape first made before 1830.

112. Pair of large vases

Size: 35.5cm (14in.) and 36.5cm (14⅜in.) high
Date: c.1840-42
Marks; Chamberlain & Co. Worcester in red script
Gift of Mr. and Mrs. Jack C. Massey, 1989.1.1-2

If it had not been for the Chamberlain & Co. marks on the bottom of these vases you could be forgiven for thinking they had been manufactured twenty years earlier. This truly magnificent pair follows all of the traditions of Flight, Barr and Barr, rather than Chamberlains. In 1840 the two very different factories were forced into a merger and the workmen and decorators found themselves on the same side, occupying just the Chamberlain premises. Production continued without any apparent break and, while most of the porcelain made after 1840 followed Chamberlain shapes and patterns, some of the moulds from the Flight factory were transported across the city to the Chamberlain premises and used by the new merged company.

The shape is known as a campana vase for the form resembles that of an inverted bell. This is ultimately based on an ancient classical shape and the ram's head handles likewise derive from ancient Rome. In 1840 such classicism was generally outdated and this is partly the cause of the closure of Flights' factory. There is, however, a certain timeless quality about this pair. The sheer quality of workmanship will have ensured it found a buyer at the time. Indeed, any factory capable of producing work like this deserved to succeed. Faced, though, with an uncertain future, Chamberlain and Co. decided to utilise their skills in new directions and most Flight, Barr and Barr designs were abandoned.

The dramatic shape, wonderful rich blue ground and lavish raised and tooled goldwork deserve full credit, yet it is the painted panels that set this pair of vases apart from almost any other Chamberlain and Co. production. Both panels feature a floral still life, where an openwork basket overflows with roses, lilacs, stocks, morning glories and more blossoms. The painting is unsigned and, while it is tempting to attribute these vases to the hand of Samuel Astles, they could equally be the work of a talented pupil. Samuel Astles had himself been a pupil of Thomas Baxter and he painted superb flower subjects for Flight, Barr and Barr.[1] Astles painted for Flights until 1840 and continued initially to work under the new partnership of Chamberlain and Co.[2] Many other skilled painters will have learnt flower painting from Baxter and Astles, however.

1. A signed plaque, possibly the one exhibited by Astles at the Royal Academy in 1827, is illustrated by Henry Sandon, *Flight and Barr Worcester Porcelain*, p. 117.

2. Geoffrey Godden, *Chamberlain-Worcester Porcelain*, p. 183.

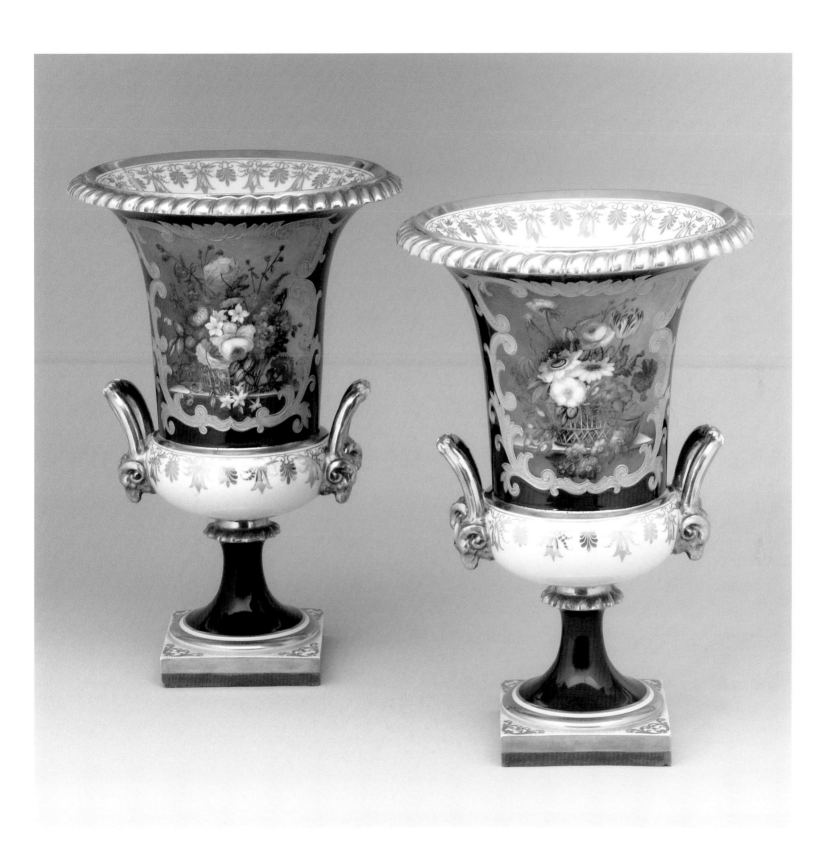

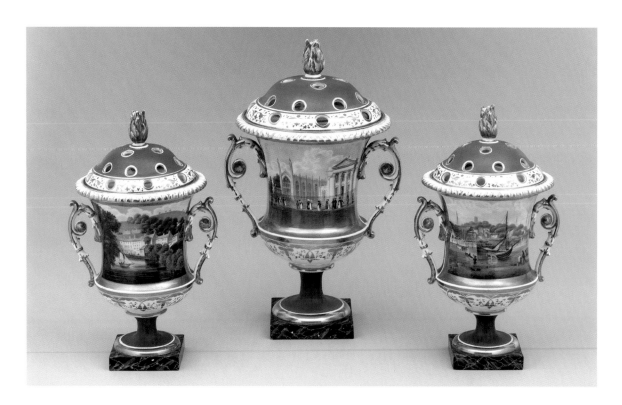

113. Garniture of Covered Vases

Size: central vase 34cm (13⅜in.) high, side vases 28cm (11in.) high
Date: c.1822-30
Marks: Grainger Lee & Co. Worcester, and titles of the views all in red script
Museum Purchase through the bequest of Anita Bevill McMichael Stallworth in honour of
Mrs. William J. Tyne, 1992.25.1-3

This is a functional set for, as well as being ornaments for a sideboard or mantelpiece, these vases with pierced covers would have held pot-pourri, the sweet odour disguising the unpleasant stench of civic sanitation. It is satisfying to find that all three of the flat, porcelain inner covers remain within these vases, for these served the purpose of keeping the pot-pourri fresh. Painted on the large front panels are three apparently unrelated views from around Britain. Titles painted underneath the marbled bases identify the scenes. On the central vase 'Kings College Chapel Cambridge' forms a magnificent backdrop. In front is a parade of scholars, masters and their families. The figures stick to a well-worn path alongside the railings, watched by a single older figure on the lawn in the foreground. This possibly illustrates an old tradition at King's College whereby only Fellows of the College are permitted to walk on the lawn, a tradition that has been respected by many generations of scholars.

On the smaller vases in the set a view of 'Matlock

Derbyshire' shows a scene well known to lovers of Derby porcelain rather than Worcester. Matlock was a popular spa town and visitors to the resort bought costly porcelain souvenirs painted with local views. The final view shows a different kind of resort. 'West Cowes Isle of Wight' is famous today as the sailing capital of Britain. Cowes has had a long association with recreational boating and the scene on Graingers' vase shows a shipyard constructing or repairing a schooner.

Grainger, Lee and Co. was the smallest of the three main Worcester factories and there is no denying that Graingers' painting is generally inferior when compared with Flights' or Chamberlains' landscape decoration. The quality of Grainger modelling, gilding and groundlay is likewise weaker than their Worcester rivals. Having said this, the technical ability needed to produce such a handsome garniture still deserves enormous credit. The handles are perhaps the most impressive feature for these are well proportioned and thinly potted. This was Graingers' most popular vase shape during the 1830s and many examples are known with painted views, including the spa towns of Bath and Malvern.

114. Pair of Reticulated Vases

Size: 20.5cm (8¼in.) high
Date: c.1885-90
Marks: Printed shield-shaped marks on the lids initialled G & Co W, Grainger & Co.
Worcester beneath, the bases marked only with the pattern number 1/733 in red
Gift of Dr. and Mrs. E. William Ewers, 1985.2.2-3

Pierced or 'reticulated' porcelain was a speciality of the Grainger factory. The technique of cutting out holes when clay was wet was an ancient method practised with considerable success in 18th century China and in 19th century Japan. In Europe some of the most spectacular specimens were made at the French National Porcelain Manufactory at Sèvres during the 1840s. Sèvres pierced teawares were copied in Worcester by Chamberlain and Co. and some of these Worcester versions were praised by the judges at the 1851 Great Exhibition.

Royal Worcester continued to manufacture versions of the Sèvres shapes (see catalogue no. 118) and by the 1870s and early '80s were producing perhaps the most remarkable pierced porcelain ever, thanks to the skills of George Owen. Owen's work was unique in that he pierced his porcelain without any moulded outline. The Royal Worcester Sèvres copies had been partly moulded, using a technique in which the Grainger factory was later to excel.

It was probably Edward Locke who introduced the technique of reticulation at Graingers. Joining as an apprentice decorator in 1845, Locke learnt all aspects of the porcelain industry and by the 1870s it is likely that he was in charge of modelling and casting. The china body known as parian exhibited a delightful creamy colour when glazed and also could be cast extremely thinly without losing its shape or strength. This was very important when making reticulated porcelain. Immediately after casting, while the clay was still moist and pliable, each hole had to be cut out by hand, one by one, using a sharp tool. The mould provided the pattern to be followed, with depressions in the surface that were cut out by a craftsman known as a 'reticulator'.

During the 1880s and '90s Grainger and Co. specialised in this remarkable work. In 1895 Edward Locke departed the firm, taking with him his sons and daughter and other Grainger workmen to set up a rival porcelain manufactory in Worcester.[1] Locke's departure does not seem to have affected Graingers' production of reticulated porcelain, for by this date the department was under the supervision of a master craftsman named Alfred Barry. Barry would have created some of the models and no doubt pierced some of the most intricate pieces himself, although no signed work exists.[2]

The shape of the vases at Cheekwood was one of the most popular Grainger reticulated forms. Islamic in influence, the style derives from Mogul ornament. These vases are finished with finely tooled gilding, just enough to highlight rather than overwhelm the delicate white pierced work. Many Grainger specimens were further ornamented with raised enamel jewels.[3] These found a ready market in the United States and some reticulated pieces were even exported to India and the Middle East.

When Graingers' factory closed in 1902 Alfred Barry transferred to Royal Worcester, where he worked until 1907, but, other than George Owen's work, relatively little reticulated porcelain was made after 1900.

1. Discussed by Henry Sandon, *Royal Worcester Porcelain*, p. 23.
2. A photograph of Alfred Barry piercing a pot and other family records are preserved in the Museum of Worcester Porcelain. See Henry and John Sandon, *Grainger's Worcester Porcelain*, p. 31.
3. Many fine examples of Graingers' reticulated porcelain are in the Museum of Worcester Porcelain collection. See Henry and John Sandon, *op. cit.*, pls. 179-182.

THE WORCESTER ROYAL PORCELAIN COMPANY

The display of Worcester porcelain at the Great Exhibition in 1851 was a huge disappointment. The once-great firm of Chamberlain and Company received only muted praise from critics for some reticulated porcelain copied from Sèvres. The last of the Flight and Chamberlain families had all retired from the business. The sole remaining director, a Dublin china dealer, W.H. Kerr, realised that the factory was making little that his customers wanted to buy. In order to transform things, Kerr appointed a new director, Richard William Binns. Binns had been Art Director of the glass sellers Apsley Pellatt & Co. and so understood what was fashionable in the glass and china shops of London.

At the 1851 Exhibition successful British makers like Minton and Copeland showed two new ceramic bodies – Parian and Majolica. Mr. Kerr and Mr. Binns agreed that this is what Worcester should have been making, and they raised the necessary finance to build new kilns. At the Dublin Exhibition the following year Kerr and Binns of Worcester were able to show the remarkable Shakespeare service combining unglazed parian figures with richly gilded china. Critics raved about it, and what Binns was to call the 'Awakening of Worcester China' had begun.

When Kerr retired a decade later, a new company was created trading as the Worcester Royal Porcelain Company. The firm is known today as Royal Worcester. Edward Phillips provided practical potting experience, while R.W. Binns was Art Director and the main driving force for new productions. Just about everything the company made was new. Chamberlain's and Flight's had avoided figure making almost entirely. Binns commissioned new figures from external modellers including W. Boyton Kirk, Hughes Protat and Thomas Brock, produced alongside figures by the Worcester factory's own modeller James Hadley. A most versatile genius, Hadley brought to life every sort of imagery Mr. Binns could conceive. Some vessels were inspired by old Naples porcelain and the ceramic art of the Renaissance. Other creations originated in rococo France or Georgian England.

By far the most important influence on Royal Worcester porcelain was the art of Japan. R.W. Binns'

vast personal collection of Japanese art was displayed in his own museum in order to inspire the factory workforce. Worcester's Japanese porcelain was shown in Vienna in 1876 and it received critical acclaim at every subsequent international exhibition. There are many fine pieces in the collection at Cheekwood. Thanks to Hadley's modelling and enamelling and gilding by Edward Béjot and the Callowhill brothers, this porcelain looked exactly like oriental carved ivory and lacquer.

Other Victorian Worcester figures at Cheekwood copy Austrian painted bronzes. By using new aerograph spray technology Worcester's decorators could imitate any metallic finish they wanted, as well as carved ivory, bamboo or even the khaki uniform on figures of soldiers. Royal Worcester had an enormous influence on other ceramic makers. Ironically, Worcester's bronze and ivory figures were copied in Germany and Austria and some of its Japanese designs were actually copied by the Japanese themselves.

It was only after 1900 that it became usual for the decorators to sign their names in full on their porcelain. During the earlier twentieth century many highly-talented painters worked at Worcester and through their signed pieces it is possible to follow their careers. Fine hand painting by the likes of Charley Baldwyn and Harry Davis brought great praise upon the company, though it must be remembered that hand decoration is only a tiny part of the output of any great china factory. At Cheekwood samples from a few domestic dinner and tea services represent a quite different aspect of Worcester's production.

Arguably Royal Worcester's greatest achievement in the twentieth century was the Doughty Birds, for their production broke so many new grounds in ceramic technology. For total realism this set of lifelike sculptures of American birds was given a matt glaze and combined with finely modelled flowers that make them look incredibly real. An almost complete set of the American Doughty Birds is at Cheekwood. These complete the story of two hundred wonderful years of porcelain making at Worcester.

Opposite: Pair of Doughty birds. See catalogue no. 139.

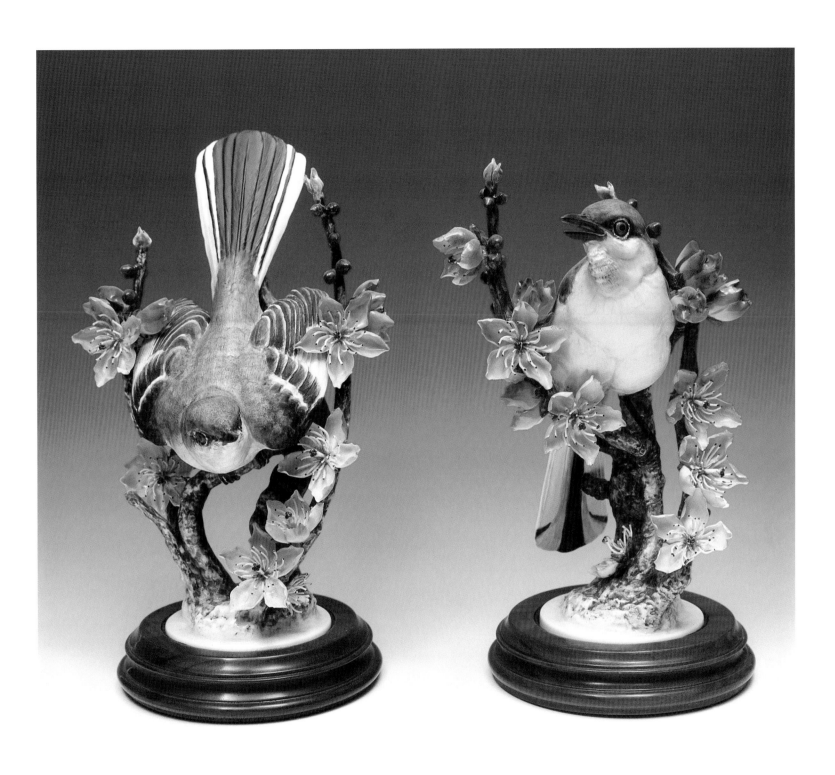

115. Armorial Plate

Size: 26.1cm (10¼in.) diameter
Date: c.1865-66
Mark: Impressed crowned circular mark with **WORCESTER** beneath, printed retailer's mark for
Phillips of New Bond Street, London
Gift of Linda and Raymond White, 2002.1-2

In June 1865 a young London lawyer, Richard Napoleon Lee, inherited a large sum of money, £400,000, from Richard Thornton, an eminent London merchant. The relationship between Lee and his benefactor is unclear. The only son of another Richard Lee of Brixton, he was possibly a nephew of Thornton's by marriage. Richard Lee had been admitted to Middle Temple as a junior lawyer in 1857 and was called to the bar in January 1860 at the age of twenty-six. Under the terms of the will Lee inherited his share of the large fortune only on the condition that he changed his name to Thornton. On 1 August 1865 the change of surname was confirmed by Royal Warrant.

Keen to promote his new identity, Richard Napoleon Thornton applied for his own coat of arms and these were granted by letters patent on 25 August 1865. His next port of call seems to have been one of the biggest china shops in London. Phillips and Co., who had taken over the New Bond Street premises vacated by Chamberlains of Worcester, specialised in providing customised porcelain sets bearing family coats of arms. From the display of specimen plates in Phillips' grand shop, Thornton selected a luxurious pattern and placed an order which was passed on to the Royal Worcester factory.

The border is a rich turquoise blue based on the *bleu celeste* ground of Sèvres. By the 1860s old Sèvres was priceless and this ground colour was therefore associated with wealth. An edge of tooled gold is finished off with 'jewelling' created by using tiny dots of white enamel as well as raised gold jewels, each applied by hand. In the centre the arms and crest of Thornton are accompanied by the family motto 'Persevere'. The exquisite craftsmanship and associated expense of this service reflect Thornton's new-found wealth.

116. Earthenware Double Vase

Size: 21.8cm (8⅝in.) high
Date: c.1871-75
Mark: Impressed crowned circular mark, incised model no. 226
Museum Purchase through the bequest of Anita Bevill McMichael Stallworth, 1992.13.1

The Royal Worcester factory called shape no. 226 'Double Draped Vase' but this name gives little indication of the origin of this curious design, for Worcester's inspiration came from Japan. In the factory estimate books shape 226 was available in a number of different glazes including 'B Blue', 'Satsuma' and 'Marble'.[1] B Blue was a plain, dark cobalt blue glaze priced at £1.1s. The Cheekwood vase is probably a version of the 'Marble' glaze which cost £1.7s.6. The 'Satsuma' finish was most likely an ivory glaze with gilded Japanese emblems, more costly still at £1.11s.6d. Considering the buying power of money in the 1870s, all of these vases were very expensive and could only have appealed to true connoisseurs of ceramic art.

In the Victorian period Worcester trailed behind other British ceramic manufacturers in the creation of Majolica, a form of earthenware with strongly coloured glazes. Royal Worcester was essentially a porcelain maker and the manufacture of earthenware was not really in its nature. Anxious to appear modern, however, they constructed a Majolica kiln at Worcester and another kiln for firing faience − their name for glazed earthenware. By the early 1870s a wide range of pottery bodies and different glaze effects were in production at Worcester. Some of these were technically superb, but Worcester's pottery manufacture was never on a large scale and commercially it was a disaster compared with the huge successes enjoyed by their rivals Minton.

In 1878 at the Paris Exhibition Royal Worcester exhibited their largest ever display of 'Japanesque' wares. Shown here for the first time was what Mr. Binns called

'...a peculiar marbled faience, on the lines of the Japanese "Namako" ware'.[2] This was probably a continuation of Worcester's experimental mottled glazes from the earlier 1870s. In 1873 the factory had established a chemical laboratory at the works.[3] Experimenting with pottery glazes allowed Worcester's craftsmen to imitate some of the exciting exhibits in Mr. Binns' extensive museum collection of Japanese artefacts.

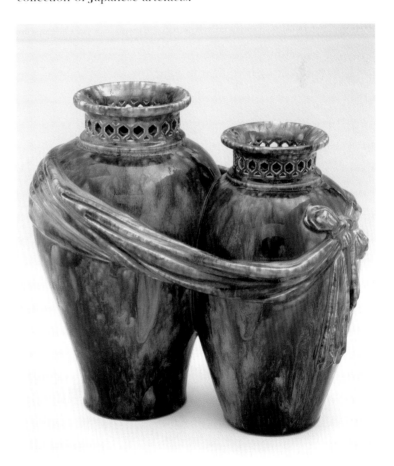

1. Royal Worcester Books #226 or Book RW4/27.6, p. 11. Worcester factory archives.

2. R.W. Binns, writing in *Worcester China, A Record of the Work of Forty-five Years*, p. 68.
3. Ibid., p. 81.

117. Pierced Spill Vase

Size: 18cm (7⅛in.) high
Date: 1873
Mark: Crowned circular mark impressed and also printed in puce, date letters 73 beneath, indistinct incised shape no.
Museum Purchase through the bequest of Anita Bevill McMichael Stallworth, 1992.13.12

Royal Worcester's 'Ivory Porcelain' is so faithful to the appearance of old ivory it is almost necessary to pick up a vase like this and 'ping' it with your fingers, just to be satisfied that it really is made of porcelain and not true ivory. This pierced cylindrical pot would have been used in a European home as a spill vase for holding the rolled paper or wooden spills used to light a fire or a candle. It copies a Japanese ivory brush pot from a scholar's desk, a delicate container for the brushes used in the art of calligraphy.

In Japan this would have been carved from a single section of an ivory tusk mounted on a bronze base. The decoration on Worcester's version imitates *shibayama*, the Japanese name for objects made from different materials brought together − ivory overlaid with lacquer, gold, carved shells and semi-precious stones. Worcester created their vessel in a single piece of porcelain. After casting from a mould, the vase was pierced by hand using a sharp tool to cut away part of the background. Made from a glazed parian body, this was then enamelled in a matt ivory-coloured finish fired in a kiln. Further enamel colours and gilding were added in subsequent kiln firings. The appearance of a richly patinated bronze base is ceramic trickery, for this metallic finish coats just one part of the single Worcester porcelain vase.

Japanese art had been shown in exhibitions in London in 1862 and in Paris in 1867. Richard William Binns was a major buyer of Japanese art at these exhibitions. Royal Worcester's 'Ivory Porcelain' received its first important showing at a display at the Albert Hall Galleries in London in 1872. In a glowing review of this exhibition, the influential *Art Journal* wrote of the sudden fashion for such pieces and how the 'Works at Worcester cannot produce them fast enough'.[1] The reviewer added: 'The Art Director [Mr. Binns] is never a slavish imitator; he has seen and appreciated the value of Japanese art, and here it is fair to say he has improved where he has borrowed, taking suggestions rather than models.'

It would be easy to accuse Royal Worcester's 'Ivory Porcelain' of simply copying Japan, but this wasn't the case. This vase is not cast directly from a Japanese ivory. Instead it is modelled by James Hadley and decorated by the Callowhill Brothers, under the direction of R.W. Binns. It is uniquely Worcester. This shape featured in Worcester's display at the Vienna Exhibition in 1873, where their Japanesque porcelain caused a sensation. Placing it ahead of Minton and any French manufacturers, one critic wrote: 'all the finest of the Worcester works have been suggested by Oriental examples, and chiefly by works in Japanese lacquer; but the application is both new and clever'.[2]

1. Quoted by R.W. Binns, *Worcester China, A Record of the Work of Forty-five Years*, p. 51.
2. Ibid., p. 52.

118. Reticulated Cup and Saucer

Size: saucer 15.5cm (6⅛in.) diameter
Date: 1874 and 1875
Mark: Crowned circular mark impressed on saucer with potter's mark 9K for 1875,
factory mark printed in green on the cup with date letters 74 beneath
Gift of Dr. and Mrs. E. William Ewers 1985.2.1ab

A staple product of Worcester porcelain makers for almost forty years, it is a shame to reveal that this classic design of a double-walled cup and saucer was not their original creation. Firstly Chamberlain and Co., then Kerr and Binns and finally the Worcester Royal Porcelain Co. all exhibited sets of this china to critical acclaim. Their reviewers never once mentioned the fact, but Worcester had simply copied exactly a design from the French National Porcelain Manufactory at Sèvres. During the 1840s Sèvres perfected the technique of reticulated porcelain and made tea services and other ornamental presentation pieces created by cutting out designs that were lightly moulded on the surface. These were produced at Sèvres for several decades.

Chamberlain and Co. showed at the Great Exhibition in 1851 their range of pierced porcelain, including double-walled teawares, perfume bottles and communion chalices.[1] These were not new productions, for similar Chamberlain pieces had featured in the *Art Union* magazine in March 1846 and in February 1849 a selection of pieces were to be presented to the famous singer, Jenny Lind, when she visited Worcester.[2] These reticulated shapes were among the few Chamberlain and Co. productions which continued to be manufactured by the new firm of Kerr and Binns.

The Royal Worcester version of the design is precisely the same basic shape as the Chamberlain and Sèvres prototypes. The pierced outer wall of the cup and the border around the saucer are carved with a honeycomb pattern reserving small shield-like panels. These reserves are enamelled in bright red with cut-out and gilded circles, while the honeycomb ground is delicately shaded in pale celadon green with a single gold jewel at each intersection. The soft pink borders around the rims of the cup and the saucer are elaborately 'jewelled' with spots of coloured enamel on a gold ribbon.

Two very tricky processes have been used to create this cup and saucer. The double-walled cup is brilliantly constructed. Only the thin outer shell is pierced, so that this could actually function as a cup and saucer. The secret was to pierce the outer layer while the clay was still wet and also before the solid, inner part was added. The two walls were united by the addition of the rim before all the clay had dried. One young potter who probably began his career piercing cups and saucers such as this was George Owen. During the 1870s his skills were so advanced that he was able to create pierced patterns without the need for any moulded guidelines

Jewelling was another skilled technique first used at the Sèvres factory, this time back in the 18th century. Each jewel was created by placing a tiny drop of enamel paste on top of the gilded border. Basically formed from coloured glass powder suspended in oil, the glass melted in the heat of the enamelling kiln and left behind a jewel-like droplet of coloured glass. The enameller responsible needed great skill to know just how much enamel paste to use. A raised pimple of enamel had to be left on top of each jewel so that it melted to form an evenly-sized dome without a sunken centre. At Royal Worcester the best gilder and jeweller was Samuel Ranford and many cups and saucers of this kind bear his initials as a workman's mark underneath. The Cheekwood example is unsigned and so it is not possible to say with certainty that the jewelling is his work.[3]

1. Geoffrey Godden, *Chamberlain-Worcester Porcelain*, p. 170.
2. These were featured in an engraving in the *Illustrated London News* of 17 February 1849. In the event Jenny Lind declined the gift as she insisted her performance in concert at Worcester was to be entirely for charitable purposes.

3. Samuel Ranford collaborated with George Owen to add the jewelling to most of his finest pieces. He also jewelled the celebrated presentation set made for the Countess of Dudley's marriage in 1863.

119. Shell-shaped Centrepiece and Two Shell Ornaments

Size: Central bowl 17cm (6¹¹⁄₁₆in.) high
Date: c.1868-72
Mark: Crowned circular mark impressed on centrepiece only
Gift of Mr. and Mrs. John A. Hill, 1985.23.1-3

The modelling of these porcelain shell ornaments is rendered with remarkable realism. Royal Worcester took their inspiration from some of the finest porcelain of Italy, Germany and France and created a unique form of decoration. In turn, Worcester's lustrous porcelain shells inspired the world-famous Belleek porcelain.

In 1862 Royal Worcester exhibited their new glazed parian body for the first time at the London International Exhibition. They called it 'Capo di Monte Ware' in honour of the celebrated early Italian china factory famed for its creamy soft paste porcelain. Worcester's version was decorated using rich but soft enamel colours and a restrained use of gilding, paying homage to the enamelling used at Naples and Doccia in Italy in the 18th century. To reflect great Italian traditions, Worcester also named this ware 'Raphaelesque Porcelain'.

Some porcelain shapes modelled after shells and coral had been made in Italy a century before, at Doccia and at Capodimonte, but the centrepiece and shell dishes seen here are more directly based on a new kind of porcelain from France. In 1857 a French ceramicist, Jules Jos Henri Brianchon, had patented a process to imitate the colours and lustre of sea shells in porcelain using salts of bismuth and other metallic salts including gold. Shell centrepieces coloured in this way were manufactured by the firm of Gillet and Brianchon at Brevete near Paris.[1]

When this patent of 1857 expired Royal Worcester adopted the technique of applying a mother-of-pearl lustre finish to delicately coloured shell forms. Royal Worcester shells decorated in this way are recorded with date codes for 1868 and 1870. The lustre produced using a copy of Brianchon's patent gives the interiors of these shells a particularly warm, pink shell-like finish. The complicated chemistry involved means that Worcester pieces decorated in his manner are rare. The factory took great care to ensure that the modelling was sharp so that their porcelain shell specimens looked as realistic as possible. Indeed it is highly likely that actual shells were used to create the moulds.

Back in the Kerr and Binns period potters at Worcester had combined china made from Irish clay and parian figures in order to create the 'Shakespeare Service' for the Dublin Exhibition in 1853.[2] Experiments at Worcester to perfect a glazed parian body ultimately led to the establishment of the Belleek factory in Co. Fermanagh, Ireland.[3] Brianchon's formula using salts of bismuth to create a lustrous finish was used extensively at Belleek, although it was very rarely used at Worcester after 1870.

Shell shapes based on Worcester models such as these ornaments proved popular at Belleek where related pieces are still made to this day. Generally, though, Belleek favoured more subtle lustre colours rather than the rich Raphaelesque tones used at Worcester.

1. Discussed in the 2nd edition of William Chaffers, *Marks and Monograms on Pottery and Porcelain* (1866), p. 502. Examples of shell centrepieces by Gillet and Brianchon were in the Colin Harper Collection of Shells in Pottery and Porcelain, sold at Phillips New Bond Street, 24/25 January 1990, lots 569-571.

2. Irish materials were used as widely as possible in the manufacture of the Shakespeare set. See R.W. Binns, *Worcester China, A Record of the Work of Forty-five Years,* chapter 2.
3. Almost identical shapes to these Worcester pieces can be seen in the Belleek Pottery 'Old Photograph Album' (compiled by Fergus Cleary, 2007), pp. 22, 34 and 60.

120. Beaker-shaped Spill Vase

Size: 13.2cm (5¾in.) high
Date: c.1875-76
Mark: Crowned circular mark printed in green with indistinct date symbol beneath,
factory mark also impressed, model no. 500 impressed
Museum Purchase through the bequest of Anita Bevill McMichael Stallworth, 1992.13.13

During the great Renaissance in 16th century Italy, craftsmen took Roman designs and adapted them to suit the more flamboyant taste of the time. In the Victorian period Renaissance designs were often 'improved' further in keeping with new ideals. It is easy to criticise Victorian taste, for the aim of many designers seems to have been to squeeze as much ornament into a single object as could possibly fit, and that was before they even started on the colouring. Many beautiful classical shapes from the ancient world were spoilt by adding too much decoration and vulgar colouring. Sometimes, though, a happy medium was reached. This 'Renaissance Spill Vase' from Royal Worcester succeeds as a piece of design, thanks to the superb quality of the modelling and the restrained use of decoration. An awful lot of ornament is present in this small piece, but it manages not to be vulgar.

Around the base four winged females support the cup on single paw feet. These are probably meant to be the heads of sphinxes, mythical creatures with the face of a woman, chest, feet and tail of a lion and wings of a bird. Brazen serpents form the handles, while at the base of each is a finely modelled and gilded satyr's head. In mythology, satyrs were half man and half goat. They ran with the followers of Bacchus, the god of wine, and, together with the border of embossed vines, these imply the proper function of this cup. Similar shapes would have been used as wine cups in ancient times, but this piece has been updated, by name at least. According to Royal Worcester's shape list, Victorians were meant to use this as a holder for spills on a mantelpiece.

In a surviving Royal Worcester factory shape and costings book, model number 500 was available in at least three finishes – white, gilt and what is listed as 'cold golds'. Many different metallic finishes have been used here. Three different colours of gold are mixed with bronze, platinum and a curious effect known as 'oxidised silver'. The body itself is 'Ivory Porcelain', coated with the delicate matt enamel usually found on Worcester's copies of Japanese ivory. In terms of potting and decoration, the quality of this vase is remarkably high and it even succeeds in being tasteful too.

121. Pair of Pilgrim Vases

Size: 24cm (9⁹⁄₁₆in.) high
Date: 1874
Mark: Crowned circular marks embossed and also printed in puce with date symbols beneath,
model no. 290 incised
Museum Purchase through the bequest of Anita Bevill McMichael Stallworth, 1992.6-7

Flattened round vases were known in China and Japan as 'Moon Vases' or 'Moon Flasks' whereas in Europe they were more usually called 'Pilgrim Vases'. This name derives from the flattened shape of the water flask or bottle that was traditionally carried around the waist by pilgrims on their travels. Whatever name was used, the shape had one major advantage as decoration in a Victorian home − the flattened shape sat comfortably on a mantelpiece.

Introduced in 1872, model number 290 was listed for convenience within the Royal Worcester factory as 'Duck Pilgrim Vase'. This really is an example of 'Japanesque' decoration, for the design combines elements of Chinese and Japanese art in a manner that had become uniquely Worcester. The pair of vases features different embossed subjects on all four sides. These are possibly derived from a series of Chinese gouache paintings representing different times of the day.[1] The decoration combines underglaze colour effects with overglaze enamels and gilding, in a manner associated with Eduard Béjot. A highly talented French ceramicist and all-round decorator, Béjot mastered enamelling and gilding and also experimented with different glaze effects. He worked at Worcester intermittently from 1870[2] and his work was very influential. The Callowhill brothers, James and Thomas, learnt many techniques from Eduard Béjot and other decorators worked in his style, so a firm attribution is not possible. The factory mark on these vases is embossed, however, an unusual feature normally found only on the Worcester ornaments of the highest quality and by the most senior decorators.

1. A vase of the same shape in the Museum of Worcester Porcelain, also marked with shape no. 290, is embossed with eight different flying cranes on both sides, see Henry Sandon, *Royal Worcester Porcelain*, pl. 65, top left.
2. See Henry Sandon, *Royal Worcester Porcelain*, p. 63.

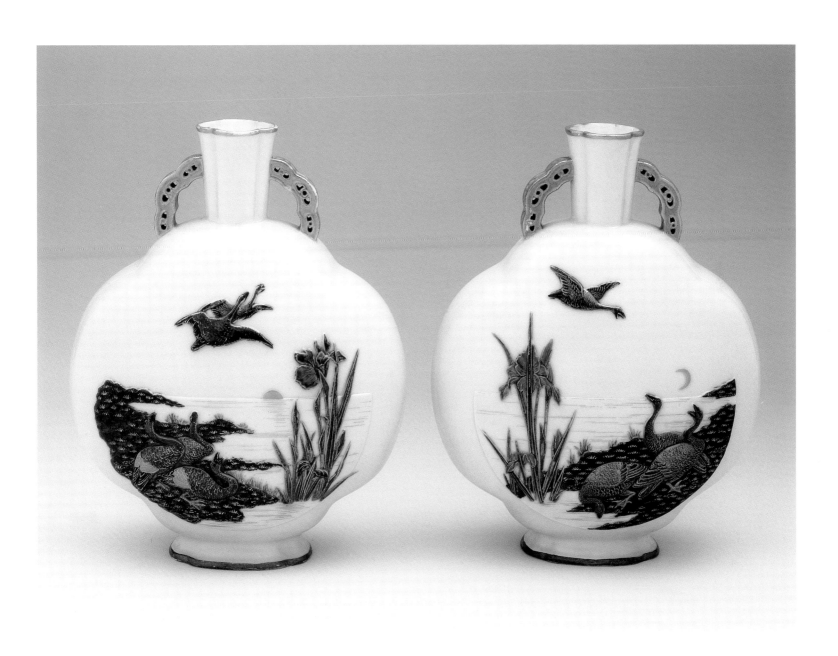

122. Figure of 'Bather Surprised'

Size: 68.5cm (27in.) high
Date: c.1875-80
Mark: Impressed crowned circular mark and stamped letter R under the base, at the back of the model
appears the moulded signature T. BROCK. Sc LONDON.1868
Museum Purchase through the bequest of Anita Bevill McMichael Stallworth, 1992.13.3

Born in Worcester in 1847, Sir Thomas Brock was educated at Worcester School of Design and started work as an apprentice in Royal Worcester's modelling department. His grandfather has been a designer at Graingers and young Thomas looked set for a career as a factory modeller.[1] Before completing the full term of his apprenticeship, however, Brock moved to London in 1866 to study with John Foley, R.A., a successful Irish sculptor of historical and contemporary portraits. Brock worked in the same subject area as his mentor and became one of the most celebrated portrait sculptors of his day. Thomas Brock received numerous commissions to carve likenesses of illustrious gentlemen. He created a few rather more exciting allegorical figures, but as a working sculptor he is best remembered for lavish memorials. His most famous work is the memorial to Queen Victoria placed before Buckingham Palace in 1901. Brock was elected to the Royal Academy in 1891, was knighted in 1911 and died in 1922.[2]

Not long after Thomas Brock moved to London he created a somewhat controversial study in marble of a nude bather. When *Bather Surprised* was first exhibited in 1868 it was well received by critics and did much to establish the reputation of the young sculptor. It was usual for eminent sculptors to sell reproduction rights for their most famous works to porcelain manufacturers. Most top sculptors favoured either the Minton or Copeland factories, but Thomas Brock was loyal to his home town and he sold the rights to *Bather Surprised* to the firm where he served his apprenticeship. Royal Worcester gave Brock's model number 486, suggesting the figure was not produced until 1875, seven years after Brock had created his original sculpture.

Royal Worcester produced *Bather Surprised* in three sizes, of which this 68.5cm (27in.) tall model was the largest. Examples could be decorated in a range of different schemes, from simple unglazed parian or plain white glaze to 'ivory porcelain' with shot silk enamels and other more lavish decoration highlighting the tree and drapery. The Cheekwood figure is an example of one of

Sir Thomas Brock in his studio, a photograph taken by Ralph Winwood Robinson, December 1889.

©NATIONAL PORTRAIT GALLERY, LONDON

Worcester's most remarkable colour schemes. This combination of terracotta and turquoise had been a feature of Worcester's display at the Vienna Exhibition in 1873 but, although it was felt to be dramatic, it did not attract universal praise. The statue is cast in terracotta, a red earthenware clay. The bather leans against a tree glazed in rich purple while her discarded robe is glazed in brilliant turquoise. The bather's modesty is protected by a thin strap picked out with delicate enamelling. Considering how Worcester were not major makers of Majolica or other forms of glazed earthenware, the way the glaze has been controlled, on the base of this figure in particular, is nothing short of remarkable. The letter **R** stamped on the base of this model may be the factory year code for 1880, but a slightly earlier date is felt to be more likely.

1. Henry Sandon, *Royal Worcester Porcelain*, pp. 121-122.

2. Thomas Brock's obituary appeared in *The Times*, 23 August 1922.

123. Pair of Japanese Figures

Size: Both models 40cm (15⅝in.) high
Date: 1878
Mark: Impressed crowned circular marks and stamped model number 2/123, printed
factory marks in puce with date letter N beneath, at the back of the female model appears
the moulded signature J Hadley S.
Museum Purchase through the bequest of Anita Bevill McMichael Stallworth, 1993.26.1

Royal Worcester's Japanese lady and gentleman caused a sensation when they were first shown at the 1873 Vienna Exhibition. Thanks to technical and artistic brilliance, Worcester had created porcelain that looked and felt exactly like ivory. Worcester's *Japanesque* display at Vienna drew a huge crowd and also attracted the attention of every reviewer and art critic. The official Austrian report praised: 'the ivory-like vases and vessels in Japanese taste... the material (the composition of Mr Binns) is most charming, and gives you the idea of beautiful old ivory; the modelling also is most excellent, and the whole exhibition calls forth an exclamation of "wonderful!" from the numerous visitors'.[1]

R.W. Binns wrote that 'The art of Japan has, in a remarkable manner, made for itself a home in the west. It has entered the drawing room and the library, the boudoir and even the nursery; for whereas English children at one time played with Dutch or French dolls, now a Japanese beauty is the object of affection'.[2] Binns himself was an avid collector of Japanese art and he displayed his pieces in a museum at the Worcester porcelain works so that they would inspire his factory craftsmen. Impressive works from the Tokyo school of ivory carving had been shown at international exhibitions in London and Paris in 1862 and 1867. It is easy to assume that the modeller, James Hadley, copied a pair of Japanese carved ivory figures from Mr Binns' collection, yet Binns made a point of telling all visitors to his exhibitions, and to his museum, that the purpose of his collection was not merely to be copied, but instead to suggest and inspire the creation of totally new works.

It is left to the viewer to decide if these are original 'Worcester' creations in Japanese style or else Japanese figures copied at Worcester. When he modelled this pair James Hadley was the senior works modeller and, as such, would turn his hand to create whatever the Art Director required – vases, teapots or figures. In the early 1870s Royal Worcester could hardly keep up with the demand for new Japanese style artefacts and Hadley was kept enormously busy.

Japanese ivories were rarely coloured. Worcester's Japanese figures are instead elaborately decorated. The colouring is inspired by a mixture of Oriental bronzes, lacquer and Japanese embroidery. The costumes are totally accurate, so there is no doubt that real Japanese robes were used to give Hadley ideas. The faces of his fine lady and proud gentleman are not really Japanese though, a fact that is clear to any Japanese visitor to this museum. Hadley did not take a cast for his heads from any original ivories or bronzes. Instead these are his interpretations of Japanese faces, combined with painted details probably by Eduard Béjot. The painting gives these faces character and shows that these are not just direct copies of old Japanese ivories.

1. R.W. Binns, *Worcester China, A Record of the Work of Forty-five Years*, p. 58.
2. Ibid., chapter 7, p. 47

124. Pair of Japanese Jugglers

Size: Both models 26.5cm (10⁵⁄₁₆in.) high
Date: 1878
Mark: Impressed crowned circular marks, also printed factory marks in puce and in green,
with date letter N beneath
Museum Purchase through the bequest of Anita Bevill McMichael Stallworth 1993.26.3ab

This pair of Japanese jugglers was modelled in 1876 and, although unsigned, there is no doubt that this is the work of James Hadley. He had left the direct employment of the Royal Worcester factory the previous year but, from his studio in Battenhall, Worcester, continued to supply the porcelain works with any models they needed, paid for on a freelance basis. The success of Worcester's 'Japanesque' porcelain at the Vienna exhibition in 1873 (see catalogue no. 123) meant that the public had an insatiable appetite for ornaments in the Japanese style. R.W. Binns continued to collect Japanese art of all kinds and, believing that the Japanese saved all their best work for America, travelled to Philadelphia in 1876 to investigate the American market for Worcester porcelain and also to purchase many exceptional pieces of Japanese ceramic art at the Centennial Exhibition. When Binns' Japanese purchases arrived back in Worcester, they were proudly displayed both to the citizens of Worcester and to the workmen at the porcelain works.[1]

Royal Worcester of course put on an impressive display of their own porcelain at Philadelphia, much of it in the Japanesque taste. A correspondent for the *New York Times* felt that Worcester's stand was one of the finest on display. The review reserved particular praise for the 'ivory porcelain', a wonder of technology and invention. The writer had no doubt been engaged in a long conversation with Mr Binns, for the article explained, 'by long and arduous labour, by the painful repetition of tedious experiments, by long lucubration and irritable midnight ponderings, the Worcester people have learned how to make a porcelain exactly like ivory in colour and consistence, that at a certain distance one cannot be told from the other. This is decorated in various ways, but chiefly by raised designs, embossed in imitation of bronze work'.[2]

Some of Worcester's Japanese models sold well, while others failed to appeal to the buying public. Some pieces were attractive and had obvious and widespread appeal, but others were perhaps too curious and found favour only with the most dedicated connoisseurs. It must be remembered that productions of this quality were expensive to make and needed to attract wealthy customers. The construction of this pair of models involved many separate moulds. Each carefully balanced ball held aloft by the jugglers forms an individual vase which could hold a flower specimen. The decoration of the jugglers' robes and the modelled border designs imitate the patina of bronze by using clever metallic effects finished off with platinum and gold. The flesh tints and facial details of the figures are carefully applied to Worcester's 'Ivory Porcelain' surface. This decoration is probably the work of Eduard Béjot who was Worcester's most respected and highly paid decorator. All this attention combined to make these a costly pair in 1878 and it is hardly surprising that very few examples of these models survive today.

1. R.W.Binns, *Worcester China, A Record of the Work of Forty-five Years*, chapter 9, pp. 61-63.
2. *New York Times*, 19 August 1876, p. 2, 'The English Porcelain'.

125. Bamboo-shaped Vase

Size: 14.5cm (5¹¹⁄₁₆in.) high
Date: 1884
Mark: Crowned circular mark printed in green, with date letter V beneath, decorator's mark CE in red
Museum Purchase through the bequest of Anita Bevill McMichael Stallworth, 1992.13.14

As Royal Worcester's 'Japanesque' porcelain received international acclaim during the 1870s, commentators singled out the 'Ivory Porcelain' for particular praise. First shown back in 1862 at the London Exhibition, 'Ivory Porcelain' was created by dusting a fine powder of matt enamel on top of an oiled surface. This ivory coloured enamel looked and felt just like real ivory from the Orient. Beneath this thin, ivory-like finish was Worcester's normal ornamental porcelain paste, a kind of parian body covered with a clear glaze.

Glazed parian had an ivory coloured tint of its own and would have been suitable for more basic imitations of Far-Eastern objects were it not for the high gloss finish. Instead of looking just like ivory, this spill vase looks more like porcelain. This was not necessarily a problem. Among a collection of Japanesque Royal Worcester, where porcelain pretended to be ivory, bronze, cloisonné or lacquer, it is actually refreshing to find a vase that doesn't try to hide the fact that it is made from beautiful white porcelain.

This spill vase is made in the shape of a section of bamboo. Normally a dark wood colour, sleeve-like sections of bamboo were hollowed out and a base was added at one end to create a vase or a 'brush pot'. In China and in Japan bamboo brushpots were used to hold the long brushes used for calligraphy. Royal Worcester's copy would have been used as a spill vase instead.

Worcester's decorative vase follows the shape of a bamboo brush pot, with bronze and gold picking out the dark outlines of bamboo leaves. A reserved panel is painted with a colourful bird perched on a hawthorn branch in tones of bronze and gold. This combines

Chinese art with a more traditional style of bird painting seen on a great deal of Royal Worcester porcelain from the 1860s and '70s. The identity of the decorator who used the initials CE is not known, but he would have been a relative junior at the factory.

126. Pair of Candlesticks

Size: 26.3cm (10⅜in.) high
Date: 1891
Mark: Crowned circular mark impressed and also printed in puce with shape no. 1050,
also impressed date letter b
Museum Purchase through the bequest of Anita Bevill McMichael Stallworth, 1992.13.8-9

The shaded decoration known as 'Blush Ivory' seems incongruous on a shape so closely associated with silver. Royal Worcester's 'Spiral Candlestick' was introduced in 1884, although the silver prototype goes back more than one hundred years earlier, from the reign of George III. The style is essentially classical, although the combination of drapery swags and paterae with beading, spiral husks and such a decorative capital would never have occurred together in any building in the classical world. Instead this is 'neo-classical', when architects and designers took elements from Greek and Roman art and created a new style that was more classical than the real thing.

Victorian silversmiths frequently copied Georgian designs precisely and so it would not be unusual to find candlesticks of this type in silver or electro-plated versions. On the other hand, porcelain copies of neo-classical silver forms are very unusual at this date. Royal Worcester have sensibly chosen plain decoration that would not contradict the symmetry of the classical form, but if their 'Blush Ivory' was meant to imitate the appearance of ancient stained ivory, it is hard to understand this combination of colouring and shape.

Very few pairs of these candlesticks were made at Worcester in the 1880s and '90s, although the shape was reintroduced in the 1950s and '60s, when very large numbers were shipped to the United States, simply and successfully decorated just in white glazed porcelain.

127. Modelled Vase

Size: 27.5cm (10¹³⁄₁₆in.) high
Date: 1886
Mark: Crowned circular mark impressed and printed in puce, date letter X also printed and impressed
with shape no. 1079, indistinct registered number, the signature J Bradley incised into the body of the vase.
Museum Purchase through the bequest of Anita Bevill McMichael Stallworth, 1992.8

A small number of vases decorated by James Bradley contain a feature not seen on any other Worcester 'Blush Ivory' porcelain – the fingerprints of the potter. This is a unique artwork, the surface individually sculpted when the clay was wet. Modelled decoration in relief is associated with Art Pottery such as Doulton's Lambeth stoneware. Sculpture in clay is suited to pottery and stoneware clay, whereas porcelain was seldom decorated in this way.

This vase is the work of James Bradley Jnr. Born c.1848, Bradley Jnr. is believed to have joined the factory as an apprentice at the very end of the Kerr and Binns period. Signed pieces show that he painted animals and birds and it is likely that he decorated many Japanesque pieces with flying storks or cranes. He taught classes on birds at the Worcester Porcelain Works Institute.[1]

This vase is in the Persian style, the form influenced by the shape of an ancient Islamic mosque lamp. R.W. Binns could not afford to purchase his own collection of early Islamic art and instead he sent his designers to the London museums to study the priceless specimens housed there. Exotic interiors based on Islamic and Mogul traditions were being constructed in modern British homes and Binns felt that this would be the next big fashion once the public tired of Japan. Some magnificent pieces were made in Persian and Indian styles, decorated in 'Stained Ivory' or 'Old Ivory' with incredible raised goldwork. The drawback, according to Binns, was that such attention to detail made the vases expensive to produce and costly for collectors.[3]

The decoration on the Persian vase at Cheekwood is curiously Oriental. A kingfisher-like bird watches a salamander on a spray of flowering water lilies, a plant known in the east as lotus. A smaller spray is carved on the reverse. Vase shape 1079 was decorated in many different ways and this corresponds with the description 'Old Ivory & Clay painted birds & Lotus' that sold for £1.7s.6d.[1] The 'clay painted' design is entirely hand modelled by James Bradley who was permitted to sign his work. This was clearly a very difficult technique and Bradley's execution is sadly lacking in the detail that Binns' ideals called out for. Very few Royal Worcester vases were made using relief carving of the clay, the Worcester factory preferring instead to leave such decoration to the Art Pottery movement.

1. Henry Sandon, *Royal Worcester Porcelain*, p. 24.
2. R.W. Binns, *Worcester China, A Record of the Work of Forty-five Years*, pp. 76-77.
3. Royal Worcester design books no. RW 4/275, p. 10.

128. Figure of an Eastern Water Carrier

Size: 44cm (17⅜in.) high
Date: 1891
Mark: Crowned circular mark impressed and also printed in puce with shape no. 594, also impressed and printed date letter X and titled 'Patent Metallic', moulded signature J Hadley at the back of the model
Museum Purchase through the bequest of Anita Bevill McMichael Stallworth, 1992.13.15

Visitors to the Royal Academy exhibitions during the 1860s to 1880s could have learnt all about exotic foreign lands from the work of artists who had been there. From the hazy interior of a souk to a crowded slave market, every colourful mystery of the Arabic world was revealed. Traders sell their carpets and trinkets in the bazaars and street markets, while in the mosques and the harems sultans and potentates, dressed in their fineries, inhabit a land totally alien to quiet Kensington or suburban Surrey.

Most of the exotic scenes were imaginary, for few artists had the opportunity to travel in the Middle East. James Hadley never left British shores, yet this didn't stop him from creating images of life in far away Japan, China, Russia, Africa and all over the Middle East. Hadley was just a factory craftsman, a skilful copyist armed with a fertile imagination. A truly versatile sculptor, Hadley could turn his hand to whatever subject Mr. Binns, the Art Director at Royal Worcester, thought would sell. Working as a freelance sculptor in his own studio at Worcester,[1] Hadley was a commercial artist. Unlike Sir Thomas Brock, who worked alongside Hadley early in his career (see catalogue no. 122), James Hadley never sought fame in London. His work wasn't cast in bronze nor shown at the Royal Academy. Instead his work was intended for mass production in the medium of fine porcelain. Once Hadley was paid a fee for each model he

was no longer concerned about how many were made, or how well they were decorated.

He had no reason to worry. Binns knew that the reputation of his factory depended on cutting no corners. The moulds were duplicated and replaced continually, so every detail of the original model was reproduced again and again without losing any definition. Customers were given a choice. Decoration could be a simple wash of ivory with slight colouring on the costume, or it could be lavish, rich and splendid, dripping with gold. Either way, the decoration always complemented Hadley's modelling.

The 'Eastern Water Carrier' is one of a pair of a male and female. The title does not imply any nationality or status. Dressed in a simple fez, the man's costume is basic but smart, not ragged. This nomadic figure comes from no particular part of the Middle East. He has brought water in a jug made from animal skin and pours it into a jar. His clothes are finished in gold and coloured washes of enamel on top of a simulated bronze effect, a particularly accomplished form of decoration called 'Patent Metallic'. Meanwhile his face, hands and legs are in 'Ivory Porcelain'. This tells us where Royal Worcester got their ideas from.

Figures made of bronze and ivory were a speciality of Bohemia and associated with Vienna. Firms such as Bergman cast figures in bronze and painted them to add realistic colouring. Heads, hands and feet were hand carved from ivory. Popular from the 1880s, Bergman's painted bronze figures were sold all over the world. Cheaper copies were made in Austria and Bohemia using either terracotta or a soft white metal called spelter instead of bronze. The surfaces of these copies were coloured to look like the more costly painted bronzes. Royal Worcester's 'Eastern Water Carrier' is another copy, but it is far superior to the Austrian terracotta versions. This may not be bronze, but technically and artistically it is every bit as fine and just as exotic.

1. Henry Sandon, *Royal Worcester Porcelain*, p. 124.

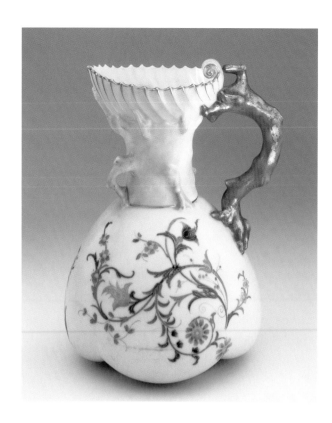

129. Coral Handled Jug

Size: 20.8cm (8⅛in.) high
Date: 1891
Mark: Crowned circular mark printed in puce with Royal Worcester England, shape no. 1507,
various decorators' marks including JB cipher in red
Gift of Mrs. Robert Goodin, 1996.5

During the Renaissance natural objects such as sea shells and coral were combined with ivory and mounted in gold to create works of art. Such ornamental ewers were intended for a collector's cabinet, far too precious to use. On the other hand, Royal Worcester's copy from the Victorian period was intended to be functional – a jug for milk, water or wine – anything you wanted to pour from it. Of course you didn't have to use your jug. Many were put away for safety and this is how they survive.

The 'Coral Handled Jug' came in five different sizes. You could buy just a single jug, or a pair, or a set in graduated sizes. The colouring on this example is true to its name, the gnarled branch shaded in rich coral red to look like a precious stem from the sea. The rim is shaped like an upturned clam shell, shaded in a warm tone known at Worcester as 'Blush Ivory', while the body is in a pale colour known as 'Ivory Porcelain'.

Made in enormous numbers, coral handled jugs were normally decorated just with printed flowers. This example is unusual in having individually drawn ornament. The floral tracery resembles the pattern of an illuminated manuscript and may be the work of William Moore Binns or his brother, Charles Fergus Binns. Two sons of the senior director, Richard William Binns, both spent much of their working lives under their father's shadow. Both sons became unofficial deputy art directors and provided a limited number of designs for porcelain decoration.[1] C.F. Binns left the factory in 1897, emigrating to America where he became a very important ceramicist. In 1900 W.M. Binns succeeded his father as Art Director at Worcester.

1. Illuminated addresses illustrated by both C.F. Binns and W.M. Binns survive at Worcester. See Henry Sandon, *Royal Worcester Porcelain*, pp. 24 and 30.

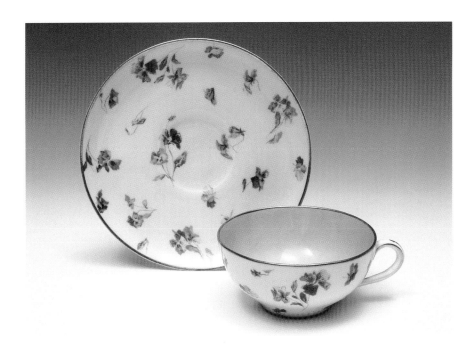

130. Cup and Saucer

Size: Saucer 11.5cm (4½in.) diameter
Date: 1891
Mark: Crowned circular mark printed in puce with Royal Worcester England,
retailer's mark 'Made for Caldwell Philadelphia'
Gift of Mr. and Mrs. Albert Werthan, 1989.5

There is a tendency to regard colour printing as a cheap and therefore inferior form of decoration. Individual hand painting was costly and back in 1890 lithography was seen as an inexpensive substitute, but it was also possible to create good design using the new technology.

When Royal Worcester produced this thinly potted teacup colour printing was new. The process was complicated, involving etching a series of stone slabs, one for each colour, and one after the other the different colours were printed on to a single sheet of printing paper, usually a thin film of celluloid. Sheets of printed flowers were then cut up and the yellow, purple and blue violets were applied individually to the varnished surface of the saucer and exterior of the cup. The decoration was then fired in an enamelling kiln.[1]

It is sometimes necessary to look very closely to tell if the decoration is printed and not painted by hand. Under a magnifying glass the shading of the flowers is made up of tiny dots or stippling. Perhaps the biggest giveaway,

though, is the duplication of the same flowers. Identical sprigs are repeated on the cup and on the saucer.

This cup and saucer originally formed part of an afternoon tea service. Pale primrose yellow and pink grounds with pretty flowers is very feminine decoration and we know from family history that this was purchased by the grandmother of the present owner who donated this one piece to Cheekwood. The set wasn't ordered from Worcester but instead came from a specialist department store in Philadelphia.

James E. Caldwell, a watchmaker from New York State, moved to Philadelphia around 1835 and established a watch and jewellery business. The company thrived and is still in business today in Philadelphia with branch stores throughout the region. J.E. Caldwell & Co. served Philadelphia's wealthiest old families, claiming to supply 'beautiful objects [that could be] relied on, and when once bought will be worth keeping'.[2] By the 1890s the company's grand store on Chestnut Street sold the finest imported porcelain. Deliveries were made to the city's mansions in the firm's distinctive maroon coloured carriages.

1. The introduction of lithographic printing at Worcester around 1890 is discussed by Henry Sandon, *Royal Worcester Porcelain*, pp. 26-27.

2. Linde Meyer. *The J.E. Caldwell Story: When Once Bought, Worth Keeping*. New York: J.E. Caldwell Co. and the Newcomen Society, 1989, p. 11

131. Spill Vase

Size: 12cm (4⅝in.) high
Date: 1894
Mark: Crowned circular mark printed in puce with year code (three dots), shape no. 956
Museum Purchase through the bequest of Anita Bevill McMichael Stallworth, 1992.13.10

By the 1890s Royal Worcester's original 'Ivory Porcelain' had been almost completely superseded by the heavily shaded decoration known as 'Blush Ivory'. Royal Worcester had made so many different effects based on the appearance of carved ivory from the Orient that the terminology becomes very confused.[1] Their original 'Ivory Porcelain' used from the Kerr and Binns period into the 1860s and '70s was pale with no attempt at shading whatsoever. This was sometimes called 'Cream Ivory'. With added shading to give an antique look to the ivory finish, the firm developed 'Old Ivory' and 'Stained Ivory', represented in this collection by the carved vase, catalogue no. 127. For a more decorative effect, a rose pink colour was added to provide contrast to the paler ivory body, while at the other end of the spectrum a pale primrose yellow was used.

'Blush Ivory' no longer resembles the natural appearance of even the most archaic elephant ivory. In some ways it is closer to the appearance of a popular type of Art Glass patented by a leading Stourbridge glass firm, Thomas Webb and Sons. Webbs' 'Queen's Burmese Ware' is usually known as 'Burmese Glass'.[2] This has a matt finish and is gradually shaded from deep cranberry pink to pale cream and then yellow. Webbs used Burmese glass for the shades of nightlights. Many of these were marketed by the firm of Clarke's who made a popular kind of small tealight candle called a 'Fairy Light'. Some of James Hadley's large Royal Worcester figures were mounted by the 'Cricklite' company as bases for Clarke's fairy lights and were supplied with Webbs' Burmese glass shades. Possibly in an attempt to match the effect of the Burmese glass, Royal Worcester added pink to its shaded ivory porcelain and found that the public loved it. 'Blush Ivory' had arrived.

During the last decade of the 19th century the Worcester factory made a simply staggering amount of jugs and vases decorated in this way. The shading was initially created by brushing oil on to the surface of the porcelain and then dusting on a fine powdered colour. As production increased, a new technique called 'aerographing' used a fine spray instead of a brush to apply the oil. This speeded up production and resulted in more gentle shading of the peach or apricot and ivory tones. The public sometimes called Worcester's 'Blush Ivory' 'Peach Ware' or 'Biscuit Ware' and these terms are used by collectors today, but these were not the Royal Worcester factory's own names.

'Blush Ivory' was mostly used on plain shapes and usually coloured-in flower prints were added as decoration. This intricately modelled spill vase shape was introduced in 1883 and earlier examples were made in 'Old Ivory' to imitate the appearance of a Chinese carved ivory brushpot. A decade later the public only wanted 'Blush Ivory' and so the colouring here has been updated. The moulding includes tiny figures among pine trees and there is a distant pagoda on the reverse. Handles are created from gnarled pine branches which give this vase a curious, almost ghost-like appearance.

1. For a simple classification of Worcester's ivory grounds see Henry Sandon, *Royal Worcester Porcelain*, p. xxvi-xxvii.
2. Burmese glass is discussed by Charles Hajdamach, *British Glass 1800-1914*, Antique Collectors' Club, 1991.

132. Part of a Game Service

Size: Covered serving tureen 34.9cm (13¾inches) long, plates 27cm (10⅝in.) and 23.5cm (9¼in.) diameter
Date: 1902 (plate) and 1879 (tureen)
Mark: Impressed crown with *WORCESTER* underneath. Pattern number B761 painted in red.
Printed factory mark in puce with retailer's mark for Richard Briggs of Boston
Gift of Michael Ryan King in memory of Dr. and Mrs. Roland Lamb 2004.5-8

When admiring the workmanship of Worcester's finest porcelain vases and figures it is easy to forget the other side of the coin. Rich ornamental porcelain is costly to manufacture. Most china factories derive far more profit from their 'bread and butter' production of everyday tableware, toilet sets and dinner services. Firms like Royal Worcester relied on its staple productions to earn the profit that would subsidise the manufacture of exhibition quality display porcelain.

Royal Worcester was primarily a maker of fine porcelain. Pottery or earthenware was rather more the domain of other manufacturers in Staffordshire. This set is therefore a surprising variation from the norm. Royal Worcester called its basic pottery body either 'Crown Ware' or 'Vitreous Ware'.

These few pieces at Cheekwood represent what was originally a full table service with colourful decoration printed in outline and coloured in by hand. The centre of each plate is printed with a different game bird and this provides a vital clue as to how the set was originally used.

During the Victorian period there was a strong belief in the ideology that design should mirror function. Game birds such as partridges and grouse were popular hunting trophies and this set would have been appropriate for owners of a country house to entertain the guests invited to a shooting party.

Pattern number 761 was introduced in the early 1880s and the design is appropriate for this period, combining a formal Victorian border with birds on flowering branches clearly inspired by Japan. Curiously, the date mark on the plates at Cheekwood shows that these were not manufactured until two decades later. These bear the name of the retailer where this particular set was purchased. Richard Briggs took over his family's china and glass business in Boston in 1861. Started in the eighteenth century, the firm catered to the upper echelon of old Boston society. Ralph Waldo Emerson, Harriet Beecher Stowe and Jenny Lind ranked among the famous customers who patronised the Washington Street store.[1]

1. For more on Briggs' trade see Regina Lee Blaszczyk, *Imagining Consumers: Design and Innovation from Wedgwood to Corning*, Baltimore and London: Johns Hopkins University Press, 2000. pp 33-40.

133. Two Military Figures

Size: 18.7cm (7⅜in.) and 19.4cm (7⅝in.) high
Date: Black Watch soldier 1912, Territorial soldier 1915
Mark: Crowned circular marks and ROYAL WORCESTER ENGLAND printed in puce,
shape nos. 2109 and 2588, printed titles 'Black Watch' and 'Territorial Soldier'
Museum Purchase through the bequest of Anita Bevill McMichael Stallworth, 1992.13.6-7

The South African War of 1899-1902 pitted Great Britain against two independent republics, the Transvaal and the Orange Free State, populated by Afrikaners or Boers, the descendants of Dutch colonists. As different European nations fought for control of African colonies, these original settlers had retained the right to self-government. The discovery of gold and other factors triggered a large influx of foreign miners and the resulting friction slowly declined into war. The Afrikaners scored early successes and the British answered with increased troops from Great Britain and its Commonwealth members Canada, Australia and New Zealand. More than 365,000 British and Commonwealth troops were deployed but, by the time sovereignty over the republics was gained in 1902, the allies had suffered 21,000 casualties, many of whom died from disease.[1]

The South African War was reported at the time by the mass media of newspapers. The British public was able to read up-to-date accounts and see battlefield photographs bringing the war to every home; they could follow the exploits of the different regiments. To coincide with the appetite for war reporting, Royal Worcester issued in 1900 a series of six figures of soldiers in the uniforms of the principal regiments. The shaded bronze and gold effects Royal Worcester had used for so many of James Hadley's figures were ideally suited to the khaki uniform

of the Officer of the Black Watch, while 'Ivory Porcelain' was used for the face and hands. The models are believed to be the work of George Evans. Although they were expensive to produce, the figures appealed to patriotism and were bought by affluent families whose sons had volunteered to fight for Queen and Country.[2]

The series performed well at the time and even after the war some of the soldier figures continued to sell even a decade later. The Black Watch figure at Cheekwood was made in 1912, when the style would have seemed old-fashioned. The interest these figures continued to generate was remembered two years later at the start of the First World War when patriotism and the rush to enlist inspired the Worcester factory to add to the series. In 1914 and 1915 three more figures were created. One was an appropriate model of an officer of the Worcestershire Regiment; the others were a French soldier and the Territorial Soldier seen here at Cheekwood.[3] The figures were once again issued in the correct uniforms of their regiments coloured in the matt greens and browns of earlier years.

The Cheekwood Territorial figure was made in 1915 by which time the horrors of the Great War had been reported along with the enormous casualties. The public no longer wanted romanticised images of officers in clean and tidy uniforms and hardly anyone bought Royal Worcester's soldiers. The First World War series is therefore amongst the rarest of all Worcester figure models.

1. Michael Clodfelter, *Warfare and Armed Conflicts: A Statistical Reference to Casualty and Other Figure, 1500-2000*. 2nd ed., Jefferson, NC and London: McFarland & Co., 2002, p. 238.

2. David Sandon, John Sandon, and Henry Sandon, *The Sandon Guide to Royal Worcester Figures 1900-1970*, Edmonton: The Alderman Press, 1987, pp. 10-11.
3. Ibid., p. 67.

134. Lyre Clock

Size: 44.5cm (17½in.) high
Date: 1907
Mark: Crowned circular mark printed in puce with **ROYAL WORCESTER ENGLAND**, date code (16 dots) for 1907, with shape no. 1385, also registration number 130273, impressed letter A
Museum Purchase through the bequest of Anita Bevill McMichael Stallworth, 1993.26.2

When this clock case was modelled at Royal Worcester in 1889 this was the height of fashion. Lyre clocks in enamel, polished wood and heavily gilded ormolu were all the rage, loosely based on examples made for the French court of Louis XVI. A famous 18th century model has been updated by adding as much modelled ornament as possible. Flamboyant, splendid and totally over-the-top, this is High Victorian taste in the extreme and, in the field of fine porcelain, the Worcester factory was among the greatest exponents.

The surprise here, however, is the date when this example was created. The year code of dots around the factory mark reveals that this was decorated and sold in 1907. This means it was made well into the era of Art Nouveau. Named after a famous pavilion at the Paris Exhibition in 1900, Art Nouveau didn't happen overnight, but was a gradual reaction against the taste in art typified by this lyre clock. Taking its lead from plants and natural objects, Art Nouveau was all about plain forms without symmetry. In British ceramics it was epitomised by Doulton's stoneware and Moorcroft's brightly glazed earthenware. Royal Worcester's great rival, the Minton factory, switched production from old-fashioned Majolica to new 'Secessionist' style pottery. Suddenly at the start of the 20th century Worcester found itself left behind.

In Worcester the year 1900 was marked by the death of Mr. Binns and James Hadley died three years later. They might have been capable of moving with the times, but without artistic leadership Royal Worcester made the mistake of resting on its laurels. The works had been in a similar situation sixty years earlier, but it failed to learn lessons from past failings. In 1907 Royal Worcester was mostly making old-fashioned shapes decorated in 'Blush Ivory'. The clay mark on this clock suggests that it was cast in 1903 but, without any orders, it was not finished with gilding until four years later. The factory's estimate book shows that when this shape was introduced in 1889 a version decorated in 'Stained Ivory' and green cost £5.10s, while the decoration listed as 'Shaded Bronzes' cost £5. The clock

movement inside the case probably doubled the cost, so by the time this went on sale in the department stores of London, New York or Sydney it would have been a very expensive commodity.

R.W. Binns had been succeeded as Art Director by his son, W. Moore Binns. The works rapidly declined artistically and survived purely on its past reputation and on the popularity of painted vases by the Stintons, Harry Davis and Charley Baldwyn. Desperate for new ideas, in 1915 Royal Worcester engaged as their new Art Director a leading designer from Minton. John Wadsworth had been responsible for bringing the 'Secessionist' style of Art Nouveau pottery to England. One of Wadsworth's first acts as Art Director at Worcester was to discontinue all Hadley style figures. All other Victorian ornaments such as lyre clocks were condemned to history.

135. Pair of Miniature Vases

Size: 3.5cm (1⅜in.) high
Date: c.1922-23
Mark: Crowned circular marks printed in gold, the painted panels signed G Johnson
Previously in the Henry and Barbara Sandon collection
Museum Purchase through the bequest of Anita Bevill McMichael Stallworth, 1994.11.4

In 1921 Princess Marie Louise, a cousin of King George V and best friend of his wife, Queen Mary, approached architect Sir Edwin Lutyens with an idea for a gift to the Queen. Queen Mary was well known for her love of collecting antiques and small objects of art in particular. The Princess believed a doll's house would be a perfect present to give to a queen who loved all things in miniature. Lutyens was carried away with the idea and expanded it into a grand house filled with every product for a royal household. He commissioned the best craftsmen throughout Britain to make the household objects in a 1 to 12 scale. Queen Mary was thrilled at the idea and determined to be involved in every aspect of the design and commissioning of the furnishings. Completed in 1924, the house stands five feet tall (1.5m) with over forty furnished rooms complete with running hot and cold water and electric lights.[1] From the fully-stocked wine cellar to the working models of cars in the garages, Queen Mary's Doll's House provides us with a perfectly preserved time capsule of British life between the wars.

Most Royal Warrant holders were approached to make miniature versions of the products for which they were famous. Other porcelain makers including Minton, Royal Doulton and Royal Cauldon made dinner sets and toilet ware. Royal Worcester was asked to supply pairs of vases for two mantelpieces and chose to reproduce a pair of vases in the Royal Collection of which they knew Queen Mary was fond.

One important function of the Doll's House was to raise money for charity, charging visitors who queued up to marvel at the minuscule spectacle. The completed doll's house was first shown at the British Empire Exhibition at Wembley in 1924 and attracted more than 1.6million visitors. Most suppliers did not expect payment for their contributions, but instead they were allowed to make duplicates which they could exhibit in their own shops and museums. A limited number of duplicates could be sold or else were given to important customers. The Cheekwood pair is an exact duplicate of the pair of vases made for the marble chimneypiece in the Saloon or Drawing Room of Lutyens' doll's house. Another pair features in the King's Bedroom. Visitors can still see these in Queen Mary's Doll's House, now open to the public in its permanent home in Windsor Castle.

The duplicate pair of vases at Cheekwood is housed in its own fitted presentation case, although it is not known for whom this was made. It reproduces a pair of hexagonal covered vases with scale blue grounds and panels of 'Fancy Birds', very similar to the vase from 1768, catalogue no. 40. The tiny copies are so exact that it is possible to make out individually painted scales in the underglaze blue ground. On both sides of each vase a reserved panel or cartouche is painted with 'Fancy Birds' in colourful enamels. During his long career as a bird painter at Worcester, George Johnson had specialised in copying these exotic birds from 18th century prototypes. George Johnson was a very tall man, with large hands, and so working on such a minute scale will have presented a particular challenge.[2] It is interesting to observe that he was one of the few craftsmen allowed to sign his name on a production for the doll's house.

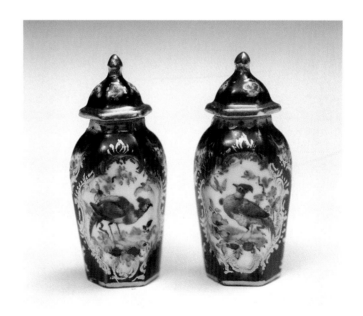

1. See Mary Stewart-Wilson, *Queen Mary's Dolls' House*, London: 1988.
2. H. Sandon, *Royal Worcester*, p.96. A similar pair of Queen Mary's Doll's House vases is in the Museum of Worcester Porcelain.

136. Painted Dessert Plate

Size: 23.7cm (9⁹⁄₁₆in.) diameter
Date: 1925
Mark: Factory mark printed in gold with date code for 1925, the painting signed H Davis
Museum Purchase through the bequest of Anita Bevill McMichael Stallworth, 1994.3.2

Known to cricket fans as 'Ranji', Colonel His Highness Shri Ranjitsinhji Vibhaji was the Maharajah Jam Saheb of Nawanagar. An Indian maharajah playing cricket for an English county team sounds like a story from a *Boy's Own* comic book, and so it is hardly surprising Ranjitsinhji's exploits on the cricket field became legendary.

Born in 1872 into a life of enormous privilege, Ranjitsinhji's family owned several exotic estates in India. Like many Indian princes, Ranjitsinhji was educated in England and while studying at Trinity College in Cambridge he showed his talent with a cricket bat. In 1894 he joined Sussex County Cricket Club, eventually scoring 25,000 runs during an illustrious career of five hundred First Class innings. He was selected to play for England in many of the greatest Test series.

Ranjitsinhji shared his time between his palaces and estates in India and his English country estate near Staines. As a county cricketer he visited Worcester on many occasions, whenever Worcestershire played Sussex at the New Road ground in the shadow of Worcester cathedral. In 1923, during one of these visits to Worcester, Ranjitsinhji ordered several different Royal Worcester porcelain services including two very special dessert services. The sets took two years to complete.

The centres of the plates and comports were painted with extensive scenes by Worcester's finest painter, Harry Davis. One set was to be used when Ranjitsinhji was in India, and this was painted with views around Sussex and scenes of Ranjitsinhji's Staines estate which he had renamed Jamnagar House. The other set was to be used when he was in England and this was intended to remind Ranjitsinhji of his estates in India. Forty years later Harry

Davis remembered the curious task he was set. Presented with a series of black and white photographs and a few coloured prints to give an impression of the Indian backdrop at different times of day, Harry had to create in his imagination the atmosphere of the Indian life which Ranjitsinhji knew so well. How could Harry Davis, who had barely left the City of Worcester, imagine sunset over a temple in far away Ghoomli, Bandh and Jamnagar? These were sites where Ranjitsinhji's ancestors had lived and he had recently spent part of his vast fortune restoring many of the ancient buildings.

Harry Davis was very fond of cricket and had often seen Ranji play. He was determined to do full justice to this extraordinary commission. For many years a single duplicate plate with one of the Sussex views, preserved in the Worcester factory pattern room, was the only surviving record of the Ranjitsinhji services. Ranjitsinhji's English estate, Jamnagar House, was sold following his death in 1933. Five plates with Indian views turned up undescribed in an auction in England in 1987 and their importance was recognised by a ceramic historian.[1] One of these was subsequently acquired for the collection at Cheekwood.[2] It shows washerwomen at Bandh, near Nawanagar, the scene bathed in early morning light. It is signed neatly H Davis and, like the rest of this remarkable service, the factory mark is printed in gold.

Harry Davis is regarded by many as the finest English porcelain painter of his generation. He received little in the way of formal art training. His father and grandfather had worked at Royal Worcester and because Harry showed talent with a brush from a young age he was apprenticed as a china painter at the factory in 1898. He was just fourteen. His early work was inspired by Claude Lorraine and Corot, while also showing a huge debt to his tutor and mentor at the Worcester factory, the landscape painter Edward Salter. Salter's premature death in 1902 brought Harry's apprenticeship to an abrupt end and he rightly took his place among the senior painters. A most versatile artist, Harry Davis could turn his hand to just about any subject. Every painting was rendered with a perfect understanding of the difficult technique of ceramic colour fused on to porcelain glaze. Harry became foreman painter and taught and inspired several new generations of china painters. He finally retired in 1969 after a career of seventy years.[3]

1. The Ranjitsinhji services are discussed by Jonathan Gray, 'The Perfect Match', *Antique Dealer and Collector's Guide*, December 1987.

2. This and four others were offered for sale at Phillips (now Bonhams) in New Bond Street, 2 March 1994, lots 476-480.

3. Henry Sandon, *Royal Worcester Porcelain*.

137. Posy Vase

Size: 6.8cm (2⅝in.) high
Date: 1929
Mark: Factory mark printed in puce, shape number G161
Gift of Dr and Mrs E. William Ewers, 1984.26.5

Within a manufacturing industry relying on mass sales, popular products have to be reproduced again and again with monotonous repetition. Craftsmanship becomes mechanical and there can often be little room for individual artistic expression. The scene painted on this small globular vase is a pleasant painting by a famous hand. James Stinton has signed his work and it is tempting therefore to think of this as the work of an artist. This is not how the painter himself will have seen things, however.

During his long career at the Royal Worcester factory, James Stinton painted this same subject – indeed this exact composition – thousands and thousands of times. There is therefore precious little artistry evident in this piece. Instead it is the work of a factory craftsman, paid on a piece-by-piece basis. As long as Royal Worcester received orders for painted pheasants on vases and cups and saucers, James Stinton was kept fully employed. The faster he could paint, the more money he would earn. The painting on this little vase is, therefore, almost mechanical. James Stinton was the machine employed by the factory to churn out as many identical vases as possible.

Each of the senior painters at Royal Worcester had their own subject which they fiercely protected, for it represented their livelihood. Scottish scenes with sheep were always painted by Harry Davis. Whenever an order was received for a painting of a Highland scene with cattle, it was passed to John Stinton who in turn allowed his son Harry Stinton to paint smaller pieces with Highland cattle. John Stinton's brother, James, was not allowed to paint sheep or cattle. Instead his subject was game birds, and pheasants in particular. Nobody else was permitted to copy his subject and deprive James Stinton of his earnings.

James Stinton began his career at the Grainger factory in Worcester. His father, John Stinton Snr., had been the principal landscape painter at Graingers during the 1870s. He taught three of his sons to paint landscapes also. Earlier pieces of Grainger porcelain painted by the three sons cannot be distinguished from one another as their work was never signed. Gradually John Stinton Jnr. and James Stinton developed more individual subjects, building their landscape compositions around prominent cattle or game birds. When Graingers was absorbed by the Royal Worcester factory, James and John Stinton simply moved across the city and carried on painting as before. The shape of this little vase was one of many inherited by Royal Worcester from the Grainger factory.

James Stinton painted pheasants at Royal Worcester until his retirement in 1951. Although he was kept busy with orders for his bird painting, he earned relatively little for his was a craftsman's wage. To supplement his income James took on a different role as an artist in his spare time. His ability to paint quickly allowed him to produce hand-painted watercolours of pheasants and other game birds and he sold huge numbers of these for a few shilling each around local pubs, clubs and shops. His many surviving watercolours show that this Worcester factory craftsman really was a talented artist after all. This skill is of course evident from every one of his painted vases, plates and coffee cups.

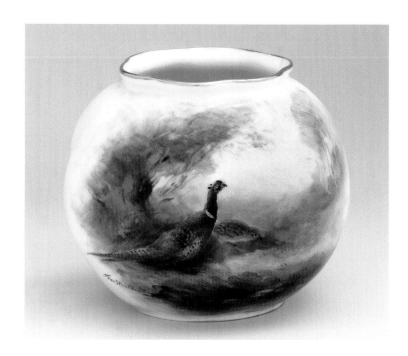

138. Pair of Vases by Charley Baldwyn

Size: 33.6cm (13⅜in.) tall x 10.8cm (4⅛in.) diameter
Date: 1898
Mark: Factory marks printed in dark green with date codes, shape number 1935, both signed in the decoration C Baldwyn
Gift of Mr. and Mrs. Clay Jackson, 2005.1

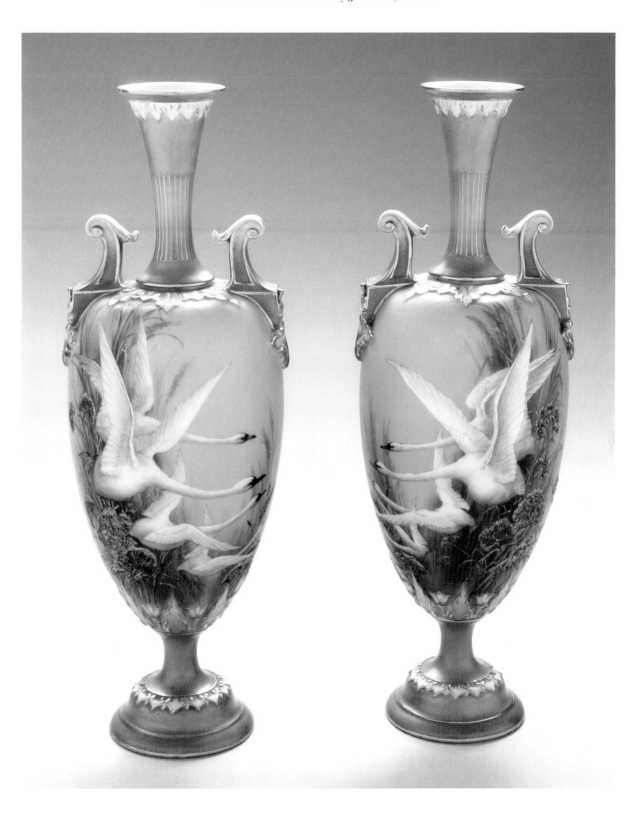

Charles Henry Clifford Baldwyn was a highly talented bird artist. His watercolour of 'Teazles', shown at the Royal Academy in 1887,[1] is outstanding, both in its composition and in the painted detail, for Baldwyn was a master at depicting the texture of foliage and plumage.

Charley was born into a relatively humble family of musicians and while young Charley enjoyed music, his real passion was studying and sketching wild birds.[2] His father tuned pianos for a living and so could not afford to send Charley to college for formal art training. Instead at the age of fifteen in 1874 he was apprenticed as a china painter at the Worcester Porcelain factory. During the 1880s and '90s Baldwyn painted naturalistic birds on teasets and in border panels of plates, some of which were shown at the Chicago Exhibition in 1893. The Worcester factory's great success at the time was 'Japanesque' porcelain. Baldwyn was asked to copy designs from Binns' Japanese collection (see catalogue no. 123) and painted birds silhouetted against moonlight. Usually placed on an ivory ground, some of the detail was picked out in tooled gilding. These patterns were not entirely naturalistic, of course, but they were very dramatic. Some vases featured swans in flight with the moon behind.

Around 1897 someone has the idea of replacing the moonlight with a matt sky blue ground. Flowers in white enamel and gold had already been painted on this background, and now popular white birds were chosen – doves, swans and even cockatoos, each painted by Charley Baldwyn. The swans were an instant success and orders came flooding in. It has been suggested that Baldwyn was influenced by the swans on the River Severn, a permanent feature swimming in the shadow of Worcester Cathedral just a stone's throw from the porcelain factory. In reality, the inspiration for this artist's most famous work came straight from Japan. Using a curious decorating technique, the swans are highly stylised. The matt blue enamel background was 'dusted' on to the porcelain surface as a fine powder that adhered to sticky oil. It was not possible to apply white enamel on top of this blue powder and instead the outline of the swans was picked out first using a resist technique. The white of the swans is the white glaze of the porcelain itself beneath a gentle dusting of matt white powder. Fine grey brushstrokes emphasise the texture of feathers and wings.

These dramatic vases represent the difference between artistry and craftsmanship in Worcester porcelain. Charley Baldwyn could paint real birds with unrivalled naturalism, but instead he spent every hour of the day creating a formulaic pattern. This is how factory china painters worked. The flying swans were Baldwyn's allotted pattern and he was the only painter at the factory allowed to use this pattern. When orders came in for flying swans, Baldwyn painted them and earned a comfortable living wage based on a few shillings per vase. This is craftsmanship plain and simple.

For a period of six or seven years Charley Baldwyn painted virtually nothing but flying swans. The pattern was so successful that by a curious piece of irony porcelain makers in Japan made copies of Baldwyn's swans. Fortunately, back in 1893, Royal Worcester had the foresight to register the pattern at Stationers' Hall[3] and this saw off other competition, keeping Charley fully employed. During what little remained of his own time he painted watercolours featuring the real birds he so adored. Eventually frustrations came to a head and he resigned from Royal Worcester in 1904 to concentrate on painting other birds and landscapes in watercolour. He employed an agent to sell his paintings and it is believed that he also did occasional freelance work for the Worcester factory until 1909. Vases with his swan paintings are recorded with date codes up until 1906. He died in 1943.

This wonderful pair of vases is a most appropriate addition to the collection at Cheekwood, for every year the institution hosts the Swan Ball, its annual fundraiser.

One of the swallows painted on the reverse of these vases.

1. Illustrated by Henry Sandon, *Royal Worcester Porcelain*, pl. 124
2. Some of his bird sketches are illustrated by Henry Sandon, op.cit., col. pl. 8
3. A copy of the registration document is at the Museum of Worcester Porcelain.

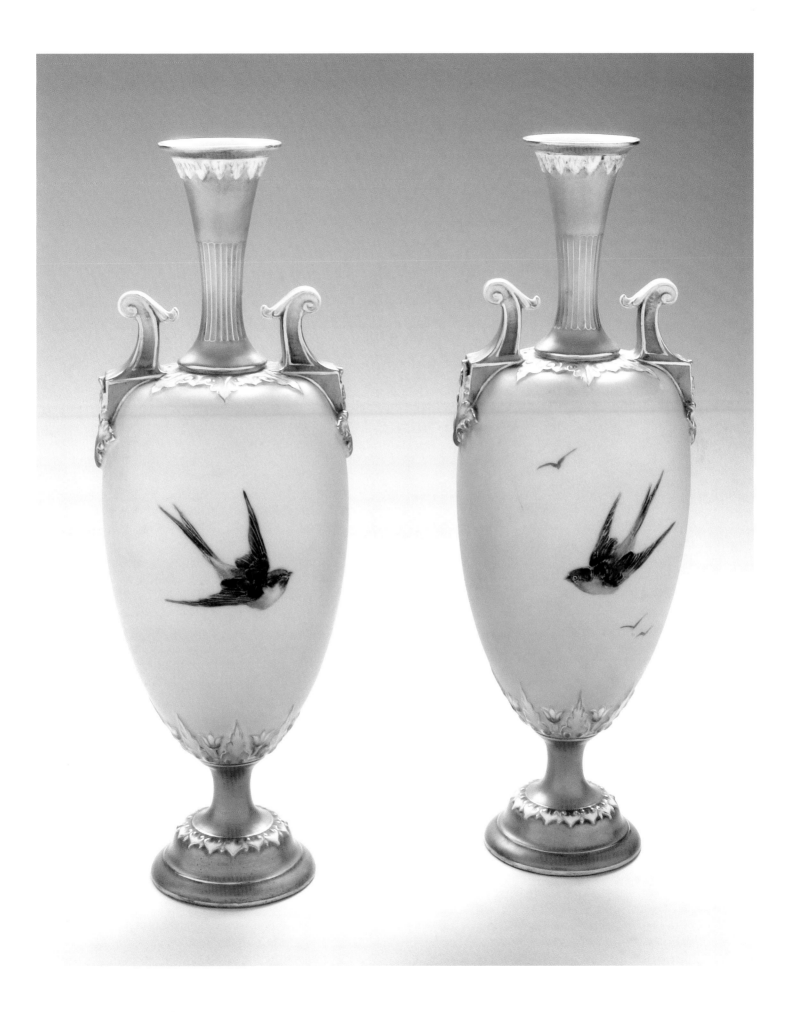

139. Pair of Doughty Birds, The Mockingbirds on Peach Blossom

Size: cock 29.2cm (11.½in.) tall, hen 28.1cm (11⅛in.) tall
Date: 1940
Mark: Factory marks printed in black with date code and facsimile signature D Doughty,
mark of the publisher Alex Dickens
Bequest of Anita Bevill McMichael Stallworth, 1987.2.2ab

The State bird of Tennessee, this pair of Mockingbirds on Peach Blossom is part of an extensive collection of the American 'Doughty Birds' at Cheekwood. The story of the American Birds is one of foresight and determination, for, in order to create this incredible set of porcelain sculptures, potters at Royal Worcester had to develop ground-breaking technology. Nothing like these had ever been made in porcelain before.

The story began in the mind of Alex Dickens, an American art publisher. He had previously commissioned Royal Worcester to make a set of plates decorated with copies of Audubon bird prints, issued as 'Limited Editions'.[1] Back in the 1930s the idea of making only a predetermined number of plates or models was a relatively new concept. Many German porcelain factories had made bird models but with a shiny glaze that destroyed their realism. Dickens asked Royal Worcester if they could create a set of American birds with a matt finish that looked more natural. Art Director Joe Gimson accepted the challenge and set about finding a skilled modeller. In the event his choice was a stroke of genius – he commissioned a modeller who had never worked in porcelain.

Gimson asked his most popular modellers, Doris Lindner and Freda Doughty if they were interested, but they were only at home with animals and child figurines. Freda mentioned that her sister, Dorothy, had a great love of birds and Freda agreed to teach her the rudiments of modelling for porcelain manufacture. And so, in 1935, the first Doughty birds, the Redstarts, were made using traditional methods. Sixty-eight pairs were sold which was a moderate success for a new venture. The pair of Goldfinches the next year also appeared stiff, but the matt glaze appealed to American buyers and the full edition of 250 pairs sold. The birds looked real but the flowers on these early models let them down.

During a visit to the factory to see her models in production, Dorothy met Antonio Vasallo whose job was to model china flowers for pin trays and brooches. At once an idea came to her – what if Antonio modelled flowers individually on her bird models, instead of casting the flowers and leaves from moulds? Although Antonio's flowered trays sold well, Gimson agreed to let him work on the American Birds and the result was the pair of Bluebirds on Apple Blossom issued in 1936. The edition sold out almost right away and set the course for the rest of the series. From now on every Doughty bird had hand-modelled flowers, mostly made under the supervision of Mary Leigh who took over the task from Antonio.[2]

This wasn't the only pioneering technique introduced for the Doughty birds. Because she was not trained as a porcelain modeller, Dorothy didn't understand the restrictions necessary to create sculptures that could be supported in the kiln. She wanted her birds to appear free-flying, joined to the tree branch by just a wing tip or tail feathers. Dorothy's plasticine models were held in place by an internal wire framework, but the potters at Royal Worcester told her that such dramatic poses could not be made out of porcelain as the models would collapse in the kiln. Dorothy Doughty was a determined personality and wouldn't take no for an answer. Bob Bradley was in charge of casting figure models and working with Miss Doughty he came up with a method of removable kiln supports. Each new Doughty bird became more daring than the last, and even more lifelike.

Because they sold in America and brought valuable revenue to Britain, the Doughty birds continued in production during the war years. The Mockingbirds, seen here, were made in 1940 at the time of the evacuation from Dunkirk. Dorothy told the factory craftsmen that the sprays of peach blossom she had cut from a tree in her garden seemed naturally to form into the shape of Winston Churchill's famous 'V' sign.

In 1953 Dorothy Doughty paid the first of two visits to America to see for herself the real birds in their natural habitat. She took photographs and made drawings, and also in the field she created three-dimensional 'sketch models' from twigs, wax, cork, plasticine and crêpe paper. She wrote: 'These sketch models are my finest work, I never touch them again. Because they follow so closely from seeing an actual bird, something of its life seems to be in them'.[3] Back in her studio in Falmouth the sketches were worked up into finished models to be delivered to Bob Bradley at

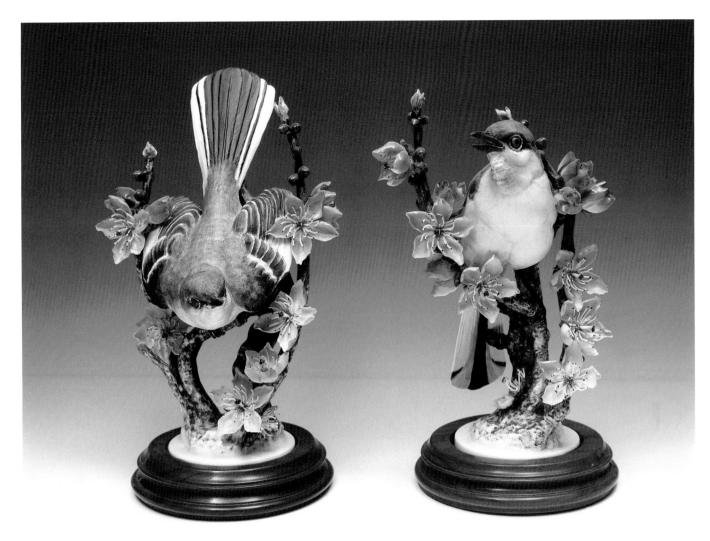

Worcester. Bradley supervised the casting, to make sure no modelled detail was lost, while Harry Davis directed the painters to capture the real patterns and correct colours of the birds' plumage. Dorothy explained to the Worcester craftsmen how her birds were 'all portraits of living birds and flowers. It is not enough that they should be beautiful pieces of china. They must, equally, be true to nature in every detail as far as we can possibly make them... I have made them as true as I possibly can − please help me to keep them true.'[4]

Dorothy Doughty created more than seventy separate American bird models as well as a series of British birds. The edition sizes had increased to five hundred and as these took so long to make, many models were not issued until after Dorothy died in 1962 at the age of seventy. Her legacy lived on, inspiring Boehm and many other makers. Porcelain sculpture today owes a lot to Dorothy Doughty's pioneering work and determination. The collection of birds at Cheekwood provides a fitting finale to two centuries of fine porcelain making at Worcester.

Bob Bradley assembling a pair of Mockingbirds.

1. Henry Sandon, *Royal Worcester Porcelain*, p. 54 and pl. 178.
2. Henry Sandon, op cit, p. 57.

3. Dorothy Doughty and George Savage, *The American Birds and Flowers of Dorothy Doughty*, published in 1962 by the Worcester Royal Porcelain Company.
4. Dorothy Doughty and George Savage, op cit.

Select Bibliography

Barrett, Franklin A., *Worcester Porcelain and Lund's Bristol*, Faber, 1966, 2nd edn.

Binns, Richard William, *A Century of Potting in the City of Worcester*, B. Quaritch, 1865, 1877 revised edn.

Binns, Richard William, *Catalogue of the Collection of Worcester Porcelain in the Royal Porcelain Works Museum*, Worcester Royal Porcelain Co. Ltd, 1882

Binns, Richard William, *Worcester China, A record of the Work of Fifty Years 1852-1897*, B. Quaritch, 1897

Branyan, Lawrence, French, Neal and Sandon, John, *Worcester Blue and White Porcelain, 1751-1790*, Barrie and Jenkins, 1981, 1989 2nd (enlarged) edn.

Catalogue of the Robert Drane Collection, *The collection of Old Worcester porcelain formed by the late Mr Robert Drane*, Albert Amor Ltd., 1922

Catalogue of the Frank Lloyd Collection, Hobson, R.L., *The collection of Worcester Porcelain of the Wall Period*, British Museum, 1923

Clarke, Samuel, *Worcester Porcelain in the Colonial Williamsburg Collection*, 1987

Coke, Gerald, *In Search of James Giles*, Micawber, 1983

Cook, Cyril, *The Life and Work of Robert Hancock*, Chapman and Hall, 1948, and *Supplement to The Life and Work of Robert Hancock*, 1955

Fisher, Stanley W., *Worcester Porcelain*, Ward Lock, 1968

Godden, Geoffrey A., *Caughley and Worcester Porcelains, 1775-1800*, Barrie and Jenkins, 1969, reprinted by the Antique Collectors' Club, 1981

Godden, Geoffrey A., *Chamberlain-Worcester Porcelain 1788-1852*, Barrie and Jenkins 1982, reprinted 1992

Godden, Geoffrey A., *Encyclopaedia of British Porcelain Manufacturers*, Barrie and Jenkins, 1988

Godden, Geoffrey A., *Godden's Guide to English Blue and White Porcelain*, Antique Collectors' Club, 2004

Handley, Joseph, *18th Century English Transfer-Printed Porcelain and Enamels*, Mulberry Press, 1991

Hanscombe, Stephen, *James Giles, China and Glass Painter, 1718-1870*, 2005

Hobson, R.L., *Worcester Porcelain*, B. Quaritch, 1910

Honey, William B., *Old English Porcelain*, G. Bell & Son, 1928, revised by Barrett, F.A., Faber and Faber, 1979

Jones, R., *Porcelain in Worcester 1751-1951, An Illustrated Social History*, 1993

Marshall, H. Rissik, *Coloured Worcester Porcelain of the First Period*, Ceramic Book Co., 1954, facsimile reprint 1970

Mackenna, F. Severne, *Worcester Porcelain, the Wall Period and its Antecedents*, F. Lewis, 1950

Reynolds, Dinah, *Worcester Porcelain 1751-1783, The Marshall Collection in the Ashmolean Museum, Oxford*, 1989

Royal Worcester, *The Collectors Handbook of Royal Worcester Models*, 1969 with supplementary pages added 1970-71

Sandon, David, Henry and John, *The Sandon Guide to Royal Worcester Figures*, Alderman Press, 1987

Sandon, Henry, *Flight and Barr Worcester Porcelain 1783-1840*, Antique Collectors' Club, 1978, reprinted 1992

Sandon, Henry, *Worcester Porcelain 1751-1793*, Barrie and Jenkins, 1969

Sandon, Henry, *Royal Worcester Porcelain from 1862 to the Present Day*, Barrie and Jenkins, 1st edition 1973, reprinted 1975, 3rd edition 1978, reprinted 1989 and 1994

Sandon, Henry and John, *Grainger's Worcester Porcelain*, Barrie and Jenkins, 1989

Sandon, John, *The Dictionary of Worcester Porcelain, Volume I, 1751-1851*, Antique Collectors' Club, 1993

Sandon, John and Spero, Simon, *Worcester Porcelain, the Zorensky Collection*, Antique Collectors' Club, 1997

Savage, George, *Eighteenth Century English Porcelain*, Rockcliff Publishing, 1952

Savage, George and Doughty, Dorothy, *The American Birds of Dorothy Doughty*, The Worcester Royal Porcelain Company Ltd., 1962

Sharp, Rosalie Wise, *Ceramics: Ethics and Scandal*, Toronto, 2002

Spero, Simon, *Lund's Bristol and Early Worcester Porcelain 1750-1758, the A.J. Smith Collection*, C. & J. Smith, 2006

Spero, Simon, *Worcester Porcelain, The Kenneth Klepser Collection*, Lund Humphries, 1984

Watney, Bernard M., *English Blue and White Porcelain of the Eighteenth Century*, Faber and Faber, 1963, revised edn. 1973, reprinted 1979

Woodger, Peter, *James Hadley & Sons, Artist Potters*, Worcester, 2003

INDEX

Page numbers in bold type refer to illustrations

VINCIT